Community Learning & Libraries
Cymuned Ddysgu a Llyfrgelloedd

This item should be returned or renewed by the
last date stamped below.

Newport Library and
Information Service

To renew telephone: 656656 or 656657 (minicom)
or www.newport.gov.uk/libraries

Obsessed

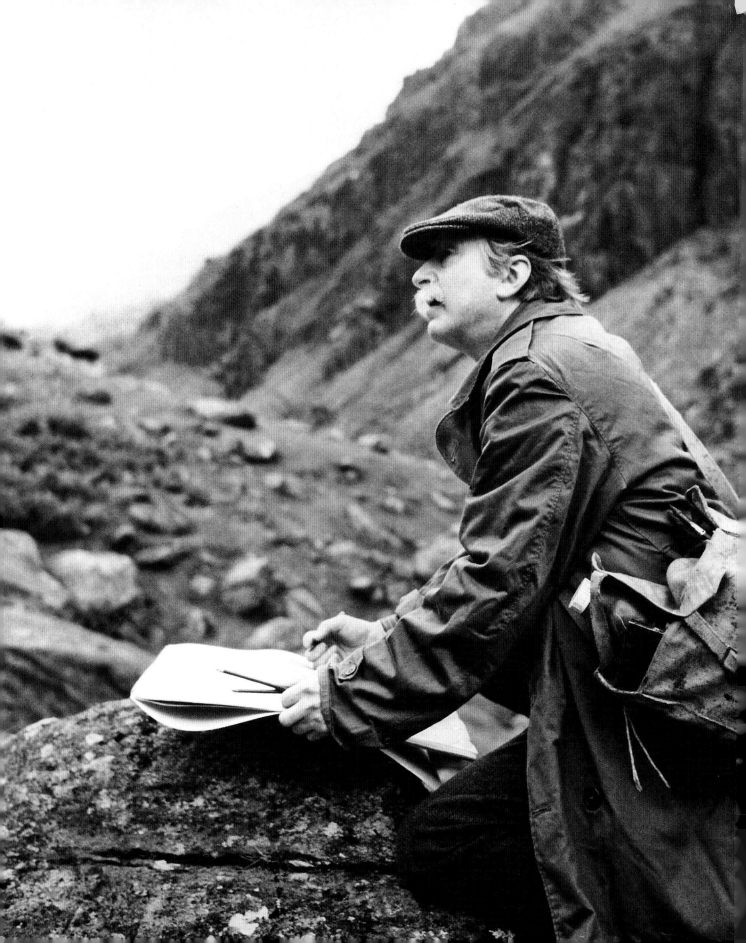

Obsessed

The Biography of Sir Kyffin Williams, RA

David Meredith and John Smith

Gomer

Published in 2012 by
Gomer Press, Llandysul, Ceredigion, SA44 4JL

ISBN 978 1 84851 484 3

A CIP record for this title is available from the British Library.

This book is published with the financial support of the
Welsh Books Council.

Printed and bound in Wales at
Gomer Press, Llandysul, Ceredigion

In memory of

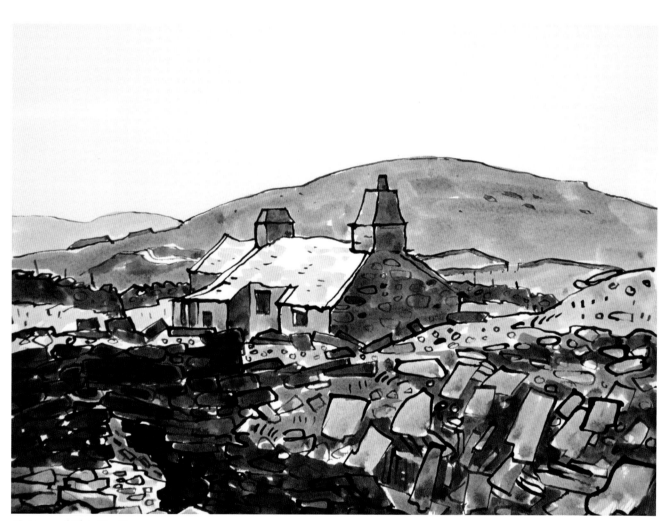

Cottage and Slate Tip, Cesarea

Acknowledgements

We wish to thank the following for their great help in the preparation of this book:

Gareth Parry, Owain Llywelyn Meredith, Lona Mason, Dr Paul Joyner, Michael Francis, Professor Derec Llwyd Morgan, John Hefin, Gruffydd S. M. Meredith, Dr Ann Rhys, Dr Glyn Rhys, Mona Roberts, Eulanwy and Gethin Davies, Elin Wynn Meredith, Charles Arch, William Troughton, Mark Overend, Vaughan Hughes, Tegai Roberts, Luned Vychan Roberts de Gonzales, Mrs Primrose Burke-Roche, Andrew Green, Llinos Jones-Parry, Ian Jones, Nicola Gibson, Dr Meic Stephens, Sir Jeremy Chance, Mrs Mary Yapp, Bengy and Annwen Carey-Evans, Chris Butler of Castle Fine Arts, Archbishop of Wales, The Right Reverend Dr Barry Morgan, Ann and Odwyn Davies, Lord Dafydd Wigley of Caernarfon, Sarah Macdonald Brown, Miriam Harriet Hughes and Fiona May Hughes, Eifiona Thomas de Roberts, Alwen Green, Laura Henry, Laura Irma Jones, Esyllt Nest Roberts, Rebecca Henry (Editors *Y Drafod*) LM, Myrddin ap Dafydd, Mari Emlyn, Gwenda Griffith, Stephen Kingston, Steve Jones, ITV Wales Cardiff, BBC Wales Bangor, Fflic, Cwmni Da Caernarfon, Boomerang, Nesta Davies, Greta Berry, Valerie Wynne-Williams, Francis Uhlman, Sheila Graham, Michael Wynne-Williams, Gwilym Prichard, Claudia Williams, John Rees Thomas, Pat West, Hayden Burns, Amanda Sweet, Anglesey County Record Office, David Smith, Highgate School, Malcolm 'Slim' Williams, Einion Thomas, Archivist, University of Wales Bangor, Llion Williams, Iwan Dafis, National Library of Wales, Ann Venables, The Marquess and Marchioness of Anglesey, Barbara Davies, Elvey MacDonald, Eleri Mills, Alun Ifans, Ann Davies, Roderick Thomson, D. A. Pugh, Henry Pritchard-Rayner, Huw Rossiter, Tegfryn Gallery, Julian Halsby, Diana Armfield, Bernard Dunstan, Margaret Thomas, Vicky Macdonald, Mr and Mrs Roger Williams-Ellis, Professor Anthony Carr, Professor Robin Grove-White, Count Nikolai Tolstoy, Ken Heptenstall, John Clifford Jones, Evan Dobson, British Museum, Gerallt Ratcliffe, *Daily Post*, Tegid Roberts, Dr Margaret Wood, Drs Morys and Pat Cemlyn-Jones, and to John Barnie, Ceri Wyn Jones and all at Gomer for their patience and invaluable guidance.

Contents

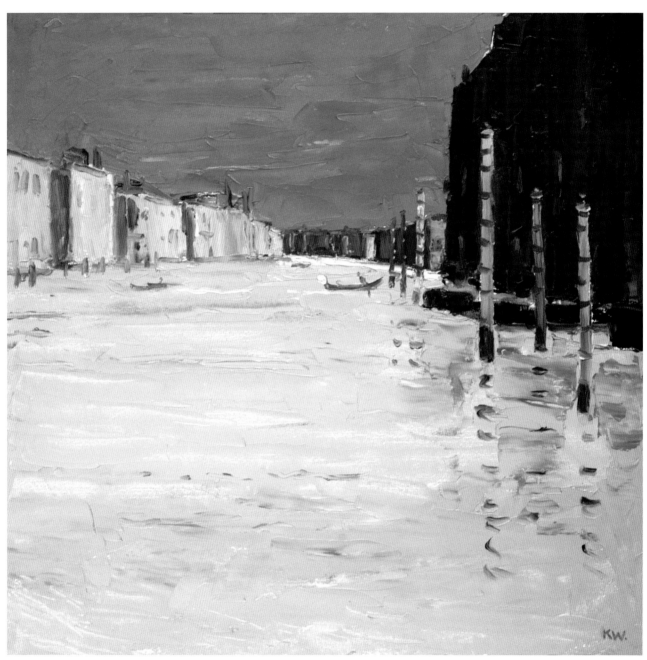

Kyffin's 'remarkable picture' *Grand Canal, Venice*

The Glory of Venice

IN 2003, AGED 85, in poor health but in great spirits, Sir Kyffin Williams RA, John Kyffin Williams or just Kyffin as he preferred to be known, pre-eminent amongst Welsh artists, accepted an invitation to take part in a television documentary on his life and work. One part of the programme would be filmed in Wales, the other in Venice. David Meredith, one of the instigators of the programme and an old friend of the artist, recalls with pleasure his experience of being with the artist on location in North Wales and being, in Kyffin's words, 'his pilot' during that last visit to Venice, a city where, as Kyffin put it, 'the sky gets very dark blue black and all the palazzos along the Grand Canal become silvery rather like in the work of Guardi'.

The filming for the documentary, *Reflections in a Gondola*, began in winter 2003. In Wales, filming took place at a number of Kyffin's favourite locations, places that had inspired some of his greatest paintings: at the cliffs of South Stack in Anglesey, in the area of the Cnicht mountain near Llanfrothen, in the Nanmor area for Yr Wyddfa and at Islawrdre, Dolgellau near the ruins of Capel Rehoboth, surrounded by the land of Gallestra Farm, where Kyffin painted Cadair Idris, a mountain he referred to as 'a long ridge' and which he first painted in 1947. Filming was also undertaken at the BBC Studios in Bangor, at the Royal Cambrian Academy Galleries at Conwy where Kyffin was a highly respected president, and at the National Library in Aberystwyth, a national institution very close to Kyffin's heart.

He had agreed, at the beginning of May 2004 [David Meredith writes] that I could chaperone him on the visit to Venice. My friend John Hefin and I had long planned to take Kyffin there. It was a city Kyffin knew well, having first visited it in 1950. The independent television company Fflic had been commissioned by BBC Wales to produce a documentary, so on 20 May 2004, Kyffin and I were on our way from his home, Pwllfanogl on the Menai Strait, to Manchester, to catch a flight to the city. The production

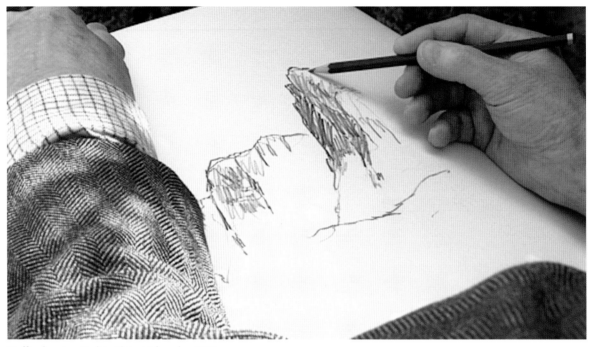

Kyffin drawing Cadair Idris at Islawrdre, 2003

team had been carefully selected by Gwenda Griffith, founder of Fflic and producer of the proposed programme. The cameraman was Stephen Kingston, with Steve Jones in charge of sound, Nia Jones as production assistant and John Hefin as director. I was the programme consultant and Kyffin's chauffeur!

Kyffin could so easily have responded negatively to the request to travel to Venice; he could have cited old age and infirmity; he could have mentioned his many illnesses. But he was a determined man and the lure of a last visit to the city was too powerful to resist.

On the day we departed, I had driven to the front door of Pwllfanogl, arriving as pre-arranged at 3 pm. My heart sank; Kyffin's yellow front door was closed and there was no sign of life. Had he changed his mind? Had he decided after all that it was too much? Then, as I parked the car, to my great relief, the front door opened and Kyffin stood in the doorway with a straw hat on his head. He was carrying a small Edwardian suitcase, held together with what appeared to be brown baling twine. On his shoulder was an old paint-stained khaki haversack for his paints and a large bottle of water (for painting). I walked towards him to be warmly greeted.

Kyffin was dressed in a grey shirt and grey tie, Harris Tweed coat, and black trousers. 'Are my clothes alright?' he inquired. To which I replied, 'Ardderchog' (excellent). Kyffin pointed to his trousers, explaining that he had painted them that very morning! 'I'd splashed white paint on them,' he explained, 'but I've painted the white spots with a black felt pen. Will they do?'

The trousers looked fine to me. If felt pen-painted trousers was the price we had to pay for taking Kyffin to Venice, then so be it. 'A real Saville Row job,' I replied. He smiled.

During the journey to Manchester Airport I learnt that Kyffin enjoyed travelling at speed by car and that he thoroughly enjoyed flying. It was a memorable flight as we sat in the comfort of the BA first-class section, and we discussed a great variety of subjects. Flying over the Alps, Kyffin wondered how on earth the early cartographers succeeded in mapping the snow-clad peaks far below us. We compared our first reactions, many years previously, to seeing the remarkable elephantine Dolomites with their striking taupe colour. Kyffin, the colour expert, knew exactly the hues that the high manganese content gave to the mountains.

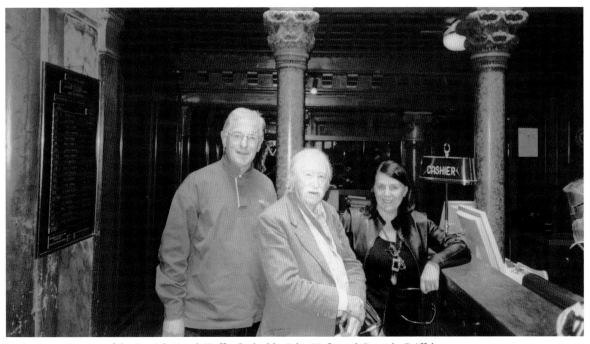

In the reception area of the Danieli Hotel, Kyffin flanked by John Hefin and Gwenda Griffith

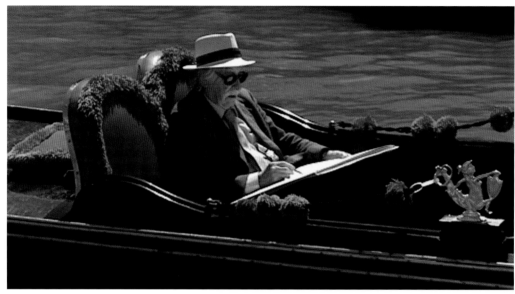

Sketching on the Grand Canal, Venice

The Church of Santa Maria della Salute drawn and coloured by Kyffin in Venice in 2004

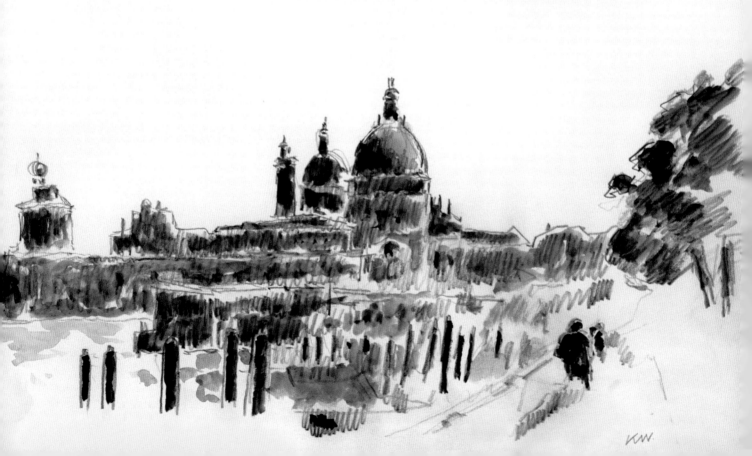

We discussed the powerful city states of Renaissance Italy, how the Republic of Venice became a maritime power and the city itself a wonderful artistic emporium. Between cups of tea, Kyffin spoke of his admiration for the work of Vincent Van Gogh and how similar their positions were, both suffering from epilepsy and both with strong family ties to the Church, Van Gogh being a minister's son and Kyffin with Church connections galore.

I had travelled to Venice many times over the years, either by car across France and down the Autostrada del Sol from Milan, sometimes by train, sometimes flying Al Italia from Heathrow to Marco Polo Airport. The journeys had been carefree summer escapes, but this journey was different, the responsibility of being Kyffin's 'minder' weighing heavily on my mind; and yet what a privilege, flying in comfort across Europe with him. It was a few days before my sixty-fourth birthday, surely things could not be better than this.

Arriving at Marco Polo Airport, Gwenda had arranged for a water taxi to take us across the Venice Lagoon to one of the best hotels in the city, the renowned Danieli Hotel, round the corner from St Mark's Square. The water taxi travelled at speed through the dark, at times choppy, water, so that we were glad when we glided with style towards the red-carpeted embankment, the main entrance of the Danieli Hotel by water. We had arrived, and Kyffin was safely ensconced in the splendour of the Danieli, where a pot of tea had been ordered.

I knew it had been touch and go, but it was only later that I learnt that Kyffin had recently been diagnosed with terminal cancer.

Having settled in the Danieli, Kyffin wasted no time. He was out sketching along the banks of the Grand Canal. Many drawings (pencil and watercolour) were produced over the next few days, some of which were coloured in Venice, while others were coloured back in Wales. One large drawing of the Grand Canal was prepared and later completed in oil in Wales. It was the only oil painting of the visit. This painting of the grey waters of the Grand Canal with a 'dark blue black sky' above is a classic example of Kyffin's mastery at painting water in oil. Author and broadcaster Jan Morris, giving the 2011 Sir Kyffin Williams Lecture organised by the Sir Kyffin Williams Trust, said of this painting:

> I suppose I have in my library at home a couple of hundred paintings of the Grand Canal, in reproduction I mean, and not one of them is remotely like this remarkable picture of Kyffin's. It is a deadpan kind of picture; the canal looks as though it might be frozen, and the sparse traffic on it – a solitary gondola, a couple of intermediate skiffs – seem motionless. The sky is a dark, rather surly kind of blue. The water, though not

rough, seems oddly perturbed…The majestic avenue of palaces looks utterly lifeless and the only recognisable sign of humanity in the picture is the blurred figure of the oarsman, in his otherwise empty gondola. The picture is entirely Kyffin. No other influence or relationship is apparent. It is his alone.

This painting is one of the last oil paintings he ever did.

During our stay in Venice, Kyffin was filmed at a variety of locations: at the Scuola di San Rocco, where the work of Tintoretto on a biblical theme reigns supreme, and gliding in a decorative gondola along the Grand Canal sketching as he went. Kyffin added to the elegance of Café Florian in St Mark's Square and inspired the film crew with talk of the Colleoni Statue (the statue to the famous mercenary Bartolomeo Colleoni), the work of the Renaissance sculptor Andrea del Verrocchio, who was in turn Leonardo da Vinci's first art master.

In the Terrazza Danieli, the restaurant high up on the roof of the Danieli Hotel overlooking the Venice Lagoon, with San Giorgio Maggiore immediately in front and the Church of San Salute to the right of us, Kyffin and I sat in the shade of a striped awning. The conversation flowed effortlessly from topic to topic, while well-groomed waiters in spotless white coats brought endless pots of tea to our white linen-covered breakfast table. I savoured these priceless moments; I knew they would never be repeated.

On arriving in Venice, Kyffin and I were told that there was a problem with our insurance. Kyffin could not get cover because he was too old (he was 86) and cover was impossible for me because of my hip operation. We received this grave news in silence, but the look we gave one another was as if we had recited in unison 'We are in Venice – who cares!'

John Hefin, who had directed many Welsh greats including Hugh Griffith, Siân Phillips and Kenneth Griffith, said that it had been a privilege to direct Kyffin. John added, 'Kyffin was recognisably different from the rest of us in so many ways. The multitude thought they knew him, in fact only a clutch had true knowledge of the melancholic maestro. He knew things that the rest of us had no inkling of, a third eye, a sixth sense, indefinable qualities which gave us the gift of a kind, perceptive, eccentric, wise Welshman.'

During the filming in Venice, John was amazed at Kyffin's discipline. He would concentrate totally on his drawing, apparently oblivious to the camera and the director, and yet alert to directorial requests as to how he should stand at locations or adopt certain positions in gondolas.

There were moments of light relief over supper, when Kyffin recited some of his limericks, or wrote impromptu new ones to the delight of the whole crew, such as the one about a 'Peculiar Fellow':

> A funny old fellow called Sam,
> Said yes I will if I can,
> If I find that I can't
> I suppose that I shan't,
> A very perplexing old man.

But all those present clearly understood that Kyffin was in Venice to work, and to complete the filming to the director's and the producer's satisfaction. He also knew, as we did, that this would be his last visit to Venice. In fact, the programme, *Reflections in a Gondola*, which was to become a television classic, was a panorama of Kyffin's life. The programme, with its theme of 'four fortuitous moments in my life', gave Kyffin the opportunity of choosing, firstly, his birthplace in Anglesey; secondly, a spiritual moment at the Ashmolean Museum in Oxford while an art student at the Slade, when he first saw Piero della

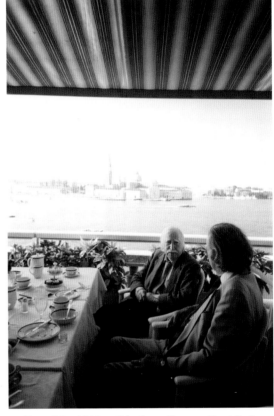

Kyffin and David Meredith chat at Terrazza Danieli, the restaurant overlooking St Mark's Basin and the Venice Lagoon

Francesca's *Resurrection* (later he was to see the actual fresco in Italy); thirdly when he was an art master at Highgate School in London in 1947, and found himself painting alone on the slopes of Cadair Idris in Merioneth, sensing at the end of the day's labour that maybe, just maybe, he could make a living by painting; and fourthly, there was Venice. Kyffin had a genuine love of Venice and knew the city well. He was an expert on the work of native Venetian artists like Titian, Guardi, Tintoretto, Canaletto, Bellini and Giorgione and the other artists who had painted in Venice like Monet, Turner, Sickert, Boudin, Whistler, Bonington, Manet, Renoir and Frank Brangwyn. But Kyffin also had family ties with the city. One of his forebears, the brother of his great-great-great-uncle, Thomas Williams MP, known as 'the Copper King', who made a fortune from mining

copper at Parys Mountain in Anglesey, had a house in Venice. Kyffin said of the city that he 'loved its opulence, its sumptuousness, and its elegance' and that everything about the light in Venice, so vital to Kyffin the artist, 'was magnificent'.

For his fourth choice Kyffin could equally have chosen Patagonia, and Fflic as a production company was highly experienced in filming in Argentina. But there were major health considerations. Kyffin's age and infirmity ruled out a twelve-hour flight to Patagonia. Venice, in contrast, was only two and a half hours by air, and so Venice it was.

Having returned home from the visit on 27 May 2004, I received a letter from Kyffin. In it he wrote:

> Annwyl David,
> Cornucopias of diolchs for your benevolent caring for the ageing artist in Venice. I hope my dotage was not too apparent, my steps not too infirm, my conversation not too fatuous and incomprehensible.

In fact, Kyffin had been active and alert and the most comprehensible of us all.

In 2006, with Kyffin in his eighty-eighth year, Gomer Press published my book *Kyffin in Venice*, an illustrated interview/conversation between the artist and myself. As I noted in the introduction, 'Kyffin avoided no questions, looked me straight in the eye and spoke with wit, clarity and humility – a great man, the greatest of artists.' The 'conversation' began at Pwllfanogl and continued at the Danieli Hotel in Venice.

Kyffin showed how vital Venice had been in the development of oil painting: 'The place it really took off was in Venice ... Venice at this time [circa 1474] was a maritime power and in their shipyards there were acres of canvas and this oil medium was painted, more or less, as a substitute for the tempera painting in the Low Countries, whereas in Venice, they had these acres of sailcloth and great artists like Titian, Tintoretto and Veronese could paint huge pictures.' One expert believed that there was (however tenuous) a Welsh link with the great Venetian painter Canaletto through one of his oil paintings. In 1749, Canaletto was in London painting and advertising his work in the hope of attracting buyers, as well as commissions. It is believed that he targeted Sir Watkin Williams-Wynn (1692-1749), the Welsh Tory MP and very powerful landowner and patron of the arts, when he painted a London scene – *The Old Horse Guards from St James' Park*. Sir Watkin's London home appears on the right-hand side of Canaletto's composition – No 1 Downing Street. Unfortunately for Canaletto, Sir Watkin was killed on 26 September

1749 in a riding accident before (possibly) having the opportunity to buy a painting of his London house by one of the greatest Venetian painters of his day.

Kyffin in Venice was launched at Oriel Ynys Môn in Llangefni, Anglesey, but Kyffin could not attend the event; he was unwell. To make up for his absence, a special DVD was prepared by Tinopolis TV with Kyffin addressing the audience from the comfort of his home. He said a little later that he was so weak that he could not sign his name, yet to his surprise, he could draw and paint in watercolour.

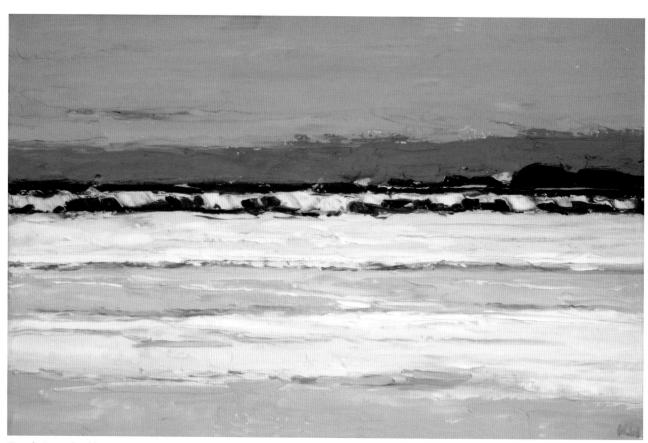

Rough Sea, Llanddwyn

The Need for Roots

KYFFIN WAS VERY PROUD of being a native of Anglesey, a county where none of the land is more than 750 feet above sea level. No wonder he often said that it was the ideal platform from which to view the huge Eryri range on the other side of the Menai Strait. He recognised that Anglesey was a very special place, the third largest island in the British Isles, with a great variety of palaeological sites and significant Pre-Cambrian rocks. Kyffin understood the geology of Wales and took pride in the fact that it was Sir Andrew Crombie Ramsay, his great-uncle, a friend of Darwin and Director-General (1871) of the Geological Survey of Great Britain, who contributed more than anyone to our knowledge of the geology of Wales. As Kyffin said: 'I often visit South Stack to watch the sea birds and wonder at the primeval convulsions that created the distorted bands of rock. The geology of Anglesey is even more fascinating than its natural history.'

Kyffin was very aware that Anglesey had been the centre for the Druids and was knowledgeable about the Roman attack on the island in AD60 , as chronicled by Tacitus. Centuries after the departure of the Romans, Anglesey became one of the main targets of Viking attacks, the Vikings giving Anglesey the name 'Ongulsey' – comprising the personal name, Öngull, and 'ey' meaning island.

In later centuries, the island became the powerhouse of the princes of Gwynedd with their main court at Aberffraw. Kyffin noted their influence when he wrote of one of the family homes, Treffos: 'Treffos is an ancient site and means "the place with a ditch" … It was certainly the property of the old Welsh Princes.' History was very real to Kyffin.

He was also very knowledgeable about the prehistoric period, especially the New Stone Age circa 4000–2000BC and the symbolism of sites such as Bryn Celli Ddu. The logo he designed for Oriel Ynys Môn in Llangefni was based on this remarkable structure. From Bronze Age sites in Anglesey (c. 2000–500BC) Kyffin would get his inspiration for

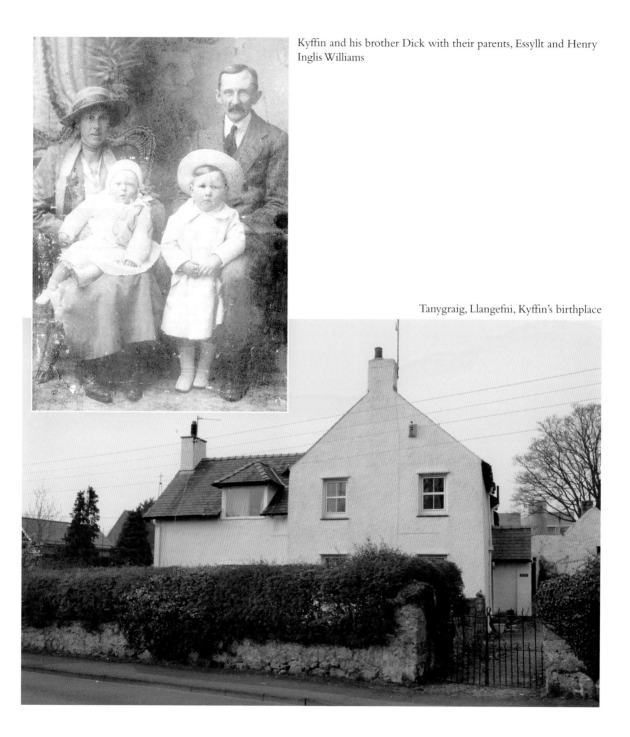

Kyffin and his brother Dick with their parents, Essyllt and Henry Inglis Williams

Tanygraig, Llangefni, Kyffin's birthplace

the logo he designed for the 1983 National Eisteddfod at Llangefni, which was based on the Meini Hirion (the long stones), the remains of a burial ground, or burial mound, comprising many graves. The findings at Llyn Cerrig Bach, near Valley, where military equipment from the Celtic Iron Age was sacrificed to please the Gods, were a great source of pride for Kyffin, pride in the rich historical heritage of his native county.

In 1979, he observed that 'Anglesey is so unlike the rest of north Wales, for it has been worn down by the passing of time and its rocky outcrops show us continually the complexity of its structure. Consequently, the island has an air of antiquity that is not immediately discernable to the visitor. We, on the other hand, are aware of the continual battle between the land and the water surrounding it and a pearly light that would have been loved by the French Impressionists has been created by its encirclement.'

Llangefni, Kyffin's birthplace, became Anglesey's county town in 1889, but it was already an important trade centre, displacing Llanerch-y-medd as the main county market during the eighteenth century.

Treffos, Kyffin's ancestral home

Llangefni also became an important religious centre at the beginning of the nineteenth century when it was home to two powerful revivalists, Christmas Evans, a Baptist minister, and John Elias, a Calvinistic Methodist preacher. Their respective chapels in Llangefni were two of the most prominent buildings in the town. These two evangelists were to have a major influence throughout Wales.

In 1996, Anglesey was given county status once more, as Ynys Môn, having been part of the new county of Gwynedd since 1974. Kyffin, a stickler for correct pronunciation of Welsh place names, would pronounce Ynys Môn perfectly and would chastise those who pronounced it with Môn sounding like 'moan': 'We don't live in a moaning groaning island, we live in Ynys Môn.'

In the nineteenth century, it became an island of numerous parishes, totalling in all seventy-six. It was in many of these parishes that Kyffin's forefathers served the Church with great distinction and dedication. With so many of the family involved in church matters, the names of the Celtic saints were part of his being: names such as Beuno, Cybi, Dona, Tysilio, Mwrog, Caffo, Seiriol, Pabo and Machraith.

In his usual sardonic style, under the heading 'Family Trees', Kyffin writes in his autobiography, *Across the Straits*: 'It is unwise to state categorically that one's pedigree is correct, for often in the past the compilers of such documents have been forced by threats or bribes to legitimise certain irregularities, in order that a family might be able to show to the outside world a line of continual respectability. Both the Treffos and Craig y Don families are descended from Wmffre the blacksmith, but whereas it is reasonably safe to assume the Treffos line to be correct, such confidence might be misplaced in the case of Craig y Don.'

Kyffin was fascinated with every branch of his family. He took particular pleasure in writing about different branches of the Williams family in *Across the Straits*. It all began with William ap John ap Rhys of Llandegfan. His son was Humphrey Williams (1661-1752) known as 'Wmffre'. He married Elizabeth, daughter of the Reverend William Prydderch, Rector of Llanfechell. Humphrey was succeeded by his son Owen (1698-1786) who consolidated the family business by buying Treffos, a 'plas' or mansion in the parish of Llansadwrn. Owen had two enterprising sons, John and Thomas. As Kyffin notes in *Across the Straits*, 'With these two different personalities, the family divided. There were the solidly prosperous descendants of John, who lived at a house called Treffos, and the wildly wealthy descendants of Thomas, who lived at nearby Craig y Don, their home on the Menai Straits…married into the English aristocracy and spent themselves on the turf.'

John, who was Kyffin's great-great-grandfather, became chaplain to Princess Augusta of Wales at Windsor and later received the livings of Llangaffo, Llanddeusant and Llanfair-yng-Nghornwy in Anglesey.

The other son, Thomas, became very successful, dominating the British copper industry, mainly in Anglesey's Parys Mountain and in Cornwall. He became known as 'Twm Chware Teg', Fair-play Tom. 'He left a vast industrial Empire which later was to form the nucleus of the industrial giant ICI,' according to Kyffin. In his day he started smelting works in south Wales and Lancashire, and the family had homes in London and Venice. Thomas also became MP for Marlow – he was a solicitor by profession. Parys Mountain in its day was the largest copper mine in the world.

If not filthy rich, Kyffin's great-great-uncle, John Williams and his family, again of the Treffos branch, were very colourful. Resourceful and ambitious, John Williams became Receiver General for North Wales. Other relatives were knighted, Sir Ralph Williams becoming Governor of Newfoundland, while Guy Williams, son of Colonel Richard Williams of Treffos, became a general as well as a knight of the realm.

In his autobiography, Kyffin notes that 'With John Williams began our association with the far north-west corner of Anglesey, and there is hardly a parish in the square of Amlwch, Llangefni, Holyhead and Llanfair-yng-Nghornwy in which we have not held a living at some time in the last two hundred years.'

The Reverend John Williams of Treffos (1740-1826), always pronounced and written by Kyffin as one word – Treffos – was Rector of Llanfair-yng-Nghornwy. He married Eleanor, daughter of the Reverend James Vincent, Vicar of Bangor. Their son, the Reverend James Williams (1790-1872), was Chancellor of Bangor and Rector of Llanfair-yng-Nghornwy like his father before him. He married Frances, daughter of Thomas Lloyd of Glangwna, Caernarfon and Whitehall, Shrewsbury. According to Kyffin his great-grandmother was a 'very intelligent girl, who brought some culture into the family'. Frances also painted well, studied astronomy and was passionate about shipping. She charted the Menai Strait before she was twenty-one. Frances and James went to live in the rectory at Llanfair-yng-Nghornwy, within sight of the sea, and were witnesses to a horrendous maritime disaster on their return from their honeymoon when the packet boat *Alter* was lost with 140 people on board. From that moment, Kyffin believes, both decided to dedicate themselves to ensure that there would always be lifeboats available to prevent such disasters. As a result, the Anglesey Lifeboat Association was formed, the precursor of the National Lifeboat Service, the Association's first boat being stationed below the Llanfair-yng-Nghornwy rectory in Cemlyn Bay.

James and Frances' son, Owen Lloyd Williams, Kyffin's 'Taid', continued their interest in the lifeboat service. Kyffin was very proud of the slate plaque in the church at Llanfair-yng-Nghornwy commemorating the valour and dedication of his great-grandparents and grandfather. The Reverend Owen Lloyd Williams (1828-1919) – 'Taid' – like his father, became Chancellor of Bangor Cathedral and Rector of Llanrhuddlad. The affable 'Taid' was a friend of the Reverend John Williams, Brynsiencyn, Anglesey, the great twentieth-century Calvinistic Methodist minister and preacher. One of the most memorable photographs of John Williams is the one of him standing in his army recruiting uniform on the steps of number 10 Downing Street, with his friend the Prime Minister, David Lloyd George.

'Taid' married Margaret Kyffin, daughter of the Reverend John Kyffin, Rector of Llanystumdwy in the old County of Caernarfonshire. Margaret Kyffin was therefore Kyffin's grandmother on his father's side of the family. Her family were from the Llansilin area near the Wales–England border, not far from Oswestry. Margaret's father, the Reverend John Kyffin (1781-1838), had married Anne Owen, born circa 1788. Anne Owen's father, Edward Pugh Owen, claimed descent from the infamous Baron Owen (Lewis Owen) who, as Sheriff of Merioneth 1545-6, was responsible for hanging a hundred or so of the local renegades, 'Gwylliaid Cochion Mawddwy' (the Red Bandits of Mawddwy), described as 'a strong tribe who lived by plunder'. Some believed them to be the remnants of one of the armies after the War of the Roses. Baron Owen showed no mercy in administrating the law, in spite of pleas for mercy from the mother of the youngest bandit he was about to hang. The Gwylliaid, however, were to get their bloody revenge when they attacked and assassinated Sheriff Lewis Owen at a location not far from Dinas Mawddwy, still known to this day as 'Llidiart y Barwn' (the Baron's Gate), near Mallwyd. Kyffin would have taken no pleasure in knowing that he was related, albeit distantly, to such a cruel and heartless sheriff and judge, but he would have told the tale with gusto.

'Kyffin' is a well known name in old Montgomeryshire, with farms such as Kyffin Ganol and Pentre Kyffin. One of Kyffin's ancestors in the fifteenth century was a Meredydd ap Madog ap Ifan. At this time Welsh people were adopting short surnames, and Meredydd chose Kyffin as his.

The Glascoed Estate in the parish of Llansilin was an ancient seat of the Kyffins. Reference is made in manuscripts to the Kyffin family of Glascoed 1585-1770. In 1595, a Richard Cyffin lived at Glascoed; he was an author and translator. Glascoed was later conveyed by marriage to Sir William Williams, one-time Speaker of the House of Commons, and later again it became the property of his descendant, Sir Watkin Williams-Wynn.

The parish of Llansilin, situated on the river Cynllaith, an area seven to eight miles long and four to five miles broad, was and is good agricultural land, with rich fertile soil and productive farms, where drovers took their stock from the mountain farms of Wales to be fattened, before walking them on to market towns in England, such as Barnet in Essex, where they were sold.

The parish of Llansilin is also the location of Wales's most famous home. 'Sycharth' was the residence of Owain Glyndŵr, described by fifteenth-century poet Iolo Goch as being surrounded by a park with fishponds and deer and with a bounteous welcome to all – 'Na syched fyth yn Sycharth' (No thirst will ever be at Sycharth). Llansilin and its environs have always played a prominent part in the history of Wales. Kyffin was proud of his connections with the area.

Returning to Owen Lloyd Williams (Taid) and Margaret Kyffin, one of their sons, Owen Kyffin Williams, became Rector of Coedana in Anglesey, and another of their sons was Henry Inglis Wynne Williams, Kyffin's father. He married Essyllt Mary, daughter of another rector, the Reverend Richard Hughes Williams, Rector of Llansadwrn, whose father, the Reverend John Williams of Rhoscolyn, was born in Llanddewibrefi in Ceredigion. His wife Martha was also a rector's daughter, her father being the Reverend John Roberts of Rhiwlas, near Bangor, who was in his time also Rector of Llansadwrn in Anglesey.

But Kyffin's family were not only deeply involved with religious affairs in Anglesey; they were also highly active in the island's social, legal and political life. John Williams of Treffos, the banker and land agent, was a chairman of the Magistrates' Bench who, in 1869, as a result of a new disciplinary ethos in prison life, was involved in arrangements to buy a treadmill for the prison service. John Williams was also considered to be the main voice of the Middling Tory Squires, closely linked with the Magistrates' Bench.

His father before him, the Reverend John Williams of Treffos, was a JP listed as acting under the Lord Chancellor's Commission.

It is through Dr Anne and Dr Glyn Rhys of Ystrad Meurig that we learn of Kyffin's previously unknown Ceredigion family roots. Anne and Glyn were personal friends of Kyffin who gave him vital support at difficult times in his life and made him welcome at Ystrad Meurig at all times.

Ann Rhys explained Kyffin's Ceredigion link: 'My family's friendship with Kyffin spanned nearly twenty years and we were privileged, indeed blessed, to enjoy his regular visits to ours and our visits to Pwllfanogl. Although he only painted one oil of Ceredigion, that a painting of Teifi Pools, he felt a close kinship with this county and asked my

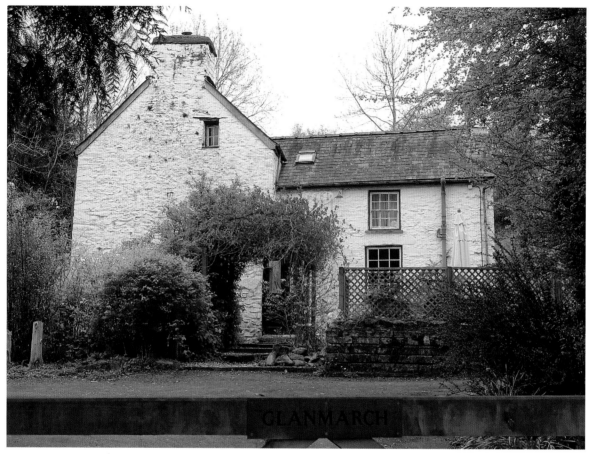

Glanmarch near Olmarch (Cockshead), Ceredigion

husband Glyn to trace his mother's roots in Ceredigion. Her grandfather, the Reverend John Williams, was one of the earliest graduates of St David's College Lampeter, in the early 1830s. He later became Rector of Rhoscolyn. Glyn was able to take Kyffin to Glanmarch, a house between Tregaron and Lampeter near Olmarch (Cockshead) where he lived, and in fact they viewed Glanmarch as it was for sale. Glyn also took Kyffin to Tywi Fechan, where his great-great-grandparents (John Williams's parents) had lived, now almost inaccessible, deep in Tywi Forestry, not far from Capel Soar y Mynydd. Kyffin took comfort that his great-great-grandmother lived there to the age of 103 and was buried at Strata Florida – Ystrad Fflur.'

Today, the only remains of Tywi Fechan ('Little Tywi') are a few stones and a rhubarb patch! In spite of its name, Tywi Fechan was a large farm – mainly a sheep walk – of circa 1700 acres. The Williams family were tenant farmers, tenants of the Powell family of Nanteos near Aberystwyth. W. T. R. Powell was Member of Parliament for Cardiganshire 1859-1865. It is thought that the Williams family had been shepherding on the Elenydd mountains since the eighteenth century, the Elenydd mountains being a part of the Pumlumon and Mallaen ranges. In the nineteenth century and before, there had been strife on these large upland sheepwalks over territorial rights, boundaries and grazing rights, and common land had been enclosed by Acts of Parliament, benefitting the large estates of Trawsgoed, Hafod, Nanteos and Gogerddan. We know some of the history of one member of the Williams family born around 1849, a Rhys Williams, shepherd. The young Rhys Williams became involved in a fracas with a neighbour over a sheep which resulted in him being sentenced to two months in gaol – a sentence regarded by all as extremely harsh. It is said that there were powerful opposing landowning forces at play on the Bench that sentenced Rhys Williams. History records that Rhys played a prominent role within his community; he was blessed 'with resourcefulness and self-reliance and a strength of character'. By attending St David's Theological College at Lampeter, John Williams broke with the Williams family tradition in this part of Cardiganshire and became a shepherd of men serving the Church rather than the squires and the landowners.

Kyffin therefore had roots in three of the old counties of Wales: Anglesey, Montgomeryshire and Cardiganshire, counties that have produced political, artistic, religious and cultural leaders who have served Wales well over the centuries.

With a great many vicars, rectors and chancellors and their wives caring for their parishioners, it is not surprising that Kyffin said of himself that he cared deeply for people: 'I too have been obsessed with people.' In fact, Kyffin was always at home with people, a trait that he had learnt from his father who was sociable and affable, as he readily testified in *Kyffin in Venice*: 'my father he loved people'. This led to him being unable to resist the challenge of the portrait.

It was also not surprising that Kyffin had great interest in the land, in agriculture and rural matters in general; not only were there the Cardiganshire, Montgomeryshire and Anglesey rural links, but his great-grandfather James Williams, curate of the Anglesey parishes of Llanfair P.G. and Penmynydd (1790-1872), who succeeded his father as rector of Llanddeusant, Llangaffo and Llanfair-yng-Nghornwy, was also deeply interested in agriculture. He made a major contribution to a book by John Owen (1808-1876) of Tynllwyn on cattle breeding, published in 1869, while another family member introduced

the first steel plough into Anglesey. Kyffin's father also had an interest in animals, keeping a cow for milk while living at Llangefni and breeding Welsh cobs as a sideline. James Williams had also been a zealous and generous supporter of the National Eisteddfod, which he rarely failed to attend.

Although Kyffin could not remember his two grandfathers, they 'nevertheless played a great part in my life and have, I suppose, exerted a strange influence beyond the grave'. 'Taid' on his father's side, the Reverend Chancellor Owen Lloyd Williams, respected by church and chapel, was one up on his other grandfather on his mother's side. The Reverend Richard Hughes Williams was only accepted by the churchgoers of the parish. 'Taid', from a wealthier and more landed family was also, according to the beliefs of the time, one up educationally. He had been educated at Shrewsbury School, whereas Richard Hughes Williams was educated at Friars School in Bangor, the one being a public and the other a state school. 'Taid' was also one up in the church structure and took 'a happy-go-lucky attitude towards life', while Kyffin's grandfather Richard Williams, 'ambitious and melancholic was always striving to improve his position both socially and ecclesiastically'.

Kyffin maintains that his grandfather was 'never called upon to do a courageous act'. This call came to his 'Taid' continually, 'and he never failed, for the lifeboats had always been part of his life and he carried on a tradition of life-saving, started by his mother and father in 1819.'

Kyffin believed that he had inherited, through his father, his Taid's 'robustness and love of people', while from his grandfather, via his mother, his inheritance was 'a certain neurosis that gives an element of melancholia to my portraits and loneliness to my landscapes.' He always maintained that he should be 'equally grateful' to both of them.

The Church in Wales, mid-nineteenth century, was served by twenty-five bishops, all of whom, with the exception of five Welshmen and one Scot, were English. Although there were exceptions, the majority were ignorant of the Welsh language and had 'not the most distant intention of ever learning it'.

On the other hand, John Williams of Treffos, Kyffin's great-great-grandfather, was elected in 1805 as treasurer to a group of clergymen in the Diocese of Bangor, an enlightened group concerned with the wider use of the Welsh language through the preparation of Welsh reading matter. It was 'a society for the publication of treaties on religious topics in Welsh'. And it was Chancellor James Williams, Kyffin's great-grandfather, who prompted an Anglesey schoolteacher named John Rhys to attend Oxford University. John Rhys

would subsequently become Sir John Rhys, an eminent Welsh scholar and Professor of Celtic Studies at Jesus College, Oxford.

With a fascinating family history behind him, it was in the county town of Llangefni, Anglesey, that Kyffin was born, in a house called Tanygraig, on 9 May 1918. His father, Henry Inglis Wynne Williams, was the manager of a local bank. The bank originally had been started by Kyffin's relative, Thomas Williams, the businessman and millionaire, as the Williams Chester and North Wales Bank, before selling out to the North and South Wales Bank, which was later sold to the Midland Bank, where Kyffin's father ended his banking career.

Kyffin was a second child, his brother Dick, Owen Richard Inglis Williams, being born eighteen months before him.

The place of the Welsh language in Kyffin's family is interesting. Kyffin said in *Kyffin in Venice*: 'Both my father and mother were fluent Welsh speakers. My mother would not speak Welsh because she thought it was rather infra dig to speak Welsh, but my father loved it. He got on terribly well with everybody.' Essyllt Mary's attitude to the language was strange since her parents were also Welsh-speaking, her father with roots on his father's side in the heart of Cardiganshire. Yet it was a phenomenon that, alas, has continued into the Wales of today. We know that Kyffin's family, as rectors and vicars, used the language as a natural means of communication. It was therefore a great irony that the second time Kyffin's grandfather, 'Taid', used the English language during a baptism in the whole of his career, was when Kyffin, his own grandson, was baptised by him. The first time was when Kyffin's brother, Dick, was baptised. Kyffin once said that his family had to speak Welsh: they would have been unable to get on in the parishes if they had not.

With her negative, prohibitive attitude to the language, banning its use in the home, Kyffin's mother Essyllt Mary brought to an end centuries of Welsh speaking in one branch of the Williams family. She, in turn, had been sent away to Camden School in England, and having run away from that school, shared a governess with three wealthy girls in Liverpool, one of whom was a Miss Tate of the Tate and Lyle family.

Kyffin regarded the ban on Welsh at home as brainwashing. It meant, as he said, that 'if anybody outside the home spoke Welsh to me I would automatically switch off'. But the language was deep within Kyffin nevertheless. In later life he would use it extensively to communicate with fellow Welshmen and women, and to write letters to friends. He would also recite Welsh poetry in style. The majority of his paintings in oil and ink wash would also (unavoidable for a landscape painter) have titles in Welsh: *Rhayadr Cwm Glas*,

Gwastadnant and *Fedw Fawr*, to name but three out of the thousands he painted. Kyffin's announcement in the '90s, 'I paint in Welsh', meant that he had finally broken free of his mother's linguistic taboo.

In a review of the book *Kyffin – His Life His Land*, broadcaster and editor Vaughan Hughes suggested in the magazine *Barn* that without a knowledge of the Welsh language, it would have been doubtful if Kyffin could have obtained the co-operation of the 'gwerin', to all intents and purposes the monoglot country people he came to know and love, and to immortalize, in Anglesey, Llŷn and Eryri, people who don't exist any more outside his paintings. Vaughan Hughes wondered whether it was not that tribal 'hiraeth', that tribal longing, which contributed the mystical ingredients in his remarkable creations.

Kyffin was interviewed in 2003 for Fflic Productions by David Meredith in what must be his only television interview in the Welsh language. 'Kyffin 'rydych chi wedi peintio'r môr a'r mynydd, p'run sydd bwysicaf i chi?' (Kyffin you have painted the sea and the mountains, which is most important to you?). He replied: 'Dwi'n licio peintio y mynyddoedd a'r môr, hefyd yr haul ar y bryniau ac ar y môr – y cymylau trwm a du a'r haul yn torri'r cymylau a'r môr yn loyw, dwi'n licio'r môr ydw' a dwi'n licio'r lleuad yn goch yn y cymylau.' (I like to paint the mountains and the sea, also the sun on the hills and on the sea – the clouds heavy and dark, and the sun breaking through the clouds and the sea bright; I like the sea and I like the moon red among the clouds.)

To everyone's surprise (Kyffin said 'It was odd'), toward the end of her life, Essyllt Mary relented and spoke Welsh to Miss Maggie Williams from Penmynydd, who had come to help her in the house. But it was too late, the linguistic damage had been done.

When Kyffin was a baby, the family moved because of his father's managerial job in the Midland Bank to Chirk in Denbighshire. Here, Kyffin discovered the nearby glory of the Ceiriog Valley: 'So when I returned to Anglesey at the age of seven, my library of memories [always given great importance by Kyffin] had already started'. But on their return, they entered into a major family quarrel over his mother's inheritance of a large house. A wealthy relative of Essyllt Mary brought a legal action against her over the proposed new family home. Essyllt Mary won the case, but the law decreed that both parties had to meet their own punitive costs.

Abandoning Anglesey once more, the family moved to south Caernarfonshire, to Pentrefelin, a village halfway between Cricieth and Porthmadog, to what Kyffin called in his article in *Artists* (edited by Meic Stephens) 'a pretentious castellated villa called Plas Gwyn and here between Cardigan Bay and Cwm Pennant, with Moel y Gadair right in

front of the house, the Tremadoc Rocks to the East and the lovely land of Llŷn to the West, the real foundation of my art was beginning'.

It was while living at Plas Gwyn and riding on horseback along the country lanes, that Kyffin would meet one of the great British prime ministers, and one of the architects of the Treaty of Versailles, Lloyd George. These occasional meetings would be a dilemma for Kyffin. As he saw Lloyd George approaching, he was in a quandary how to greet the Prime Minister. Added to Kyffin's dilemma was the knowledge that his father was not an avid supporter of Lloyd George. Common courtesy prevailed, however, and a 'Hello' was said, to be kindly acknowledged by 'the Welsh Wizard'. In his article for *Artists*, the precursor of his autobiography *Across the Straits*, Kyffin's descriptive powers are at their best:

> I was too often on Moel-y-Gadair with my small terrier (Bonzo) and gun, and I used to forget about the rabbits I had set out to destroy, as I lay on the grassy slopes and absorbed the sounds and sights that began to be my world. Between Moel y Gest and the Tremadoc Rocks, I could see the Moelwyns; behind me Moel yr Hebog sat ponderous and confident while below me across the marsh of Ystumllyn the whole taut bowstring of the Bay stretched from St Tudwals to St David's Head. I lay there for hours on a summer evening and the spirit of that immensity seeped into my bones.

At thirteen, Kyffin counted himself 'very lucky to start hunting a lot with the farmers after foxes in the mountains and the fox took me to places people don't normally go and I saw the mountains of Gwynedd in all weathers.' As a result, he began to follow Captain Jack Jones and his Ynysfor Hounds.

Kyffin, in his eighties, would remember how the farmers of Eifionydd used to stand in a long line on the mountain tops and pass messages, one to the other, by shouting 'The fox is in the rocks at Tynybwlch', and repeat the words over and over so loud that the echo of their voices would rebound from mountain to mountain.

It was while living in Llŷn that Kyffin painted one of his early portraits, of Gwilym Iestyn Owen, a native of Aber-erch. Gwilym told the story of posing for Kyffin to the Welsh artist and teacher Ellis Gwyn. 'I remember what I liked to have. They had a very peculiar Swiss roll and a good cup of tea. Half a crown, a cup of tea and the Swiss roll, and the Swiss roll was more valuable that the other two put together.' The portrait painting project meant three visits of two hours at a time and always the same reward. Ellis Gwyn noted that Kyffin won an award at the Slade for his portrait of Gwilym and that this was the beginning of Kyffin's career in portrait painting. However, Mrs Eifiona Hughes of

Porthmadog, whose mother would occasionally help Kyffin's mother while they lived at Doltrement in Llŷn, remembers Kyffin painting a portrait of 'an old man' when Kyffin was only fifteen years old. Kyffin also gave Eifiona a painting of his dog Bonzo, a portrait now sadly lost. Eifiona gives us an interesting insight into the character of Kyffin's mother, Essyllt, who wrote to Eifiona, on the occasion of receiving a piece of the latter's wedding cake. It is a warm-hearted letter, evidence of a person able to convey her thoughts in print in a very clear manner:

<div style="text-align: right">

Doltrement
March 3rd 1949

</div>

Dear Eifiona,
Thank you very much for sending me a piece of your delicious wedding cake and such a nice card with it.

You are having lovely weather to start your married life and I hope you will be blessed with sunshine through your life.

All good wishes.

<div style="text-align: center">

Yours sincerely
Essyllt M. Williams

</div>

Glascoed, Llansilin

3

Early School Days

Moreton Hall, Trearddur House and Shrewsbury Schools

KYFFIN'S FIRST RECOLLECTION of school was when he attended Moreton Hall School in 1924 for about a year. The Williams family had moved from Llangefni to Chirk in 1920, when Kyffin was two years old. His father, Henry, became the bank manager at the Chirk branch of the Midland Bank, a bank linked with his family, through the Chester and North Wales Bank, many years before. Moreton Hall School was established in 1913 by relatives of Kyffin, the Lloyd–Williams family. Ellen Augusta Crawley Lloyd-Williams started the school when she was left with a family of two sons and nine daughters to care for on the death of her husband, John Jordan Lloyd-Williams, who had been headmaster of Oswestry Grammar School. John Jordan was also a World War One flying ace and had been awarded the Military Cross. Moreton Hall School is situated in the parish of Weston Rhyn, three miles from where Kyffin and his family lived over the Welsh border in Chirk village. Offa's Dyke is not far away from the school, and to the north the river Ceiriog marks the boundary between England and Wales. The countryside around is glorious and, along with the Ceiriog Valley, was much appreciated and explored by Kyffin as a child. He recalled wandering along the Ceiriog river watching kingfishers, and occasionally seeing a dipper searching out caddis-fly larvae in the fast-flowing shallows of the river. Kyffin's meanderings along the Ceiriog took him into the heart of Welsh-speaking Wales, where he absorbed the beauties of a land 'clothed in honeysuckle, dog-roses and bluebells'. Clearly, even at this early age, he was aware of the lure of his homeland. To Kyffin the valley village of Llanarmon Dyffryn Ceiriog, with its rural tranquillity, seemed to be real Wales in a way that Chirk was not. Llanarmon stands on the intersection of several drovers' roads, and the village's ford was once the scene of a myriad of Welsh mountain flocks making their way to English sheep markets. Kyffin often returned home from his excursions with 'wonderful straight sticks' from the

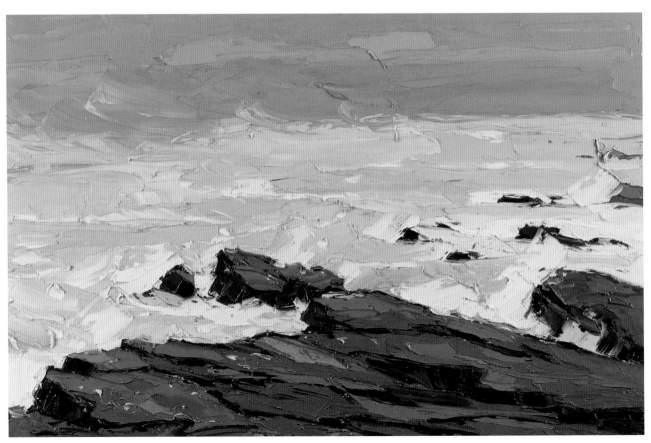

Rocks, Trearddur (where Kyffin used to swim)

abundant hazel groves in the valley. Kyffin and Dick played with these sticks at their new home, the Old Vicarage. The house was nicknamed 'Treffos' after the Williams family's ancestral home in Llansadwrn, Anglesey. The hazel sticks became rifles for marching with and, sometimes, lances for charging as cavalry officers as Kyffin played with his brother.

Kyffin was around six years old when he was first collected by Moreton Hall School's governess cart from his home near St Mary's Church in Trevor Road, Chirk. By this time Dick had departed to Trearddur House School, Anglesey, and Kyffin's governess tutor, Daisy Jenkins, had been dismissed. The three-mile journey to school took him along Telford's old road and crossed the border into England. Kyffin was always amazed by the spectacular view, a little to the west, of Chirk's aqueduct and viaduct. At weekends he would sometimes venture onto the Ellesmere to Llangollen canal aqueduct (built 1796-1801), part of the Shropshire Union Canal, with his friend and local doctor's son, Pat Salt, and peer into the canal's eerie 400-metre-long 'Darkie tunnel'. It was here that Kyffin would see laden barges silently enter the tunnel as rats slipped into the water from the dimness of the ramshackle towpath. These forays were strictly against Kyffin's mother's instructions but Pat's sense of adventure often led them both astray. Kyffin's journey to school then carried him on the winding road over Chirk Bank's canal bridge and on to Weston Rhyn where the governess cart turned towards Moreton Hall School. Kyffin often had to sit on the floor of the wet cart and endure the buffeting of several girls' feet. He recalled the girls were 'immense in size and played cricket, hockey and all sorts of ferocious games'. When asked, Kyffin could not recollect many of the pupils at the girls' school, though he did form a friendship with the only other young boy there, a French lad who spoke no English. He remembered more clearly leaving the school, after about a year, and going to Trearddur House School:

> Before I was seven I was sent off to a boarding school in Anglesey where my brother Dick had gone before me…and, of course, whenever I was at school with him he looked after me well.

In later years, Kyffin especially recalled the outstandingly well-designed war memorial in Chirk, commissioned by Lord Howard de Walden of Chirk Castle. It was created by the sculptor Eric Gill (1882-1940) and unveiled in 1920. Gill, when based at Capel-y-ffin, south Wales, was associated with David Jones (1895-1974), whom Kyffin knew around 1960 in Hampstead, London. Kyffin particularly appreciated the poignancy of Gill's soldier bent over his bayoneted rifle, wearing a greatcoat and helmet, and in beautifully

Moreton Hall School, Weston Rhyn

Moreton Hall School, 1927, Kyffin front row, second from left

carved Portland Stone. He had always loved good sculpture and often purchased pieces he liked from galleries. Kyffin was particularly aware of the memorial's link with local regiments, the Royal Welch Fusiliers and the King's Shropshire Light Infantry. It is also close to the HSBC Bank (Midland Bank) where his father once worked.

Trearddur House School

Kyffin arrived at Trearddur House School in May 1925, just before his seventh birthday on 9th May. He was promptly christened 'Jacko' by his new school pals because of his protruding ears. He admitted he was skinny, to the point that his hips would not hold his trousers up, so he kept his hands in his pockets. He benefitted from the presence of his brother Dick at Trearddur House School. Dick was nearly two years older than Kyffin and had arrived at the school in 1923. Dick was a keen sportsman and excellent scholar and would eventually move on to Shrewsbury School, but for now would be a font of knowledge and support for his younger, slightly hesitant brother.

Kyffin was always a very nervous lad, vulnerable to his own imagination and often recalled his fears of the 'giant Cormoran's larder', in *English Fairy Tales*, retold by R. A. Steel and superbly illustrated by the artist Arthur Rackham. This legendary, sadistic, Cornish giant was brought to life by Kyffin's nurse as she read to him before bedtime at their mock-Tudor, Old Vicarage home in Chirk. At Trearddur House School these past fears led him to creep warily from the darkness of his new dormitory, as the other boys slept, and along a passageway to the refuge of the light shining under Headmaster Williams's door. Here he would curl up by the door until, much later, noises inside caused him to retreat quickly back to his bed. These fears gradually diminished as he came to understand his surroundings and make new friends. His nervousness, which he always claimed he inherited from his mother and her family, never curtailed his adventurous spirit. He was able, even as a young boy at the school, to wander far and wide and with a great sense of freedom. His ability to feel secure in his own company and alone with nature would reward him later as an artist. As he settled at Trearddur House he was able to enjoy the privileges of a private education in a well-established and carefully organised school.

Prior to Kyffin's arrival at Trearddur House a large trunk was packed by his mother, Essyllt Mary, and dispatched to the school. This trunk contained the school's required list of clothing, sports gear and washing materials – indeed, everything needed for the school year. In all, nearly a hundred items were crammed into the trunk, including a scarlet school blazer, with a crest on the pocket which displayed a pair of charging horses and the

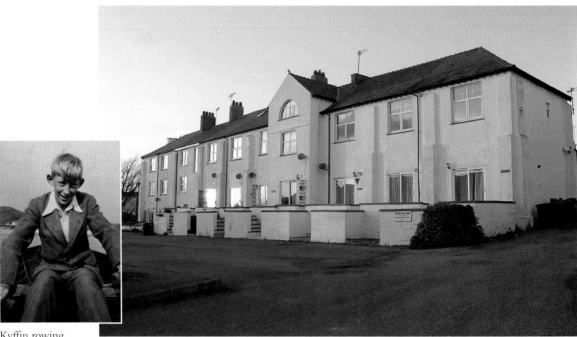

Kyffin rowing
at Trearddur

Trearddur House School dormitories

motto, 'They can because they think they can'. Twelve handkerchiefs, one dessert spoon, two forks and one teaspoon, not silver and not initialled, were also included in the chest. The school recommended taking out insurance protection for the school fees, in case of a child's illness and any unforeseen circumstances. The basic requisite for this insurance was that the child was physically and mentally fit, and of the normal standard of health and physique for a child of his age. On Kyffin's recollection he did not achieve this standard but nevertheless gained acceptance. He later lost considerable time from school due to illness after an operation on his tonsils.

Trearddur Bay is a lovely part of the Anglesey coast on Holy Island. The location has a large enclosed bay, ideal under most conditions for safe bathing. At one stage the pupils had great fun learning to swim from an old school rowing boat, and then diving from a floating raft in the bay. In 1925, as Trearddur developed as a resort, annual swimming and rowing races were started in the bay. The safe conditions in the bay are in contrast to the rugged coastline that meanders in and out of rocky coves and northwards towards South Stack. Kyffin would often reminisce about Trearddur Bay and his childhood walks and

pony rides towards Porth Dafarch. Roger Williams-Ellis was at the school at the same time as Kyffin and recalled many of the games, pastimes and the great sense of freedom they both experienced there. Kyffin's memories of this schoolboy autonomy were particularly intense when he lived and worked in London. He produced many sketches and paintings of the stormy wintertime seas that sweep into Trearddur Bay from the Atlantic. One of his best known finished oil paintings is *Storm, Trearddur*; a version of this was purchased by Oriel Ynys Môn in 1987.

The headmaster at Trearddur House School was Iorwerth O. Williams, M.A. (Oxon), F.R.G.S. He was a local person and from a well-known and wealthy Anglesey family. The location for the school was 'specially chosen' for its climate. It was claimed in the school prospectus that in winter it was similar to Falmouth, but with less rain. The school was described as being 'Preparatory (ages 7–14) for Public School and Dartmouth'. The prospectus also claimed the bay '...has wide, safe sands and a great sweep of open country all around, stretching twenty-five miles to the Welsh hills.' Trearddur House itself, with its adjacent school facilities under cover, was built on a spur of rock close to the playing fields and the sea. Besides the football and rugby pitches, there were tennis courts, cricket pitches, a pool for sailing model yachts, allotments for practising gardening, as well as providing produce for the school kitchens, and many other amenities. Kyffin loved the school and felt Mr Iorwerth Williams was 'an absolutely brilliant headmaster'.

It was not only a 'wonderfully happy school' for Kyffin, but also for his school friend, Roger Williams-Ellis. He was a little younger than Kyffin and became one of his best friends. Roger remembers making camps in the gorse bushes that thrive on the rocky outcrops close to the school. He also recalls two of the school buildings being joined by a long corridor which served as a training area, roller skating rink and for the performance of plays, with the boys making and decorating the stage scenery. This corridor, some 200ft long and 20ft wide, was later accidentally burnt down. Roger remembered on one occasion, when he stood with Kyffin near the school dormitories, watching an 'incredible but dangerous thunderstorm' that blasted in from the Irish Sea. The sky was full of brilliant flashes of lightning and loud rumbles of thunder that echoed around the village and made a great impression on them both. Roger also remembers sports days on the nearby playing fields: 'I was playing soccer on the wing on a very wet, cold and windy day. The ball never came my way, and I wasn't very happy.' Roger discovered, after a few years at the school, that his parents were not very happy either, particularly with Headmaster Williams' efforts to educate him. This was probably, as Roger explained, 'due to my dyslexia', which was later correctly recognised during his World War Two army career, when he was based for

a while in the Indian subcontinent. Nevertheless, Roger was promptly removed by his parents and sent to a private school in Gloucestershire.

Roger continued to be a lifelong friend and, many years later, would go with Kyffin to Parys Mountain where the artist's entrepreneur great-great-uncle, Thomas Williams, made his fortune as the 'Copper King'. This little mountain was once, as Kyffin described it to Roger, 'the largest copper mine in the world'. Roger himself saw it as 'an immense area of beautiful, richly coloured minerals'. Roger was also taken to the north coast of Anglesey, near Llanfair-yng-Nghornwy, to absorb the magnificent coastal views and see the places where Kyffin's father had taken him as a child. As the two friends wandered near Cemlyn Bay, looking out to sea towards the Skerries lighthouse, Kyffin recalled his great-grandfather, James Williams, establishing Anglesey's first lifeboat station in the bay. The two friends would also shoot together on the marshes of the Broomhall estate near Pwllheli, where zigzagging snipe were brought down with considerable skill with single barrel .410 shotguns. And when time allowed, the Ynysfor Hunt was a regular Saturday feature of their active lives. Roger was always invited to Kyffin's exhibitions, including the 1993 'Portraits' and 1995 'Landscapes' exhibitions at Oriel Ynys Môn. Kyffin respected Roger greatly for his skills as a forester and as a successful, hard-working businessman, and always appeared pleased to meet up with him to chat about the past and their experiences at school.

Kyffin was occasionally asked why his parents sent him away to boarding school in Trearddur Bay for his education. It was sometimes alluded to by friends, and even by Kyffin himself, that his mother had little time for him, as she much preferred his brother, Dick. To support this Kyffin recalled the tales his father had told him of his mother sending him to be nurtured for his first year of life by a farmer's wife at Brynddu, Llanfechell. Professor Robin Grove White of Brynddu had also been told this story by Kyffin. It is possible that Kyffin was sent to a 'wet nurse' (a common practice in earlier times) on the estate or that his mother was unable physically or psychologically to cope with her newly-born son.

Kyffin explained that to his parents 'it was the done thing' to send him away to boarding school, in order to pass Shrewsbury School's common entrance examination. He conceded that his parents had very little money for his education, as his father had only worked in banking for a few years. The family appear to have been dependent to a certain extent on inherited monies. Indeed, in 1916 his father, Henry, is recorded in his brother, Rev. Owen Kyffin Williams's will as a 'bank accountant' and as receiving a legacy of just over £400. Henry married Essyllt Mary in 1910, and he was forty-eight years of age when Kyffin was born in 1918. Kyffin often contemplated his mother and father's

relationship, considering their dissimilar personalities. He recalled his father telling him that when he was about forty years of age, he was issued with a revolver and a Jack Russell terrier by the Midland Bank, and put in charge of a branch in Penydarren, Merthyr Tydfil, with its renowned ironworks and tough industrial culture. His father's sense of adventure and eccentricity was countered by his mother's apparent Victorian formality and insecurity. Kyffin would sometimes allude to being of a noble Anglesey bloodline, which he claimed had been revealed to him by local historian, Helen Ramage, when she lived in Menai Bridge. He would often regale friends with these stories, hinting at his family's past dalliances and liaisons. He would intimate that his lineage went back to the Williams-Bulkeley family of Baron Hill. Whether he believed this or whether it was just repartee is difficult to know, but he often revealed the truth with a twinkle in his eye. One also suspects that his father was responsible for cultivating much of his vivid imagination.

Roger Williams-Ellis knew Essyllt Mary and Henry Inglis Williams quite well, especially when they moved in the late 1930s from Plas Gwyn, Pentrefelin, to live in Doltrement, Aber-erch, which is not far from Roger's estate home at Glasfryn. Roger explained, 'Henry was quite lame and at times struggled to move along. He was also beset by a particularly noticeable stammer.' They were both pleasant enough people but Roger found Essyllt Mary somewhat pensive. He added, 'She didn't have a great deal of imagination and tended to be strict.' Kyffin sometimes postulated that his mother's condition was due to their financial predicament. But he also intimated that it was possibly due to her temperament and upbringing in a strict, 'unimaginative family'. Kyffin drew this conclusion from reading the staid diaries of his

Kyffin with his father, Henry Inglis Williams

Essyllt Mary Williams, Kyffin's mother

mother's father, the Reverend Richard Hughes Williams, Rector of Llansadwrn. Kyffin probably overlooked the fact that his own 'obsessive' nature, so strongly linked with his eventual artistic success, may have emanated from his maternal line. But, on the issue of his parents' wealth and his schooling at Trearddur House and Shrewsbury School, he conceded:

> We didn't have much money …I don't know how they managed it. I don't know how they managed to send me to Shrewsbury, I think it's because I got in cheap!

This is an unusual conclusion as it is difficult to believe that anyone could get in 'cheap' at Shrewsbury School, especially in 1931, during what was, according to John Maynard Keynes, the greatest economic catastrophe in modern history.

During research into Kyffin's mother, Essyllt Mary and her relatives, particularly Mary Pritchard-Rayner (1877-1944) of Trescawen, and their mutual aunt, Ellen Pritchard of Brynhyfryd, Llangoed, the funding of Kyffin and Dick's Trearddur and Shrewsbury schools education was discussed with Henry Pritchard-Rayner. Henry is a local farmer and at one time, as a boy, lived at Trescawen Hall, and knew of Mary Pritchard-Rayner as his mother, Jane, was her nurse. His father, Gerald Dickson (1881-1959), was first married to Mary Pritchard-Rayner, which took place at the Catholic Church in Bangor. Mary persuaded Gerald to change his name to Pritchard-Rayner. After Mary's death in 1944 Gerald married Jane. Henry recalled, as a young lad, going with his mother to Treffos to see Aunt Sisli Vivian, a relative of both Mary Pritchard-Rayner and Essyllt Mary. Henry recounted the story of Mary Pritchard-Rayner bringing a court action against Kyffin's mother regarding her inheritance of Brynhyfryd, Llangoed. The house was bequeathed to Essyllt Mary by her wealthy aunt, Ellen Pritchard. Ellen was related to Essyllt Mary through her grandmother, Catherine Moulsdale, and her sister, Martha Moulsdale's marriage (in 1837) to Henry Pritchard of Trescawen. Henry Pritchard-Rayner recalled that Kyffin was also at Aunt Sisli Vivian's house on this occasion, and was with a very attractive female friend. Henry was only a boy at the time, and was fascinated by the anecdotes being revealed by Kyffin and Aunt Sisli about their Anglesey families. Henry was asked why the Brynhyfryd court case had come about, especially considering Mary Pritchard-Rayner was Essyllt Mary's second cousin. His inference was that their mutual aunt, Ellen Pritchard, was funding Kyffin and Dick's education. This arrangement was on the understanding that Kyffin and Dick would 'in some way' be brought up in the Catholic faith. This 'pledge' had not, according to Henry, been complied with and so

Mary Pritchard-Rayner attempted, through the courts, to disinherit Essyllt Mary of her Brynhyfryd legacy. This appears to be an incredible deduction and although interesting is not supported by Kyffin's own account.

Kyffin claimed that Ellen Pritchard bequeathed Brynhyfryd to his mother because she disapproved of her niece, Mary Pritchard-Rayner, forcing her newly-wed husband, Gerald Dickson, to change his name to Pritchard-Rayner. This was because Mary did not fancy being called by his surname. Aunt Ellen Pritchard reprimanded Mary by removing her from the will. To Aunt Sisli, Aunt Ellen Pritchard left £500 to buy a couple of hunters, and a third niece was given the land around Brynhyfryd. In total, the spinster, Ellen Pritchard, left £71,527 8s 6d in her will after her death on 21 August 1925, a sum equivalent to several million pounds in today's money. The will was drawn up by her solicitor, Thomas Warren Trevor of Penmon. Kyffin was originally to receive the Brynhyfryd legacy but alleged this was changed. He quipped that to be 'Cut out of the will at such an early age is rather interesting'. He also chastised some of the Pritchard-Rayner family for their 'drunken ways' and their later abhorrent behaviour towards his mother. They were an important part of the Anglesey hunting fraternity, and held social and political influence in many parts of Anglesey. With this status, as well as their land ownership, Kyffin felt they made life very uncomfortable for his mother after the court case.

At the Brynhyfryd court case the judge found in favour of Essyllt Mary, but both parties had to share the considerable costs. Mary Pritchard-Rayner had no problem settling her costs but Kyffin's mother struggled, and was soon forced to sell Brynhyfryd. Essyllt Mary decided to auction some of the contents of the house, but Mary Pritchard-Rayner intruded, demanding particular family heirlooms. Kyffin's father, Henry, intervened and convinced Mary that she should leave. Essyllt Mary retained a lot of furniture, originally from Ellen Pritchard's Trescawen Hall home, which was passed to Kyffin and displayed at Pwllfanogl as a poignant reminder of the feud.

Brynhyfryd, Llangoed, was eventually purchased by a relative, Geoffrey Williams, the son of Ralph Champneys Williams. Geoffrey had previously sought family support to buy Treffos, the Williams family ancestral home. Kyffin, with little tact, considered Geoffrey 'mentally unbalanced' as he was, apparently, trying to gain access to *Burke's Landed Gentry* under 'The Williamses of Treffos'. Geoffrey eventually settled for an entry as 'The Williamses of Brynhyfryd', which Kyffin found extremely droll. Kyffin's family then appear to have spent a short time living at a relative's property in Victoria Terrace, Beaumaris. This was alluded to by Kyffin when he visited his friend, Greta Berry,

at her seafront house. Here he looked around the Victoria Terrace property, overlooking the Menai Strait and Snowdonia, and immediately recognised the layout, recalling the narrow servant's staircase where he once played happily as a child. After the Williams family's spell in Beaumaris, they moved to Plas Gwyn, Pentrefelin. It was from here, after moving from Chirk and Moreton Hall School, that Kyffin recalled most of his links with Trearddur House School.

Trearddur House School was attended by about sixty boys, but Kyffin recalled one girl who was quite sporting and tough. This was Frances Webb and she played a very good game of 'rugger'. As Kyffin describes her, 'she was often on the wing and ran very fast indeed'. He felt that her name and her sporting abilities linked well with William Webb Ellis, the 1823 inventor of rugby football. Kyffin's seven-year period at the school, from the age of six until he was thirteen, served him well. That is until at the age of nine he was subjected to what was a panacea for all ills at the time, the removal of tonsils and adenoids. When Kyffin described his operation one could easily have thought he was jesting, but it was a very serious matter, which could have led to his death. His surgeon had a heart attack during the operation and cut out all his soft palate, uvula, as well as his tonsils and adenoids. This accident set back Kyffin's education as he could not return to school for two terms. When he did go back to school he considered:

> I was not quite the same boy as I was before. I was supposed to be very bright, and I was going to get a scholarship to Shrewsbury and that sort of thing, but when I went back there, of course I was stupid and couldn't concentrate.

His brother Dick recovered well from his operation but Kyffin was kept at home and a nurse cared for him during his long recovery. Kyffin had the embarrassment, when he first arrived at the Trearddur House, of being classed by his mother as a 'delicate child'. This required Mrs Elsie Williams, wife of the headmaster, to gently sponge him down in the mornings, whereas the other boys had to take a regulatory cold shower. This story, even in his later years, held an element of discomfiture for him. If this was commented on by other pupils at the time, as one suspects it might have been, it never appeared to affect Kyffin's good relationship with them. Similarly, he also felt he had a good rapport with all the masters at the school.

One of the masters was Francis Henry Glazebrook (1893-1967) who taught art and geography, as well as geometry. He had seen active service in World War One and was promoted to a lieutenant on 9 November 1914. Glazebrook's daughter, Mrs Rima

Francis Henry Glazebrook's painting of the Irish Mail

Martin, revealed that her father joined the Royal Welch Fusiliers and fought in the ill-fated Gallipoli Campaign. He suffered quite badly from the effects of the war and was beset with stomach ulcers for most of his life. This did not deter him from serving in World War Two, where he joined the Royal Air Force Coastal Command based in Anglesey. Because of his knowledge and experience he was allowed to use his own yacht, *Mermaid*, to navigate and report on Anglesey's coastline to the military. His initial arrival in Anglesey was linked with family holidays to the island when he was a child. He fell in love with the island's natural history and scenic coastline. His love of the island and its flora, fauna and coast also inspired Kyffin at the time. Glazebrook, on one of his many later adventures, resided on Llanddwyn Island in the old boathouse, and sometimes in the pilots' cottages, observing and sketching the wildlife. He even made a BBC radio broadcast from the island and referred to its abundant birdlife.

Kyffin kept a collection of Glazebrook's Anglesey Antiquarian Society articles that reveal a passion for the island and its natural history. Glazebrook took an interest in local people and knew Mrs Elizabeth Jones, 'a wonderful character', who, with her husband, William, was a boat pilot on Llanddwyn. Kyffin recalled that Mrs Jones would traipse from Llanddwyn, through the sand dune tracks with her pony and cart, and donkey, to Newborough for her provisions. She also greatly assisted in the RSPB's protection of the island's rare roseate tern population between the wars. Glazebrook was a fine artist who, according to Kyffin, had studied at the Slade in London. He was commissioned to do advertising posters for the Irish Mail that depicted a train hurtling in dramatic perspective across a bridge. Kyffin, when discussing Trearddur Bay and Glazebrook, noted that the Britannia Bridge was the bridge depicted in his art master's paintings. Kyffin, knowing of Glazebrook's publicity posters, picked up some of his initial interest in art at this time. He appears to have also learned some of his watercolour techniques and use of perspective from him. Kyffin always had good things to say about 'Mr Glazebrook' and, in later years, would chat to him about art.

When Glazebrook first married, he still visited Anglesey from his home in Birkenhead, and stayed in rooms above the old Post Office in Trearddur Bay. This location is very close to the Trearddur House School and may have inspired him to seek work there. It was also very convenient for his other passion, sailing. He was a member of the local sailing club and became very knowledgeable in this area, particularly in navigating the coasts of North Wales. He wrote an authoritative book in 1961, the *Anglesey and the North Wales Coast Pilot*, which was revised and reprinted several times. Glazebrook was a keen fisherman, and took a photograph of Kyffin as a schoolboy, standing dwarfed by a very large pollock.

Kyffin's memories of Trearddur House School were often vivid. At the age of seven, in 1925, he won a sixpence for a poem about snow; at the time he was ill with chickenpox. He would recount in his later years that this was his first experience of being conscious of 'mood'. 'Mood' and 'love' were essential requisites for a painter, as he indicated; they are associated with 'angst', a German word linked with mood, stemming from apprehension. He recalled that just before the snow came the sky turned a mustard colour, which impressed him greatly. He would sometimes recite part of the poem he wrote:

> The snow is simply beautiful and all the world is white,
> And everybody thinks it is a very lovely sight ...

Clearly, Kyffin never forgot the snow that fell on the school, and returned to paint this coastal location many times, especially after his arrival back in Anglesey in 1973. His schoolboy exploits by the sea, on foot and on horseback, marked out in his memory the best places to view the great storms that lash this rugged coastline. He discovered later that the 'mood' of this location had sunk into his consciousness, which to him was extraordinary.

On another occasion Kyffin remembered as a child roaming on the coast near Porth y Post, an inlet beyond Trearddur Bay on the South Stack road, and seeing the wreck of a ship there. The captain, whom he thought was Russian, was standing nearby and Kyffin noted that he was distraught. This ship was probably the SS *Asmund*, a Norwegian steamer that was bound for Manchester with a cargo of grain. The ship was holed on 2 December 1930 at the rocky inlet, on the south-west coast of Holy Island. The ship was later refloated but sank again in Holyhead harbour. It was eventually beached at Porth Penrhyn Mawr where its rusting hulk remains. Kyffin was about twelve at this time and, some seven decades later, he was still able to recall the tragic incident in detail. This ability to recall detail easily would serve him well throughout his life as an artist and writer.

Similarly, he remembered playing the piano in school when the music mistress, Miss Liz Fisher, fell ill. He volunteered to play 'Onward Christian Soldiers', adding that he had never played a piano before. All those present sang along with his unbounded and enthusiastic playing. He had a fine tuneful tenor voice that had resonant overtones, and reckoned he could have studied music as he often enjoyed playing tunes by ear. This was a musical skill his father had also acquired, and put into practice at services in Ynyscynhaearn Church, near Plas Gwyn, the home his family moved to in Pentrefelin. As Kyffin later revealed, 'This church is the resting place of David Owen, the famous harpist and composer known as Dafydd y Garreg Wen, who died aged 29 in 1749.' It was also a place where Kyffin loved to roam as a boy during his Trearddur House school holidays. He loved the places near the marshy Afon Cedron and Llyn Ystumllyn. Kyffin added that there were plenty of snipe near the Afon Cedron. This river was formerly called the Afon Dowarch and, hence, the village of Pentrefelin was originally called Aber Dowarch. He appeared to pick up information like this from his father and, later, from George Yale and Donald Hardcastle, his Pwllheli-based land agency principals.

Kyffin's mother and father would sometimes attend the Sunday services in Trearddur House School chapel. These were usually held at 11.15am or as an evening service at 6.00pm. On one occasion Kyffin recalled his mother, father and his loveable Aunt Mamie

singing loudly and heartily at a chapel service. This was much to his embarrassment as the other schoolboys glowered at him. The chapel was built by the school carpenter and, although beautifully decorated with ornate altar and pseudo-Gothic windows, it had an asbestos roof. The roof, unfortunately, not only resounded with the internal vocalists' endeavours but also amplified the rain falling outside. Kyffin also recalled Trearddur's seagulls finding the roof attractive for practising their courtship dances on during services.

He remembered other occasions at the school when he explored the area seeking adventure. One day he came across a nearby landmark he had noticed for some time. It was Trearddur Mill, known locally as Melin Stanley, which was built in 1827 as a corn-grinding mill. The tower mill impressed Kyffin greatly with its immaculate white rendering and what appeared to be gigantic sails akimbo. It came to the end of its life as the last working windmill in Anglesey in 1938, after suffering structural damage. Kyffin would venture from the school, sometimes with friends, and peek in through the dusty, cobwebbed mill windows, and catch a glimpse of the millers wearing protective sacks around their waists. The flour dust was everywhere, covering all surfaces and the millers' hands and faces, and 'formed a white fog in the air'. Kyffin sympathised with the millers and their incredibly dusty conditions and felt 'They must have got farmer's lung and all died early deaths'.

Many years later, when Kyffin had resettled in Anglesey from London, he recalled taking one of his regular trips to Trearddur Bay, intending to make his way along the coast to a favourite spot on South Stack cliffs. As usual, as he passed through Trearddur Bay, he glanced at his old school and the playing fields now used by the local football team. He passed the Trearddur Bay Hotel where parents visiting the school would often stay. As he was driving to South Stack, along Lôn Isallt, a little way out of the village, he slowed to pass a lady walking her dog. The dog, according to Kyffin, suddenly leapt into the road and was run over by his car. The animal was killed instantly and Kyffin, in considerable shock, got out of his car and apologised profusely to the lady. After lengthy exchanges of details and offers of help to the lady, Kyffin said he would have to report the incident to the police. He then carried on with his journey to South Stack.

Understandably, still upset and shaken, he parked at South Stack and made his way towards the cliff top to appreciate the panoramic views of the Irish Sea. Within seconds of starting his walk he heard a car, engine screaming, coming up the steep hill behind him. As the car screeched to a halt, Kyffin looked behind to see two young men leaping out of a red sports car and rushing in his direction. This puzzled him, so he stopped and turned around. Just before the men reached Kyffin they started shouting abuse and bellowed,

'Are you the bastard who killed the dog in Trearddur?' He was completely shocked and replied, 'There was an accident with a dog but I apologised to the lady.' The men rounded on him and intimated that they would throw him off the nearby cliff. He was nervous and frightened but still tried to remain calm. Kyffin explained to the men that the incident with the dog would be reported to the police in Holyhead. His response and an element of teacher-like firmness appeared to bring the situation under control. As Kyffin said, 'I gave them my schoolmaster's stare.' The men apparently left the scene still cursing and waving clenched fists. After a while, and still a little apprehensive as he awaited their departure, he drove to Holyhead and reported both the incident with the dog and the threatening behaviour of the men to the duty police sergeant at the station. Some years later, when recalling this event, one could see that he was still a little disturbed by these memories.

With his time at Trearddur House School coming to an end, after six years of fun and enjoyment, he prepared to sit his common entrance examination for Shrewsbury School. His brother, Dick, had won a scholarship there two years before. Kyffin was the only boy taking the exam at Trearddur, which was invigilated by the Vicar of Holyhead. Kyffin struggled with the algebra paper and the benevolent vicar offered to help. 'Are you having trouble?' he enquired. Kyffin, realising the possibility of failure, agreed that he was having trouble with the algebra paper, so the vicar sat down to help him. Kyffin suspected, ethically, that this was not quite the way to undertake an examination but did not complain. When the results of the examination came through, Kyffin had passed in all subjects except algebra. He took the paper again, and this time it was invigilated by the headmaster, Iorwerth Williams. Fortunately Kyffin passed without assistance and was accepted to Shrewsbury School. Typically, as he recollected these memories, he was self-deprecating and commented that, 'I think I was let in. I think it was because my brother had a scholarship and was extremely bright. They thought well, his younger brother can't be a complete cretin, so they let me in.' It would take many, many years before Kyffin came to terms with the fact that he was just as good as his brother and, indeed, coped far better with life's traumas and idiosyncrasies.

Shrewsbury School

At the age of thirteen Kyffin left his beloved Trearddur House School and entered Shrewsbury School. It was January 1931, and the winter had been bitterly cold, with over two feet of snow in many parts of Britain. But this was nothing compared with the coldness he later claimed he experienced at Shrewsbury School. Kyffin entered Cuthbert

William Mitford's house at the school. To Kyffin, this immense change in culture would reveal itself as an extremely sad part of his life. Mitford, on leaving university, had taught at Highgate School, North London. By coincidence he had resided with the 'remarkable' Miss Josling of 12 Bisham Gardens, Highgate, where, many years later, Kyffin would also lodge when he taught at Highgate School (1944-1973). Kyffin despised Mitford's 'sadistic nature' and considered his time in his house at Severn Hill a disaster. Bullying was rife and Mitford, to Kyffin, appeared to condone this behaviour, as well as having his favourite pupils. These were mainly pupils who were achievers, good at sports and games, and invariably from wealthy families. Boys from these more affluent families were made monitors and, with Mitford's approval, 'administered the sort of terrible behaviour that only young boys can inflict on one another'. Clearly, these traumas had a long-lasting effect throughout Kyffin's life. Without his brother's support Kyffin, at a mere 4ft. 10in. and only four stone ten pounds in weight, would not have survived. Mitford's callousness was relentless; indeed he took every opportunity to ridicule weaker pupils,

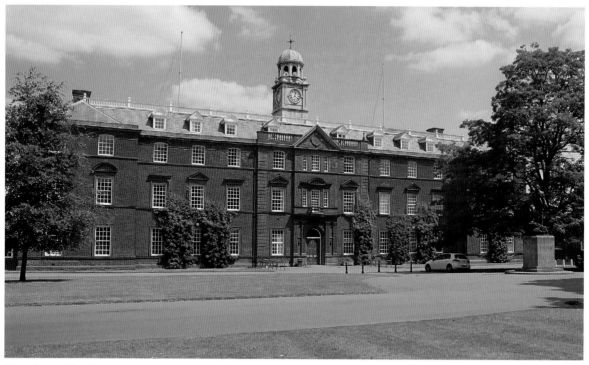

Shrewsbury School

and with Kyffin he appeared to take a particular delight in embarrassing him. A comment by the headmaster in Kyffin's end of term report read, 'He could do well with a pinch of modesty.' This comment, in reality, was probably Mitford's perception of the young Kyffin trying to make a small mark in this large and daunting institution. To Kyffin the school's motto appeared to be, 'Boys were to be seen and not heard, and one so small as I had to remain entirely mute.' This process of breaking Kyffin in went on for some terms until, as he conceded, 'They at last succeeded.'

Kyffin was unable to make friends at Shrewsbury School, probably because he was so small and, until he developed more, he was not capable of fully participating in activities like rugby and other sports of strength and weight. He commented that:

> I always had friends, especially when I was at Trearddur House. It's extraordinary; I was never without a friend at that school. When I went to Shrewsbury I never had a friend, not one boy would really have anything to do with me. I don't remember being all that worried about it. My house was the furthest one away from the school buildings, it was about half a mile, and we used to have to walk backwards and forwards, and boys always paired up, and no boy would ever walk with me, which I found a little strange, but it didn't worry me unduly because I always was a loner.

This 'loner' characteristic served him well in later life as an artist, and at Shrewsbury it led him to take a greater interest in the countryside around the town. He was always keen on nature, particularly bird watching, and would follow the meandering River Severn through Shropshire's rich farmlands. But in contrast to his assertions that he made no friends, he did visit a number of relatives who lived in or near the town. Kyffin felt that his historic family connections paved the way for him to go to Shrewsbury School. His great-grandmother was Miss Francis Lloyd of Shrewsbury and Glan Gwna, Caernarfon. The Lloyds, according to Kyffin, were closely connected with Samuel Butler. In 1797 Butler was elected a fellow of St John's, and in 1798 became headmaster of Shrewsbury School. In 1802 he was presented with the living of Kenilworth, and in 1822 to the archdeaconry of Derby. He held all these appointments concomitant with his headmastership at Shrewsbury School. He died on 4 December 1839. The Butlers, Lloyds and Darwins, as well as Kyffin's Williams family, all knew each other. Indeed, at a later period, Kyffin's grandfather, the Reverend Owen Lloyd Williams, travelled from Anglesey to Shrewsbury School by stagecoach along Telford's road. Owen's sister, Louisa, married the eminent geologist Sir Andrew Crombie Ramsay, who became Director of

the British Geological Survey. Ramsay corresponded with Charles Darwin at his home, The Mount, Frankwell, Shrewsbury, and provided essential evidence of Pre-Cambrian life forms. This involved his extensive surveying discoveries in Anglesey whilst lodging with the Williams family.

Even though Kyffin was aware of all these historic, excellent family relationships, he still could not come to terms with the incredible incongruities at Shrewsbury School.

It appears that cheating was endemic at Shrewsbury at this time and Kyffin, probably because of his upbringing and the values bestowed on him at Trearddur House, felt unable to cheat like many of the other pupils at the school. He complained bitterly:

> It sounds rather pious, but when I went to Shrewsbury School it was expected of you to cheat like mad, in fact you couldn't get out of the lower school without cheating, you had to cheat your way out. Well, maybe it's the fact I was brought up with an immense amount of guilt, I could never cheat, so I was always, because of that, at the bottom of the form.

Kyffin revealed that his brother Dick never had to cheat as he was bright and went straight into the upper school when he first arrived. Kyffin had to fight his way out of the lower school:

> This was amazing to my father because the reports he got on me were so appalling that he thought that I must be half-witted. I mean one senior master said, 'Never in my whole experience have I met a boy with less ability.' Another master said, 'This boy has no power of lucid thought.' And my house master said, 'It is a tragedy, he is the despair of all who teach him.' Now what is astonishing is I must have been brighter than the average, and yet they didn't realise that I was the only boy who didn't cheat, they just didn't twig what was going on.

When Kyffin progressed from George Simmons' Lower 4, 2b form, to the upper school, where he would eventually take his School Certificate, his new form master, John Key, said he did not want to teach him. Kyffin quoted him saying, 'I will not be responsible for getting this boy through his School Certificate. He is too stupid. I refuse to teach him.' Kyffin noted that this was pretty strong stuff from the master, whose job it was to teach. With the master's apparent intransigence, Kyffin was taken under the wing of another more benevolent master called David Bevan. Kyffin found Bevan to be 'a most remarkable school master', who understood him from the beginning. Kyffin

remembered 'the first time he walked into the room he wrote on the blackboard "Heute beginnen wir Deutsch zu lernen".' Kyffin felt that at last he really was beginning to learn. He progressed well and took his School Certificate, passing with a credit in every subject except general science, which he at least passed. Many aspects of his life at Shrewsbury stuck in his mind for years. Much of this period was recalled with friends and, later, in his 1973 autobiography, *Across the Straits*.

The puerile school traditions grated with him intensely. He claimed the elimination of any vestige of regional accent was conducted with clinical precision at the school. Boys, especially those with Welsh or north-country accents, were presented with a boy tutor who would ensure the removal of all regional brogues. On an appointed day, usually after a month's training, a speech test was conducted, and if the boy failed with his 'How now brown cow' he was severely beaten. Kyffin was appointed tutor to north-country lad, Kenneth Lowe. On the day of the test Lowe failed miserably to impress his examining monitors. With Lowe's regional intonations still ringing in Kyffin's ears, they were both taken aside and unjustly beaten. When asked if he considered this to be bullying he answered 'No! I was never bullied at Shrewsbury; I think this was because my brother was a prefect.' Clearly, this situation would not be acceptable today; but Kyffin felt he had to endure the school's ancient traditions, as his relatives had done so before him.

Kyffin often mentioned that he was not religious. He had come to understand the idiosyncrasies of Christianity but was not a 'believer', although he delighted in singing in the Shrewsbury School chapel choir on a Sunday. The tradition and atmosphere of security in the chapel gave Kyffin some respite from the challenges of school weekdays. He enjoyed the singing and being dressed in his white surplice and rich red cassock. He felt at ease in this ornate and beautifully built place of worship and considered 'Christianity as a basically good religion', while admitting that he had never really been a true Christian. 'I never really understood what worship was about', he claimed. He could only relate the word 'worship' with the adoration of women. Mitford, again, seems to hold some responsibility here for Kyffin's dislike of religion, as it was he, together with the school chaplain, who held the confirmation classes which Kyffin attended. At the time, the whole religious ceremony made Kyffin cringe with what he perceived as its hypocrisy. This was especially the case when, with Mitford standing close by, the chaplain would announce that 'Human beings are like unto peaches, smooth and beautiful on the outside and a nasty gnarled stone in the middle, and this is sex.' The boys undertaking confirmation with Kyffin were united in their disdain for the chaplain and, of course, Mitford. Mitford's name is respectfully recorded in the school chapel on a well-polished

brass plaque at the rear of the nave. It was here that seated housemasters surveyed Sunday's rituals as 'Jerusalem' was joyfully sung by Kyffin and his fellow choristers. The school is today one of the most popular in Britain, and has magnificently kept grounds and high-standard facilities. It overlooks a panoramic landscape that takes in most of Shrewsbury, the River Severn and its surrounding beautiful countryside. There are also good rowing facilities below the school near Kingsland Bridge. Kyffin's time at Shrewsbury School should have been a memorable and rewarding experience. It seems a great pity that he did not enjoy such privileges more.

Kyffin claimed he experienced greater emotional sensations than any religious feeling when he developed epilepsy in later years. He also contended that his new-found freedom in the mountains of north Wales with the Ynysfor Hunt was far more rewarding than the confines of any church. To him God's beauties are all around, to be seen freely, and not interpreted with what he saw as prejudice. On one occasion in the mountains around Llanfrothen and Beddgelert he experienced the vision of a Brocken Spectre, which is caused when the sun shines behind the observer and creates a mysterious spectre shadow in the misty sky. This fascinated Kyffin as the spectre responded to every movement he made on the mountain top. He explained that it usually occurs when one is on a ridge or high point in the mountains with the sun quite low in the sky. On one occasion Kyffin observed this effect when he was out hunting with Captain Jack Jones of Ynysfor. Captain Jack was pretty stoic about the event, but to Kyffin it was an intensely rewarding experience that triggered his deep inner responses. Roger Williams-Ellis had noticed that Kyffin invariably carried a small sketchbook and 4B pencil when out hunting, and often sketched scenes and incidents that impressed him.

After Kyffin passed his School Certificate with flying colours, Kyffin's father was incensed with the school for leading him astray about his son's abilities. He wrote to the headmaster in disgust and complained that 'I have no faith in Shrewsbury and intend taking my son away'. He added, 'You've been denigrating my son all these years and now he has proved he is one of the most able boys taking his School Certificate.' The headmaster was incapable of explaining these circumstances. The difficulty was that Kyffin, in a peculiar way, rather liked the headmaster. The Williams family were, as Kyffin explained, distant relatives of the headmaster and the whole affair became rather tainted and embarrassing. To make matters worse Kyffin had to struggle on for one more term. To soften this blow and alleviate his misery he made visits to his many relatives in the area. There were the Lloyd family from Whitehall, where the Reverend Thomas Lloyd, through conscience, undertook to rebuild his lightning-damaged St Mary's church spire. This proved to be

a financial disaster for the Reverend Lloyd. Kyffin also visited many other Shropshire cousins such as the Corbets, Dugdales, Hunts and other distinguished county families. He often referred to the Corbets' lineage and the crow (chough) emblem on their coat of arms, which was also used by his own Williams family of Treffos. Kyffin explained that Corbet is a corruption of Corvid, the Latin for crow. This emblem is depicted on his father's grave at Aber-erch churchyard where he was buried in 1942. The grave has a similar cross design to Kyffin's grandfather Owen Williams's grave in Llanfair-yng-Nghornwy, but with a crow depicted at the top. Kyffin explained the Corbet link, and mentioned that the crow was in fact a Cornish chough with a fleur-de-lys clenched in its raised claw, and the motto 'Duw a ddarpar i'r brain' (God prepares for the crows). Kyffin, similarly, recounted his schoolday links with relative Agnes Hunt of Baschurch, Shropshire, who was the instigator of the Robert Jones and Agnes Hunt Orthopaedic Hospital now based at Gobowen, near Oswestry.

With one term to go before he finished at Shrewsbury for good, Kyffin anticipated that the misery he had experienced at the school would continue. He was put into a form of pupils he referred to as 'fellow misfits', and taught by Mr McEachran, his newly arrived form master. Frank McEachran was assigned to a form of what Kyffin describes as 'thugs', adding that 'he would be cannon fodder for the boys'. The new master's forte was literature and poetry. Contrary to Kyffin's prediction, the boys gradually fell under the spell of McEachran's recitals. He was able to bring the boys totally under control through the beauty of his readings. Kyffin and the rest of his form were astounded by their reaction to the new master. Instead of inflicting misery on him, they were mesmerised by his way with words, particularly with the poetry and prose he chose. Kyffin fell in love with the written word, especially McEachran's reading of T.S. Eliot's *The Waste Land*. Much later, when Kyffin was a teacher at Highgate School, he discovered that T.S. Eliot joined the Junior School staff in 1915 and taught a young John Betjeman. Part of Eliot's poem is based upon the life around Lower Thames Street, London. Kyffin was able to quote extensively from this work and liked to emphasise the lines:

> . . . where the walls
> Of Magnus Martyr hold
> Inexplicable splendour of Ionian white and gold.

Kyffin was also greatly inspired by Trench, Rimbaud, Verlaine and Rilke, but with the frisson of interest in Eliot's work at the time, this won the day. McEachran appears

to have also inspired another boy in Kyffin's new form, Richard Hillary. He became a Second World War RAF pilot and was shot down during the Battle of Britain and badly disfigured. Kyffin explained that Hillary always appeared to be a loner who was termed as a 'non-co-operator'. He seemed aloof and stood away from the other boys at roll calls. He later wrote a book, possibly inspired by McEachran, *The Last Enemy*. After being shot down and spending many months recovering, he returned to flying, even though initially he had been unable to hold a knife and fork to eat his food. In 1943 he crashed his Bristol Blenheim on a training sortie and was killed with a fellow airman. Kyffin praised McEachran for encouraging Hillary's tremendous writing skills.

As mentioned, Kyffin would sometimes refer to the chaplain at Shrewsbury School and his antics with boys. 'He was a terrible man and used to love taking small boys for rides in his motor car.' Kyffin was once asked if he was aware of homosexuality among the boys at Shrewsbury:

> It's the most extraordinary thing that never the whole time I was at Shrewsbury School did I know that such a thing as homosexuality existed. Now, afterwards, I mean talking to other boys at other schools, I'm sure it did exist but I never realised there was such a thing.

Richard Charles Cobb (1919-1996), a fellow pupil, who rose to be the Professor of Modern History at Oxford University, wrote a book about Shrewsbury School called *A Classical Education*, published in 1985. At the centre of this rather macabre book is an Irish school friend who murdered his own mother. Cobb allegedly urged the Irish police to investigate this matricide. He maintained contact with his felonious friend and, after his long detention, invited him to the Balliol high table. Placing him next to the Oxford Emeritus Professor of Law he announced 'My guest is keenly interested in the Irish penal system'. Cobb, who was always keen to emphasise his frivolity, also wrote about the 'dreadful chaplain' at Shrewsbury, and, unlike Kyffin, actually named him. Many years later, some of these events were recalled by pupils, and the playwright Alan Bennett, after talking to his friend Paul Foot about these incidents, wrote *The History Boys*, which was based on Frank McEachran's intellectual model, whom Bennett named Hector for his film and stage productions. Bennett's hilarious and poignant play fictionally incorporates some of the people Kyffin was both impressed with, and intimidated by, at Shrewsbury.

McEachran produced an anthology of poems called *Spells*. He encouraged the boys to recite poetry and prose, sometimes in a chorus standing on their desks. This was disapproved

of by the headmaster who often reprimanded McEachran for the form's rowdiness, but could not rebuff him because of his tremendous successes. A 'spell' is a Salopian term for a short passage of poetry or prose, chosen for its suitability for recitation aloud. The word was used to describe passages that Frank McEachran taught at Shrewsbury from 1935 until his death at the age of 75 in 1975. Kyffin loved poetry and later employed it in the form of limericks about Crawshay Bailey together with his marvelous cartoons in *Boyo Ballads*, in collaboration with David Burnett of Excellent Press (1995). Kyffin claimed that even though he liked poetry, for some reason, he always developed a headache when reading it. When he wrote his autobiography, *Across the Straits*, he could not initially find a publisher for the book so he sent the manuscript to Curtis Brown the literary agents, and they submitted it to the major London publishers. It was turned down by every one, but Kyffin claimed that Michael Joseph, publishers, sent the manuscript to Shrewsbury School for scrutiny. The school was apparently 'furious about its content'. Kyffin did not name the chaplain but was, nevertheless, castigated. This was in contrast to the forthright Richard Cobb, who did name the chaplain, and was praised by the school for his literary skills. Kyffin considered Cobb 'rather naughty' as:

> He used to play tricks on him [the chaplain]. He said once he wrote a letter to him purporting to come from the Bishop of Zanzibar, and said, 'It has come to my notice that you are very favourably disposed towards little boys. I am much perturbed about this and I would like to interview you on the matter on Shrewsbury Station tomorrow at 12 o'clock.' Well Richard Cobb apparently went down to Shrewsbury Station and he hid behind one of the pillars and waited, and this agitated man turned up and dashed around looking like this [facial expression], furtively looking for the Bishop of Zanzibar.

Kyffin would occasionally break into verse, sometimes with his own poetry and limericks, and occasionally what he had learned from Frank McEachran. One of his favourite pieces was part of Samuel Taylor Coleridge's 'Kubla Khan':

> And all should cry, Beware! Beware!
> His flashing eyes, his floating hair!
> Weave a circle round him thrice,
> And close your eyes with holy dread,
> For he on honey-dew hath fed,
> And drunk the milk of Paradise.

McEachran encouraged boys to stand on a chair, around which he had drawn three chalk lines, and recite fragments of poetry. 'Kek', as the boys called him, compiled all these recitations. He taught and inspired the poet W. H. Auden, and many other distinguished pupils. He was also a socialist who lectured widely in Britain. His passions, beliefs and ideology led him to take part in the Spanish Civil War. Shrewsbury School still has high regard for Frank McEachran and his achievements over a period of forty years. They commemorate his immense success with an annual award, the McEachran Prize, for prose or poetry.

One of the more adventurous, and perhaps lighter, occasions Kyffin recalled was when the school won the Ladies' Challenge Plate for rowing at the Henley Regatta in 1932, a tremendous achievement as it had first been contested by them in 1912. Many of the boys celebrated and, in an overzealous state, they threw laboratory specimens, including dogfish, out of the school windows, and set fire to paper as well as setting off fire hoses. The masters, realising the situation was out of hand, disappeared from sight. The boys then cavorted as a mob in the direction of Shrewsbury town. As Kyffin confessed, 'I was caught up in an ecstasy of wild exhilaration.' They made their way, shouting and screaming, down Ashton Road and along Canonbury, passing where McEachran lived in a small flat. With the cacophony of voices and clatter of shoes echoing off the tall buildings, they strode on, crossing the arched red sandstone bridge that straddles Kingsland Bridge Road, turning by the bridge's old cast-iron gas lamp and through an iron swing gate, and then descending the twenty-one broad steps towards Kingsland Bridge. Crossing the bridge over the River Severn, their target was now in sight. Earlier, in the excitement at the school, the shout had gone up 'Let's get Dunn!' Over the years the grumpy Mr Dunn, Kingsland's tollgate keeper, had taken many valuable pennies off the boys, thus reducing their quota of weekly tuck. They felt justified in throwing him, in a celebratory manner, into the nearby Severn. The 'vast phalanx' of howling boys surged forward, as Mr Dunn, hearing the din reverberating down the street, reacted quickly, brandishing a yard broom. The boys' threats and intimidation would not be tolerated by old Dunn; he stood in a defensive, almost military stance, wielding the broom threateningly above his head, protected to the rear by the jutting doorway of the old tollhouse. He had not reckoned on the support of his dutiful but innocent wife, who appeared suddenly in the doorway behind him. A thrashing rearward stroke from Dunn, to threaten the boys, caught her on the temple and sent her collapsing forward, unconscious. Kyffin and the boys, in apologetic panic, quickly retraced their tracks back to the refuge of the school's hilltop dormitories, where they denied all knowledge of the incident. Mrs Dunn quickly

recovered, but the accident had probably saved Mr Dunn's life, as the fall from Kingsland Bridge, to the turbid depths of the River Severn, is several metres.

When the boys were allowed free time in Shrewsbury, especially when they had pocket money for sweets and tuck, and were less boisterous, they would cross Kingsland Bridge, dutifully paying their penny to the diligent Mr Dunn. After passing the town walls, they would negotiate Swan Hill and then on into the centre and through the plethora of alleyways called 'shuts and passages'. The route into town passes several public houses, the Coach and Horses and Admiral Benbow, as well as the large Victorian Police Station with its ample number of cells. The alleyways must have been a veritable rabbit warren for the boys' antics and pranks. The narrow passageways have existed here since the mediaeval period, serving as shortcuts around the town for those knowledgeable enough not to get lost. These routes allowed Kyffin easy access to his many Shrewsbury relatives. With all these experiences and sagas behind him, the time had now come for him to leave Shrewsbury School and return to his beloved Wales where he would be free to wander in Snowdonia and also seek a new role in life.

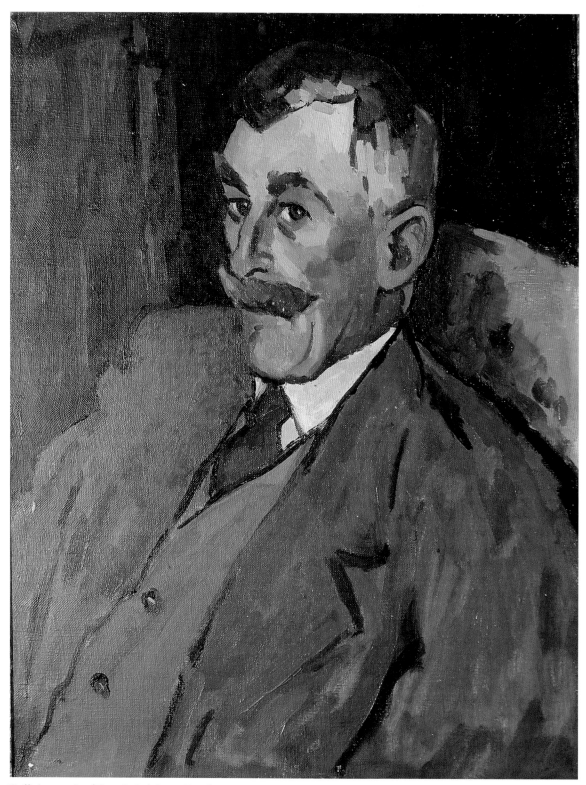

Kyffin's portrait of Captain Jack Jones, Ynysfor

4

Inspiration – Kyffin and the Ynysfor Hunt

OX-HUNTING ON FOOT, in the traditional Ynysfor way, was never intended for the faint-hearted. Roger Williams-Ellis, Kyffin's friend, described a typical hunt with Captain Jack Jones which entailed covering a large tract of the mountain terrain around Llanfrothen and Prenteg. As usual, Captain Jack, the former First World War Royal Welch Fusilier and Gallipoli survivor, led the hunt. Kyffin and Roger followed with the rest of the hunt in close pursuit. The chase eventually climbed steeply above Prenteg towards Mynydd Gorllwyn. With the pack of hounds closing in on the fox, the direction now wheeled sharply northwards and steeply upwards towards Moel Ddu with its twin peaks and its views of Moel Hebog and Yr Wyddfa (Snowdon). The hunt had been underway for some hours, as they often started very early in the morning, and fatigue was setting in for the hunt followers. There were the usual stragglers but Captain Jack, Kyffin, Roger and several others were still in contact with the hounds. Kyffin and Roger were always amazed at Captain Jack's stamina and skills with a hunting pack. He knew when to push the pack forward and was experienced enough to be able to hold them back at the right moment. These particular hunting skills were an accumulation of 200 years of family experience, latterly with his father and brother, and were executed with military precision. Some of the hunt followers found 'delays' frustrating, but would never voice their opinion within earshot of the Captain. The nature of Captain Jack's character, his incisive mind and terse speech, were seized upon by the novelist Patrick O'Brian, a hunt follower living in Fron Wen, Cwm Croesor from October 1945 to September 1949, and formed the basis of Captain Jack Aubrey in *Master and Commander*, as well as O'Brian's other twenty-one successful novels. Raking over Moel Ddu the hunt sped in the direction of Llyn Cwmystradllyn. After negotiating the old slate quarry and circling the lake at the head of the cwm, the scent of the fatigued fox became less evident for the hounds to follow.

With the lateness of the hour and the hunt virtually over, Kyffin and Roger decided to set off home on foot as darkness descended. Understandably, they were very tired, and the prospect of walking home a considerable distance was daunting but the excitement of the day sustained them. They made their way, after crossing the Caernarfon to Porthmadog road, in the direction of Pentrefelin where they passed near Kyffin's former home, Plas Gwyn. They plodded on, hoping for a lift, and as weariness gradually set in they were cheered a little by the lights of Cricieth. They still had several miles to go when they passed through Llanystumdwy and over the Afon Dwyfor and Afon Dwyfach. When they reached Kyffin's home, Doltrement, Roger still had several miles to walk to his family home at Glasfryn. On a rough reckoning Roger felt that they probably trudged twenty miles or possibly, twenty-five miles that day. Often a hunt ended with great efforts to dig out and extricate a trapped Jack Russell terrier. Kyffin would often be seen digging, head-first and body length, down a fox earth attempting to retrieve a trapped terrier. Michael Wynne Williams recalled Kyffin digging out Captain Jack from an earth on one occasion. Many of these hunting activities may have gone against the grain within artistic circles but Kyffin was never conventional.

His many friends in the art world could not understand his interest in 'blood sports', and often avoided talking about the subject with him. Kyffin was always frank with these people, and would explain that it was 'the way of the land' and that the mountain farmers' flocks needed protection from the ravages of foxes. Kyffin, as he explained to interested friends, was not a bystander in some frenzy for blood. He claimed in *Across the Straits* that he disliked the killing of an otter at a Llanystumdwy hunt he once attended, but felt it was a necessary process with foxes, to protect a farmer's livestock and livelihood. He observed that Captain Jack Jones would have little to do with some of the older hunting traditions. The Captain never subscribed to the English tradition of 'blooding', the smearing of fox blood on a newcomer to the hunt. Jack detested the 'goings-on' in the Anglesey hunts, particularly the hunt balls at the Bulkeley Hotel in Beaumaris. The throwing of hot pennies to the waiting children also angered him as he felt the tradition embarrassed the poor. Captain Jack Jones was a privileged landowner and had a long family history, but he disapproved of many of the antics of the aristocracy. Ynysfor's hunts were for invitees only and, as the author Patrick O'Brian discovered, Captain Jack's yardstick for inclusion was that 'a man is only judged by his commitment to the hunt, not by his status or background'.

Kyffin spoke of the slaughter of an otter on the Afon Dwyfor, near Llanystumdwy, where the hunt followers were baying for blood at any cost. The otter, completely

fatigued, was eventually penned in by a 'stickle' (hunters' notched staves forming a line or circle around the otter). The hounds were driven forward to finish the poor animal. But the carnage was a disgrace and infuriated Kyffin. He felt it was not a clean kill, as hunting 'laws' dictate, as the otter drowned through fatigue. A fine distinction, perhaps, but clearly a matter of conscience in Kyffin's complex mind. This incident, however, did not curtail his enthusiasm for hunting and shooting.

Another incident during a shooting trip in the 1930s, involving Kyffin and his brother Dick, changed the relationship between the two brothers and may have persuaded Kyffin to give up shooting. They were both out shooting rooks one day when Dick winged a young bird. Kyffin was half expecting Dick to finish the squawking bird off but he cowered away from the scene. This greatly upset Kyffin as he felt his brother had more character than to let the bird suffer. Kyffin completed the job, but years later doubted his own skills with a gun, and wishing not to inflict any suffering, eventually gave up shooting altogether.

The incident also revealed a chink in Dick's armour. Kyffin had always revered his brother and frequently considered himself a failure who was lacking in many areas. Dick's fitness and prowess in all types of sports had always impressed Kyffin. But Dick's tragic end to his life made Kyffin realise who was the stronger. This realisation shocked Kyffin greatly, especially when, one night at Pwllfanogl, Dick revealed his deep-seated problems, laying bare all his demons and phobias. After this breakdown, Dick was no longer a tower of strength in Kyffin's eyes, especially when he declared he was unable to cope with life. Kyffin tried to understand Dick's drinking problems, and pleaded with him to stop. Kyffin even tried to get him to understand the turmoil he had sustained in his own life, his disastrous bouts of epilepsy and, later, the pressures put on him through his relationship with his mother. But his brother's revelations tore Kyffin apart; all his beliefs in Dick were shattered. When Kyffin revealed this to a friend he was close to tears. How did he manage to continue painting with this burden? Things only got worse when Dick, by now a long-term alcoholic who was also very ill with lung problems, became extremely depressed. Kyffin had no inclination to paint at this time, as Dick was his major concern. When Dick stayed with Kyffin at Pwllfanogl he appeared to have few interests in life other than alcohol and horse racing. He invariably went to bed with a secreted bottle of alcohol and slowly drank himself into a stupor. Kyffin, to save his own sanity, managed to set Dick up in a flat in Llangoed. From here his brother could easily travel by bus to Beaumaris to drink in the Bulkeley Hotel. Dick, because of his lameness and poor health, persuaded the hotel porter to take his racing bets to the local bookie. His 'bookie's

runner', as Kyffin referred to him, was an amiable fellow and always keen to share a good betting tip. The situation deteriorated rapidly, and Kyffin felt tremendous guilt when Dick died alone in his little flat one night.

Roger Williams-Ellis was aware of Dick's great sadness in life, particularly his terrible accident with a Bakelite grenade. Roger explained that the Bakelite grenade was an offensive device developed during World War Two. It was adopted as it had a smaller destructive radius than the standard grenade, the Mills bomb. This, according to Roger, allowed the thrower to use a grenade even when there was little in the way of protective cover for the thrower. Dick appears to have had an accident with a grenade during training and blown his foot off. Kyffin mentioned that at the time of the accident he experienced an excruciating and debilitating pain in his own leg. The timing of these incidents was confirmed when Kyffin visited Dick in hospital at Bovington Camp, Dorset. Kyffin felt this was a tragic turning point in Dick's life. He had realised that Dick, with his abilities and fine mind, would have gone on to have a long and successful career in the Army. Roger Williams-Ellis confirms that Dick had a brilliant mind and great potential as an officer. His post-Army career, as a solicitor, was relatively successful but was marred, much later, by his 'social drinking'. Dick did little in the way of socialising with Kyffin and excursions and holidays together were often doomed to failure. Dick was always troubled and insecure to the point that alcohol was the only relief he gained from his anxieties. Kyffin considered that he suffered from agoraphobia but he never sought medical treatment. Roger Williams-Ellis explained that Dick had an additional upset when a failed courtship triggered further despair. Dick was working with a firm of solicitors in Pwllheli when the relationship with his girlfriend broke down. Her parents were probably to blame and persuaded her

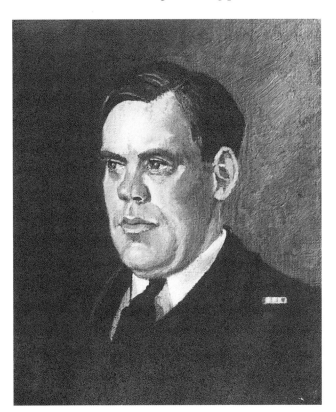

Early portrait by Kyffin of Richard (Dick), his brother

to break off the liaison. These events appear to have accumulated in Dick's mind. He explained to Kyffin that his problems started when he was psychologically hurt when a Shrewsbury School prefect called him 'funny face'. This asinine comment appears to have scarred Dick for life but only became apparent when he revealed all to Kyffin at Pwllfanogl, not long before his death in September 1982.

Kyffin now tried to restore some semblance of normality into his own life. His painting continued to make progress and he still had his hunting and shooting. Roger Williams-Ellis tells of a shooting trip with Kyffin to Glasfryn Estate. There was little to shoot on the outing as it was out of season, and only rabbits were to be taken. As they returned from what seemed an unsuccessful outing, a large rabbit shot out from cover and bolted towards a bush. Kyffin aimed and fired and then went to retrieve the creature. To his surprise there was no rabbit in the bush only a shot hen pheasant. Clearly, the unfortunate bird was roosting, concealed in the bush as the rabbit swept past. He found this embarrassing and had his leg pulled about it for a long time.

Kyffin had always been keen on shooting, even as a young lad. He was immensely proud when his father presented him with a single-barrel .410 shotgun. His frequent shooting forays on his school friend Roger's family estate of Glaslyn eventually prompted Kyffin's mother, Essyllt Mary, to introduce him to Colonel Evan Jones and Captain Jack Jones of the Ynysfor Hunt. Ynysfor is sited on what was once an island before the embankment at Porthmadog was constructed. It is in fact in the upper reaches of what was an estuary, Aber Glaslyn. In later life, Kyffin recalled that his mother wanted to introduce him to the local hunting fraternity, the hunt at Ynysfor being the oldest and best in the area. This introduction to hunting and the 'bonheddigion' or land-owning gentry was perceived by his mother as part of the Williams family tradition. Kyffin's forbears, particularly John Williams of Treffos, had always hunted in Anglesey. It was through hunting, before his epilepsy manifested itself, that Kyffin's inner character and strength would develop, or at least this is what his mother felt. It was also, in 1982, a means, along with his painting, of distracting himself from the terrible circumstances of his brother's death.

The Ynysfor Hunt was strongly linked with the area around Llanfrothen, Croesor and Cnicht but also many other areas in north Wales. When Kyffin was introduced to the hunt, Colonel Evan Jones was the master, and was assisted by Captain Jack, his younger brother. Evan was influential in Kyffin's life but it was Captain Jack who was to have an important and, possibly, inspirational role. The Ynysfor family have a long and significant military and hunting history. The 'music' of Ynysfor hunting dogs has been echoing in the mountains around Llanfrothen and into Cwm Croesor since 1765. At this time,

another John Jones of the Ynysfor family was master of the hunt. This family tradition would continue until after World War Two. John Jones was called 'Jackie', to distinguish him from the many later generations of John Joneses. Jackie gained his degree at Oxford where his descendants would also gain degrees. His love of sport, particularly hunting, led to a life deeply involved with the traditions and landscape around Llanfrothen. This tradition was, many years later, conferred on Captain Jack Jones after his elder brother, Colonel Evan Jones, died in the early 1940s. Colonel Evan left behind a considerable family heritage. He had fought in the Boer War and World War One; he was a tenacious but very fair man. Captain Jack, who learnt a lot about hunting and character building from his brother Evan, would continue this tradition.

Kyffin had known Captain Jack Jones and the Ynysfor family of seven sisters for a number of years before Colonel Evan died. Kyffin's mother, Essyllt Mary, initially took him to the hunt where he met up with his old school friend, Roger Williams-Ellis. Kyffin, when he worked for a period at Ynysfor, frequently assisted Captain Jack with preparations for the long, arduous fox-hunting trips into the mountains around Llanfrothen. These trips encompassed the Moelwyns, Arddu, Cnicht, Moel Ddu and Moel Hebog towering over Beddgelert. Earlier on, Kyffin had discovered why Captain Jack was held in such high regard, and why he was such a tough and determined character. His upbringing in farming and hunting was only part of the story. He also had a distinguished military career, and had been involved in the fateful attack on Turkey at Gallipoli between 1915-16. It was here, amid the slaughter of many thousands of allied troops from the volleys of Turkish machine-gun bullets, described as being 'like swarms of attacking flies', along with disease and frostbite, that Captain Jack's tenacious character was fashioned. Even when he was well into his 60s, and out hunting, he was able to outpace men half his age in the tough mountain terrain. He was a very determined individual and had a keen mind, which, as Kyffin noted, 'he needed to outwit the fox with its cunning ways'.

Captain Jack Jones was a plain-speaking, soldierly man who had no concern for social pretensions. He was also a magistrate of local repute. He possessed a constitution so tough and resilient that invariably he often led the pursuit of the fox. He was first to wield a pickaxe or crowbar on arrival at the fox's earth and relished physical activity in all guises. He was often blunt in speech, and he valued a man not for his title or status but for his allegiance and dedication. He never spared himself and gave little credence to what critics thought. Indeed, there was little in the Captain's appearance or attire to distinguish the Master of the Ynysfor Hunt from his 'little band of followers', mostly farmers and youths, all of whom hunted on foot over the mountainous terrain near

Ynysfor. Kyffin was impressed by the Captain's tenacity and discipline, and wished to emulate him by becoming an officer in his old regiment, the Royal Welch Fusiliers. Much of this characterisation of Kyffin's hunt master has been corroborated by Count Nikolai Tolstoy in *The Making of a Novelist*, his biography of his stepfather, the author Patrick O'Brian.

A regular visitor to Ynysfor, and Kyffin's good friend, was Sandy Livingstone-Learmonth. He loved to stay late into the evening at Ynysfor, drinking and telling stories with Captain Jack, and later with his nephew, Major Edmund Burke-Roche. The Major took over the hunt when Captain Jack was killed in a hunting accident near Dolgellau. Massive rocks collapsed on him as he attempted to dig out a faithful terrier trapped deep in a fox earth. Mrs Primrose Burke-Roche, wife of Major Edmund Burke-Roche, now owns Ynysfor and recalls Sandy as a charming and benevolent Scot who had married into and became a director of the J. W. Greaves family slate-quarrying company in Blaenau Ffestiniog. Sandy lived on the north-west side of Afon Glaslyn, at Tanyrallt, a lovely, fine historic house above Tremadog where Percy Bysshe Shelley once lived. Shelley, as Kyffin would often relate, managed to anger local farmers by shooting what he thought were scab-ridden ewes. Shelley arrived in Tremadog to support William Madocks, who was mortgaging and renting his properties in the area to fund his 1811 cob-crossing scheme. Shelley was Madocks's first tenant at Tanyrallt. The poet's subsequent interference with local farming methods and his unpaid debts antagonised local traders, causing him, eventually, to beat a hasty retreat. He also avoided paying Madocks his Tanyrallt rent.

Sandy was fascinated by these tales as well as some alleged supernatural happenings at Tanyrallt. Sandy, with Kyffin, or a suitably receptive audience, preferably late at night, would describe noises and happenings at Tanyrallt involving a ghostly apparition in a tricorn hat which, on one occasion, crashed onto Tanyrallt's roof at night. Kyffin would later attempt to rationalise these tales by suggesting that 'Pirates and vagabonds of old wore tricorn hats similar to that worn by Dick Turpin, and this may have been linked with legends of when Afon Glaslyn was navigable, and a haven for mariners in stormy conditions.' As Michael Wynne-Williams humorously explains, 'Sandy had a fondness for this type of legend and many guests, including Kyffin, loved to hear these often exaggerated, entertaining anecdotes.'

Another story told by Michael Wynne-Williams was about when Sandy once stored gelignite in his AGA stove at Tanyrallt for safe keeping. This was much to the consternation of its discoverer, his housekeeper Mrs Roberts, who called the police. Sandy was also a magistrate for the former county of Caernarfonshire, which does not tally well with his

other activities involving firearms. On one occasion he was out driving with two friends. Sandy, who was unusually quiet, was seated in the back of the car. Unbeknown to the others he was carrying, as he often did, a loaded Army revolver in a shoulder holster. Suddenly there was an ear-splitting bang that resonated around the car's interior, causing the driver to pull sharply to a halt. Sandy, still taking aim, was casually shooting at rabbits that frolicked in the roadside meadow. His companions sat shocked, gradually recovering from deafness and ringing ears.

Sandy's daughter, Jeannie Nagy, understood her father's mischievous behaviour and described his skill and sense of fun as a bagpipe player at Royal Welch Fusilier functions. From her home in the south of France she recalled his close friendship with Kyffin:

Plas Tanyrallt, Tremadog, home of Sandy Livingstone-Learmonth

Yes indeed, Kyffin (whom we called variously John, Johnnie, Sioni or, most often, Johnnie Kyffin) was a close friend of many years standing. He and my father first met in '40 or '41, both were in the Royal Welch Fusiliers, 6th Battalion (Territorial) and neither had been accepted for active service, my father because he was just too old, and John Kyffin for health reasons. The latter problems caught up with Kyffin on the station platform when their battalion was mustering at Wrexham, and luckily 'Pa' knew how to step in and help. This incident was the beginning of a long friendship, which lasted until the death of my father in 1984. I saw more of John Kyffin in the early '50s when he was teaching at Highgate and I was at the Royal College of Music, but whenever he got back to Wales, and later of course when he returned for good, he would come and stay at Tanyrallt, our house near Tremadog, to shoot with 'Pa' or go into the mountains to paint.

Jeannie explained that the location for their shooting expeditions was 'At a pool near Afonwen, between Llanystumdwy and Pwllheli, on the Bron Eifion estate and other shoots "Pa" rented.' Understandably, Kyffin's own reputation as a raconteur was fostered in this type of company. But more importantly, Kyffin appears, through these activities and interests with friends and the Ynysfor Hunt, to have gained some respite from the gradual onset of epilepsy, which he later euphemistically referred to as 'life's torments'.

Lliwedd

5

Kyffin and the Army

K YFFIN HAD DREAMED of joining the army from his youth:

> One of my most persistent dreams was of Ensign Williams charging at the head
> of a troop of cavalry, sword flashing, the thunder of hoofs in his ears. But the early
> suggestion that I should join the army, and of course it had to be the cavalry, was
> turned down by my father because of our lack of wealth.

However, Kyffin did dabble in military matters. At boarding school in Shrewsbury (1931-36), he played the bugle in a military band, as well as going with the OTC (Officers' Training Corps) to camp at Tidworth, north of Salisbury in Wiltshire. He remembered how he 'stumbled rather than marched' to the station, with his brother Dick taking his heavy rifle from him and carrying it with his own. Later Kyffin was found to be suffering from meningitis. So, although he failed to carry his rifle at his first military experience, and although joining the cavalry seemed a very remote possibility, meeting Sandy Livingstone-Learmonth, the red-haired, red-moustached Scot from Hampshire, while living in Llŷn, resulted in him joining the 6th Battalion Royal Welch Fusiliers, as well as leading to a lifetime friendship. Sandy, or to give him his full name, Somerville Travers Alexander Livingstone-Learmonth, and Kyffin, would inspire each other to write 'Crawshay Bailey light verse'. Songs about Crawshay Bailey, the industrialist who was born in 1789, were initially written in the south Wales Valleys in order to discredit the great ironmaster in his attempt to win a seat at Westminster. The songs originally concentrated on the newly invented railway engine ('Crawshay Bailey had an engine') and the fact that it travelled 'four miles an hour'. Kyffin and Sandy added to the Crawshay Bailey 'Song Book', with Kyffin, on numerous occasions, leaving illustrated verses as a present to Sandy and his family after enjoying their hospitality at their Tremadog home, Tanyrallt.

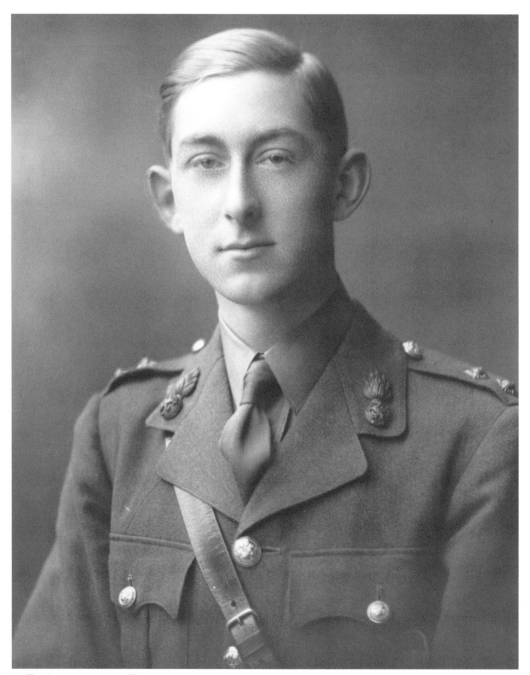

Kyffin, the young army officer

Among the forty-two verses published in *Boyo Ballads* are these two memorable ones:

> Crawshay Bailey's brother Tomos
> He has now departed from us,
> For he went and caught pneumonia,
> In the mountains of Snowdonia.

> Crawshay Bailey's brother Dic
> Was at shooting very quick
> But in trying to shoot much quicker
> Shot Aneurin Jones the vicar.

The Crawshay Bailey poems are normally sung on the traditional Welsh tune 'Mochyn Du' (The Black Pig).

Kyffin was proud of his poems and illustrations and was highly pleased that they came to his friend Sandy as a 'light relief' and that he 'enjoyed their lunacy'.

When Sandy died, his daughter asked Kyffin to give the illustrated verses to the National Library. All these poems were written and illustrated on rough bits of paper, so Kyffin added another hundred illustrated limericks and then presented them to the National Library in Aberystwyth. They were subsequently published in book form by the Excellent Press in 1995 as *Boyo Ballads*, the title suggested by Kyffin's friend and admirer Dr Glyn Rhys.

Kyffin once said that in the arts world, it wasn't the 'done thing' for artists to illustrate such light verse, adding 'awful snobs in the art world, they drive me round the bend!'

In the 1930s, it was Sandy Livingstone-Learmonth who directed his path toward the Army on the premise that he would get plenty of 'good shooting'. Kyffin, who at the time was eighteen, could blow a bugle fairly well, had been in the OTC band for a year while at Shrewsbury School, and had been at that OTC camp!

After a successful medical from a drunken doctor in Caernarfon, he was invited to the Battalion's St David's Day dinner at the well-known Anglesey Arms Hotel at Menai Bridge. Kyffin was anxiously waiting for his army commission. This St David's Day dinner would prove to be a fateful event.

He attended it with his friend Sandy, and after the customary celebrations, of goats led round the uniformed company, and officers with one foot on the table eating leeks, Kyffin, having consumed a small amount of beer and a glass of port, went to bed at about

12.30am in the hotel, next to the Menai Suspension Bridge. When he awoke, he found himself lying beside an open window, cold and covered with snow – there was a taste of blood in his mouth and his tongue was terribly painful. He had suffered an attack of grand mal – epilepsy. Later, he was instructed by a doctor in Liverpool not to exercise his brain excessively and not to think of taking any examinations. When Kyffin returned home a few days later, he received his commission in the 6th Battalion Royal Welch Fusiliers.

In later years Kyffin, while having lunch at the very same Anglesey Arms, could relate the story of his epileptic attack with total detachment.

Back in 1937, Sandy Livingstone-Learmonth continued to influence Kyffin in military matters. Sandy was in charge of the Pwllheli detachment of the 6th Battalion Royal Welch Fusiliers and with great patience tutored Kyffin in the art of commanding an infantry platoon.

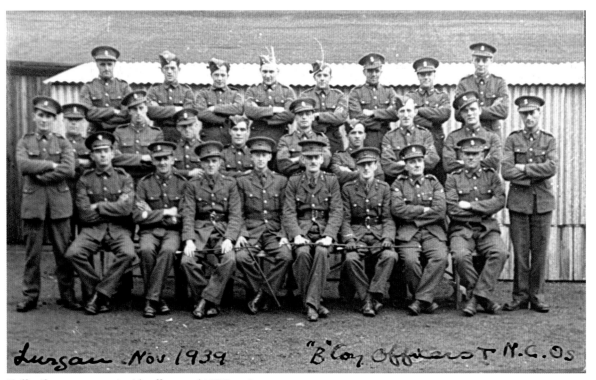

Kyffin (front row, centre) with officers and NCOs at Lurgan

Kyffin would brilliantly describe his platoon as a collection of poachers, farm labourers, railway men and slaughterers from the abattoir, a mixture of humanity who had joined to enjoy a fortnight's holiday every year when the battalions went to camp. During a royal visit to Caernarfon, with Kyffin heading his platoon, he suffered from what he termed in his diary at the time as an attack of amnesia, probably associated with his epilepsy. Later he was to suffer another attack of epilepsy, with his friend Sandy Livingstone-Learmonth coming to his rescue. To Kyffin's surprise the Army, in spite of these attacks, still wanted his services. Finally, after many months of training, Kyffin and his 'local' platoon were moved to the town of Lurgan near Belfast, in County Armagh.

Lurgan was a small town near the shore of Lough Neagh, a town with a broad high street, one side Protestant, one side Catholic, with the IRA, as Kyffin said, 'invisibly active'. It is interesting that Kyffin in his reflections on the period remembered that he had to remind his platoon members to challenge people in English, not in Welsh, as was their practice in Pwllheli. Kyffin was then posted to an army camp at Wrexham in north-east Wales, where he was to meet up with his brother Dick, who was also in the Army as a member of the Royal Corps of Signals. It was in Wrexham that another well-known Welsh hotel was to play a central part in Kyffin's life. At an army dance at the Wynnstay Arms Hotel, Kyffin was slipped an alcoholic drink instead of the water he had requested. The following day, he had another grand mal attack. Nevertheless, he continued to make preparations to play rugby for his regiment only to be stopped actually on the rugby field by his orderly Lewis. Kyffin insisted he was alright, attempting to brush Lewis aside, only to be met with a very positive 'No' from Lewis who said very firmly, 'No sir, no sir, you're not [alright], you're sick.'

Kyffin was sent to Moston Hall Hospital in Chester. There he records that no one took any action. But later, after he had returned home, he was ordered to report to a military hospital outside Oxford. It was here, after a series of tests including a painful lumbar puncture and an electroencephalogram, that a doctor told Kyffin the words that he himself was to repeat many, many times in print and verbally: 'Williams, as you are in fact abnormal, I think it would be a good idea if you took up art.'

In spite of his protestations, Kyffin would never return to army life. Dejected, he returned home to live with his parents at Aber-erch.

Kyffin felt a duty towards his friend Sandy, his platoon, and his country. He tried his utmost to stay in the Army. Even after his rejection, he appealed to the Military Secretary, a major in the Scots Guards. Kyffin even went to Cheltenham and obtained a one-to-one interview with the major, but to no avail. Although he always maintained that he had

been a 'hopeless soldier', he had made good friends in the Army. He was on good terms with his men; they were all Welshmen together, fully confident that the war would be won. Kyffin regarded himself as 'fit' and was angry that the authorities didn't consider him fit for service.

He hadn't been afraid of death while in the Army, always maintaining that he was trained not to think about it.

Reminiscing about army days, Kyffin enjoyed telling friends about the interviewer who asked him how he felt about the Army business of polishing belts and shoes and such demeaning repetitive acts, and how he had been able gently to inform the interviewer that he never did that sort of thing, he had others to do it for him. Kyffin after all was a second lieutenant!

Although he was never put to the test of killing somebody in the war, he regarded the idea of killing a fellow human being as awful and barbaric, maintaining that he didn't think he could have done it, accepting at the same time that possibly he would have had to.

In later years, when Kyffin told audiences what the doctor had said at the Oxford Hospital, he would deepen his voice and would place the emphasis on his surname, 'WILLIAMS, as you are in fact abnormal . . .' He would relish telling the tale, thankful that the medical man had pointed him in the direction of art, but pouring obvious scorn on the cruel jibe 'abnormal'. At the same time, he would take great pleasure in uttering the word in the secure knowledge that he had made an abnormally successful career for himself and that he had given great pleasure to so many people through his painting.

In developments that Kyffin could never have imagined, he was to return to Oxford to train for his true vocation, as an artist.

6

To the Slade – Gwyneth Griffiths Leads the Way

GWYNETH GRIFFITHS played a very important part in Kyffin's life at a crucial moment. In 1941 she wrote to the Secretary of the Slade School of Fine Art in London, where she had been a student, to see if it was possible for Kyffin to go there. In 1941, after being invalided out of the Army because of his epilepsy, Kyffin had tried, in his own words, for 'several dull and unsuitable jobs', only to get none of them. Following Gwyneth's intervention and Kyffin's subsequent interview with Professor Randolph Schwabe, Principal of the Slade, Kyffin was accepted in 1941 and was very grateful to Gwyneth. As he said later in *Across the Straits*, 'Gwyneth started me off.' Wales and the world of art are very much in her debt.

Prior to Gwyneth's intervention, at the suggestion of Ralph Edwards, one of his early supporters, Kyffin had contacted Percy Hague Jowett, Principal of the Royal College of Art. He, in turn, had suggested to Kyffin that, because of his highly creative style, he should consider attending the Slade rather than the Royal College.

Gwyneth Griffiths, born of Welsh parents in London in 1915, attended Haberdashers' School there, followed by further education at a finishing school in Switzerland. She then went on to the Slade, where she won many awards. She continued to do teacher training at college in Swansea, becoming an art teacher at Coventry and then at Ysgol Dinas Brân in Llangollen, Denbighshire, home of the world famous International Musical Eisteddfod. Gethin and Eulanwy Davies, leaders in legal, musical, educational and eisteddfodic circles in Llangollen, who knew Gwyneth Griffiths well, bear witness to her artistic zeal and versatility and remember her 'very independent spirit'.

Gwyneth and Kyffin's paths would cross often over the years. They had first met when Gwyneth became a land girl in Llŷn when Kyffin lived at Pentrefelin and Aber-erch. Gwyneth was related to the Davies family of Llandinam and Gregynog, one of the great

Eryri Waterfall

industrial, philanthropic and art collecting families of Wales. This was the girl who Kyffin referred to in *Across the Straits* as 'an artist turned land girl. She had fallen out with her goat loving employer and came to us as a refugee. She was a beautiful gazelle-like girl who had been trained at the Slade and had been one of the most brilliant students of her year.'

Although the reference to 'a gazelle-like girl' and 'brilliant student' caused much embarrassment to Gwyneth, secretly she was proud of the connection with Kyffin and would often, among friends, leave *Across the Straits* around the house, open at the offending page!

Not only was Essyllt Williams jealous, but unfortunately for Kyffin and Gwyneth, she very much disapproved of their friendship. There was a parting of the ways. However, in later years, Gwyneth would rent a cottage at Rachub, near Bethesda, and would on occasion visit Kyffin at Pwllfanogl and he in turn would visit Rachub. We know that Kyffin painted scenes at Rachub and Bethesda. On one occasion, when he was exhibiting his work at Llangollen, he inquired as to Gwyneth's well-being, checking with a mutual friend that she was not in any financial need.

Kyffin and Gwyneth were very independent souls. They were both highly artistic, Gwyneth specialising in ceramics. Her figurines in brown, green and pink, although never exhibited by her, were much valued and appreciated by her friends. After her death in 2006, two of these figurines – a shepherd and shepherdess – were presented to Kyffin at his home at Pwllfanogl by Eulanwy and Gethin Davies, in Gwyneth's memory.

Gwyneth Griffiths with her mother at Rachub, Bethesda

Gwyneth Griffiths was head of art at Ysgol Dinas Brân in Llangollen for over thirty years, where she excelled at set designs and painted in oil and watercolour, though being a very private person she never exhibited her work.

She was not a native Welsh speaker but she persevered in learning the language and would, on occasion, insist on speaking nothing but Welsh at intimate dinners or suppers with her Welsh-speaking friends.

Gwyneth, who died at the age of 91 in 2006, was to remain a spinster all her life. Kyffin, likewise, never married. We can only surmise what their lives would have been had not Essyllt Mary come between them.

In 1941, at the Slade School of Fine Art, which had moved from London to Oxford during the War, Kyffin attended lectures by the Finnish art historian Professor Tancred Borenius. Borenius was recognised as one of the leading experts on Italian art of the early Renaissance. He inspired Kyffin in the history of art and in time he himself would become an expert in the subject.

Following one of Borenius' lectures on the much loved artist Piero della Francesca, Kyffin went to the Ashmolean Museum Library to study his paintings. It was there that he first saw a photograph of Piero's masterpiece *The Resurrection of Christ*, the original being in the town of Sansepolcro, in Umbria, in the form of a large fresco measuring 88 x 78 inches. The painting is divided vertically, Piero portraying winter on the left-hand side and summer on the other. This contrast in the seasons underlines the rebirth of Christ himself – he is the central figure with his foot on the edge of the grave, making it appear as if he is going to step forward. The sleeping soldiers in the foreground provide a vivid contrast with the live, alert Christ standing with his eyes wide open.

In his interview in *Kyffin in Venice*, Kyffin records his reaction when he saw the painting on the page:

> It actually hit me, poleaxed me, the emotion in it and the mood, incredible mood, powerful mood. It made me weep when I saw it; tears just rolled down my cheeks – it was embarrassing – and that was my road to Damascus – my conversion really, because I began to realise then that there's something spiritual which should come into painting, something which is almost entirely lacking today, which seems such a tragedy. In these old painters, there was a tremendous love of humanity as a spirit.

As well as Professor Randolph Schwabe, Kyffin was taught at the Slade by Allan Gwynne-Jones. Of Welsh, Cornish, Irish and English ancestry, Gwynne-Jones, in Kyffin's

words, would talk about 'painting and tones and half tones…and local colour'. He would also make drawings in his sketchbook to show the students what to do.

Adrian Heath, who also studied under Allan Gwynne-Jones, said of him, 'Allan Gwynne-Jones, as would have been expected of the man, always imparted his views with consummate tact and urbanity. A student was never left to feel clumsy, inept or tasteless, but merely that he had been pursuing a muse unworthy of his talent, nothing that could not be rectified by a trip to the National Gallery or a more rigorous examination of the world about him.'

This could equally be said of Kyffin, who imparted knowledge in a totally non-condescending way and with 'urbanity and consummate tact'.

Anthony Baines, another student at the Slade (1938-1941), remembers Allan Gwynne-Jones giving advice 'about the placing

Professor Randolph Schwabe, self-portrait

Kyffin at the Slade School of Fine Art (front row, extreme left with Professor Schwabe front row, centre)

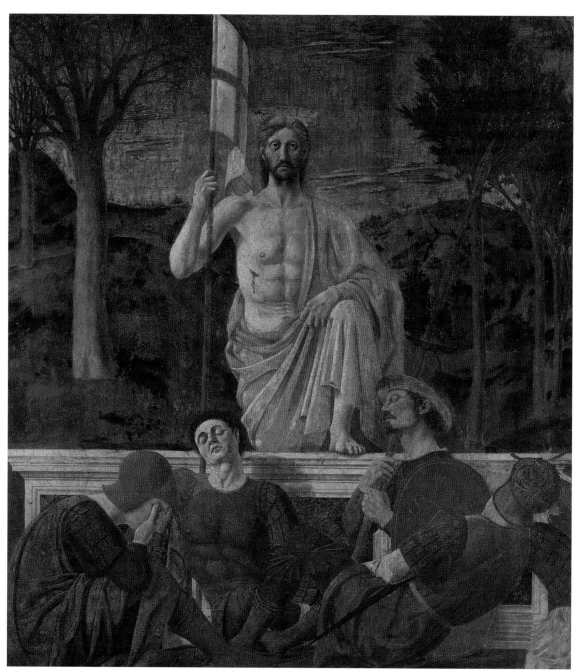

The Resurrection by Piero della Francesca

of canvas in relation to the model when painting "sight size", the choice of palette or range of colours that could be used harmoniously within one painting and the varied warm and cold colour changes depending upon the angle of a particular surface to the light.' Useful advice for Kyffin as a future portrait painter.

Also while at the Slade, Kyffin came under the influence of a fellow student, William Cole, who taught him about the subtlety of colour – that 'everything is colour' – even a roof with rain on it!

In spite of many self-derogatory remarks about his painting ability while at the Slade, Kyffin was to leave the School of Art having won the Robert Ross Leaving Scholarship. Between 1943 and 1944, he was highly commended for head drawing and also won first prize for head painting. He was also highly commended for figure drawing and painting.

The fee per term payable by Kyffin at the Slade was nine pounds and nine shillings.

In his years at Oxford, he had learnt so much: the importance of drawing as the very basis of his art, the use of colour, how to mix colours, the technicalities of painting, the 'tricks of the trade', and above all, the momentous realisation that there was more to art than putting an image down on paper or canvas or board, that there was love and mood deeply woven into the whole process.

On the social side, he had met fellow students, who, according to his own testimony, cured him from being a 'prig'. He had felt 'at home' in Oxford where many of his forefathers had attended Jesus College. Kyffin also had relatives living in the city.

But there was one skill he learnt at Oxford, while at the Slade, which was possibly to be of equal importance to his artistic skills, which was writing limericks! Professor Randolph Schwabe was a brilliant limerick writer, and it was he who passed on this ability to Kyffin, a skill that the latter exercised with style for the remainder of his life, and which gave him and others great pleasure.

Kyffin was extremely fortunate to have met Randolph Schwabe. There were two coincidences that linked them together: both were born on the 9th of May and, like Kyffin, Schwabe was prevented from serving in the Army due to ill health. Schwabe (1885-1948) was born at Barton, Lancashire. His grandfather came from Germany in 1820. He attended the Royal College of Art and the Slade, where he was appointed a professor and principal. He was an accomplished draughtsman, illustrator and costume designer. Kyffin was not the only Welshman that Schwabe got to know well. In an article in the *Burlington Magazine* in 1943, he reminisced about his fellow students at the Slade, among them Augustus John (from Pembrokeshire) and J. D. Innes (from Llanelli).

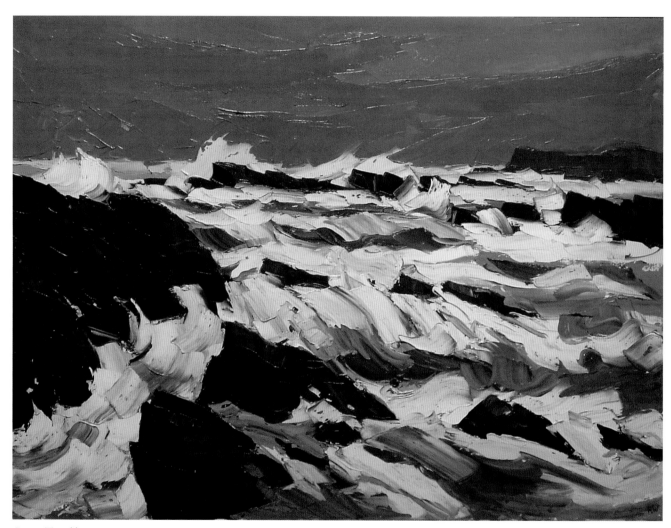

Storm, Trearddur

Highgate – Once a Teacher . . .

K YFFIN LEFT THE SLADE IN 1944. He immediately set about securing a place of work but with little initial success. At one stage he claims he sold artists' materials for Windsor & Newton and commented, 'I wasn't very successful'. He applied to a number of public schools for posts but this was again without success. His fortunes changed when he realised his company commander in the Oxford Home Guard was also the appointments officer of the Oxford University Appointments Committee. Letters were promptly dispatched to a number of public schools but with no immediate outcomes. A few interviews were eventually arranged, Harrow being one. Here, Kyffin recognised the headmaster as a former assistant master at Shrewsbury School. The headmaster's dog was lurking in front of the fire and, although old, immediately got up and bit Kyffin in the leg. Understandably, he didn't secure the Harrow post.

He was then interviewed for Christ's Hospital and was promptly sent off to meet the art master in Christchurch, Sussex. Kyffin describes the master as being a 'mournful man', who decreed that if Kyffin ever wanted to be an artist, 'He must never teach or get married'. It appears that Christ's Hospital were very keen to rid themselves of an assistant art master. It was explained that this master only taught the pupils how to draw fairies 'and things like that', which Kyffin noticed on their drawing boards. Again, Kyffin was not appointed or even keen on a position at such a school. His next attempt for a position was at Merchant Taylors, where he tried to endear himself to the headmaster by commenting on an engraving by Samuel Palmer on the wall of the headmaster's study. Kyffin's remark that he was glad that Palmer was an old boy at the school fell on stony ground, and drew the comment from the headmaster, 'Samuel Palmer? Never met the chap!' Kyffin was rejected on the grounds of insufficient experience.

By now, and in exasperation, he applied to Highgate School, London. Here he stayed overnight with the headmaster, Geoffrey Foxall Bell (1896-1984), a renowned English

Kyffin in the classroom at Highgate School

Highgate School 1946, Kyffin (3rd row, 5th from right) amongst teachers and pupils

cricketer and educationalist. Bell played first-class cricket for Derbyshire and Oxford University. He had seen service in World War One and had won the Military Cross. He was born in Stapeley, Derbyshire and was related to the Evershed brewing family. After the war he went to study at Oxford University. He later secured a job as a schoolmaster, and in 1927 became headmaster of Trent College where he was held in high regard by the boys, and seen as a forward-thinking educationalist. In 1936 he became headmaster of Highgate School where he was an austere but much respected figure.

Bell offered the Highgate teaching post to Kyffin and said, 'Well I think this will do. I'll start you off with a salary for six days a week of £325 per annum.' After thanking Bell, he rejected the possible £355 per annum salary for a housemaster's post because of the extra time involved with the boys. Many years later and in jest he reasoned, 'I would have been in contact with the little perishers all day and most of the night.' Clearly, he did not want to curtail any time available for painting, no matter what financial hardship it might bring. This was in September 1944, and Kyffin's only regret was that he had not tried Highgate in the first place as it was so near all the central London galleries he loved to visit.

He considered Highgate a very good school that catered for all types of boys who were from a range of backgrounds, from the sons of ambassadors to the sons of the bookmaker at the bottom of Highgate Hill. He felt that:

> I did not enjoy teaching really, but was very lucky I had some bright pupils. It would have been extraordinary had I not had bright pupils because it was a North London school. It had a watershed of Golders Green, Hampstead, Finchley and there were bound to be some bright boys from that area.

As he indicates in *Across the Straits*, two-thirds were day boys and a third were boarders. When Kyffin first arrived at the school it had been commandeered by the government, with the school being evacuated to Westward Ho and Hartland Point in Devon. The boys returned in 1944, probably slightly prematurely, as one afternoon a V-1 flying bomb exploded in the field behind the Junior School. Luckily, the only serious casualty was a cricket score box. Theodore Mallinson, a teacher at the school who was with the boys in Devon, recalled another colleague, Mr Hunt, saying that a 'doodlebug' would never get up Highgate Hill. Kyffin also recalled that Edward Bullin, an elderly, bald master known as 'the Egg', acted as a magnet to these flying bombs. He was blown out of his house in Talbot Road, a little to the north of Highgate School, and then moved to Bisham

Gardens, where a V-1 also scored a near miss on him. Bullin was also involved in the 1944 explosion on the Junior School cricket pitch score box. He was taking a class, not far away, in the cricket pavilion when the flying bomb impacted close by and detonated. The inside of the cricket pavilion became a haze of dust, with debris scattered all around. As the dust settled there was no sign of 'the Egg'. The boys were shaken and feared the worst, as their master had disappeared. The blackboard lay over his desk and, eventually, a dishevelled Edward Bullin emerged, yet again, unscathed.

Kyffin discovered that the boys had not received art lessons while in Devon and had decided that they were not going to have any on their return to Highgate. From the beginning he believed that boys should not be punished with beatings. He felt he broke this promise to himself only three times in all the years he taught at Highgate. This was when some boys' insolence forced him to recommend that their housemaster, and Kyffin's good friend, John Coombs, administer beatings with the cane. Smiling, he would say, 'I was at Highgate for twenty-nine years and you can't go for twenty-nine years without clobbering the odd boy!' Such were the archaic punitive educational practices at that time. Though he would often say that he was very lucky with the particularly good pupils he taught, listing certain notables, like artists Anthony Green and Patrick Procktor.

Anthony Green was born in London, the son of a tyre merchant and a French, though English-born, mother. He studied at the Slade in London, where he later taught. During his schooldays, Green claims that Kyffin, as his art master, was his greatest influence. It was Kyffin who encouraged Green to enter the Slade, which he did at the age of 16. Green, at this time, maintained that 'the emphasis on drawing was paramount'. It was at the Slade that he met Mary whom he married in 1961 after spending a year in France on a government scholarship. His family holidays were spent in France with his mother's family. This is where the nineteenth-century works of Gros, Géricault, Delacroix and Courbet impressed him greatly. Green was elected an Associate Member of the Royal Academy in 1971 and, having won the Royal Academy Summer Exhibit of the Year in 1977, was elected a full member. Green, a larger-than-life character, was greatly admired by Kyffin, perhaps because of his outgoing nature. His name would always crop up when Kyffin was showing and discussing his Highgate pupils' works, which were kept in his dark studio cellar at Pwllfanogl.

Kyffin would often discuss the work of another larger-than-life character, Patrick George Procktor. Procktor was born in Dublin in 1936; he became a Royal Academician in 1996 and married Kirsten Benson (née Bo Andersen) in 1973. Kyffin felt he was a

painter of exceptional intelligence and refinement and always spoke of him with a sense of pride and affection. The annual dinner at the Royal Academy, an occasion which Kyffin eventually came to abhor, was often the focus for 'Procktor's antics', some of which verged on anarchy. His six-foot-six frame, frequently topped by a fez, seemed to teeter and sway, much to the amusement of observers. Procktor liked Kyffin as his art teacher at Highgate School. Kyffin recalled that 'Patrick just drifted into my art class, knocked off some very pleasant watercolours and oils, and drifted out again.' Later, Kyffin wrote with great admiration of his most famous pupil who was, by then, also a fellow Academician. Procktor could often be seen around his Marylebone flat, flaunting hats and trailing scarves, somewhat reminiscent of what pupils noted of Kyffin's flamboyant appearance as a newly appointed teacher at Highgate in 1944. Procktor was a friend of David Hockney and a significant figure in English art's heyday of pop, fashion and society culture that epitomized the period. Tragically his flat was destroyed by fire in 1999, which drove him from his forty-year-long artistic encampment. With his velvet coats and carpet slippers he presented a camp persona that concealed, within his complex character, great artistic strengths. Kyffin greatly respected Procktor's 'compassion and deep artistic conviction'.

Although the school and pupils were an important part of Kyffin's life, his social life in Highgate and London was what sustained him most, especially through his serious bouts of epilepsy and depression around 1948 and 1949. His socializing is recalled by his friend Michael Wynne-Williams:

> I was studying Law in London and I had digs in West End Lane, which is the Jewish sector of Hampstead. Also nearby were four girls whose mothers I knew back in Wales, and who had finished school and wanted to go to a secretarial college and other places in London. They were Valerie Price (my girlfriend at the time and later my wife), Annwen Williams, Greta Berry and Sue Evans. I found a house for them in Hampstead. A lot of people used to come there. I remember a particular party John Kyffin came to as well as David Jones the artist and poet. David Jones was very nervous, very disturbed after action in the First World War, and came in a London taxi from Harrow on the Hill, and kept it there for the duration of the party. He didn't want to think that he might be stuck without transport home to Harrow late at night. I don't know if he was wealthy then but well-off, perhaps. I think the Tate have a gallery dedicated to his work; I think he was selling his pictures for good money in those days.

Michael recalled that this was about the period when Kyffin was fond of Annwen Williams. Kyffin would have known David 'Bengy' Carey-Evans, who later became Annwen's husband. Bengy was at school in London as his father was a doctor in Harley Street. He later joined the Navy and would regale friends, like Kyffin and Michael, with his experiences at the D-Day landings. Winston Churchill crossed the Channel aboard HMS *Kelvin* as he wanted to see the Normandy landings, as well as meet Montgomery, and landed at Courseulles-sur-Mer six days after D-Day, on 12 June 1944. Bengy was an officer aboard the ship and accompanied Churchill on the bridge. At the time Bengy was concerned that Churchill would discover that he was Lloyd George's grandson. Lloyd George and Churchill were great friends and if the ship's officers had found out, Bengy's life would have become unbearable with leg pulling. Churchill at the time sent President Roosevelt a postcard saying: 'Wish you were here.'

Annwen Carey-Evans remembers her first meeting with Kyffin at the house she stayed in with Greta, Valerie and Sue in Pattison Road, near Hampstead Heath:

> I returned back to the house one evening and as I entered this man (Kyffin) was sitting there, and his hair was lit up in a shaft of sunlight that streamed into the room. Valerie introduced him to me and we all got on really well together. He looked thin and I recall he spent a lot of money on his paints and canvasses. He was obsessed with painting and used our house to store them as he had filled his own lodgings. His first meal with us at Pattison Road was beans on toast.
>
> Kyffin was a lovely man and wanted to paint my portrait. I arrived at his studio in St John's Wood and he was concerned that the dress I had on was not suitable. He asked if I would change in his bathroom into a white shirt and another dark garment. I now think the finished portrait looks more like my daughter. Kyffin came over regularly for meals and social gatherings at the house. He was such fun and was always telling stories about his ancestors and the aristocracy. He knew everyone on the Llŷn peninsula and in Anglesey. In later years he would regularly come and stay with Bengy and I at Eisteddfa, Pentrefelin; we were great friends. We have so many fond memories of a wonderful artist and man.

Kyffin enjoyed these gatherings with his friends and one Christmas he was invited by Michael and Valerie Wynne-Williams, together with Dick, his brother, to Dorothea, their Dyffryn Nantlle home. Kyffin had tried to prepare Michael and Valerie for his brother's 'problems' at this time; but it all turned out to be very enjoyable. Contrary to Kyffin's anxieties, Dick was on great form and really good company. Valerie commented

that Kyffin worried a lot about Dick; he was always concerned about his health, especially in his last years when he resided in Llangoed.

In London, Valerie's friendship with artist David Jones evolved into a lifelong empathy and respect for his prodigious output of art and literature. Their initial communications, through the letters pages of *The Times*, went on to produce more than fifty letters of sincere and personally valued correspondence.

On 27 June 1974, David Jones wrote to his lifelong friend and literary executor Harman Grisewood (1908–1997) describing his feelings for Elri (Valerie):

> I know that an involvement in 'Welshness' has an awful lot to do with my intrication with Elri . . . I'm paying dearly for my doctrine of signa! She's the only Welsh woman I've ever met really, and it came about through those letters to *The Times* in such a 'fatalistic' and unplanned manner that perhaps I may be forgiven for mistakenly thinking that it must in some way be significant and not without meaning.

Kyffin respected and admired David Jones's art and poetry, which were also much lauded by Jones's contemporaries, W. H. Auden and T. S. Eliot. Jones was a friend of Saunders Lewis who, in 1925, was one of the original figures involved in establishing the National Party of Wales (later Plaid Cymru), becoming president of the newly formed organisation in 1926. Lewis converted to the Roman Catholic faith in 1932, as Jones had done in 1921 when he attempted to escape the terrible memories of trench warfare on the Western Front. Jones worked with Catholic convert artist, Eric Gill, in Ditchling and Capel-y-ffin, and was engaged to Gill's daughter, Petra, for a while. He moved in April, 1964 to a large room at the Monksdene Hotel, Harrow. He spent his last four years, after a stroke in 1970, in the Calvary Nursing Home of the Blue Sisters, on Sudbury Hill, Harrow. Helen Sutherland, Jones's friend, realised he had little income and, when she died in 1964, left him £6,000 in her will. Helen, also a Catholic convert, first met Jones at her house, Rock Hall, Alnwick in 1929. As Kyffin indicated, friends quickly gathered round Jones and added to this sum, enabling an annuity to be purchased. Kyffin, although not directly involved in any of these developments, was clearly aware of their embryonic nature and important artistic, political and philosophical implications in Wales.

Kyffin also made friends with a wide range of other artists in Highgate and Hampstead, particularly Bernard Dunstan and his wife, Diana Armfield, and Margaret Thomas. Bernard Dunstan was a friend from his days at the Slade. Diana was also at the Slade and studied textiles. She did not know Kyffin at that time but became great friends later. She

recalled Kyffin's autobiography, *Across the Straits*, where he appears to be in constant conflict with various people, especially his landladies:

> He seems to have been in a kind of warfare in London with his landlady. When she was making his food he said he could eat anything, she appeared to want to annoy him by making him macaroni cheese, which, unfortunately, he hated. It was Kyffin's way of saying these stories that had the children glued to their seats, that's our three boys, Andrew, David and Robert; they always ate with us at meal times.

Diana also said that when they invited guests to supper her sons usually slipped away before the meal was over, but with Kyffin they stayed to the end. There would be lots of general conversation, as well as quite a lot of discussions about art and painting. This was all much to her sons' delight as it would be punctuated with Kyffin's marvellous anecdotes. The boys always waited until Kyffin had finished his stories. They loved the fact that the stories were against him, and were couched in humorous terms. Kyffin further engaged the boys with his exaggerated accents, which he invariably carried off to perfection.

Diana mentioned Kyffin's self-deprecating nature and this emphasis in his anecdotes fascinated her, particularly when he was poor and trying to sell his work in London. On one occasion he had an exhibition in the New Arts Centre, in Knightsbridge, which was run by two women. Diana described how they gave Kyffin an exhibition and a man came into the gallery and said 'I'll have that picture', which was marvellous, as sales were not easy at the time. This was in the late 1960s, and the man said, 'But I've got my cheque book in the car.' The man went out to get his cheque book and fell dead on the pavement with a heart attack. When Kyffin told this story to Diana and her family, the man was quite opulent, a new client, and this sale would have made all the difference to his life and fortunes. Kyffin built him up as if everything was going to change and the man was going to be a major patron.

Diana explained that Kyffin was always sensitive, even in full flow with an anecdote, and aware of the boys' presence:

> In between he had the courtesy and fondness for the children . . . he decided he was interested in them. He would see to it, every now and then, that they enjoyed it . . . He'd draw for them, very often he would draw them a dog doing something and he just had that capacity that's marvellous for children.

She felt Kyffin would have made a good father as he had the skills and patience, but she acknowledged that he was epileptic and, to counter this, was obsessed with his art.

Diana and Bernard also noticed that Kyffin became quite anxious at times, and his concerns were often shared with them at their little cottage. He had always shared his thoughts with close friends, usually in a rational manner, as befitted his nature, but this appeared to change over time:

> And the other thing we found in later life was that a lot of his worries were repeated, and they began to be really paranoid. So that the first half an hour, when he used to come here (near Bala) it was half an hour of getting rid of it all, and it was still a little bit humorous and very much more anxiety. If a visitor came in, immediately he switched and became the delightful raconteur. We knew that after this short outburst he would be fine.

Diana intimated that Kyffin was immediately fond of women and loved to be in their company, and they were fond of him:

> He was affectionate – a very affectionate person and he took an interest, and I wonder if you've got the poem he wrote me for my birthday not many years ago now, because he wrote me a poem about God and Blair.

She also found Kyffin extended this interest if he saw talent in an artist, and would always try to help them, whether female or male. She discovered that some artists are quite selfish, but Kyffin went out of his way to help. He attempted to get good artists into the Royal Academy of Arts, as in the case of Peter Prendergast. He fostered artists and introduced them to established galleries like the Albany Gallery in Cardiff and the Thackeray Gallery in London. Diana found this part of his character endearing – particularly when extended to her and Bernard:

> He got me and Bernard to be members of the Royal Cambrian in Conwy, and I'm sure it was he who encouraged Gwyn Brown (Tegfryn Gallery, Menai Bridge) to give me a show; that trait is very attractive, helping other artists, not just thinking about himself.

Diana pondered why, with his character and charm, he had never formed a long-term relationship, but conceded:

> I always found he held back because of the epilepsy; he had this side. There was a cousin [Gwen, alias Sue Kyffin] in Austria whom he, perhaps, would have liked to marry, but he held back or perhaps she held back, I don't know. But he was obviously . . . he didn't develop that side, he didn't develop sexuality.

Margaret Thomas (b.1916), who lived at Half Way Cottage, 11a North Road, opposite Highgate School, was also a very supportive friend and provided Kyffin with picture frames, as well as painting his portrait. At ninety-six, she still paints and exhibits at the Cork Brick Gallery, Bungay, Suffolk, and fondly recalls Kyffin's encouragement and kindness.

But back at Highgate School, even with all this support from so many good friends, Kyffin's life was not easy. His epilepsy never diminished, and taunted him relentlessly; he found it difficult to cope with the condition at times. He gained some respite by taking regular breaks in Wales and holidays abroad.

Kyffin was at Highgate School between 1944 and 1973, a period of 29 years dedicated to the teaching of art. A great many former pupils have testified over the years that

Snow scene at Westhill, Highgate, 1940s

Kyffin was a gloriously informal teacher, an informality that attracted pupils towards art as a subject. Julian Halsby first met Kyffin in 1961 at Highgate School. Julian was born in London in 1948 and after Highgate School studied history of art at Emmanuel College, Cambridge. He then joined the staff of Croydon College of Art, lecturing in the history of art and design, where he became senior lecturer and head of the Conservation Department. He was always impressed by Kyffin's 'energy, sense of humour, and his melodious voice made a deep impression'. Another ex-pupil and artist, David Porteous-Butler, visited an energetic Kyffin in 1993. Kyffin was in his seventy-fifth year and he introduced David to his favourite mountain landscapes. They visited Cwm Pennant, a location that Kyffin loved and often painted. By coincidence they met up with Nesta Davies, Kyffin's friend, who was visiting the historic valley with a companion. Kyffin revealed many of his favourite techniques to David, especially his method of drawing with the wrong end of a brush sharpened to a wedge and using Indian ink mixed with sepia or peat-brown paint. Kyffin mentioned that he had painted on the continent and in Venice and Patagonia, adding 'However, it is Wales that I can paint with the greatest freedom.'

Kyffin always said that he had been lucky in failing to get jobs at art schools, allowing him to stay at Highgate School and 'develop my own work in peace'. He was very fortunate in having a benevolent headmaster, Geoffrey Bell, at Highgate. When Kyffin was caught on one occasion painting on the nearby Hampstead Heath during school hours, when he should have been teaching a classroom of children, far from being sternly rebuked, Bell kindly suggested to him that perhaps he would wish to return to the school and attend to his duties.

Kyffin's great ambition while at the Slade was to be an art master at a comfortable public school with playing fields, and rooks nesting in trees behind the chapel – in short, the gentle civilised life of a master at a public school. He had never thought of becoming a serious painter. But the freedom he was allowed at Highgate, together with his long holidays in Wales, were conducive to painting and to him developing as a serious painter with his own unique style.

It was while at Highgate that Kyffin realised the great damage done to generations of English children and to the image of Wales by the libellous nursery rhyme 'Taffy was a Welshman, Taffy was a thief'. Talking to a class of 25 boys one day Kyffin told them how during the War a priceless collection of paintings by the old masters and others had been removed from the National Gallery to Wales for safekeeping, and secured in the slate quarries of Blaenau Ffestiniog as well as a cave near the National Library in

Cardiganshire. On hearing this, the whole form 'was reduced to a state of uncontrolled laughter'. Asking the reason for their mirth Kyffin was told that the paintings would not be very safe in Wales; after all, Taffy the Welshman was a thief!

Kyffin's experiences at Highgate were pivotal in so many ways; teaching in London gave him ready access to London's great art galleries, the British Museum, the Royal Academy, the Victoria and Albert, the Tate, and to many smaller specialist art galleries. Being based in London also meant easy access to mainland Europe, as well as frequent contact with his many social acquaintances in the city, particularly with the London Welsh Society (where he played rugby, tennis and badminton) and countless other societies that helped him develop his social skills and provided him with friendships which were to last a lifetime.

Highgate School still holds Kyffin in great esteem, thanks in a large part to the enthusiasm of David Smith, Head of Physics, and the active encouragement of Headmaster, Adam Pettitt. There is a Kyffin Williams room at the school with fine examples of his work. Kyffin was always generous to the school and made several visits there over the years. As well as a portrait of Mari Prichard in oil, the Kyffin room holds many prints of his work. There is also a powerful self-portrait keeping a watchful eye on all proceedings. In a glass case is a specially bound edition of the book *Kyffin Williams, His Life, His Land* published in 2008 and bound at the National Library of Wales. In a piece of detective work, David Smith tracked down an oil painting by Kyffin of a Highgate pupil in football kit sporting the colours of 'School House' that had ended up at the Glynn Vivian Art Gallery in Swansea, a gift from the Contemporary Art Society in 1956 – a rare Kyffin painting linking him directly to Highgate. As David Smith has written, 'the painting is a charming portrait of a knobbly-kneed footballer, dishevelled and flushed after a game, a wonderful example of Kyffin's skill at capturing personality with a palette knife'. Many of Kyffin's paintings have fascinating stories linked with them. The 'knobbly-kneed' footballer painting had been damaged by a patient while on loan to the Cefn Coed Psychiatric Hospital in Swansea, but repaired by the National Museum of Wales and by Kyffin himself. The author and former Kyffin pupil, Roderick Thomson, has shown that another of his paintings languished behind a tea urn at the Mary Ward Centre in Tavistock Place, London: the portrait of Dame Eileen Younghusband, a painting framed by Kyffin's favourite London framer Robert Sielle (his original name was C. L. Roberts). The portrait is now safe at the National Portrait Gallery in London. David Smith also arranges the Sir Kyffin Williams Lecture at Highgate School, held annually since 2009, and continually researches and plans exhibitions, working closely with the National Library of Wales and Oriel Ynys Môn, all in memory and celebration of the genius of John Kyffin Williams RA.

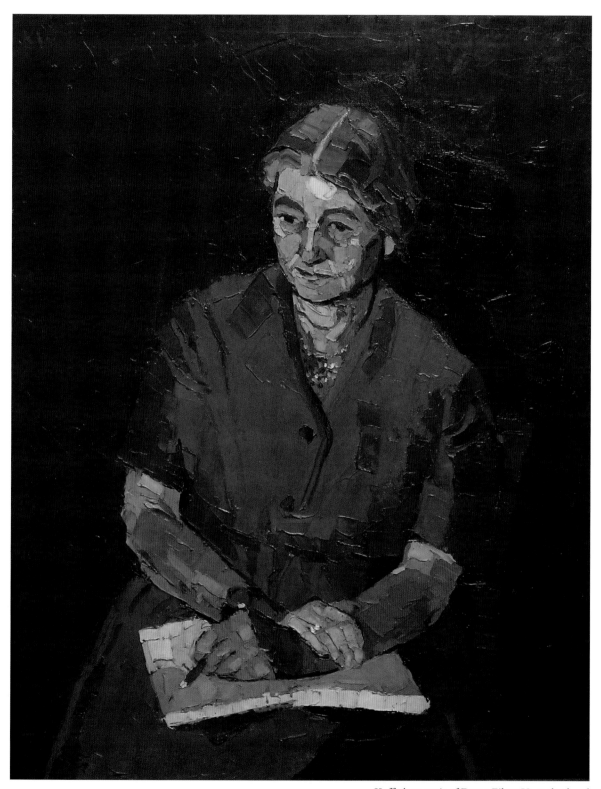

Kyffin's portrait of Dame Eileen Younghusband

Farm in France

8

Working Holidays Abroad

D R MORYS CEMLYN-JONES met Kyffin when they were in the Royal Welch Fusiliers in 1939 based in Caernarfon. Kyffin was not in Morys's company but met him in the officers' mess and they became firm friends. Kyffin was Morys's best man when he got married in 1958. Morys was a medical student before the war, and he noted that Kyffin did not have an eye reflex to light, as well as having no yellow vision. Kyffin was in quite a bad way at this time with frequently recurring epileptic attacks. He was being given different drugs to help ease his epilepsy. These included luminal, and belladonna, and after these Kyffin was prescribed phenobarbitone. His condition became so bad, even with this heavy medication, that occasionally his mother and his brother had to lift him out of bed and lay him on the floor. At times he was in such a sedated stupor that he could not wake up. A drug called epanutin was then tried, but this did not alleviate the disastrous effects of his epilepsy either, so he was prescribed tridione. This drug was discovered in 1944, and was considered to produce a striking amelioration of petit mal seizures, but to have only a slight effect on grand mal seizures. These drugs were available to be taken in certain combinations, but all had side effects. The tridione in particular affected Kyffin's blood and he was unable to see properly in bright sunlight. He eventually reached a state of despair when he was put back on epanutin, and then, later, in the 1960s, a drug he hated called ospalot:

With Morys Cemlyn-Jones, 1958

91

I wanted to give up taking these anti-convulsive drugs. But they kept me alive, undoubtedly, but they ruined my life. Well, I say ruined my life, I suppose I've been pretty lucky really, because I'm a painter.

Kyffin's friends, Annwen Carey-Evans and Bengy, her husband, noticed that over many years, when Kyffin was invited to lunch or a function, he invariably phoned just before the appointment to cancel it. This had happened so many times, and with so many people, that they thought it was a life-long problem. Annwen noticed this phenomenon disappeared completely when he eventually, in later life, came off his medications for epilepsy.

Kyffin considered he needed a break, a holiday, but how could he undertake this with teaching and other factors that affected him? Alcohol, stress and overexcitement had always exacerbated his epileptic condition. By now, he totally avoided alcohol in its many guises, and would even leave social gatherings if he detected minute amounts in his food. Greta Berry, a longtime friend, recalls him rapidly rising from a table and leaving a function where he discovered the addition of alcohol to the food. Nesta Davies had also seen him similarly excited on discovering the presence of alcohol in food. He knew he could not take risks and detested the thought of having a grand mal seizure in public. This anxiety reached a climax in 1949, due to recurring petit mal seizures – up to nine a day. This disastrous period of ill health, coincidentally, followed the death of his great friend and mentor, Captain Jack Jones, in 1948. Kyffin often spoke of Captain Jack and would visit his grave at St Brothen's Church, Llanfrothen on occasion in later years. Kyffin referred to his own poor health saying, 'It was absolute Hell at the time.' After a severe bout of depression, and almost suicidal, Kyffin pleaded with doctors, who eventually sent him for treatment to St Mathew's Hospital, Northampton. He was able to do a little painting at the hospital but was too fatigued to be really inspired. He felt the only thing he gained was a sanctuary from the pressures of life. After three months of treatment, and a little recovered, he returned to his lodgings in Bisham Gardens, Highgate. This was under the medical instruction that he should not teach for a year. Kyffin was truly fortunate in having a sympathetic headmaster, Geoffrey Foxall Bell, at Highgate School who, after discussing his serious health problems, supported his twelve-month sabbatical. A break and new surroundings were suggested, so Kyffin decided to embark on a holiday abroad. Pope Pius XII had declared 1950 a Holy Year, a year of special pilgrimage to Rome: 'Let our humble thanks go to divine Providence, which, after formidable events which shattered the earth during the second world conflict and in post-war years, has granted humanity some improvement in general conditions.'

Kyffin also felt that he had been involved in formidable events that had almost shattered his life:

> Well after I had been ill I was advised to go abroad, and in 1950, which was Holy Year, I went to Rome to stay with some friends, and that was fascinating. It was in February I went there, and the smell of mimosa was absolutely tremendous, I gloried in it. In Rome in February the florists sell bunches of mimosa below the Spanish Steps. Bright yellow puffs of flowers dangle from the silvery branches, and they smell of southern spring. But unfortunately that was at a time when I was using the drug Tridione, which meant I couldn't see in the sunlight, so the pavements of Rome were a continual glare, and I couldn't see really. I had to wear dark glasses and I had to wander around. But when the sun went in, of course, it was much better.

Kyffin recalled doing quite a lot of drawing on this trip to Rome. He travelled as a pilgrim, even though he was not a Catholic, and carried a document known as a 'tessara', that enabled him to travel to and enter galleries at a much reduced rate. He stayed with friends in the British School at Rome (BSR). Following significant adaptation by Lutyens in 1916, the BSR moved into its current home in Via Gramsci, in Rome's Valle Giulia. Kyffin found the two words he remembered from his Shrewsbury School lessons, 'basta' (enough) and 'troppo' (too much), which served him well on his tours of the city. These words were especially invaluable when he decided to enter a barber's shop for a haircut. On another day he ventured down the Spanish Steps into Via Babuino where he discovered, in a darkened coffee bar, the difference between a cappuccino, a café grande and café latte, instantly increasing his Italian vocabulary to five words. His attempts at improving his Italian often got him into trouble, as listeners were under the misapprehension that when he regaled them with some heroic tale, he was talking about himself. Clearly the nuances of Italian were alien to Kyffin, even with his eagerness to learn.

One day he visited the Vatican Galleries where he thought he could put his 'tessara' to good use. The document was duly stamped by a clerk at a desk and Kyffin crossed the hall to a lift that was about to ascend. Suddenly two carabinieri, armed with swords, blocked his way. He managed to burst past them into the lift but the caribinieri started shouting towards the clerk who had stamped his 'tessara'. Eventually the lift closed and made its ascent to the galleries. Kyffin, a little confused, stepped out of the lift to be touched on the shoulder by an American woman who politely whispered 'Pilgrims walk up the stairs'. He had travelled widely in Rome but was particularly impressed by the paintings and

frescoes he saw in the Vatican Gallery. Kyffin considered the Raphael and Michelangelo paintings 'absolutely stunning', and was impressed by the portrait of Pope Innocent by Velázquez in the Galleria Doria-Pamphili. He emphasised, though, that the Holy Father's portrait depicted a rather nasty-looking man in holy robes and was a little incongruous. He painted and sketched in Frascati, where he drew a rather robust carnival lady. Frascati is a town and commune in the province of Rome in the Lazio region of central Italy and is located 20 kilometres south-east of Rome. Kyffin also sketched in Memi, Tivoli and near the Pope's Palace at Castel Gandolfo. He travelled down to Anzio and did a range of drawings there on the war-battered sea front. By now, and in a rather bizarre manner, he considered his illness a blessing in disguise, although he felt his work was not his best because of the effects of the drug he was taking for his epilepsy. Kyffin remembered an Italian officer, Count Barbasetti de Prun, commenting on his painting technique:

> I remember, because I was staying with diplomatic people in Rome; they had contacts with people, and Count Barbasetti de Prun was a very jolly Italian naval officer who, at that time they hadn't got a navy really, and he made pots in the Via Babuino, and he came up and looked at my paintings, which I had done on small panels. I remember him saying, 'Un vero Inglesi, tutti umbro' (a true Englishman, paint as dark as pitch).

Kyffin regretted not having any canvasses, only small panels, when he visited Orvieto to do two paintings. He had only taken panels as he thought these more practical to carry. The scenes in Orvieto could have been depicted better on fairly large canvasses.

At the BSR, Kyffin stayed with Norman and Jean Reddaway. Norman was a highly respected expert in the field of intelligence and an enthusiastic promoter of closer relations between Britain and its European neighbours. As a most distinguished diplomat he served around the world, before ending his career as ambassador to Poland between 1974 and 1978. He was linked with the 'Phantom' unit, part of GHQ Liaison Regiment (a special reconnaissance unit formed in 1939). Some years later Kyffin, after leaving his lodgings with Miss Josling in Bisham Gardens, stayed with Norman and Jean (née Brett) in London. The move seemed advantageous at first, but Kyffin felt, as he writes in *A Wider Sky*, that he was being put on, and so he eventually left. He was desperate, and in his autobiography he recounts his stormy relationship with Norman and Jean. Jean wrote to Kyffin about his recollections in his autobiography, and asked him to remove his paintings from her house. Kyffin never pursued this matter and tore up the letter.

On his return from Rome he gradually settled back into a routine with the boys at Highgate School, who, he considered, were never particularly enthralled with his art classes. Sometimes Kyffin was sensitive to their disinterest and would try to encourage their education in other directions. The actor Robin Ellis of the BBC's *Poldark* series and a former Highgate pupil recalled:

> Kyffin Williams would stride into the art room at Highgate School, north London, for the last lesson before the Christmas holidays with his copy of Damon Runyon under his arm and a twinkle in his eye. Instead of painting, he gave an inspired reading of one of his favourite stories from the legendary chronicler of New York low life. Exchanging his cut-glass vowels for a nasal, flat Brooklyn accent, Williams gave authentic voices to characters like Harry the Horse, Big Julie and Nathan Detroit. To us he was exotic, exciting – and a little dangerous, too.

Kyffin was greatly respected by many of the boys at the school and had good periods of health when he painted with great eagerness. These periods of energy and vigour were all too often punctuated, however, by serious bouts of epilepsy and depression.

In 1952, even with all his inherent problems, Kyffin contemplated travelling abroad again for relief and inspiration. He had accumulated a vast amount of art experience by this time, particularly in art history, and clearly wanted to get away from London. His friend Morys Cemlyn-Jones had visited Kyffin's basement room in Bisham Gardens. Morys recalled the smell of artist's turps, horribly combined with the stench of cats' urine. Morys sympathised with Kyffin and his accommodation and, more particularly, with how poor he was at the time. Money was extremely tight and rationing had run for a decade, and would not finish until July 1954. Luckily Morys had a number of old tweed jackets that fitted Kyffin perfectly. Kyffin's heavy impasto technique and habit of wiping excess paint off on his clothes badly damaged his jackets and trousers. By 1952 Morys had finished his medical training at a London hospital. As a celebration, Kyffin, along with Morys and his sister, Gaynor, decided to travel across to south-west France and then on to discover the wonders of Rome and Italy. Kyffin arranged the whole event and planned the route and cultural itinerary from his previous travels and experiences abroad.

He also bought the means of transport, a Jowett Javelin car, registration FUN 845. Morys wondered whether this registration would be a good omen. One difficulty at this time was that travellers could only take a small amount of money out of Britain. Morys resolved this by contacting his cousin in America who mailed money to France, where it

The famous Jowett

Gaynor Cemlyn-Jones in France

could be collected from the Post Office. Extra money was needed for the journey as they intended spending around five weeks on the Continent. They all conceded that this was a long holiday at the time. Kyffin's choice of a Jowett car was rather unusual, but it was the right price and large enough to carry three people with all their clothes and camping equipment. The Jowett Javelin was produced from 1947 to 1953 by Jowett Cars Ltd of Idle, Bradford. Morys liked the car, especially for its 1486 cc engine which gave it a speed of about 77 mph, which was fast at the time. The design had one major weakness, though, as Kyffin and Morys discovered later: the radiator was behind the engine and tended to overheat.

A trial run up Llanberis pass proved disastrous as the Jowett started to boil up. The radiator was somehow not getting enough air to keep the engine cool. This was resolved

by opening the bonnet and jamming Kyffin's easel underneath to maintain an air flow. Evidently, this was not a good start for their several thousand miles adventure to Rome, but with all the camping gear safely lashed on the roof rack, they set off for Dover. Their crossing from Dover to Calais was 'unceremoniously' disrupted when a German mine was spotted adrift near the entrance to the French port. This meant the ferry had to go much further up the coast to Oostende, which threw Kyffin's map calculations out a little. Prior to setting off on their journey to Dover, there had been a minor upset when Gaynor announced she would not be driving either in Britain or on the Continent. Kyffin was not able to drive because of his epilepsy and medications, and to add to the complications, Gaynor insisted on sitting in the front seat to have a better view and more space. As a result, Kyffin had to sit rather uncomfortably in the back seat to act as navigator. This all put quite an onerous burden on Morys, who had to undertake all the driving and communicate with his navigator in the rear seat. On their first evening in Belgium, feeling rather exhausted, they discovered the delights of bed and breakfast. They also found it so reasonably priced that they decided not to do any camping at all on their travels.

Kyffin had planned to go to the Dordogne in south-west France as they all wanted to see the beautiful castles and prehistoric caves there. Gaynor would eventually buy a holiday home there. Morys recalled Kyffin painting a lovely picture of a French town which he gave him as a present. They visited the famous Lascaux caves where they were able to see the 17,000-year-old cave paintings, whereas visitors today have to make do with replicas. The caves are located near the village of Montignac, in the Dordogne département. They contain some of the best-known Upper Palaeolithic art. As Morys explained, the caves are no longer open to the general public because of the sensitivity of the paintings to algal infestation due to artificial light and moisture from human presence. Most of the major images have been painted onto the walls using hand-ground mineral pigments, although some designs have also been incised into the stone.

Their journey then took them eastwards, in the direction of Lyon and then on toward the Swiss Alps, where they coped with snow banked up on each side of the mountain pass. By now the car was performing well and Kyffin's navigation was excellent, even if still remote. The Autostrada then took them down to Turin and on to Florence where they were all keen to visit the Uffizi Gallery. Kyffin, Morys and Gaynor made the classic mistake, however, of visiting the gallery on a Monday, the day when many European galleries are closed. Kyffin was not at all disconcerted, and proceeded to knock on the Uffizi's great door in a determined manner. An agitated attendant eventually answered

and Kyffin explained their dilemma, and asked if it would be possible, as he was an artist, to look around the gallery. The gallery director was sent for and he, rather amiably, and much to Morys's astonishment, agreed to give them a private tour. This delighted Kyffin, who proceeded to build up a good rapport with the director. Morys was impressed with Kyffin's confidence and ability to communicate at such a level. The Uffizi is the premier public gallery in Italy and houses some of the country's greatest collections of paintings. As Morys revealed, Kyffin had certainly done his homework and knew that Giorgio Vasari designed the sixteenth-century palace for the Grand Duke Cosimo I de' Medici. It once housed the government offices, hence its name. The gallery is a treasure trove of art with paintings by many of the world's greatest artists, such as Botticelli, Leonardo da Vinci, Michelangelo and Raphael and Titian. It also houses a remarkable collection of self portraits of leading European artists, amongst them Rembrandt, Rubens and Ingres. It is acknowledged as one of the great art galleries of the world.

After the delights of Florence they travelled southwards to Rome and visited all the galleries Kyffin had planned to see there. They found that the easiest and cheapest way to eat was to buy food from local shops for a picnic at lunchtime. Often this consisted of wonderful fresh Italian panificio bread, cheese, delicious local tomatoes, and fruit. This was invariably eaten in a cemetery outside Rome, as these were quiet and clean, and nobody disturbed them. The route to these cemeteries was usually in a southerly direction out of Rome. Morys seemed to prefer the cemeteries with large tombs, because these were more comfortable to dine on. Every day they would see the same policeman on a particular traffic island, and he always waved in a friendly but rather excited manner as they passed. Evening meals were taken at a restaurant near the Pantheon, on the Piazza della Rotunda. People came to see Kyffin every night at the restaurant, as he was such a raconteur. Somehow, they just loved listening to his stories, and watching him sketching. Kyffin proved such an attraction at the venue that the restaurateur provided free meals for him, as well as Morys and Gaynor. With great reluctance they departed from Rome and moved on to see the Palio di Siena, a distance of 115 miles, arriving on 16th August. This is a grand horse-racing event around the streets which, unfortunately, was not to Kyffin's liking, as it was a wild affair, with horses falling and badly injuring themselves. Kyffin felt it was awful for the horses and so cruel. The whole event upset him and made him feel ill so the three friends continued their journey. As they moved on, Morys felt Kyffin had a wonderful sense of the countryside on this trip. He often wore a cloth hat to keep the sun out of his eyes as he sketched and painted. Morys was also fascinated by how Kyffin managed to carry several wet oil paintings together. Most of these panels were small,

foolscap size (A4), and he would pin corks in each corner and stack and tie the paintings neatly together to prevent the painted surfaces touching. Morys noted that in his black and white drawings with Indian ink wash, he continued to use spit to dilute his ink. Kyffin claimed this gave a better effect. Again, Morys noticed that he added a little dab of brown paint to his black Indian ink. Kyffin would paint quickly and seemed oblivious to the many curious Italian observers who frequently gathered around to see him depicting the landscape. The three travellers then went to the Dolomites one lovely day, where Kyffin painted a number of scenes of the famous limestone topography. Morys was fascinated by Kyffin's habit of flicking and wiping his brushes on damp grass to clean them. But he was also irritated by his habit of wearing dirty boots as he lay on his bed. He appears to have developed this practice from his youth or his early days in the Royal Welch Fusiliers, or possibly at the Slade, where he acquired some Bohemian traits. When Morys mentioned this to Kyffin, he just laughed. The cost of the tour around Europe was very reasonable, as they just paid for the room and shared other expenses like fuel and food. On their return north through France to Calais, Morys recalled that they stopped off in Paris and had a really good breakfast in a restaurant close to the Bastille. On their journey they averaged a steady 220 miles or so a day, and had no problem with petrol supplies or its cost, though it was rationed in Britain at the time. Even with the initial upsets and concerns, it was considered by Morys as a very successful and rewarding holiday, especially with Kyffin's planning and vast cultural knowledge.

The next holiday was a Swan Hellenic cruise in the Mediterranean. Kyffin had read that the Hellenic cruise catered for 'impecunious schoolmasters'. So he and Morys travelled by train through France to Italy, and then on to the port of Genoa to board the ship. The train journey turned out to be long and arduous, and to make matters worse Morys had a terrible pain in his neck, which he endured all the way to Italy. After boarding the ship it was realised that their cabin was directly over the propeller shaft. Morys claims Kyffin came to the rescue and asked for an upgrade which, fortunately, was forthcoming as the noise would have been unbearable throughout the voyage. Morys remembers Kyffin's sartorial elegance on the ship, especially his wonderful bright yellow waistcoat. The voyage was not without its upsets. The Mediterranean appeared to be unusually rough during their voyage. They were also unable to enter Tripoli harbour as part of the itinerary, because of the inclement weather. Again, Morys noticed how Kyffin became almost entranced when he was sketching, and was invariably oblivious to the presence of the curious crowds that surrounded him. These many adventures abroad enhanced Kyffin's knowledge of art which he was always eager to share with friends and

colleagues at lectures and gatherings. He was a mine of information and could delight all who listened to his often lively anecdotal revelations.

Kyffin's great friends Gillian and Richard Rowlands of Derby remembered the time they went on holiday with Kyffin in his Volkswagen camper van. They journeyed to France, making their way to the Dordogne for a month's drawing and painting. Kyffin offered to sleep in a tent outside while Gillian and Richard had the relative comfort of the VW camper van. This all worked rather well but, as usual, there were problems. It appears that on several nights when fellow, slightly inebriated, campers ('intruders' as Kyffin called them) were returning to their pitches, they tripped over Kyffin's guy ropes and bumped into his tent. This alarmed him at first, as he thought he was being attacked, but, typically, he never mentioned this to Gillian and Richard until they moved to their next site.

Gillian had first met Kyffin when she worked at Colnaghi's in London. She recalled 'walking out' with him in the late 1950s, and became a close friend for life. She felt he was such a wonderful character and loved his paintings as they were so different to the art scene in Colnaghi's and around London at the time. Gillian later met and married Richard Rowlands, who had been an officer in the Army. Kyffin was their best man and, as Richard was good at mathematics, Kyffin gained him a teaching post at Highgate School. Richard recalled, 'Kyffin was instrumental in getting me, a most unprofessional, professional soldier and totally unqualified, my first teaching post at Highgate.' Richard settled in well at the school and the three friends enjoyed many social evenings together. When Richard and Gillian later retired, Kyffin often visited them at their home in Derbyshire where he enjoyed Gillian's splendid meals. He was particularly fond of sausages, and these were usually bought specially for him from a farmers' market near Derby. Kyffin loved their hilltop house and the wonderful countryside of Derbyshire. He also delighted in their deaf Labrador dog, 'Dogger' (Bank), who Kyffin renamed 'Buggerlugs'. Gillian and Richard also visited Kyffin in Anglesey and helped him 'tidy' Pwllfanogl on occasions. As Gillian commented, 'What fond memories we shall all keep of him.'

Another holiday Kyffin often recalled was when he visited his cousin 'Gwen', whose real name, Susan 'Sue' Kyffin (b.1921), he concealed in *A Wider Sky*. She lived in Austria at one time and Kyffin disclosed that he was half in love with her when he was at the Slade in the Ashmolean, Oxford. Sue was, to Kyffin, 'Tall, beautiful, high-spirited, and apparently without fear, she led a wild, outrageous youth, flirting, captivating, ensnaring and often destroying, for as well as being glamorous she could be ruthless,

as many an admirer had learned to his cost.' Kyffin was frequently persuaded by Sue's many admirers at Oxford to help ease the way to her heart. This not only included many amorous students at the university, but also a military officer whose family made sporting guns. Sue had a mind of her own and Kyffin, in fact, had little influence over the whims of his flirtatious cousin. He nevertheless, all be it guiltily, still accepted gifts from her eager suitors. These were often items in very short supply during the war, such as shotgun cartridges and sumptuous meals at the Oxford Union. On his own confession, Kyffin was considerably impoverished at this time and for many years after he would always accept the offer of food. Kyffin's cousin, John Kyffin, who he called 'Owen' in his autobiography, was Sue's father. Kyffin's relationship with this family was through his grandmother, Margaret Kyffin.

Sue Kyffin married Creighton John Edward Broadhurst but divorced him in 1950. She then married Michael Baille-Grohman on 4 April 1952 in St Columba's Church House Chapel, Cadogan Square, London, and lived in Wiltshire before moving to Tilehurst, Reading for a period. Kyffin recalled that Michael and Sue travelled overland in a Hillman Husky van to India where Sue allegedly shot a record-length tiger. They later lived in Schloss Matzen, Brixlegg, Innsbruck, Austria, which was Michael's father's castle. Situated high in the Austrian Alps in the picturesque north-western province of Tyrol, Schloss Matzen is surrounded by 2,500 acres of parkland. It is just ten minutes from excellent skiing, a half-day from Vienna, and conveniently close to Italy, Switzerland and Germany, making it an ideal holiday venue for Kyffin. The Romans built a watch tower here and named the site Masciacum, hence the name Schloss Matzen. It is one of the few castles in Austria that has always remained in private hands, though it was commandeered in the two world wars. Kyffin had previously been asked by Sue whether she should marry Michael, a naval commander, or a millionaire brewery owner. In the end, the idea of living with a commander in a beautiful castle in Innsbruck proved irresistible to her. Kyffin had many encounters while on holiday at the castle and ventured into the mountains on an exhausting hike one day with Michael. His energetic character led him to persuade Kyffin to climb the highest mountain in the Tylolean valley, Sonnwendjoch. Knowing of his illness at the time, Michael offered to assist Kyffin with his easel and paints, and carried them to a hut high on the mountain. Here Michael succumbed to sleep in the warm morning sunshine, leaving Kyffin to complete the climb to the summit carrying his own equipment. He found little suitable painting matter in the Alps, probably because of the thin air and lack of subtlety in the light. Much to Michael's amusement, Kyffin did paint a signal box beside a station in Jenbach.

Sue appears to have held Kyffin's attention and heart for many years but always disappointed him with her rebelliousness. On one excursion to Schloss Matzen he realised that the marriage to Michael was under strain, and eventually, after some tense exchanges, it ended in divorce yet again. On her return to England, after the divorce in 1958, Sue moved into Freshfield Manor, Horsted Keynes, Sussex. In the early 1960s she moved again to Keeper's Cottage, Coleman's Hatch, Sussex before buying 88 Ebury Street, London. She changed her name by deed poll to Victoria Gordon, hence her car number plate VG 88. Kyffin continued to contact Sue but was dismayed when she decided to marry again.

This time, in 1962, she married Percy George Herbert Fender at Crowborough. Percy Fender (1892–1985) was an English all-round cricketer who played 13 tests for England. He was a middle-order batsman and bowled mainly leg spin. Kyffin discovered that Fender had served with his cousin, John Kyffin, in World War One and hoped that, as Susan's father, John would advise her more wisely. After their marriage they bought Cox Farm, Warnham, Horsham, but kept on both their London flats. She had separated from Percy Fender by the time of her death when she was about 42.

Kyffin attended her funeral and cremation in one of the 'drearier suburbs of south London', which he considered a very sad affair with few other relatives in attendance. He noted, 'For many years she allowed me to join her in an exotic world that was very far removed from the one I had been born into.' She was wealthy, indulged and spoilt, but full of fun. She greatly impressed Kyffin, and no doubt elevated him from his serious bouts of depression at times. Kyffin enjoyed her company, warmth and vitality, and these qualities outweighed her many flaws.

9

The Vital Years –
A Relentless Quest for Perfection

BETWEEN 1948 (when he held his first exhibition at Colnaghi's Gallery in London) and 2004, Kyffin held regular exhibitions in London and in Wales. His productivity was amazing and he had a total of 62 solo exhibitions and many more exhibitions and displays in co-operation with other artists. Before each exhibition, there were many months of preparatory work. When he was asked in 2004 how many paintings he had painted over the years, his reply was 'thousands'.

Beginning in 1968 and continuing into the 1970s, he held regular exhibitions at the Tegfryn Gallery in Menai Bridge, Anglesey. His solo exhibitions at the Albany Gallery, Cardiff and the Thackeray Gallery in London began in the 1970s and continued to 2004, with special exhibitions in Kyffin's memory held at both galleries in 2006.

Over the years, exhibitions were held at Oriel Ynys Môn in Llangefni, Ynys Môn, the National Library in Aberystwyth, the Glynn Vivian Gallery in Swansea, the Mostyn Art Gallery in Llandudno and at Oriel Plas Glyn-y-Weddw, Llanbedrog.

Between 1948 and 1970, Kyffin held regular exhibitions of his paintings at the Colnaghi Gallery and the Leicester Galleries in London, and from 1959 at the Howard Roberts Gallery in Cardiff until 1968 when the gallery closed its doors.

Other exhibitions were held at the National Eisteddfod in 1971 and at the Architectural Association in London, at the Bladon Gallery, Hurstbourne Tarrant, the University College Swansea and at the Stone Gallery, Newcastle upon Tyne in 1981.

Kyffin spent a great deal of time and energy on all these projects. With every exhibition, he was responsible for framing the collection, mentioning to a friend in the late 1990s that the framing of an exhibition had cost him personally £26,000.

The years 1950 to 1968 were important years for Kyffin, as he firmly established himself on the British art scene.

Y Cnicht (1938), an early Kyffin painting

In 1950, his name appears in a booklet produced by the Welsh Arts Council listing 'Some purchases of the Contemporary Art Society for Wales'. Kyffin's name appears alongside Ceri Richards, Cedric Morris, Allan Gwynne-Jones, David Jones and twenty-four other artists.

In an article in the *Welsh Anvil* for July 1951 under the title 'Contemporary Welsh Painting', David Bell, Assistant Director for Wales, Arts Council of Great Britain, commented on the work of many Welsh artists of the day and evaluated their art. These included Cedric Morris, Brenda Chamberlain, Ceri Richards, John Elwyn, Evan Walters, and artists who became accepted as Welsh artists, such as Joseph Herman and Ernest Zobole. Of Kyffin, David Bell wrote,

> Kyffin Williams comes from Caernarfonshire – mab y mynydd, and though he works much from London and elsewhere, it is the mountains which until recently have furnished his best subjects. In his pursuit of the beauty of the mountains he is fired with the same enthusiasm which Joseph Herman brings to the tired miner, pausing for a moment against the sunset. He (Kyffin) will set off in the morning with two or three canvasses under one arm, a palette under his other arm and a box of paints strapped to his back, climb four or five mountains and return at dusk with his canvasses covered.

He also commented: 'That he is a fine and sensitive draughtsman is shown in the Indian ink drawings which he also makes among the mountains.' Bell maintained that because of the fire and energy with which Kyffin worked there was a need for discipline. He also noted that Kyffin had recently been painting in Pembrokeshire away from North Wales, thus avoiding repetitions of a formula.

At the time, Bell's reference to Kyffin as being from Caernarfonshire was factually correct but he was, as we know, an Anglesey man through and through, and he certainly was not 'mab y mynydd' (son of the mountains), although Bell perhaps was right in the sense that part of Kyffin's soul was in his beloved Crib Goch, Y Cnicht or Cadair Idris.

In 1952, one of Kyffin's portraits was featured in the Arts and Crafts Pavilion at the National Eisteddfod at Aberystwyth, not in competition but as part of a special exhibition of work by well-known artists.

In 1953, a special Coronation year exhibition, featuring the work of 43 artists under the title 'British Romantic Painting', toured three locations in Wales: the National Museum in Cardiff, the National Library in Aberystwyth and the Glynn Vivian Gallery in Swansea. Kyffin's painting *Meini Hirion* was reproduced on the cover of the accompanying booklet

Exhibition leaflets and booklets

and his name appears amongst such well-known artists as Lucien Freud, Stephen Spender, Graham Sutherland and Gwen John.

In 1954 the Welsh Committee of the Arts Council of Great Britain organised an exhibition of 'Thirty Welsh Paintings of Today'. Kyffin's contribution was a painting of Llyn y Cau, Cadair Idris. This booklet had an introduction by the poet, playwright and political figure Saunders Lewis, where he praises the artists, stating that the Wales of the twentieth century would have a richer spiritual life because of the 'honest poetry of the painter's brush'.

In 1955 Kyffin's painting in oil *Head of a Boy* was part of an exhibition 'Pictures for Welsh Schools' organised by the Arts Council of Great Britain's Welsh Committee, with a foreword by Leslie Moore, an art advisor to the Glamorgan Education Committee, in which he quotes Delacroix, whose observation Kyffin would have been in agreement with: 'The first merit of a picture is to be a feast to the eye.' Kyffin's painting for this exhibition was priced at thirty-six guineas. Also in 1955, his painting *Llanberis Pass* was exhibited at the Leicester Galleries in London in an exhibition of 'Artists of Fame and of Promise', which comprised 146 exhibits by British artists.

During his time in London, Kyffin was to write a highly readable account of the importance of light in painting:

> Wales is a land of ochres and umbers only occasionally going mad in a riot of colour.
>
> In my London studio, it is the average day, with the sun behind the cloud and dampness

of the rocks that comes to my mind. I work facing the light so that my canvas is in a shadow and not bathed in brilliance that would hurt my eyes, unduly sensitive as they are to startling light. Sun in the distance I can absorb, sun on my canvas I cannot. I naturally crave excitement so the light behind a jagged ridge or the sheen on a wet rock face stimulate me as alcohol or drugs may do others.

As part of the Festival of Wales in 1958, Kyffin had two paintings in an exhibition of portraiture organised by the Association of Professional Artists, and held at the Wales Gas Board Showrooms in Cardiff.

In 1961, the Welsh Committee of the Arts Council organised an exhibition to show the work of prominent artists to a wider public in Wales. The work of three artists was featured: Kyffin Williams, Jonah Jones and John Petts. In the accompanying booklet, Kyffin wrote a brief biographical note which gives the reader a fascinating insight into his painting methods, as well as which artists inspired him:

> As I am not the first artist my family has produced, I have always had help at home and owing to my knowledge of the landscape of North Wales I have always known what I should paint.
>
> The first picture to make a real impact on me and showed me what art was about was *The Resurrection* by Piero della Francesca. Other painters who have meant much to me are Botticelli, Crivelli, Memling, Titian, Tintoretto, Rembrandt, Courbet, Van Gogh, Modigliani, Soutine, Rouault and Braque.
>
> I paint in two ways, tight factual pictures done on the spot and loose interpretive ones done in the studio with a restricted palette. These latter ones I consider the better. I would like to paint many more portraits as I feel I can wring more emotion from the human face, but models are hard to come by.

It is interesting to note how many of these artists mentioned by Kyffin painted in oil. Many like Kyffin painted portraits and landscapes and were involved in print-making; they loved paint as Kyffin did. All of them were obsessed with their craft and supremely skilled. Nicholas Sinclair, in *The Art of Kyffin Williams*, has shown that over the years there were other artists who influenced Kyffin or with whom he had an affinity, such as Théodore Géricault (1818-1877) who was an expert portraitist; Albert Marquet (1875-1947) who was concerned with mood in a painting, who used rich colours and was a

Self-portrait

painter of 'great integrity'; Georges Rouault (1871-1958) whose aim was 'to release in the viewer a spiritual feeling through the use of colour, harmony and form'; and Oskar Kokoschka (1886-1980), a highly original portraitist.

But of all these creative men the two that Kyffin mentioned most often in conversation were the Dutch artists Vincent Van Gogh and Rembrandt Harmenszoon Van Rijn. Kyffin said of Van Gogh: 'He loved more deeply it seems than anybody else and was able to communicate that love, he just had to paint his love of things, be it flowers or people or landscape and that was it.'

In a letter to his brother Theo, dated 31 July 1882, Van Gogh wrote: 'The duty of a painter is to study nature in depth and to use all his intelligence to put his feelings into his work so that it becomes comprehensible to others.'

It is interesting to note that in Van Gogh's Dutch years he considered shades of brown and green as the best way of putting sentiment and mood into his work. Kyffin also used these colours extensively, always stressing that mood was vital. To him mood was emotion: 'I react to pictures that are emotional.' Kyffin certainly studied nature in depth and most certainly used his intelligence to put feeling into his work. Like Kyffin, Van Gogh suffered attacks episodically of what his doctors considered to be a form of epilepsy. Kyffin would often compare their respective circumstances. Of Rembrandt Kyffin said: 'I suppose he's the most loved artist in the world.' Kyffin admired his passion and added: 'some paintings by Rembrandt make me weep, that full spirit and love of a picture is being transferred to me.' Rembrandt painted extensively in oil and drew a great number of biblical scenes in silver point. Kyffin admired Rembrandt for the mood and spirituality of his paintings.

When Kyffin was asked if artistic influence was important to an artist he gave a very full reply:

> Well, artistic influence is vital, I think, for any artist up to the age of 30 or 40. If, by then, you have not begun to find the influence by yourself, you will never be a painter. You use other artists for the best reasons and out of that there should come your personality. That is what gives the mood in a painting and if you are still imitating after 40, you've had it, I think. In all the years up until you're 40, you should be finding yourself and using other artists in order to enable you to find yourself.

Continuing his biographical note in the 1961 Welsh Committee of the Arts Council exhibition brochure the modest Kyffin writes:

As I am naturally lazy I have set myself a programme of two pictures a week. These I have to do if I feel like it or not and very often my best pictures have come when I have felt least like painting. I also feel I must paint out of some sense of duty, but duty to what I am not quite sure. At the moment (1961) I am trying to get greater breadth into my paintings and I suppose they are becoming more abstract, but I reckon I like landscapes and people too much to paint real abstracts.

It is interesting to note that by the time he wrote his autobiography *Across the Straits* (1973), he had clarified his thoughts regarding his sense of duty: 'Duty to what or to whom it is a difficult problem to solve but I feel it is something to do with Wales and the importance of recording its landscape and people.' Kyffin had 24 paintings in the exhibition.

Also in 1961 at the Howard Roberts Gallery in Cardiff, the leading gallery in Cardiff at the time, a fifth anniversary exhibition was held, with Kyffin contributing fourteen works, six oil paintings and eight drawings. The highest price of the oils was ninety guineas and the highest price of the drawings twenty-five guineas.

In 1968, again at the Howard Roberts Gallery, Kyffin exhibited twenty-five oil paintings, six gouache drawings and twenty-three ink and wash drawings. It was a remarkable exhibition, the titles of the paintings reading like music. They are classic Kyffin – *Welsh Blacks on the Moelwyns*, *Gwastadnant (Winter)*, *Welsh Mountain Ponies*, *Yr Wyddfa*, *Snow at Cesarea*, *Pentrecanol*, *Plas Cemlyn*, *Crib Goch from Deiniolen* (the above in oil). The largest of the oil paintings was 48 x 48 inches, a few measured 36 x 48 inches and the majority 20 x 44 inches and 20 x 24 inches. In gouache, he exhibited, among others, *Snowdon from Pont Llyfni*, *Crib Goch*, *Above Nant Peris and Gallt yr Ogof* and *Tryfan*, and in ink and wash, *Houses Llanddona*, *Foxhound*, *Farmer on Welsh Cob*, *Houses Dinorwic* and *Capel Tabor Pentrepella*.

The Tegfryn Art Gallery held a tenth anniversary exhibition, 'The Anglesey Scene', in 1976, with Kyffin contributing six paintings, the highest at a price of £450.

The year 1968-69 was exceptional in the life and career of John Kyffin Williams. These were the Patagonian years. On his return from the journey of a lifetime to South America, Kyffin held many exhibitions of his Patagonian paintings at numerous locations, amongst them the Leicester Galleries, London (1970) and at the National Eisteddfod in Bangor (1971). The exhibitions of his Patagonian masterpieces were a triumph for Kyffin. Welsh art had never seen anything similar before.

Because of printing costs, Kyffin failed to find a publisher for his Patagonian collection.

In later years, brochures were produced to accompany individual Patagonian exhibitions and the National Library of Wales published the book *Gwladfa Kyffin/Kyffin in Patagonia* in 2004, recording the unique Patagonian paintings and drawings in the Library's collection.

In the 1970s and 1980s, the queues for Kyffin's exhibitions in Cardiff and London were proverbial, with people sleeping on pavements to be first in line for the exhibition opening. There were stories of very ardent Kyffin fans travelling cross-country for a forgotten cheque book while a relative kept watch in the queue, to ensure that they were first into the gallery the following day in order to secure the painting they desired!

Gwastadnant, Nant Peris

10

Manfred Uhlman and Kyffin

K YFFIN WAS INFLUENCED by many artists, not always in style or technique but often by their experiences, attitude and response to art; he especially recalled his long friendship with Fred Uhlman. The two first met in London in the 1940s but in the early 1950s, when Uhlman was on holiday, they met up in Cwm Croesor, sometimes with artist and friend Leslie Jones as another guest. At an earlier time Fred used to holiday in a cottage close to Portmeirion, which Kyffin always indicated when travelling that way by road. Along with many well-known artists, Uhlman was attracted to holiday in North Wales in accommodation let by Clough Williams-Ellis. Clough was a great promoter of the arts, particularly painters, authors and poets from England. Fred eventually moved to live in Cwm Croesor where his son Francis now lives.

It was here, in Cwm Croesor, in a haze of Fred's pipe smoke, that Kyffin and Leslie 'put the artistic world to right'. Uhlman had known Kyffin in London; indeed Kyffin was given refuge by Uhlman in his Hampstead home after Kyffin's eviction from his St John's Wood lodgings. Kyffin stayed with the Uhlmans for some time but later on in North Wales their relationship did not always run smoothly.

Dr Manfred Uhlman (1901-85) was of Jewish origin; he qualified as a German lawyer in September 1936 and eventually arrived in England with few assets. He married Diana Croft, the daughter of Sir Henry Page Croft MP. Uhlman became a celebrated painter and novelist in what fellow Llanfrothen artist and friend, Eleanor Brooke, terms the 'naïve art style'. Fred, or Freddie as he was sometimes known, was born in Stuttgart, into a prosperous middle-class family. He studied at Freiburg, Munich and Tübingen universities and graduated with a degree in Law followed by a Doctorate in Civil and Canon law.

Uhlman moved to Paris to start a new life there after Hitler's rise to power in 1933. However, he could not work as a lawyer without breaking French law, so he supported

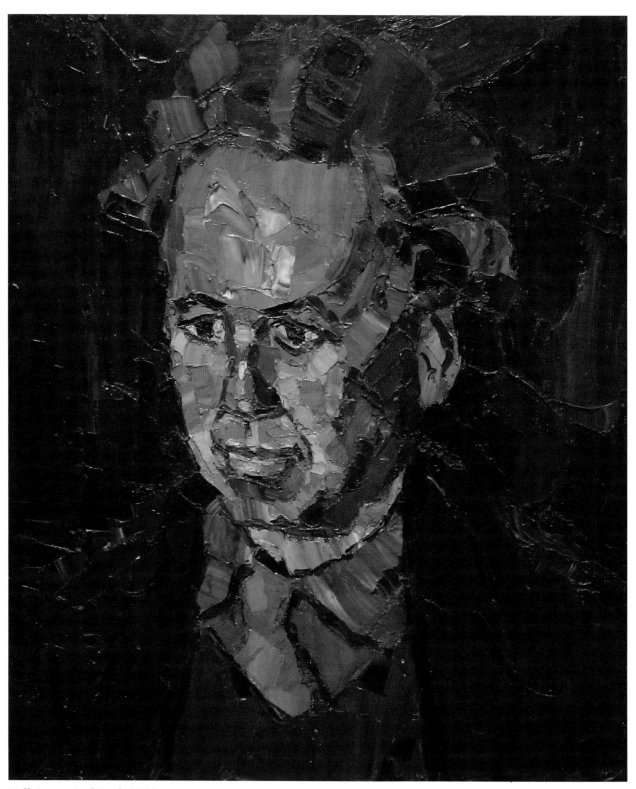

Kyffin's portrait of Manfred Uhlman

himself by drawing, painting and selling his work when he could. Sales were difficult, and in April 1936 he moved to Tossa del Mar on the Costa Brava in Spain. The outbreak of the Spanish Civil War forced him to return to Paris, visiting Marseilles en route.

He had met Diana Croft in Tossa del Mar and had developed a close friendship with her. Later, while phoning her, Uhlman lost his wallet with his money and his passport inside. It was probably stolen, but it was returned to him when he got back to Paris by a fellow Jew (who rewarded himself with 10 percent of the cash). On 3 September 1936, Fred Uhlman travelled to England. At this time he had virtually no money and very little grasp of English. Fred rejoined Diana Croft and they married on 4 November 1936.

In June 1940 he was interned by the government on the Isle of Man, along with many other foreign nationals. He continued to work there as an artist and, with great sorrow in his heart, managed to complete some poignant work. His release came six months later, when he was reunited with Diana and their newly born daughter.

The Uhlmans eventually settled at the artistically renowned 47 Downshire Hill in Hampstead, a location linked with John Heartfield and in earlier times John Constable, Fanny Brawne, Dante Gabriel Rosetti and, close by, Keats. The house belonged to the Carline family in the early twentieth century. Later it would be the haunt of Stanley Spencer and his brother Gilbert. Paul Nash was also a regular visitor.

The Carline family moved to Pond Street in 1936, and the Uhlmans took up residence at 47 Downshire Hill. Fred and Diana continued the tradition of attracting artists to the house. They also became politically engaged and set up the Free German League of Culture, as well as the Artists' Refuge Committee. This was all well within Uhlman's remit as a lawyer, his prime goal being to assist artists escaping from Nazi-occupied Europe. Uhlman understood the value of support for those fleeing the horrors of war-torn Europe. The Artists' Refuge Committee helped many to set up a new life in England, including John Heartfield, Oskar Kokoschka, Kurt Schwitters, and Martin Bloch. Kyffin mentioned that another artist friend, Diana Armfield RA, wife of Bernard Dunstan RA, was also involved with Diana Uhlman's benevolent activities for artists abroad.

Uhlman had his first solo exhibition at the Galerie Le Niveau in Paris in 1935. In London he exhibited at the Zwemmer Gallery in 1938, and from then on he exhibited regularly in one-man shows as well as mixed exhibitions throughout Britain. Kyffin recalled a retrospective exhibition of Uhlman's work held at the Leighton House Museum in London in 1968. His work is represented in many important public galleries, including the Fitzwilliam Museum in Cambridge and Victoria & Albert Museum in London.

Uhlman also exhibited in Wales at Portmeirion, where some of his work is still displayed. One exhibition was entitled 'Portmeirion 1958, an exhibition of Painting and Sculpture by Artists Working in Wales'. The artists were Eleanor Brooks, Jonah Jones, Selwyn Jones, Gwilym Prichard, Fred Uhlman and Kyffin Williams. Gwilym Prichard recalled that it was very busy at the time as Portmerion was the base for the Snowdonia filming of *The Inn of the Sixth Happiness,* starring Ingrid Bergman. Kyffin would often regale friends with the story that on the day of the opening of the Portmeirion exhibition the artists arrived early to arrange and complete the 'hang'. Fred was not present at this stage and arrived much later. On his arrival he busied himself and within a short time had rearranged the whole exhibition, putting his own work in prime positions. This was much to the chagrin of Kyffin and the other artists. It is interesting to compare some examples of titles and catalogue prices of Kyffin and Uhlman's work in the exhibition:

JOHN KYFFIN WILLIAMS

21.	*Snowdon from Drws y Coed*	50gns
22.	*Llyn Ogwen*	25gns
23.	*Conway*	25gns
24.	*Ponies*	50gns

FRED UHLMAN

31.	*Welsh Cottages (1944)*	£40
32.	*The Red Church*	£35
33.	*The Light House*	£60
34.	*Welsh Hills*	£75

Kyffin recalled the time when Uhlman phoned him from London and asked if he would do some sketches of mountains so that he could paint scenes of North Wales. The review of the exhibition castigated Kyffin as being an imitator of Uhlman. This upset Kyffin for a long time and complicated their relationship. Later, there appears to have been another disagreement between the two artists. In 1973 Kyffin had written his first autobiography, *Across the Straits,* and was planning to celebrate this with a book launch with the publisher Colin Haycraft and his wife Anna. It was Anna who first met Kyffin on Euston Station and later arranged the publication of *Across the Straits* with him. She was the much-respected fiction editor of Gerald Duckworth & Co, the publishing house run by her husband Colin. Anna and Colin were famous for their spectacular publishing

parties at the Duckworth offices, Old Piano Factory, Camden Town, where they came to exemplify north London literary Bohemia. These gatherings attracted celebrities like Jonathan Miller, A.J. Ayer, Kingsley Amis, Beryl Bainbridge, Oliver Sacks, and the occasional tramp who managed to detect their champagne revelries. Uhlman somehow discovered the planned book-launch celebration for *Across the Straits*, and not having received an invitation, reproved Kyffin in writing for this oversight, telling him, as his oldest friend, not to bother coming to their next Monday night meeting or any future gathering. This spat eventually healed as they continued to be friends up until Uhlman's death in London in 1985.

Kyffin frequently referred to Uhlman's book, *The Making of an Englishman*, a fascinating life story which covers many aspects of politics and the culture of Germany from World War One to the early 1930s, subjects which were close to the hearts of Kyffin and other artists at this time. As a lawyer, Uhlman often defended Social Democrats against Nazis in the late 1920s and early 1930s. He was a member of the Union of Social Democratic Lawyers in Württemberg. The whole law profession in Germany was strongly biased against the Weimar Republic, and almost without exception sympathized with the right, including the Fascist radical right.

In his book, Uhlman recounts returning to Stuttgart not long after the war, in 1951. The city was like 'a large cemetery in moonlight', and he felt like 'a ghost among ghosts'. At the Jewish cemetery he found his grandmother's grave. He would also have visited the graves of his parents and his sister, but they were far away, if they existed at all – somewhere between Belsen and Auschwitz: 'I collapsed. I cried as I had never before and hopefully never will again. I was now fifty years old. I cried about the murder of my family, my dead friends, my poisoned memories. I cried about thousands of murdered Jews and Christians, and about Germany. I cried about the ruins of the many beautiful old cities from my youth. I cried about lost faith and lost hope and the transience and insignificance of life.'

Clearly these were distressing memories for Uhlman, and potentially moving enough for him to interpret through his paintings. Instead, he appears to have favoured more serene subjects in England and Wales. This is probably after being inspired by Kyffin's approach to the Welsh landscapes.

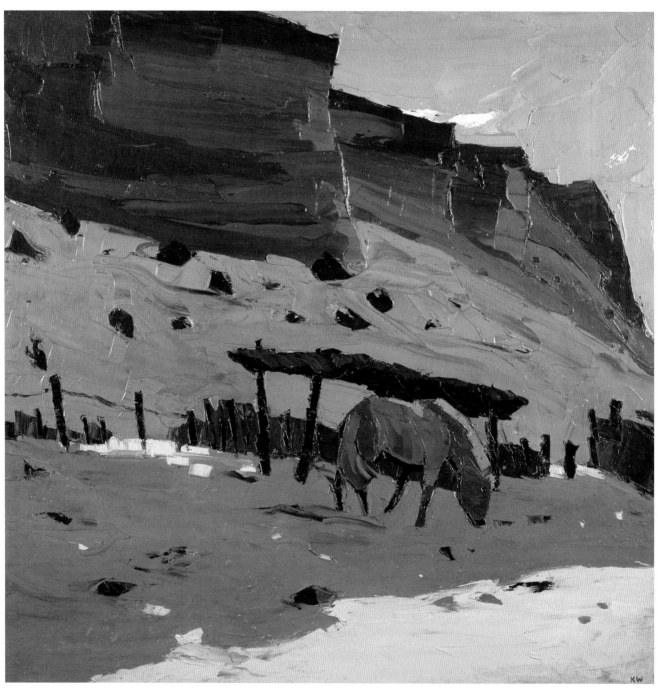

'*Ceffyl yn y Lle Cul*' ('Horse at Lle Cul'), Patagonia

11

Patagonia – Kyffin's Great Adventure

IT'S 1968 AND KYFFIN had been a senior arts master at Highgate School for twenty-four years. We can imagine how he wanted a complete change; in fact he was ready for adventure, for excitement, as he said in *A Wider Sky*: 'The most exciting and memorable period of my life was during my brief visit to the Welsh Community in Patagonia.'

By 1968, Kyffin's mother Essyllt Mary and his father Henry Inglis had died (Essyllt Mary in 1964 and Henry Inglis in 1942). His brother Richard was by now living with Kyffin's help in a flat not far from Beaumaris, and had a fixed daily routine. Kyffin, as a bachelor, had no family ties to prevent him travelling to distant lands, nothing to restrict him, apart from his health. Patagonia was an open invitation.

There were two reasons behind Kyffin's choice of Patagonia. Firstly, his father's cousin Ralph Williams had been on a great adventure to South America in 1868, passing through Patagonia on his way to the Straits of Magellan, where he lived for a time with a tribe of native Indians, the nomadic Tehuelche.

The romantic story of cousin Ralph was embedded in the Williams family, where romantic tales of brave adventuresome aunts, uncles and cousins were a source of great inspiration. Kyffin said, 'I remember Ralph Williams [who was Knighted and became Governor General of Newfoundland, Former British Agent in the Transvaal and Governor in Chief of the Windward Islands] as a huge and formidable man in a broad check suit, a sombrero on his head and a large drooping moustache [Kyffin called him the Boomer]. His father [Reverend Thomas Norris Williams of Treffos, Rector of Aber and brother of Kyffin's 'Taid'] had sent him to Australia to get rid of him but he returned and, with another small financial blessing, went to Patagonia.'

Kyffin also notes that, 'At the end of the last century [i.e. the nineteenth], two of my uncles had left the safety of my grandfather's Rectory in North West Anglesey, to cross

Patagonia Exhibition brochure – Bangor 1971

to South America to fight for the Revolutionaries in Chile. One stayed to join the Chilean Navy while the other returned with a South American horse, to receive a reprimand from his father who asked what was wrong with the Welsh breed!'

Kyffin notes that his uncles and Ralph 'gave me an urge to follow their example'. Uncle Ralph wrote a book *How I Became Governor*, published in 1918.

Strangely for us today, Kyffin writes that his Uncle Ralph did not venture deep into the Welsh community since, as a staunch Church man, son of a rector, it would not be the done thing to mix with Nonconformists, i.e. the majority of Patagonians. Kyffin therefore had the excuse, or the reason, to persevere with his plans for the great adventure, to prove himself as adventuresome, or more so, than his relatives, especially Uncle Ralph with 'his substantial moustache'.

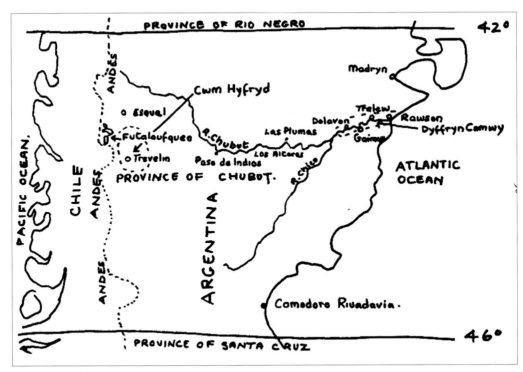

Kyffin's map of Patagonia

The second reason for mounting plans for a visit to Patagonia was Kyffin's dream of recording the life of the people of the Welsh colony. As he said in *Kyffin in Venice*, 'I'd always wanted to go to Patagonia, because to me it was a fantastic story – this transposing of these Welsh people from Wales to such a remote part of South America and they were so determined to carry on with the Welsh language and the Welsh way of life miles away from home. I wanted to meet all the Welsh people there so far away from home'. He added, 'I'd [record] the people, the birds, the animals, the flowers, the landscape in the lower valley and the valley in the Andes, Cwm Hyfryd.'

And maybe there was a third reason. Karel Lek, Kyffin's fellow artist and friend, reported that Kyffin always said that he wanted to achieve something by the time he was 50. In 1968, the year of the Patagonian escapade, Kyffin was 50 years old.

Kyffin's linocut work

In spite of great dreams, Kyffin had to be practical. He had to consider how he would finance such a grand plan since his salary as a teacher was by no means substantial. When he discovered that the Winston Churchill Memorial Trust was offering scholarships or fellowships, he immediately sent in his application. The Trust had been established following the death of Winston Churchill in 1965. Thousands of people, in gratitude and out of respect for the man and his inspired leadership, gave generously so that a living memorial could benefit future generations of British people.

The mission statement of the Trust states that it exists for 'the advancement and propagation of education in any part of the world for the benefit of British citizens of all walks of life in such exclusively charitable manner that such education will make its recipient more effective in their life and work, whilst benefiting themselves and their communities.'

Today on their website, they note that approximately 100 British citizens are awarded fellowships for a wide range of subjects every year. Fellows must travel overseas for between four and twelve weeks. Previous award winners, they note, have included nurses, artists, scientists, engineers, farmers, conservationists, craft workers, artisans, members of the emergency services, sports men and women and young people.

Kyffin appeared before the Churchill Memorial Trust in the autumn of 1968. He writes with relish about the experience in *A Wider Sky*. The Committee was chaired by Sir Trenchard Cox who had recently retired as Director of the Victoria and Albert Museum.

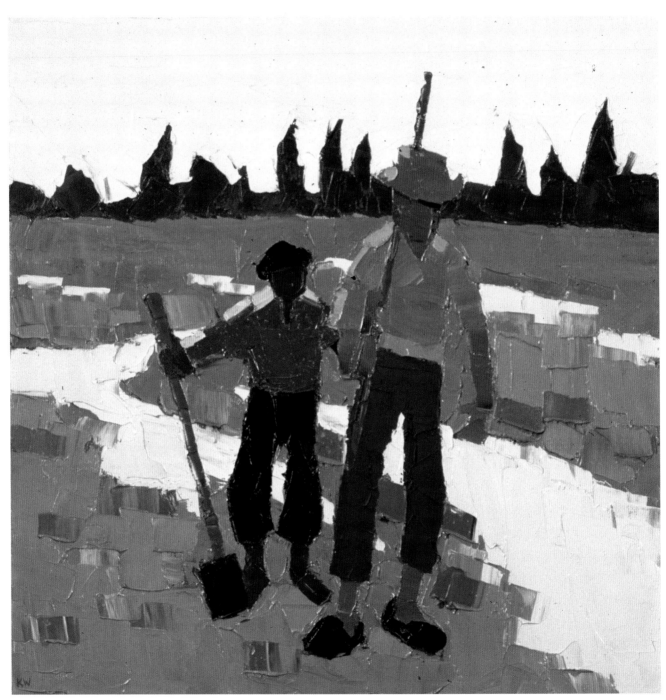

Euros Hughes irrigating his fields

'Before him,' writes Kyffin, 'lay my project to visit my fellow countrymen in Patagonia in order to make a pictorial record of them and their land and the birds, animals and flowers of that Country.' Trenchard Cox gave Kyffin 'a kindly smile' and said that he didn't really believe there were Welsh men and women in Patagonia. The Churchill Memorial Trust was a powerful group of people. Among its Council Members in 1968 were Lady Alexander of Tunis, Lord Byers, Michael Cadbury, and Lord Cooper, with Churchill's son, Randolph Churchill, and Sir Edward Boyle MP among the Trustees. As luck had it, another member of the Council was none other than Lady Amy Parry Williams, Kyffin's compatriot. Her support was crucial. Lady Amy assured the Trust that there were indeed Welsh people living in Patagonia, that they did speak Welsh and that they had emigrated from Wales in the nineteenth century. Lady Amy's sister Mrs Llywelfryn Davies remembered well in 2010 that it was her sister who made the difference, giving her wholehearted support to Kyffin in his quest for a scholarship. Lady Amy, the wife of the great Welsh poet and scholar Sir T. H. Parry-Williams, Professor of Welsh at the University of Wales, Aberystwyth, was a well-known teacher, lecturer and author as well as a regular broadcaster for the BBC in Wales. An expert on folk singing and President of the Welsh Folksong Society in 1986, she became a highly influential founder member of the Welsh Board of Harlech Television, the ITV company for Wales. She was also the first woman member of the Board. She continued her support for Kyffin in many other artistic projects.

Kyffin had won the day. In the interview with a condescending, smiling chairman, Lord Trenchard Cox, Kyffin had put before the Committee his plans for Patagonia, including 'My hopes of hiring a horse in the lower valley (i.e. the Gaiman) and then riding it across the four hundred miles of desert to Cwm Hyfryd at the foot of the Andes (in the west). The idea had appealed to the members, the fellowship was awarded.'

Kyffin soon realised when he arrived in Patagonia, however, that if he travelled on horseback for four hundred miles across the desert, he would be dead. His plans were changed!

In true independent style, his first decision was to travel to South America by boat and not by plane. Asked in 2004, 'You went to Patagonia by boat. Why by boat?' Kyffin's ready reply was, 'Well, I had an idea that my Spanish was non-existent and that I'd meet some Spanish people on the boat who'd teach me – I did, I shared a cabin with a lecturer in English from the University of Buenos Aires, a fantastic gaucho called Luis Gonzales and a pastry cook from Montevideo called Gennaro Bastos, but they all spoke English to me, which wasn't much good. So I arrived in Buenos Aires without speaking any Spanish at all!'

His decision to travel by boat led to correspondence with the Winston Churchill Trust. In reply to Kyffin's letter requesting clarification concerning the grant and the duration of the fellowship, Anthony Lazulles, the Director General, replied as follows:

> The Winston Churchill Memorial Trust
> Queen St Mayfair
> Patron Her Majesty The Queen
> 27 May 1968

Dear Williams,

I think you asked about going to Patagonia by ship and whether it counted against your 4 months fellowship.

The normal procedure of the Trust is to provide the fellow with the cost of the return airfare at tourist rate. If a fellow likes to go by sea, he can certainly do so. A sea passage usually costs rather more than the airfare and the fellow is normally expected to pay the difference himself. If your sea passage to Patagonia costs £130, I would have thought that this would be quite a bit less than the airfare. How you travel to and from Patagonia if you do not go by air would not normally affect your 4 months fellowship in Patagonia. If you went by air you would get there in one or two days, if you go by ship it may take six weeks, but for grant purposes this would be calculated as one or two days, so you would still get the four months in Patagonia.

It would affect residual expenses, for if you need them you will need them for six weeks longer or twelve if you returned by ship than if you travelled by air.

> Yours sincerely
> Anthony Lazulles CB,CBE,DSO

Director General

J. K. Williams
Bolton Studios
17b Gilston Road
London SW10

As part of his preparatory plans, Kyffin sought the help of Valmai Jones of Caergwrle in north-east Wales. Valmai had been born in Patagonia and had two sisters living there. Her contacts in Y Wladfa proved invaluable to Kyffin. Valmai, born in the Gaiman, moved to Buenos Aires and then to Wrexham in 1955. She had been chairman and treasurer of Cymdeithas Cymry Ariannin – The Society of the Welsh People of Argentina. She died in 1994 aged 84.

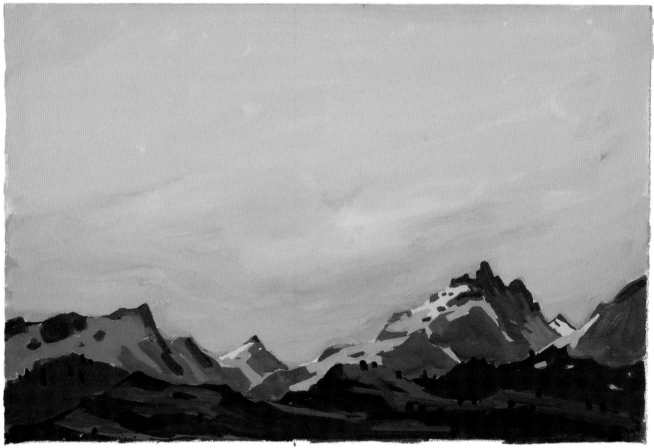

Gorsedd y Cwmwl

The tremendous help Valmai Jones gave Kyffin cannot be overemphasised. The information she supplied was detailed and comprehensive. Kyffin would not be entering into a void in Patagonia, but would rather be welcomed with open arms by 'a large family'. Valmai Jones had contacts through Cymdeithas Cymry Ariannin in every part of the land: in Buenos Aires four families Kyffin could contact, in Trelew another four families, in Porth Madryn three people, in the Gaiman eight families, in Dolafon one, in Cwm Hyfryd, in Esquel and Trevelin six families, in Commodoro three families and in Sarmiento two. Valmai noted that all the people she had listed 'are well known in these towns'. Detailed notes were provided: Gaiman to the Andes 300 miles, all desert;

where to see irrigation canals, oldest house and chapel in Y Wladfa. There were likewise informative notes with the names and addresses: 'sheep farm, orchards, geological structures of interest, wealth of contrast for your palette.' Kyffin would have no shortage of places to stay, he would be safe in a faraway land, with many of the families inter-related. Outside the family network, Valmai gave him information regarding inexpensive accommodation.

In addition to all this, as if more was needed, Kyffin had a dossier of names and contacts from his friend John Ormond, who had been filming for the BBC in Patagonia.

So Kyffin was extremely well catered for during his Patagonian adventure.

Another person who gave him great help was Reverend Bryn Williams. He had been born in Patagonia but left South America to live in Wales. Bryn Williams had become

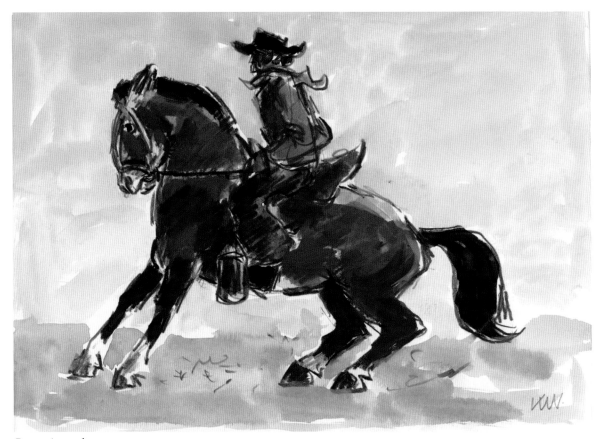

Patagonia gaucho

Archdruid of Wales, was an excellent poet and published many books about Patagonia: *Agar* (Calvinistic Methodist Press), *Croesi'r Paith* (Llyfrau'r Dryw), *Crwydro Patagonia* (Llyfrau'r Dryw), *Cymru Patagonia* (Hugh Evans), and *Gwladfa Patagonia* (Gwasg Prifysgol Cymru). His son Glyn Williams also wrote books on Patagonia, including *The Welsh in Patagonia* (1991).

Bryn Williams wrote novels about his homeland as well, notably *Y March Coch*, an exciting adventure novel about the gauchos and the bandidos. Reverend Williams personally briefed Kyffin about the do's and don'ts of Argentina. 'Travel light,' had been Bryn Williams' advice, 'for it will be very hot out there.' Luckily for Kyffin, he had ignored his advice that a sleeping bag was unnecessary, commenting in *A Wider Sky* that without his sleeping bag, he would hardly have survived! Kyffin arrived in Buenos Aires at the end of 1968 and flew on to Trelew, the town named after one of the founders of the Welsh colony, Lewis Jones.

In *A Wider Sky* Kyffin writes with affection and humour about his visit to Patagonia. In those four months, he experienced great kindness, had the most memorable experiences of his life and recorded everything he heard and saw. He excels at noting conversations, his keen eye recording on paper the people, their bone structures, their clothes, their homes and ranches, and their animals, the flowers that grew around them, and the birds and animals he saw. Men, women and children at work on the land are recorded, as well as the remarkable geology of Y Wladfa. The magnificence of the Andes is painted by him with awe in such works as *Gorsedd y Cwmwl*, and the sunset over *Dyffryn Camwy*. In all, forty-five canvases were painted by Kyffin on his return to London. While in Patagonia, he also made many hundreds of drawings and took seven hundred still photographs.

Today at the National Library of Wales his Patagonian paintings and drawings are looked after with care. It is a remarkable collection. Kyffin was the first Welsh artist to record Y Wladfa in oil and watercolour and the first Welsh artist in the history of Patagonia to record life there with such brilliant photographs. The Kyffin Williams Patagonian Collection at the National Library today contains eleven paintings in oil, sixty in gouache and watercolour, and drawings donated to the Library by Kyffin, as well as the seven hundred photographs, the latter being multi-purpose, as they were invaluable for reference purposes and would be essential to the lectures he was committed to giving back home under the agreement with the Churchill Trust. These photographs are works of art in their own right, however, since the same compositional skills that come into play in his drawings and paintings are evident in his photographs. However, Kyffin, the

highly disciplined artist, eventually stopped using his camera as he felt it was in danger of impinging on his drawing work. Fortunately for us he only stopped after taking 700 remarkable images.

In 2004, the National Library published *Gwladfa Kyffin/Kyffin in Patagonia*, edited by Paul Joyner. As the National Librarian, Andrew Green, noted in the Foreword: 'This volume is a tribute to the achievement of one of our greatest artists, an artist who has the gift of enlivening his chosen subject with joy. He presents a strange landscape with his familiar style. He helps us to see that the "Wladfa" and Wales are part of a collective heritage, whether we have visited that land or not.'

His paintings and drawings and watercolours cover every topic, with people looming large: portraits of *Norma Lopez*, of *Brychan Evans* and *Elias Garmon Owen*, of *Ceri Ellis Drinking Mate* and of *Henry Roberts Bryn Gwyn* and *Farmer and Dog*. Horses and their riders feature prominently: *Rider in the Desert*, *Riders in Cwm Hyfryd*, *Riders above Esquel*, *Rider at Trevelin*. Kyffin was truly inspired by the landscape with dramatic paintings of rocks in the desert: *Los Altares*, *Road in the Valley*, *Caves at Madryn*, *Gorsedd y Cwmwl* and *Sunset Dyffryn Camwy*. Painting the flowers of Patagonia gave Kyffin great pleasure, exercising his skills with memorable paintings of *Flowers Near the Ffos*, *Patagonian Daffodil* and in a tour de force of colour *Willow in Wind*. He delights in capturing on paper and canvas other animals apart from his much loved horses, such as *Ostrich in the Desert*, *Guanaco* and *Patagonian Hare*. Kyffin had always painted buildings related to human habitation and they feature prominently in his Patagonian collection: *Old House Gaiman*, *Capel Moriah*, *Capel Bryn Crwn*, *Pentre Sydyn*, *Barn above Trevelin*. Such a list would not be complete without Kyffin's inspired drawings and paintings of birds, including *Parrot at Lle Cul*, as well as tern, southern lapwing, red robin, kite and golden eagle.

One painting in particular has become the symbol of Kyffin's visit to Patagonia, *Ceffyl yn y Lle Cul* – Horse at Lle Cul. Kyffin was at Lle Cul when he heard a dog barking and someone shouting 'Paid, Paid' (Stop it). It was then that he met the Reynolds family, father, mother and son. The family had emigrated from Cardiganshire and were surprised that Kyffin didn't know John Evans or John Thomas, or John Jones from Llanddewibrefi – the great singer! The Reynolds family were the owners of the horse in the rough corral at Lle Cul.

Paul Joyner of the National Library of Wales, an expert on Kyffin's work, said of the Patagonian Collection: 'Seeking to interpret Patagonia was a visual catalyst that matured Kyffin's art and prepared him for a long successful career as an artist of national and

international importance. Patagonia, therefore, is a part of our history and of our present. Patagonia helped create one of our most notable artists and has helped us to learn about ourselves.'

On Kyffin's arrival in Patagonia at Trelew, he was met from the plane by Glyn Ceiriog Hughes. Kyffin's recording of the meeting led to some lively correspondence between the two. 'When we landed on an arid field outside Trelew,' writes Kyffin, 'I had somehow failed to notice the valley and the meandering Chubut. I felt immeasurably depressed. I got out of the plane and stepped into a bitter wind that seemed to blow dust from every quarter. I carried my bags to join some men who were sheltering behind a shack that served as an airport building. Again, from somewhere, I heard the enquiry Kyffin Williams? And a serious-looking man pushed forward introducing himself as Glyn Ceiriog Hughes.' This was the version of events chronicled by Kyffin in *A Wider Sky*, published in 1991. But Kyffin had written an earlier account published in *The Anglo-Welsh Review* under the title 'An Artist in Welsh Patagonia'. This first version was slightly different! In it he wrote that he 'had landed at Trelew airport. It was immeasurably depressing – wished I was back in Wales…I made my way towards an uninviting building on the edge of the airfield, where a few people were sheltering from the wind and as I joined them, I tried to hear if any of them were speaking Welsh. Suddenly a voice at my shoulder whispered "Williams?" I swung round and saw a stocky sad-faced man. "Kyffin Williams?" he asked. "Yes, yes", I replied eagerly and he smiled, gave me a strong Patagonian Welsh handshake and introduced himself as Glyn Ceiriog Hughes.'

After these words appeared in print, Kyffin took the bit between the teeth and wrote to Glyn Ceiriog Hughes, facing head on the fact that he had referred to him as a 'sad-looking man'.

22 Bolton Studios
17 B Gilston Rd
1.3.70

Dear Glyn.

St David's Day & yesterday Wales beat England in one of the most exiting Rugby matches I can remember. I am really writing to say that quite without thinking I have described you in an article in the 'Anglo-Welsh Review' as a 'sad looking man'. What I really meant was a 'serious looking man' or 'dyn prŷdd'. I was very worried when I saw it in print and then it was too late to change it. I do apologise. I have two exhibitions in London now, one of my Patagonian drawings and one of the

oil paintings I did from them. You are exhibited mending your fence, so are Elias Garmon Owens, Ceri Ellis, Brychan Evans, Llywellin Griffith and little Norma Lopez of Trevelin. People in London now know where Patagonia is.

I am sending you a copy of the *Anglo-Welsh Review* & also of the book if it is published but that is a big IF. Publishers say it will cost too much. Do give my very best wishes to your wife and family & all my good friends in the valley. I don't think I have ever enjoyed myself so much as I did down there. Ever yours.

Kyffin. W.

Glyn Ceiriog replied with an excellent measured letter ending on a humorous note: 'Yours The Sad Man'.

Kyffin and his painting *Henry Roberts, Bryngwyn, Patagonia*

Avenida Gales 323, Trelew, Chubut, Argentina.

Mawrth 24, 1970

Bonwr Kyffin Williams,

22 Boston Studios

17 B. Criston Rd.

LONDON S.W. 10.

Dear Kyffin:

I was very glad (not sad, mind you) to receive your letter of the 1st instant. I also have to acknowledge your card for Christmas. I haven't received the *Anglo-Welsh Review* yet, and I can say I am really waiting for it to see what else do you say about us in Patagonia. I don't know why, but most writers manage to say something about us in Patagonia, that we don't like. Many years ago (about 35 years, I think) two North-American bone-diggers Gaylord Simpson and Williams were in Comodoro Rivadavia and they wrote a very interesting book about Patagonia, it was named 'ATTENDING MARVELS' but it sait some nasty things about the Englismen then living in Comodoro Rivadavia, they were absolutely mad when they received a copy of the book. They had done their best to attend the Americans and had dined and wined them to the limit.

Also Alun Williams and his crew from the Welsh B.B.C. when they were down here took the worst views of the place. They showed our 'shanty towns' (Villas miserias as we call them) but none of the modern buildings we have. Another vieu was a 'peon' a very badly clothed man walking down one back-allys with no pavement and full of garbage cans . . .

I received a letter from Mr Shawyer, the ex-Consul Británico in Buenos Aires. He says he went to see your exhibition in London, and that he had met you there. He also mentioned your 'gafe' about the 'sad man'. Don't bother about that, I don't mind at all. But I will take care the next time a 'Wild Welshman' comes along I shall smile my guts out. I don't feel sad at all, but I can't change the face I have . . .

Next time you come to Patagonia, do it in summer so you can see the place in its best and enjoy our apples, pears, peaches, etc.

The kindest regards from myself and May,

Your 'dyn prydd'

Avenida Gales 323,

Trelew, Chubut,

Argentina.

In the early 1970s many letters were sent by Kyffin and Glyn Hughes to and fro from Wales to Patagonia and from Patagonia to Wales. In one letter dated 18 April 1970 Glyn wishes Kyffin every success with his Patagonian lecture tour in Wales and remarks that his brother Euros was 'tickled to death about his picture being bought by the National Library in Aberystwyth, and wonders what they can see in a painting of that kind'. Kyffin had painted Glyn's brother Euros irrigating his fields in a striking oil painting measuring 20 inches x 20 inches. In 1973 Kyffin assures Glyn that he always says that Patagonia is a 'lle ardderchog' (an excellent place), and informs Glyn that he intends giving up teaching in July of that year and will then go backwards and forward between London and Wales:

> I will be moving to a lovely little house on the Anglesey shores of the Straits if only the builders will get working. Let me know what everyone is doing if you have time.
>
> Somehow I keep on painting and always hope I am not getting worse. People seem to buy my pictures which is very extraordinary as I paint only to please myself. Do give my very best wishes to everyone. They are too numerous to name.
>
> Yours ever
>
> Kyffin

These letters are very illuminating. They tell us much about Patagonian attitudes to what are perceived as incorrect journalistic reports about their country, and inform us of Kyffin's movements in London and Wales, as well as the steps he took to promote his Patagonian paintings more generally in Britain. They also show the close bond that had developed between Glyn Ceiriog and Kyffin, a bond that continued when Glyn Ceiriog's daughter Miriam came to Britain and worked as an Assistant Lecturer at the Spanish Department of Leeds University for about three years, when the Welsh author Gareth Alban Davies was professor there. These letters further reveal that Kyffin was never happy to let bad feelings fester; he always had to put things right.

In an e-mail in June 2010, Miriam Harriet recalls how she first met and became friends with Kyffin:

> Kyffin and I met for the first time in London in 1974. I was born in Patagonia but in 1968-69 I was already at college in Buenos Aires. After my graduation I decided to go on holiday to Europe and I went to the UK first. My father, Glyn Ceiriog Hughes, wrote to Kyffin telling him about my trip and my plans to stay there for some time. It was then that we met and became very good friends in spite of the age difference. I

visited him at his home in Pwllfanogl several times and after I came back to Argentina in 1978, we wrote to each other for many years. I enjoyed his company, his sense of humour, his comments, his creativity, everything.

My closest connection with his visit to Patagonia in 1968-69 is through what both himself and my father told me about it. Nothing you haven't heard about, probably. I guess they must have had a good time together going around the farms, visiting people and talking about life. Kyffin said once that a 'sad looking Welshman' had picked him up at Trelew airport when he arrived but my father didn't agree with that description of himself at all! My father went to the airport because he spoke English well.

Among the many letters sent to Miriam Harriet by Kyffin, she remembers one letter in particular, written by Kyffin after the death of her father Glyn Ceiriog:

<div align="right">Pwllfanogl – Llanfairpwll
26-6-94</div>

Dear Miriam

I have been thinking a lot about my visit to Patagonia 28 years ago, now that I have heard of the death of your father. I was so lucky that he took me under his wing and led me through the wilderness. I hope he enjoyed my company as much as I enjoyed his. Although he must have been failing, I am sure you will miss him very much as well as all your family.

At the advanced age of seventy six I seem to be having to work harder than ever and I have two shows next year, one a big one in Llangefni of all my very big pictures. Also I have to provide work for the Royal Academy in London and the Royal Cambrian Academy. Anyhow I am reasonably fit so can cope for the time being. I heard from Gareth Alban Davies last week. He has been writing again on Y Wladfa and will, I am sure, be writing to you as I told him of your father's death.

I will always remember his kindness.

<div align="center">Love
Kyffin</div>

Glyn Ceiriog's very name meant so much to Kyffin, as he wrote in *A Wider Sky*: 'This name to me was nostalgic, for he had been christened after the gentle tree-clad valley that wanders down from the Berwyn Hills to the English border. As a boy, I had lain on the banks of the River Ceiriog to watch kingfishers and had walked through the bluebell woods in the valley.'

<div align="right">*133*</div>

Kyffin was fascinated by so many aspects of Patagonia, especially the glorious Welsh-Spanish names of the people: Señora Gwenonwy Berwyn de Jones, Señora Williams Avenida Roca, Señora Luned Roberts de Gonzales (who with her sister Tegai are great-granddaughters of Lewis Jones) and Señora Mair ap Iwan de Roberts, to name but a few of the welcoming Patagonians.

Not long after his arrival in Chubut, Kyffin wrote to Gwyn Brown at the Tegfryn Gallery in Menai Bridge including with the letter a glorious cartoon, portraying himself as a bird carrying a message to the Gallery.

This cartoon, it is believed, takes its inspiration from a well-known Welsh poem written by Reverend A. E. Jones, better known by his bardic name of Cynan, a poet of great ability who became Archdruid of Wales and who lived not far from Kyffin at Menai Bridge. Cynan wrote a poem full of pathos from Macedonia where he was a soldier in the war, imploring an imaginary bird, a goldfinch ('nico' in Welsh), to take a message for him from the deafening sound of the big guns in Greece to the peace of his home garden in Glandŵr in Wales, to tell those at home that he longed to be with them. Kyffin had extensive knowledge of Welsh poetry, surprising Gareth Parry, his fellow artist, on one occasion by reciting from memory a poem by Dafydd ap Gwilym in Welsh.

Gaiman Chubut 15.11.68

Dear Gwyn Harry a teulu Tegfryn.

Gracious me my Welsh has gone to my head. I am struggling with my Cymraig coman. I have done a broadcast in it on Radio Chubut. But what a place miles from the end of the world and far on the way to nowhere. Each side of the valley is nothing but desert for endless miles. The valley at first acquaintance seems dreary, but there are lovely little settlements along the river and the canals, and the people are supremely contented and dignified.

There is nothing beyond the will.

I have done a bit of drawing (about 50) and taken over 100 photographs. The dust, the piercing wind and the sun make drawing tricky and they are not very distinguished I fear. The wind is really bestial and the farmers show its effect in their bloodshot eyes.

It is a very kind valley, the birds only move out of your way so they and the people have made a truce and there is no shooting. There are some wonderful names here, Eryl Williams de Ramires, Victor Hugo Hughes, Winston Churchill Rees and Juan Asvaldo Jones and they all fit in happily with the Indians who squat on the edges of the habitations and the Spaniards. You can always tell the Welsh as they are tall fair and

ginger moustached. No little dark specimens down here. There are parrots all over the place screeching like mad, they nest in the escarpments that bound the valley. Have been at Dolavon and Capel Glan Alaw today by way of Pont Twm Bach. Had a gruesome journey by boat. Was supposed to be no class but was very definitely 10th by my judgement. Was met in Buenos Aires by an exuberant little Welshman called Dan Lewis and a very elegant girl from the valley called Delyth Jones, also by an Antarctic wind of such ferocity that it had me in bed for a day. I arrived hardly speaking any Spanish only to find I was unable to speak English either.

Do (as my agent in North Wales) give my very best wishes to your artists one and all and love to all the Tegfryn family. Sorry to use you as a bush telegraph but will write more individually later. I stayed a week in a pub in Trelew, am now in a house in Gaiman and move to a farm in the valley next week. I fear it may be a bit primitive but from what I have seen around here, it is bound to be spotlessly clean.

Ever yours

Kyffin

In the great story of Patagonia, Kyffin was particularly interested in two people, Lewis Jones of Holyhead and Captain Love Jones-Parry of Madryn, giving them pride of place in his chapters on Patagonia in *A Wider Sky*. In addition to the fact that they both played a crucial role in the establishment of the Welsh settlement in Patagonia, they both came from parts of Wales very close to Kyffin's heart. Lewis Jones, who became first president of the settlement Y Wladfa, was a native of Holyhead in Anglesey, Kyffin's beloved island. Captain Love Jones-Parry of Madryn came from Llŷn, a part of Wales that Kyffin knew well. Kyffin had lived in Eifionydd and had worked in Pwllheli, living nearby in a house on the Broomhall Estate at Aber-erch.

It was these two men, Lewis Jones, a Liverpool printer but a native of Holyhead, and Captain Love Jones-Parry, a country squire living in style at Madryn Castle on the Llŷn Peninsula, who travelled together to Patagonia to inspect the land. Lewis Jones must have been an able diplomat: it was he who was chosen to travel to Buenos Aires to discuss with the Argentinian Government the idea of establishing a Welsh settlement. They sailed along the coast of Patagonia to the mouth of the Chubut River, Lewis Jones keeping a detailed diary of their journey. Captain Love Jones-Parry and Lewis Jones inspected the land for a week. Returning to Buenos Aires, they signed an agreement in 1863, which gave them permission to create a Welsh Settlement in the Chubut Valley. Both men eventually had towns named after them, Trelew (inland) from the name Lewis − Tre

Lewis (Lewis's Town) and Madryn (on the coast) named after Love Jones-Parry's home area.

There were others who played vital roles: Michael D. Jones of Llanuwchllyn and Bala who was the first to call for the setting up of an independent settlement where the Welsh language was supreme and where there was political and religious freedom; Edwin Roberts, who was raised in the USA but returned to Wales in 1860 to promote the Patagonian venture; Hugh Hughes, who worked as a carpenter in Caernarfon, whose drive and ability were crucial in ensuring that the venture went ahead; and R. J. Berwyn who lived in London and the USA but who returned to Wales to help establish Y Wladfa. He worked diligently in Patagonia where he had many important social roles. Abraham Mathews, a minister of religion, became a spiritual and political leader there.

It must have been very exciting for Kyffin to meet Tegai Roberts, the person in charge of the museum in Gaiman and her sister, headmistress Luned Gonzales, who were great-granddaughters of Lewis Jones.

In 2010, Tegai Roberts remembered the first time she met Kyffin in Patagonia at the guesthouse where he first stayed in Trelew. She recalled him 'running or indeed jumping down stairs, he made me think of a large rabbit or a character from Alice in Wonderland!' Tegai also remembered Kyffin speaking Welsh in a radio interview on Radio Chubut de Trelew during a programme of Welsh music and discussions. Tegai's sister Luned Gonzales remembers Kyffin in Patagonia with great clarity: 'He was very kind and generous giving art lessons to the pupils of Camwy School. Later he sent two or three original paintings by Welsh artists to Camwy School via the British Embassy. They are still hanging on the walls to this day.' Luned visited Kyffin's studio on the Menai Strait and had a warm welcome. Kyffin would faithfully send her a Christmas card – the much sought after Kyffin Christmas Card – and she would send him a letter in English once a year.

Luned records with sadness that the last letter she received from him was in 2006 when a nurse had replied on his behalf.

Another person who became very close to Kyffin in Patagonia was Hector MacDonald. He was of great help to him, driving him around the Gaiman in his car. Back home in Wales, Kyffin always spoke very highly of the MacDonald family, acknowledging their sterling contribution to Patagonian society. It was a very poignant moment for Hector's son, Elvey, who had emigrated to Wales, when he met Kyffin at a north Wales Eisteddfod. Kyffin reminisced about meeting Elvey's father in Gaiman and the welcome he received there.

Mari Emlyn, the editor of *Llythyrau'r Wladfa* (Letters from Y Wladfa) published by Gwasg Carreg Gwalch, writes about Kyffin's visit in one of many perceptive explanatory notes: 'We had a remarkable description of Kyffin Williams by Barbra Llwyd Evans…The people of "Y Wladfa" took to Kyffin in a big way, perhaps without realising at the time the extent of his artistic abilities' (i.e. his stature as an artist).

The following is part of a letter from Barbra Llwyd Evans to Eiddwen Humphreys giving a fascinating description of Kyffin on a visit to Tŷ Ni in Patagonia:

Tŷ Ni − March 25 1969

…He was very strange, totally dedicated to his paintings and drawings. He was here twice…Well to continue with Mr Williams, its his appearance that draws most attention. He came here with Tegai (Roberts) in his shirtsleeves, the shirt was coloured green and black with one sleeve button missing, a blue jean trousers, a dark green felt hat on top of his head as if it was too small for him, rather yellowish hair across his forehead and a huge moustache under his nose. He was nice and pleasant to speak to, he saw everywhere very large, the sky clear and blue, the birds very tame and the men wearing 'albaragats', he called them slippers. He took a photograph of Ger and myself here in the garden.

Tegai was leaving him here because Henry Rts and Eifiona expected him for lunch, and would be calling to collect him about mid-day…he came here afterwards in a motor car belonging to Sampini the brother in law of Mrs Valmai Jones and their small boy with him for company; he wanted to make a drawing of me in pencil − if I was agreeable. Well I let him do it, since he had arrived − and that about the time I prepare lunch with the potatoes just put to boil. He put me to sit still, I thought he took a long time, I remembered the potatoes were on the boil, but at last he finished, luckily the fire had gone out. He wouldn't stay for lunch since he and the little boy were due to go back. Having started the car, it came to a full stop!

Well, I called for Ger to help, we saw that he had very little 'Naptha' (petrol). Ger went to the garage …and then they were alright. The remarkable thing was that he would get about without any Spanish. He went down as far as Tierra del Fuego from The Andes and then back down here again somewhere to the North of Esquel. Someone had told him about a relative (Ralph Williams). As he started back H and Del went to see him. He was wearing a woollen shirt and on top of that he wore a 'campera' a coat. It was an exceptionally hot day and he had to take his coat off − he was preparing to reach London. He was in great strife later. Del had a letter from him telling the story. He

just could not find his paintings on the plane (Avion), pulling out all the parcels twice but the third time he found them.

We will long remember him.

I hope this letter will arrive.

<div align="right">Anty B.</div>

If Kyffin described Patagonia and its people with great detail, we can see that they in turn turned the microscope on him.

On Kyffin's arrival in the Camwy Valley, the local daily paper *Jornada* carried a brief report of a lecture Kyffin gave at the Institute of Higher Studies in Trelew, where he landed from Buenos Aires:

> *Jornada* 20 November 1968
>
> The Welsh painter Kyffin Williams lectured about the arts across the ages at the lecture hall of the Institute of Higher Studies in Trelew.
>
> Writer, painter, sketcher, recipient of the Winston Churchill Foundation (an organization established to perpetuate the memory of the British statesman), Williams is in Chubut to fulfil the objective he set himself when applying for the scholarship: namely to record Welsh cultural activities as currently expressed among us. He will make this public on his return to Wales by publishing a book which he will illustrate himself. He has been wandering all over our Valley, observing and taking notes. He will also visit the Andean zone, around Trevelin, also a region settled by the Welsh.

The paper also reported on his arrival under the heading 'Welsh Painter Visits the Valley':

> Kyffin Williams writes his surname with a 'K', in the way it was written in the past, wherever he goes and wherever he speaks, he is proud of his race and nationality . . . Yesterday he visited *Jornada* in the company of Glyn Ceiriog Hughes.
>
> We had a long conversation – and spoke about Wales and the Welsh in Argentina, because Kyffin Williams comes from Wales.
>
> We asked him if he likes the Valley and he responded that it is beautiful, that it is welcoming and that he feels enchanted with the welcome of the Argentine Welsh. We told him about Esquel and that there he will be able to observe warmer aspects, as the mountain people, by nature, are more affectionate. Kyffin Williams told us

that he would be happy to receive the same kind of welcome he has been given in the Valley, but that he will be prepared to experience new emotions in the mountains.

Before leaving he added that, on returning to Wales, he will give talks about the region and its people, and repeated his gratitude for all the kindness extended to him. This made it easier for him to fulfil his commitments.

Shorter reports about Kyffin in Patagonia were also carried in *Jornada* toward the end of 1968. The paper records that Kyffin gave his audiences in Patagonia a bit of history of art and a little history of Anglesey: 'the teacher was never far from the surface with Kyffin'.

He had been advised on his arrival in Trelew that the first person he should visit was Señor Luis Feldman, the Jewish and pro-Welsh proprietor of the *Jornada*. 'I was placed in a chair in his office and photographed,' Kyffin remembered, adding that the photograph was taken when he was hardly prepared for it. Tongue-in-cheek, he writes that the photograph appeared and 'struck such terror into the hearts of the good people in the valley that they felt a pause was necessary to reconsider their offers of hospitality: for gazing sullenly out of the pages of the "Jornada" was the face of an unmistakable lecher, rapist and alcoholic. In Gaiman, Señorita Tegai Roberts, alarmed by the photographs, had got in touch with Señora Albina Jones de Zampini and together they discussed the wisdom of their offers of hospitality. They sought the opinion of Henry Roberts, a deeply religious local farmer and with considerable tolerance came to the conclusion that I might not be as bad as I looked and that patience and observation were what was necessary.' Kyffin would have enjoyed writing about these imaginary reactions; he always had a great sense of the ridiculous.

Kyffin spent a month in Dyffryn Camwy where he made over 200 drawings and paintings in watercolour, ink wash and gouache. Then, as he said, 'It was time that I left for Cwm Hyfryd…that lay four hundred and fifty miles to the West.' As he had decided, Kyffin did not in the end go by horse but in an ancient Mercedes bus. He would visit the towns of Esquel and Trevelin, capture the glory of Cwm Hyfryd (Beautiful Valley) in his drawings and record the majesty of Gorsedd y Cwmwl and the other high peaks of the Andes that bordered Chile. He spent a month in the west meeting extremely hospitable

Kyffin hits the headlines, Patagonia 1968

Welsh families, drawing and painting portraits of people such as Brychan Evans, recording the birds, witnessing condors flying high, and drawing and colouring the high-stepping horses of Cwm Hyfryd.

But Kyffin had also decided to visit Tierra del Fuego, the land he described as the place 'where the mighty Andes disintegrates into a disorderly coccyx of jagged peaks and islands finally to disappear into the terrible waters around Cape Horn'.

Kyffin visited Ushuaia, the most southerly town in the world, visited by Charles Darwin in 1832, and which, Kyffin learnt, a distant relative of his had also visited in his Navy days, before becoming a missionary with the Indians of Tierra del Fuego.

Arriving back in London in February 1969 after a journey of a lifetime, Kyffin set about turning a number of his drawings into oil paintings. He painted forty-five canvasses based on the drawings he had made in Dyffryn Camwy and in the west in Cwm Hyfryd and the Andes. In Kyffin's own words, 'It was my forty-fifth canvas and I knew the spell was broken. I never painted another picture of Patagonia.'

Kyffin's books *A Wider Sky* and *Across the Straits* are regarded as classics of autobiography. Kyffin, however, with his usual modesty in a reply to Norah Isaac, the educationalist and author who praised *A Wider Sky*, writes: 'Having returned, I tried to get a whole Patagonian book published with all my drawings and watercolours, but no publisher would take it on. The result was a rewritten effort turned into a sort of Cook's tour guide book.'

Once back home, he initially offered his Patagonian collection to the National Museum: 'I offered them to the National Museum of Wales and I wrote to the Keeper of Art and I arranged to go down and see him, and I drove down from Anglesey and found he wasn't in, he turned up an hour late, and he said he was too busy to see me, and I said I had come down to offer him any of the drawings I had done, and he said, "Well now you're here I might as well see them". So he looked at the drawings for a bit and I said "You don't want any do you?" He said "No. Good day". And so I drove back to Anglesey and I offered them to the National Library, who said thank you very much!'

Patagonia was a watershed for Kyffin in so many ways. It inspired him to abandon London and was one of the high points of his career. Among other things, it strengthened his Welsh identity.

Kyffin is quoted as saying: 'The people were intriguing. They were very, very Welsh, they were easy-going, gentle people…and they were extremely hospitable…They had never met anybody quite like me before, they had never met anybody who spoke such bad Welsh and claimed to be a Welshman…but I got on well with them. It was a very fascinating experience.'

When Kyffin was asked on his return if he had been homesick, he immediately replied, 'No, no not at all, mainly I suppose because they were so Welsh.' Kyffin had a long correspondence with his friends in Patagonia over many years – with very kind remarks being exchanged. Tegai Roberts writes: 'Albina thinks it was your special personality that awoke hospitable feelings in people. They all remember you fondly…We hope your book will come out soon – we are always scanning the papers to see if something comes out about you or the book' (Gaiman 25 May 1969). Tegai's letter begins in Welsh. Delyth Llwyd Evans, an able artist herself, writes in June 1969 after hearing that Kyffin's flat was trashed while he was away and that he had had trouble with his car: 'Did you lend them to somebody? Three things you should not do: You shouldn't lend your car, your toothbrush or your wife!'

The letters Kyffin received after leaving Patagonia bear witness to the close connections he had made. They discuss everything, as family letters always do. The weather is a regular topic, buying new Wellingtons, family movements, people travelling to New York, new jobs in the Venezuelan Embassy, buying new cars, family illnesses and operations. They are warm, intimate and fascinating to read. Fred Green writes from Pennant Trevelin to tell Kyffin that the best farm in Patagonia is for sale and asks Kyffin if he thinks a small company could be put together to buy it – nice timber, 300 head of cattle, excellent country for The Du Cymreig (The Welsh Black) and about 5,000 sheep, Merinos. Brychan Evans writes, 'Pryd cawn i'ch gweld chi eto yn Patagonia a Trefelin?' (When can we expect to see you again in Patagonia and Trefelin?) He also asks in Welsh, 'Pa les, pa fudd i'r Llyfrgell Genedlaethol fod fy llun i yno?' (What good will it do the National Library that my portrait is there?)

Kyffin is asked for advice about places for Patagonian students to study in Wales in a letter from Gweniro de Jones, the letter ending with 'no rain, pampas dry – animals dying'; and Tegai Roberts suggests Kyffin should publish his book in Argentina. Miriam Hughes writes after her visit to Pwllfanogl, 'The place itself and you with your special personality make me feel different, happy in peace with myself'; while Delyth de Jones had discovered that one of Kyffin's relatives, Thomas Lloyd Kyffin MA, Vicar of Llanbadrig Church, had performed the marriage ceremony of a distant relative of hers in 1875.

When Kyffin arrived in Patagonia, he was invited to speak in Welsh to the Patagonians. Among the things he said was: 'I trust my stay here will be fruitful and creative. I know the experience is one to be remembered and the opportunity unparalleled which will stay with me for my whole life…To an artist a chief pleasure is to be in such a charming country, rare, different, it's a personal inspiration to me, and as a painter I rejoice in your

countryside – the expansive views, the remarkable colours and shapes and the Southern Hemisphere light which is utterly new to me.'

On his return to London in 1969 Kyffin was interviewed by the actor and TV documentary maker and presenter Kenneth Griffith, for the Harlech Television (HTV) Arts programme *Etc, Etc*. They stood in Kyffin's studio in London at Bolton Road, looking through the Patagonian portfolio. Kenneth Griffith asked Kyffin many questions, among which were the following:

KG: These are some of your Welsh mountains.

KW: That's a portrait of Nant Ffrancon looking up towards the Glyder, that is an interpretation, I know the mountain so well I can interpret it.

KG: These are the Patagonian mountains?

KW: Yes well, I went to Patagonia and that was a completely different problem, I was only there for a few months and I thought it was fatuous to interpret, I just thought it would be ridiculous and arrogant to try it, so I went there really as a journalist and I wanted to make a record of the people and the landscape and just put down what I saw, and then probably interpret later when I thought about it.

KG: I can think of many reasons for wanting to go to that exotic bit of the world, what were your reasons?

KW: I suppose I had been called a romantic painter. I've felt that this is an incredibly romantic story about the Welsh out there and I've always been impressed by their bravery and fighting the incredible odds they had to put up with. I never thought I'd get there but suddenly heard about the Winston Churchill Foundation and fellowships and thought well, if I apply I might possibly get a grant to go to Patagonia, so I put forward my scheme . . . and the word Patagonia seems to do something to people, sometimes they don't know if it's a dog or a tree or an architectural term, they just don't know, the name seems to attract them!

KG: Do you feel . . . this must have been a very violent, dramatic visual experience for you, you've been used to painting Wales and what Wales stands for . . . well of course this must have a lasting effect on your work in future mustn't it?

KW: All I hope is that it improves my painting, perhaps it will have a sort of jolt, will improve my painting because I've been painting the same thing for twenty-five years more or less and I hope it will give me a sort of jolt.

The result of this 'jolt' inspired Kyffin for the remainder of his life.

Kyffin and Pwllfanogl –
Twixt the Mountains and Anglesey

D R PAUL JOYNER of the National Library of Wales, reviewing *Kyffin – His Life, His Land* (2008), makes extremely pertinent points when he observes that

> This volume is all about connections, we find here how Kyffin was a man of Ynys Môn with generations of his family having lived and worked on the island . . . Connections were part of the reason for Kyffin's success as an artist and as a national and international Welshman. His early experiences with the landscape and the local people of his beloved island, the understanding of his fellow Royal Welch Fusiliers, the comradeship of his student days and later meetings with the members of the Royal Cambrian Academy, all helped to form his unique ability to relate and communicate with a diverse and ever-changing society.

The Cambrian Academy grew out of an artists' colony centred on Betws-y-coed in the late nineteenth century, securing royal patronage in 1882. Kyffin was president of the Royal Cambrian Academy on two occasions in 1967-75 and from 1992 until his death in 2006. Since the launch of the Academy in 1881 there have been many eminent presidents, among them Augustus John. Vicky Macdonald, the curator between 1993 and 1999, worked with Kyffin for twelve years and was witness to the dramatic changes brought about by him in the development of the Academy. According to her, Kyffin

> undertook a programme of bringing in artist members from all over Wales, with a concentration on Mid and South Wales – he raised the number of members to over a hundred. Kyffin and his Council introduced a programme of nine exhibitions per year. Typically of Kyffin who was a strong believer in co-operation between art organisations,

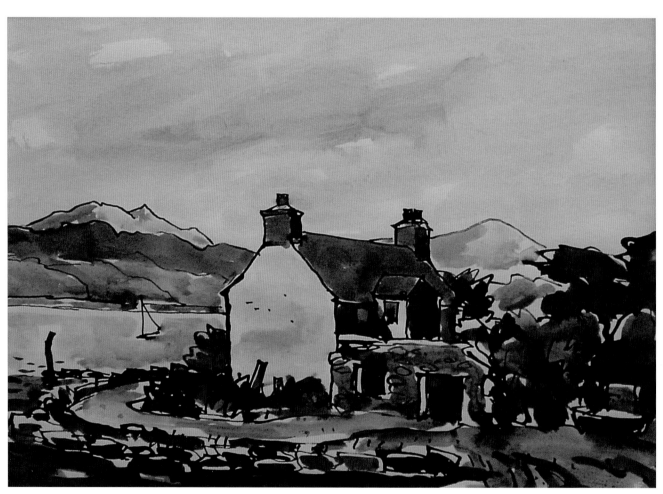

Kyffin's view of the mountains from Pwllfanogl

new links were forged with other galleries in Wales, and the Academy for the first time in many years sent an exhibition to the National Museums and Galleries of Wales in Cardiff…a new 'Friends of the RCA' was formed …

Vicky Macdonald noted that it had been a great honour for the Academy when Kyffin was knighted in 1999 since it was instrumental in 'raising the already high profile of the President and the Academy'. In a tribute, Vicky described Kyffin as a charismatic person, remembering 'that a private view would light up' when he walked into a room and that people would be 'enthralled just talking and listening to him', adding that Kyffin was such a kind and gentle person, though he was never afraid to 'speak his own mind'. Kyffin's presidency of the Royal Cambrian Academy was crucial in giving it a new thrust. Under his leadership, distinguished artists and sculptors from across Britain were elected as members. In 1995 Welsh artist Ivor Davies became vice-president of the RCA, with Maurice Cockrill being elected president to follow Kyffin in 2006. Maurice Cockrill resigned in 2011 and Dr Ivor Davies succeeded him as president. As vice-president, Dr Davies would visit Kyffin often and accompany him to his favourite painting locations in Anglesey. Today membership of the Royal Cambrian Academy reads like a *Who's Who* of creative artists in Britain.

Moving back to live in Wales and seeking a permanent base meant that Kyffin could strengthen and even deepen the numerous contacts he had made over the years, contacts that kept him in touch with every stratum of society and with a myriad of different professions – farmers, teachers, actors, politicians, poets and professors, ministers, vicars and priests, archbishops, sculptors, school children, TV producers and directors, fellow artists, neighbours, printers and promoters, housewives, doctors, policemen (off duty!), solicitors and Welsh pop singers such as MC Mabon who would, at Kyffin's request, take a message to his friends in Patagonia where Mabon was going to record, and James Dean Bradfield of the Manic Street Preachers who, after his visit, released a pop song titled 'Which Way to Kyffin'. Pwllfanogl was also a mecca for old school friends and former pupils – when the 'Mr Chips' syndrome was at work.

He had been on the move since childhood: Llangefni, Chirk, Beaumaris, Pentrefelin, Aber-erch, Lurgan, Oxford, a series of ropey digs at assorted locations in London, Llansadwrn (the small house of Cefn Gadlys which his mother had bought when she moved from south Caernarfonshire).

After her death, Essyllt Williams left the house to her favourite child Dick, Kyffin's elder brother. When Kyffin was not teaching in London, his brother let him use the

house, allowing him also to build a studio in the garden. Kyffin, however, had never been happy with the arrangement; the light was not right. Now in 1973, with Kyffin leaving London and moving permanently to Anglesey, he had to make some difficult decisions. The lack of light at the Cefn Gadlys studio at Llansadwrn was depressing him to such a degree that he could do no work. Concern for his brother's state of health was also probably a worrying factor at this time and a major distraction for Kyffin the artist. Not being able to paint meant that his livelihood was in peril.

Kyffin loved his brother Dick dearly, and although Dick was older than him, they had also always been good friends. But it had been made obvious to Kyffin from childhood that Dick was his mother's favourite. Dick always had to have the best chair in any room, while Kyffin had to fetch and carry. It was Kyffin who had to lay the table and, as he said, 'lift the potatoes and skin the rabbit'. Even when he developed epilepsy, his mother would continue to show more anxiety about Dick, even though he was fit.

Kyffin said of her in 2005: 'My mother basically was a very affectionate person, but she did not think it right ever to be affectionate. So I was brought up without any cuddling or kisses or anything like that. It was very sad for my mother, she just could not do it.' Kyffin also said that his mother had looked after his brother Dick and himself 'incredibly well', and that they hadn't wanted for anything. She was, however, always terrified that they would catch various illnesses, such as pneumonia, so that he, Kyffin, was brought up with a sense of a totally apprehensive mother, with fear written all over her face. Kyffin believed that his mother was a 'good person' who had lost her way.

His brother Dick had often stayed with Kyffin at Pwllfanogl, but friends who visited while he was there were horrified and perplexed to see Kyffin tending to his every need, as if he were a servant in his own house. We can only imagine Kyffin's concern when Dick, suffering from collapsed lungs, or other ailments, would be taken to hospital in Caernarfon or Bangor.

Back in 1973, at a low point in his life, Kyffin needed stability, and he needed the security of a well-lit purposeful studio. Help was at hand, however. Lord and Lady Anglesey of Plas Newydd, near Llanfair P.G., had some empty properties on their vast estate and they wondered if one of their many buildings could be of use to him. On a day of inspecting the buildings, Lady Shirley Anglesey took Kyffin down a rough track towards the Menai Strait. He would later joke that this (very) rough track would remind Patagonian visitors of their roads back home in the Gaiman!

After a quarter of a mile the track turned sharply, and from a bridge over the River Braint Kyffin could see a cluster of buildings beside a small harbour. He was looking at his

future home, his sanctuary and anchor – Pwllfanogl. The name is a compound of 'pwll' (pool) and 'ffenigl' (fennel), with fennel growing in plentiful supply around the house. Kyffin would later note that Pwllfanogl was a haven for anyone interested in wildlife. Over the years, he would record nearly ninety different species of birds, watching mallard in the harbour and kingfishers as they dived to catch fish. Herbs grew well in the garden and the Menai lapped the shore a few yards from the house. Even Kyffin could not have painted such an idyllic spot.

Artist William Selwyn was a great admirer of Kyffin and spent many happy hours at Pwllfanogl in conversation with him. There were similarities between the two artists, for both had been art teachers. More important, however, was their delight in portraying the landscape and people of Gwynedd. William Selwyn exhibited four times with Kyffin at the Thackeray Gallery in London, at Kyffin's invitation, and it was Kyffin who inspired Selwyn to paint the incomparable Castell Carreg Cennen in the Tywi valley. William Selwyn worked with Kyffin in expanding the influence of the Royal Cambrian Academy for the benefit of the arts.

Artists find havens where they are at peace with themselves, but more importantly havens that are conducive to their work as artists. In 1888, Van Gogh found new confidence working in Arles and was at the height of his powers living at Saintes-Maries-de-la-Mer in the same year. Monet found peace and inspiration at Giverny, Cezanne at Aix en Provence.

Kyffin certainly found his haven at Pwllfanogl, near the village of Llanfairpwllgwyn-gyllgogerychwyrndrobwll-llantysilio-gogogoch in his beloved Anglesey. This long name for the village is strictly for the tourists. The locals refer to it as Llanfair P.G., although Kyffin went as far as Llanfairpwllgwyngyll on his specially designed letter heading. It was in this village that Kyffin could buy his provisions, post his numerous letters, dine at the local inn and, most important of all, collect his daily *Times* from the Volvo Garage. Perhaps it was this Volvo link that led an unknown wit to remark that 'success in Wales is a house in Pontcanna, Cardiff, a Volvo in the garage and a Kyffin on the wall.'

Kyffin moved to Pwllfanogl in May 1974. His diary entry reads: '20th May move to Pwllfanogl 8.30.' On Friday 24 May, we know he was at the Bangor Guild of Graduates meeting. The following week he met the Director of the Welsh Books Council, the late Alun Creunant Davies. At 7pm on 29 May he gave a lecture at Holyhead School and on 1 June at 10.30am he was at Plas Mawr, Conwy, on Royal Cambrian Academy business, as the Academy president. Kyffin had arrived home and had set a punishing pace for himself which was to be the pattern for the next thirty-two years of his life.

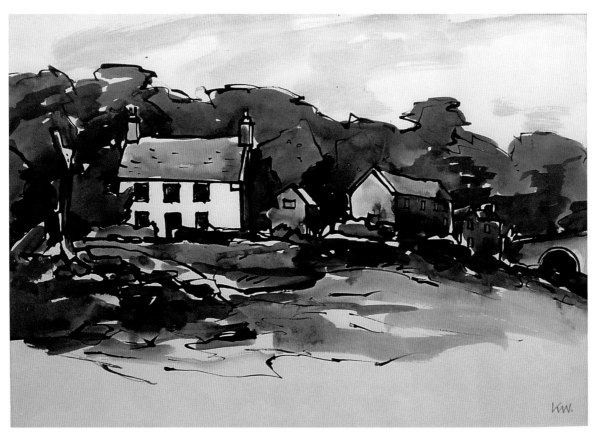

Kyffin's ink wash drawing of Pwllfanogl, house with studio behind

It was here on the shore of the Menai Strait that Kyffin found the ideal building that he could adapt as a studio. The deciding factor was not the house itself or its environs, but the question of whether the light in the studio was right for painting. As Kyffin remembered it: 'I was told (by the landlords) that I could decide whether to take the house when the problem of the light was solved. The situation was perfect so I asked a builder to work on the roof of an adjoining building to the house. One day I put a canvas on an easel and started to paint. The light from the new window was perfect. I decided immediately that Pwllfanogl would be my future home.' Beyond this dynamic production centre, where old telephone directories would soon be used to clean brushes and palette knives, and where discarded canvases and paint tubes would litter the floor, Kyffin would gaze across

the Menai Strait towards the mountains right in front of his front door, to see if the light was good enough for him to paint in one or other of the valleys of Eryri.

Most of his mountain paintings were done in the vicinity of Nant Ffrancon and the slopes of Nant Peris. He knew exactly where to go in order to be sheltered from the different winds. Standing outside his front door, not far from the water's edge, he would decide, if the clouds hung too heavily over the mountains, to go either to Aberffraw, or to the cliffs of South Stack in the north-west, or to Llanddona in the east of Anglesey 'where groups of cottages and farms huddle above Traeth Coch'. Ironically, Kyffin was to say that because of the many distractions of his paradise at Pwllfanogl, it was difficult to discipline himself to work, 'for the whole atmosphere of Pwllfanogl is not conducive to labour of any sort'.

Kyffin would operate a rigorous regime of self-criticism in his studio. People would arrive expecting to collect a commissioned painting, only to be told on arrival at Pwllfanogl that he was not happy with the work – 'the slant of the rocks was wrong'; 'the light was not right'. On occasion, he would rework a painting, but at other times it was abandoned, and the client would be advised to buy one from one of the galleries where he exhibited.

Over the years at Pwllfanogl Kyffin would design logos for a variety of purposes: for wine bottles, for eisteddfodau, and for record covers, as well as for galleries and cultural events. He was regularly asked to design book covers, such as the outstanding design for the Caradog Pritchard novel *Un Nos Ola Leuad* (One Moonlit Night) and was always happy to use W. O. Jones, the local printer in his home town of Llangefni, to print the posters that he had designed.

Pwllfanogl

Pwllfanogl has been a place of habitation since prehistoric times. However, the house that Kyffin saw in 1973 had been built about two hundred years previously and had been the home of a sea captain who, so Kyffin believed, had been involved in the slave trade. It had later become a public house, the Pilot Boat Inn, catering to seafaring men and local people. There had been a thriving community there. Slate books were produced in a large shed, with slate transported from Llanberis. The slate was cut to size, placed in wooden frames, and despatched to schools worldwide. The large shed was later converted for curing bacon. There was also a slaughterhouse and a small centre for the production of reed mats. In its heyday, Pwllfanogl had been an industrious community in one of the most beautiful straits in the world. In Kyffin's time, the harbour was used by small trading vessels and for carrying stones from a nearby quarry.

The house, which was adapted for Kyffin's use, had been empty for six years. There were, however, other buildings. At one corner of the harbour there was a large building used for storing beer, which had a flight of stone steps outside that led to the first floor. This was to be Kyffin's studio. From the artistic point of view, it was to become one of the most important locations in Wales.

Kyffin was to say, when he settled on Pwllfanogl, 'I entered on one of the most satisfactory periods of my life as the tenant of Henry Paget, Seventh Marquess of Anglesey'. We can feel the relief in these words: for the first time in his life he had found a home he could call his own.

His time in the Army and his years as a schoolmaster had taught Kyffin the importance of discipline. He was a highly disciplined person, getting up at Pwllfanogl every morning at 7.09 on the dot. Provided he didn't feel ill, his day would be planned with care. There was drawing and colouring and painting to be done, letters to write, phone calls to be made, paint to be purchased, visitors to be welcomed.

In the years after his return to live in Wales, Kyffin became a national institution who frequently commented on Welsh matters. At the opening of his portrait exhibition at Oriel Ynys Môn in 1993, Cledwyn Hughes, the popular Member of Parliament for Anglesey, who became Lord Cledwyn of Penrhos, quoted Kyffin when he said: 'The ear of the Welshman is a more important organ than the eye and Welsh children are christened because of the attractive sound of the name, whilst the English child is given a name that looks good when written down.'

Kyffin was much in demand as a lecturer from societies up and down the land. He was also called upon as an adjudicator by the organisers of art competitions. Individuals and groups setting up art galleries all wanted his expertise. People from all walks of life

brought paintings to Pwllfanogl for Kyffin to comment on their authenticity. While living in London, museums and galleries had for many years relied on his expert knowledge of artists and Wales to check that the caption 'Harlech Castle by ...' was indeed Harlech Castle and not Carreg Cennen or Rhuddlan. Likewise over the years, charities came to depend heavily on Kyffin to support their annual fundraising events. He would give one of his paintings to be raffled for many worthy causes, such as Shelter, or the Epileptic Society. He would also allow prints to be made of one of his oil paintings, a limited number of which would be signed by him and sold for £200 or £300, thus raising large amounts of money for a variety of causes. When the Royal Welsh Agricultural Society celebrated its centenary in 2004, Kyffin agreed to have his ink wash painting, the dramatic and moody *Farmer in a Storm* (the original being owned by Mrs Margaret Rees) to be made into an attractive print. The signed limited edition raised many thousands of pounds for the Centenary Fund to assist the development of a society that Kyffin supported passionately. He had thought at one stage in his life of becoming a farmer, and his paintings of farmers and their dogs were iconic. His keen eye observed the farmers of Gwynedd in rain and sunshine, in summer and winter. He walked and talked and hunted with them for over fifty years.

Kyffin's oil painting of a farmer walking through thick snow on a steep mountainside in Eryri is so real that John Jones, who formerly lived at Nantybarcud at the foot of the Aran Mountain in Merioneth, can see his late father Robert Jones in Kyffin's figure, battling against the elements while rounding up his sheep on Aran Fawddwy.

Kyffin communicates in such a clear, direct manner that there is no need for copious notes or learned essays for people to appreciate his art. A painting like the one of the farmer mentioned above works on at least two levels: for the general public, it provides a romantic scene of a rugged figure battling the elements, while for the upland farming communities, it is a record of the hardships they face while providing for their families and perpetuating a way of life.

Long before his involvement in the Royal Welsh Centenary, Kyffin had allowed his ink wash painting of a *Welsh Black Bull* to be made into a print in support of the Anglesey Advisory County Committee of the Royal Welsh and their county appeal. As O. G. Thomas, an Anglesey farmer and the owner of the bull said, by the time Kyffin finished painting it, the painting was worth more than the bull!

Kyffin was highly approachable and people felt at ease in his presence. Those who ventured down the potholed road to Pwllfanogl – a road Kyffin drove up and down at great speed, causing passengers to hold on to their seats – would always be rewarded with a warm welcome, a cup of tea and a biscuit, as well as a fair opportunity to plead their cause.

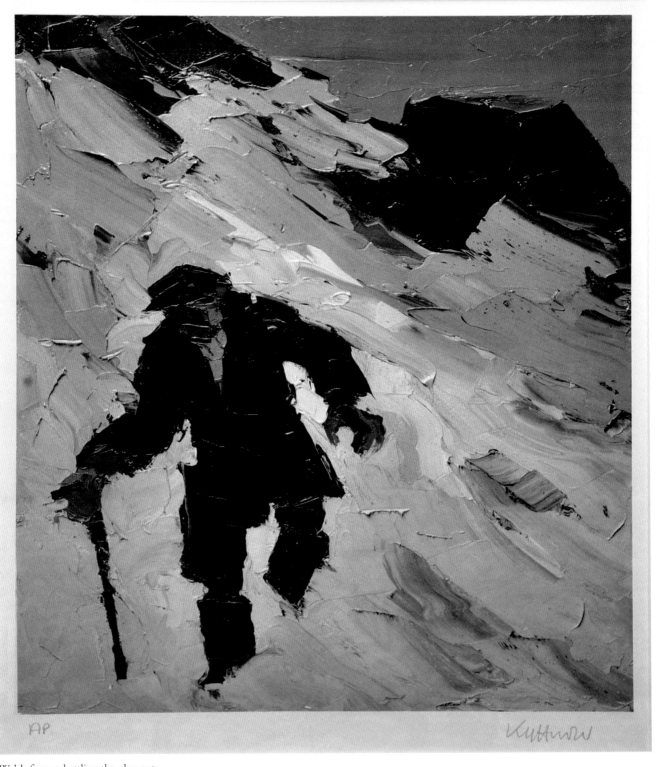

AP Kyffwrw

Welsh farmer battling the elements

But there were occasions when people became too demanding, asking for large paintings that Kyffin had scheduled and promised for the Royal Academy, or the Thackeray or Albany galleries. The manner of their approach would not be approved of. Knowing that a certain demanding visitor had expected the moon (and the stars), a close friend asked Kyffin how the visit had gone, only to be told, 'They came, they took me out to lunch and they went!' There was no sign of a free painting that day!

Though Kyffin often took pity on people. Anyone who had been swindled by a Kyffin lookalike print or painting would be comforted and would depart from Pwllfanogl with a rolled-up signed print under their arm. Visitors from Patagonia would also arrive and they always gave Kyffin great delight. Television and radio presenters and producers would make their way to Pwllfanogl to arrange inserts and interviews, and to plan documentaries for ITV, BBC or S4C. Newspaper and magazine art editors would visit to be given their money's worth and their headline, especially when Kyffin attacked modern art with great style and gusto. Secretaries of state would find their way to the house to be photographed with the maestro. The Kyffin industry had become powerful and influential. If a book about Kyffin or by Kyffin was produced, newspapers such as the *Daily Post* would produce special inserts and run competitions in the paper with Kyffin giving a signed print as the prize, or an author or publisher giving a number of books as prizes. Sometimes, the demands became excessive, bordering on the balmy, such as the time when Kyffin heard a knock on his front door and standing there was a complete stranger who greeted Kyffin and said that Heulwen, his wife, had come to collect her painting of the bridge. Kyffin looked beyond the man and there, at the bottom of the garden, stood Heulwen, another complete stranger. In true Kyffin style, they were both welcomed into the house. Neither Heulwen nor her husband was in the least embarrassed or diffident, they had simply come to collect the painting of the Menai Suspension Bridge which Kyffin had promised Heulwen. In total bafflement, Kyffin explained that he had never painted the bridge! And, he could have added, neither had he ever met Heulwen or her husband! But, without any fuss, a signed print of a mountain view was fetched from the parlour and presented to the said Heulwen. Total strangers, they went away happily, if slightly disappointed that the print was not of the bridge, leaving Kyffin in a highly bewildered state.

Conversations with Kyffin were extremely uplifting. He had the ability to talk about art without being condescending, although conversations on occasion ranged far and wide, covering anything and everything except artistic matters. Kyffin himself would admit that his conversations with his friend, the poet R. S. Thomas, did not include artistic or poetic

matters – they were more likely to discuss birds and rugby! But the menace of so-called 'modern art' was different; there was always room to discuss this hot topic!

When art was the subject of conversation, it was always a pleasure to discuss the great European galleries with Kyffin: the Uffizi in Florence, the Prado in Madrid, the Louvre in Paris, the Rijks museum in Amsterdam. Or to listen to Kyffin in lighter moments describing the ideal artist: a little bit of Modigliani, a bit of Michelangelo…and a little bit of many other artists until the combined genius came about! His knowledge of art and artists was vast but he would readily admit that he had never heard of an artist if he hadn't, or if there was a gallery that he had not visited. There was never any pretence with Kyffin, never any attempt at one-upmanship in artistic matters. As he said, 'I hate pretension, this is something to do with my upbringing, any sort of pretension in art, and so much art is pretension, and the people are pretentious and that aggravates me.'

Kyffin receiving his honorary D. Litt. from the University of Wales, presented by HRH Prince Charles. Also in picture are Mary Robinson, former President of the Irish Republic, and the Aga Khan

Kyffin's humorous take on a serious ceremony

From time to time, friends would call at Pwllfanogl to find Kyffin in a worried state. On one occasion, an author whom he regarded as a friend had written about Kyffin's family in a disparaging manner, producing a manuscript full of inaccuracies and falsehoods. Kyffin banned the publication only to find himself being pestered by the author for money, a lot of money, the final figure turning out to be even more than the sum Kyffin had originally mentioned. Friends advised Kyffin to ignore the journalist, some going so far as to advise Kyffin to tell him to jump in the lake. But Kyffin always had to put things right. Against better advice, the man was paid – but Kyffin had kept his dignity. To their credit, the publishers did not proceed with publication at that time, but to the disgust of many, it appeared after Kyffin's death.

When visitors arrived at Pwllfanogl, Kyffin would meet and greet them at the yellow (in later years) front door. Once inside, Kyffin would invite them to 'sit yourself down'. Then, in the living room, Kyffin would sit with his back to the light, with his guest opposite him, in the light. Light was vital to Kyffin, light on the human face, light on a mountainside, shafts of light on a stormy sea. For him to pick up a palette knife or a brush, the light had to be right – after all he would not have been at Pwllfanogl at all if the light through the adapted studio window had not been right.

Downstairs was the living room which you entered from the front door and to the left was y parlwr – the parlour. At the back of the house was a small horizontal kitchenette, leading to the back door. From there via a covered area you entered the garage. Walking along the back covered area, you could also enter a small, high-walled garden which was mostly lawn. At the far end of this, on a large rough boulder, stood a sculpture in bronze of a young girl by David Williams-Ellis.

Kyffin, on occasion, would arrange sittings for portraits in the parlour, while using the kitchenette for drawing and colouring when he was too weak to climb the stone stairs to his studio at the back of the house. In the small garden at the front of the house, among the fennel bushes, Kyffin had installed a large slate bowl or plate by Blaenau Ffestiniog slate plate maker W. J. Rice.

The sitting/living room was full of furniture: two large easy chairs, an oak *cwpwrdd tridarn*, an oak chest with a magnificent sculpture of a panther in bronze by Kyffin's friend Ivor Roberts-Jones. Kyffin championed Ivor's work for many years, considering him the greatest of European sculptors. He was disheartened and angry that the National Museum of Wales never gave Ivor a major retrospective exhibition.

On the Llanberis slate surround above the fireplace, on an oblong piece of slate, was an ornate carving by sculptor Jonah Jones of a quotation from the Book of Psalms: 'Fel y brefa yr hydd am yr afonydd dyfroedd, felly yr hiraetha fy enaid amdanat ti, O Dduw' ('As the hart panteth after the water-brooks, so longeth my soul after thee O God').

Kyffin receiving another of his many honours

Also in the living room, on the cwpwrdd tridarn, was a glorious bust by Ivor Roberts-Jones of Yehudi Menuhin in bronze, which Kyffin bequeathed to the National Library to be exhibited at the Tabernacl Art Centre in Machynlleth, in accordance with Kyffin's wish.

The walls were covered by various works of art: paintings by Kyffin's great-grandmother Frances Williams, an inherited painting of St John by Ricci, and a linocut of black cattle by Kyffin himself, which he was very fond of. One bookcase held examples of leather-bound editions of Kyffin's books, and Gregynog Press publications which Kyffin had illustrated. Leaning against the walls at various times were paintings in transit by Kyffin's fellow artists, people like Donald Macintyre and Keith Andrew. The room was an inspirational creative emporium with Kyffin at its centre.

Upstairs, there were three bedrooms and a bathroom. Kyffin used one room himself, kept one spare room for guests, while the third, with two single beds, was used to stock his many prints. Certain visitors would be welcomed to that room to select their preferred signed print.

Kyffin's diaries for the Pwllfanogl years bear testimony to his endless commitments at this time. He was always very exact where time was concerned and would often arrange to have lunch at 1pm at his local Penrhos Arms, inviting his visitor or visitors to arrive at the house by 12.40pm before proceeding to the Penrhos at Llanfair P.G. In 1970, he was elected associate of the Royal Academy, becoming a member in 1974, an honour Kyffin considered the greatest honour of all. In 1978, he received an honorary MA from the University of Wales. In 1983, he was appointed OBE and in 1987 he became Deputy-Lieutenant of Gwynedd. Honorary fellowships at the University of Wales, Swansea, and Aberystwyth followed. In 1992, he became president of the Royal Cambrian Academy of Art for the second time. Kyffin gave the Royal Cambrian sterling service. He was an inspirational president. He also made a valuable contribution to the North Wales Association of the Arts, chairing one of its committees (the European Architectural Heritage Year Committee 1975) and delivering lectures on behalf of the association.

He became a member of the National Museum Arts Advisory Committee and was a member of the Court of Governors of the National Library of Wales. Kyffin had extensive involvement with Oriel Ynys Môn in Llangefni and was deeply concerned and involved with its development. In 1991 he was awarded the Medal of the Honourable Society of Cymmrodorion, and in 1995 the MOMA Machynlleth Glyndŵr Award for outstanding contribution to the arts in Wales.

In 1999, Kyffin was honoured with a highly deserved knighthood by Her Majesty the

Queen for services to the arts. His many admirers and fans worldwide rejoiced and Kyffin was delighted: he was now, after all, on a par with Uncle Ralph, his father's relative who was knighted in the nineteenth century, and another Williams of Treffos, the general Sir Guy Williams, as well as Sir Andrew Ramsey who married Kyffin's Aunt Louisa.

When the media broke the news of Kyffin's knighthood, few people realised what a struggle it had been to gain such an honour for him. But Sir Meurig Rees of Tywyn, Merioneth/Gwynedd was a determined man. Sir Meurig was Lord Lieutenant of Gwynedd between 1989 and 1999 and chairman of the Royal Welsh Agricultural Society with a deep interest in the arts, in social matters, and in the cultural affairs of Wales. With his passionate belief that Kyffin should be honoured, he was the man who led the campaign which was to lead to the 'six crempog boy' becoming a knight of the realm.

Sir Meurig reminisced in 2011 that it took a concerted effort over a three-year period for him to achieve his aim. In a final push, support for his nomination of Kyffin was sought from political leaders of all political persuasions: men of the calibre of Richard Livsey, later to become Lord Livsey of Talgarth, one of the pillars of the Liberal Party in Wales; Lord Cledwyn Hughes, a Labour Party stalwart; and another Liberal peer, Lord Hooson of Llanidloes, Powys. During his three-year campaign, with Kyffin's name put forward on an annual basis, Sir Meurig had been aware of resistance to Kyffin being knighted, and that that resistance came from Arts Council quarters in Cardiff – the eternal problem of 'a prophet in his own land'. In later years, Sir Meurig could let it be known to Kyffin how he had won the day and was able to witness at first hand Kyffin's obvious pleasure at the appointment, which gave Sir Meurig great satisfaction. Sir Kyffin Williams RA, artist, and Sir Meurig Rees, farmer, shared a common passion, they both loved the mountains of Wales. One farmed them and the other painted them!

Throughout his Pwllfanogl years, 1973 to 2006, Kyffin produced thousands of paintings and held countless regular exhibitions at the Tegfryn Gallery in Menai Bridge, the Thackeray Gallery in Kensington, London, the Howard Roberts Gallery in Cardiff, and the Albany Gallery also in Cardiff, as well as the Glyn-y-Weddw Gallery in Llanbedrog, Llŷn – not to mention the Royal Academy and other galleries in the United Kingdom. Kyffin's Pwllfanogl years were years of constant work, of public service given and public honours awarded. He took great pride in the knowledge that he was one of the first, if not *the* first, Welsh artist to earn a living by being a professional artist in Wales.

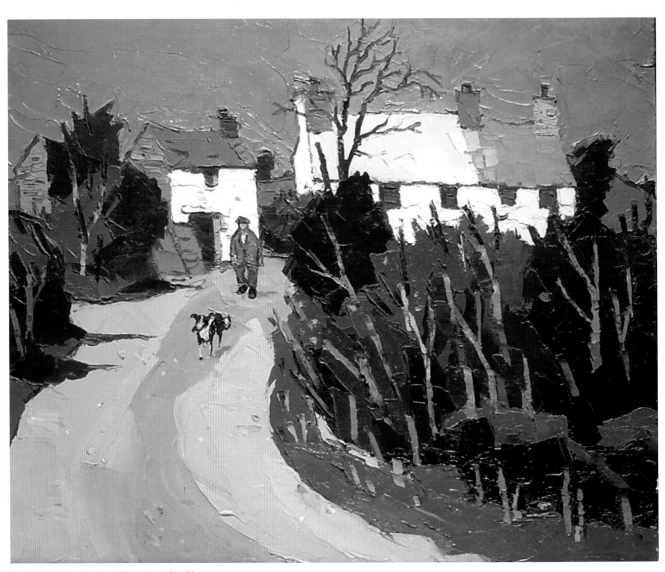

Iconic Kyffin painting, *Tangraig, Llanddona*

13

Tunnicliffe, Oriel Ynys Môn and Exhibitions

John Smith recalls his deep interest in the work of Charles Tunnicliffe, and his first meeting with Kyffin Williams and their friendship over many years:

WHEN I FIRST VISITED the Tegfryn Gallery in Menai Bridge I met Harry Brown who ran the art gallery with his wife Gwyn (Gwyneth). Harry was a wonderful character who also owned a local garage business in Bangor. He explained that his wife was the artist, mainly specialising in botanical art, and she was the real art enthusiast. I got on particularly well with Harry, probably because we were both interested in engineering. After explaining my interest in the work of wildlife artist Charles Tunnicliffe, Harry took me behind the exhibition areas and opened an old chest of drawers. At first he fumbled with some crumpled tissue paper that covered what appeared to be black and white illustrations. These I quickly realised were original Tunnicliffe scraperboard illustrations. I could not believe my luck as I examined the incredible art in my hands. This was exactly the material I was looking for: an art form Tunnicliffe had become a master of, and used in such detail in his book *Shorelands Summer Diary*. There were dozens, if not hundreds, of these scraperboards, depicting a plethora of subjects. The quality of the work fascinated me and I apologised to Harry for spending so much time there. He kindly allowed me to visit Tegfryn whenever I wished. As I had studied art at Leamington Spa Art College in the early 1960s, and now intended painting again in Anglesey, I took advantage of his offer.

The Tegfryn was visited several times over the following weeks as I tried to absorb Tunnicliffe's technique and skills. Feeling guilty spending so much time in the gallery, I bought one of the beautiful Tunnicliffe illustrations: a pair of great crested grebes performing their elaborate courtship display, which Tunnicliffe had captured to perfection. After the purchase I crept back to the gallery's back room and its drawer to discover more

Charles Tunnicliffe at Shorleands Studio, Malltraeth

art wonders. Within a couple of minutes I heard a bell ring and Harry greeting someone in a very cheerful tone. I could hear the individual's resonant, mellow voice, which reverberated around the gallery. I heard them chatting about the weather and the exhibition. Feeling I might have outstayed my welcome and, a little curious, I walked out to see Harry with a moustachioed man. Harry introduced us, and my first impression was of a charming Salvador Dali-like character. It was Kyffin Williams. He had come to see Gwyn Brown and to check on his sales, and see how things were going in the exhibition. Kyffin frequently visited the gallery and often parked his car there to go to the bank and shops in town. Harry had earlier brought to my attention one of Kyffin's grand Snowdonian landscapes on display in the gallery. As I stood there being introduced, with a large Kyffin painting in view, I tried to recall any awkward comments I may have made. I glanced at Harry, who returned a perceptive smile. Bidding farewell, I left the gallery and made my way towards Anglesey's west coast to look for wildfowl that Tunnicliffe had so aptly depicted in his illustrations. On one occasion, while bird watching and sketching on Malltraeth Cob, close to Bont Farm's stone gateway, I spotted Tunnicliffe in his car sketching pintail ducks preening in the shallows of Cob Pools. The pintails had perfectly mirrored reflections in the glassy brackish water. The temptation to leave my car and chat to him about the vagaries of bird painting was thwarted by the thought of the pintails suddenly flying off. Revealing this encounter to Kyffin, many years later over lunch, drew a euphemistic response: 'He wasn't a patient man if disturbed, and even less patient if you disturbed his birds.' Kyffin's voice of experience vindicated my moment of hesitation.

After Charles Tunnicliffe's death on 7 February 1979 there was a great deal of concern regarding the wording of his will. Because of its apparently ambiguous nature, and the Tunnicliffe legatees' intention to sell his art collection, Kyffin, Tunnicliffe's friend, consulted with several solicitors he knew in London, 'legal eagles' as he referred to them. These were mainly friends and, in some cases, supportive ex-pupils from Highgate School. Kyffin corresponded with the various solicitors but was unable to resolve the exact terms of Tunnicliffe's will. Kyffin explained that the will stated that his studio collection of measured drawings and sketchbooks should be disposed of as previously discussed with

his sister Dorothy Downes. Dorothy initially sought the advice of Tunnicliffe's friend, Sean Hagerty, on this matter. But even when it was declared by Sean and other friends in affidavits that Tunnicliffe wanted the collection to go to a national institution, there was no response from the Midland Bank, the artist's trustees. Kyffin was disconcerted, and agreed with his friends that the collection should go to the Royal Academy of Art or the National Museum of Wales, but he had no proof to support his claim. The collection was put up for auction by Tunnicliffe's legatees at Christie's on 15 May 1981. Kyffin said later that this case was similar to the Rothko debacle, and emphasised 'how artists should not draw up a will'. Kyffin's loyalty to Tunnicliffe stretched back many years; indeed, he had been the instigator of the major retrospective of Tunnicliffe's work at the Royal Academy of Art (RA) in London in 1974.

Kyffin's friendship was based on genuine respect for Tunnicliffe and his art. After seeing Tunnicliffe's large studio collection of reference work in Malltraeth many times, he considered it should be exhibited at the RA. He attempted to convince Sir Thomas Monnington, President of the RA, and some committee members, of the great significance of Tunnicliffe's studio collection. This approach initially failed but in 1972 Kyffin returned to the RA with a portfolio full of Tunnicliffe's measured drawings and a selection of sketchbooks. These were displayed, for convenience, on the floor of Monnington's office. As Kyffin explained:

> I just placed them around the room and on the floor; I could tell from the first reaction that members of the committee, especially Monnington, were impressed, if not astonished at the beautiful and exquisitely depicted measured drawing studies and sketchbooks.

Kyffin explained Tunnicliffe's detailed technique, commenting that they were accurately drawn to a millimetre. He used a pair of callipers to measure every feather and annotated details on the drawing. Monnington eventually agreed to hold an exhibition of Tunnicliffe's collection of drawings and sketchbooks in the summer of 1974. Kyffin's success at the Royal Academy, on behalf of his friend, was not without its problems. Tunnicliffe was extremely grateful for this lifetime's opportunity but was reluctant to be without his cherished reference collection of art over the summer months. Kyffin understood this, since 'Tunnicliffe worked daily at his painting and drawing, indeed, from dawn to dusk, so he needed his reference material.' Kyffin overcame this dilemma by suggesting that much of the collection should be photographed, so that Tunnicliffe had at least some reference source for his prodigious output of art.

Kyffin realised after the opening of the exhibition, 'Bird Paintings by Charles Tunnicliffe RA' (3 August – 29 September 1974) at the RA Diploma Galleries, that bird art of this magnitude had not been seen in London for many years, perhaps not since John James Audubon arrived in London in 1826 seeking British help to print his *Birds of America*. The ever-modest Tunnicliffe was delighted with the highly successful exhibition of his work, which drew over 20,000 visitors from all around the world. Kyffin mentioned that Axel Amuchastegui was one of the many artists who made their way from distant places to see the exhibition. As Kyffin discovered in conversation, Axel was born in 1921 in Córdoba, Argentina, and was a self-taught artist. He developed a unique technique for his paintings using Chinese inks and watercolours. There is now a tremendous appreciation for Axel's work and he is considered one of the great ornithology illustrators of the twentieth century. He complimented Tunnicliffe on his art and on the superb London exhibition. Kyffin sensed this was a tremendous tribute to Tunnicliffe, and also felt justified himself in having Tunnicliffe's work revealed to the world. For his efforts in arranging the exhibition Tunnicliffe presented Kyffin with a beautiful pochard measured drawing, which he treasured to the end of his life.

After Kyffin's death this particular drawing became part of his bequest (Codicil 17 October 2002) to the National Library of Wales. When questioned about this gift, which he displayed to the right of his front room window, next to a Theodule Ribot still life, he said, 'For organising the exhibition Charles gave me that beautiful drawing of a pochard, which I had actually shot, but I was humbled when Charles presented it to me.' The two artists differed in many ways but Kyffin made it clear that he gained great inspiration from Tunnicliffe's dedication to art. He would often refer to Tunnicliffe's commitment and integrity, emphasising that he was a 'professional friend'.

Some of Kyffin's great empathy for Tunnicliffe's art came from his own love of wildlife. His animal and bird studies drawn on his 1968 Patagonian visit are delightful examples. The drawings he made of the Patagonian guanaco, a small type of llama, are among his very best animal depictions. He was also a knowledgeable ornithologist and probably gained entrance to the Slade in 1941 with his depiction of silhouetted ducks over Llanystumdwy's bleak marshes, painted in the style of Sir Peter Scott. It was Scott who once praised Tunnicliffe as 'the greatest wildlife artist of the twentieth century'. Kyffin also described Tunnicliffe as a 'genius', especially when referring to his post-mortem studies of birds and mammals. He also commended his long and frequently benevolent association with the RSPB and many other charitable organisations. Similarly, and very close to Kyffin's heart, he admired Tunnicliffe as one of the great British draughtsmen. The admiration was mutual.

On 21 October 1977 the much-respected chief executive of Anglesey Borough Council, Peredur Lloyd, a brilliant solicitor, perceptive administrator and keen mountaineer, was killed in a tragic motorcycle accident near Llangefni. His wife, Eleri Lloyd, asked the borough council to commission artwork to commemorate Peredur Lloyd's distinguished and innovative role on the island. Initially Charles Tunnicliffe was contacted, but he declined the commission saying 'Kyffin Williams is the only artist worthy of doing such a painting of the mountains of Wales'. Kyffin, true to Tunnicliffe's words, painted a wonderful oil painting of Lliwedd, Peredur Lloyd's favourite climb, which has been exhibited many times at Oriel Ynys Môn and other venues.

Kyffin's outstanding draughtsmanship and bold impasto painting is easily recognised, and is well liked by mountain enthusiasts as well as art-lovers. Draughtsmanship was a discipline once taught in art schools and colleges and, in Kyffin's mind, was now lost forever. This theme, along with his condemnation of some institutions, such as the Arts

Oriel Ynys Môn staff, 1993 Portraits exhibition

Council of Wales and National Museum of Wales, would become his lifelong mantra. Kyffin was committed to good draughtsmanship and training in art schools and colleges. He wanted artists to leave college able to earn a living, not dependent on 'grants and handouts'. For this he considered he was often dismissed as a 'relic of the past, a dinosaur'. As many of his friends and devotees have claimed, such dismissal denied his true worth, his genuine and supreme commitment to art in Wales. His quest to establish a gallery for Welsh art, probably in Cardiff, was never fulfilled. He desperately wanted to see a home for the best Welsh art from the eighteenth century to 1950, and pointed out repeatedly that 'We are one of the only countries in the world that has not got a gallery for the nation's art.' His politeness never allowed him publicly to reveal the anger he felt toward the art directors and art groups who, to him, appeared to gaze in envy across the border to England and even further to Europe. There were several art groups and artists who were implicated in his public criticism of the situation and he was frequently rebuked for his comments. He was rarely oversensitive, however, to critics' comments on his own work, such as 'Once you've seen one Kyffin you've seen them all'. The art and dance critic, Nigel Gosling once reduced his criticism of Kyffin's solo exhibition at Colnaghi's in the 1950s to three words, 'Herman and Soda', which Kyffin felt was ridiculous because he did not, then, know the artist, Joseph Herman, or indeed his work. A friend at the time mentioned to Kyffin that 'Any publicity is good publicity, especially when given by Nigel Gosling'.

On one occasion a smile came to Kyffin's face when he quoted from a 2002 paper given at Gregynog by the artist and author Iwan Bala:

> The paintings of Kyffin Williams are undoubtedly the equivalents of male voice choirs; they are iconic and accepted as such in Wales and outside, but as landscape paintings, as art, they have been stuck in the same groove since 1950.

Kyffin commented that this kind of comment had little validity as such writers were limited in their comprehension of his range of work, particularly his drawings, oil paintings, linocuts and illustrative work. He also cited his own ability to adjust, with considerable subtlety, to a variety of subject matter and media, as seen in his Patagonian and Venice studies.

Kyffin's own persistent railing against individuals and the art establishment was an integral part of his make up, an expression of his wonderfully tenacious character. This tenacity could sometimes be used to gauge his state of health or energy levels. If he had been dwelling on a particular subject, one could guarantee that he had read up on the

matter. Once he had given voice to his concern, usually with friends and colleagues, his tone would mellow and interesting conversation about art and other subjects would follow.

One issue which Kyffin came out strongly against was the implementation of the 1960 Coldstream Report which, to him, seemed to deny the principle of good drawing skills as being essential to sculpture, design and painting. To him this was sacrilege and he would oppose it for the rest of his life. He perceived that the implementation of this report had massive implications for art education, in particular for the relationship of studio practice to art history and theory. Kyffin was in many ways a sensitive and shy person but, as many friends can confirm, a vociferous voice gained momentum when he was challenged on his profound belief in 'good art education'.

When Kyffin and Tunnicliffe first met in the early 1950s they got on very well together, especially with regard to their beliefs in the merits of good art. They were both brilliant artists but they were also both great storytellers. Tunnicliffe, after one of Kyffin's anecdotes, would always say 'No, no Kyffin…get away with you', in a deliberately broad Cheshire accent. They would then both burst into laughter. They could also be serious, however, and were in agreement when it came to the belief that students of art should be taught the basics of drawing. Kyffin felt these essential skills enabled artists to interpret their feelings with confidence, and with greater comprehension of their subject matter. The two had struggled to establish their own names in the art world and, understandably, had empathy with young artists who were in a similar position. No budding artist or art enthusiast was ever turned away from Tunnicliffe or Kyffin's door, as the Welsh artist and illustrator, Jac Jones, remembers after visiting Tunnicliffe at his studio as a young man. Tunnicliffe recognised his abilities and encouraged him to attend Liverpool College of Art, as well as emphasising the advantages of draughtsmanship to him. Similarly, Kyffin, if asked, was always keen to help, advise and encourage young artists or indeed anyone who approached him. One day at Pwllfanogl, while I was having tea with Kyffin, a knock came at the front door. Kyffin asked me to answer it and standing there, looking rather troubled, was a young man. He explained he was from Beaumaris and had ventured into buying and selling art. In Chester he had bought what he considered to be a 'Kyffin'. He politely asked, 'Would Sir Kyffin be willing to look at the work?' Kyffin overheard this, seated in his red armchair, and invited him in. He carefully examined the watercolour painting and with a grimace immediately declared, 'It's not my work or signature.' There was a deathly silence and an air of gloom descended upon the young man. Slowly, and with sadness in his eyes, he slumped down on the old settee. He seemed to gaze forward

at sculptor Jonah Jones's Welsh version of 'As the heart panteth after the water-brooks, so longeth my soul after thee, O God', carved in slate above Kyffin's hearth. But, in reality, his gaze was much further away. He explained, in a subdued voice, that he had paid nearly £2000 for the fake. While looking at the worthless piece of art he held in his hands, Kyffin ambled upstairs. Within a few minutes he returned and, with a little sigh, sat down by the duped man. He then, methodically, put on his dark-rimmed spectacles and took out a 4b pencil from his jacket pocket. Kyffin was clutching an original watercolour he had retrieved from a bedroom. He began signing the lovely mountain scene with his full signature, and casually handed it to the young man saying, in a dulcet tone, 'Don't be so silly with your money in future.' Kyffin had boundless generosity and kindness, even for an unfortunate stranger. The young man left with probably a considerable profit in his hands, and a less anxious expression on his face, chanting, as he hurried to his car, 'Diolch yn fawr' (Thank you very much).

In the early 1950s Kyffin and Tunnicliffe extended their commitment to art in Anglesey by working together with the Anglesey Arts Society, established under the auspices of Anglesey Rural Community Council (Cyngor Gwlad Môn). The council had its beginnings at the end of World War One, around the time of Kyffin's birth in 1918. It was principally a charitable organisation set up to assist Anglesey's communities in advancing education, including fine arts. This scheme led to annual exhibitions, music festivals and, eventually, in 1964, an Arts Fund. Financial support for these innovative schemes came from local authorities on Anglesey, the Arts Council of Wales and the Gulbenkian Trust. As Kyffin explained, the Anglesey Arts Committee showed considerable initiative and forward thinking at this time in its commitment to purchasing fine art for the island.

Kyffin's friend and fellow artist, Gwilym Prichard, recalled that he first met Kyffin in a 1950s art exhibition organised by the Anglesey Arts Committee, held in Llangefni Town Hall. There were many local artists exhibiting and Gwilym remembered that 'Kyffin and Tunnicliffe were involved in the running of the show'. Gwilym won the bronze prize and his painting was given to Llangefni Secondary School, where he recently rediscovered it. Other works that were purchased were displayed in libraries (Llangefni in particular) and the island's various public buildings. The so called 'Anglesey Art Collection' was the island's modest but embryonic venture into the world of public art. The collection has risen in importance by today, especially as it is housed at Oriel Ynys Môn. The initial collection has grown considerably and contains the work of several famous artists.

Because of his early involvement, Kyffin was always keen to view the collection at Oriel Ynys Môn and, occasionally, to add to it with works of art he purchased himself.

He bought a lovely watercolour painting by his friend Ernest Naish from an exhibition in Oriel Ynys Môn. Unbeknown to Kyffin, Ernest did not really want to sell his work and so priced it high. Luckily the two friends, who had known each other for many years, did not fall out over this. Some of the Anglesey Art Collection paintings purchased by the Arts Committee were: Charles Tunnicliffe, *Heron's Cove* and *Wild Swans at Malltraeth*, George Cockram, *Solitude*, Donald McIntyre, *Rhostryfan*, Gwilym Prichard, *Snow, Llangoed*, Andrew Vicari, *Whitsun Procession at Aberdulais* and Arthur Pritchard, *Mynydd y Garn*. The collection extends now to in excess of one hundred works, and artistically and historically depicts an important period in Anglesey's evolving fine-art culture. There are, for example, several Harry Hughes Williams paintings in the collection. Williams attracted a great deal of interest in the 1940s and early 1950s and was admired by many artists. According to one artist friend from Cheshire, Williams was at times a recluse and shunned publicity. Later on Kyffin, with his growing reputation from the late 1940s, became as well known. There appears, indeed, to have been a Kyffin influence over the art of the island at this time which was loosely termed by some artists as the 'Anglesey School'. Gwilym Prichard disagrees with this idea but concedes that there was a similarity in the past between his own and his brother Arthur's work. He also felt that Tom Gerrard and Kyffin's paintings were a little similar in style. He also recalled the 'North Wales Group' of artists in the 1960s which included Kyffin Williams, Joan Hutt, Tom Gerrard, Elis Gwyn, Roy Ostle, Karel Lek, Arthur Pritchard, Claudia Williams, Donald McIntyre, Jonah Jones, Helen Steinthal and Peter Chadwick. Kyffin and Tunnicliffe were also at this time in regular demand with other charitable functions, particularly as judges at a variety of art venues and competitions.

On one occasion Kyffin and Tunnicliffe were asked to judge the art competition at the 1955 National Eisteddfod in Pwllheli. On arrival, they were joined by a third judge, William McAllister Turner, an artist they knew well from the Chester area. The three artists had a great rapport and a similar empathy for what they considered to be good art. For a while their Eisteddfod art-judging skills and lengthy deliberations went well, but they just could not decide who should receive the first prize. They pondered for what seemed an age until, as Kyffin put it 'We were sacked by the Eisteddfod officials'. Instead of finding this embarrassing, especially as another Eisteddfod official, a referee, had to make the final decision, they found it quite amusing. The eventual outcome was that the Gold Medal for Fine Art was awarded to D. C. Roberts. Kyffin adjudicated at the National Eisteddfod from 1955 to 1989. He also continued to comment on the changing direction of Eisteddfod art. He found the Eisteddfod's 2005 award for the fine-art medal

particularly galling, with its video of individuals in combat fatigues burning a garden shed. Kyffin received much support from people in Wales and further afield when he commented, '...it's like awarding the championship in the Welsh Black cattle class to a sheep'. The Turner Prize also drew sardonic comments from him. He was particularly impressed with Welsh Minister, Kim Howells, when he remarked that the Turner Prize was 'cold, mechanical, conceptual bull'. Howells said in 2011, 'I have always admired Kyffin's work, mainly for its superb depiction of the Welsh mountains. The technique, using a palette knife, is unusual, and fascinating at the same time.'

Kyffin and Tunnicliffe maintained their friendship over the years and would meet up in the 1960s at the annual Cyngor Gwlad Môn Art Committee functions at the Bull Hotel in Llangefni. They would both socialise with other Anglesey artists including Sean Hagerty, his wife Tilda, Arthur Pritchard, and his brother Gwilym Prichard and his wife Claudia Williams, as well as many other art enthusiasts and friends. Kyffin would also see Gwilym and Claudia at their parties at Rhos Cottage near Llangoed. Kyffin was usually the life and soul of these parties with his tremendous energy and repartee, but always without drink. He occasionally escorted Gwyn Brown to 'very pleasant' dinners at Rhos Cottage in the late 1960s. Prior to this Gwilym and Claudia lived in Old Bank House in Beaumaris, where hilarious games of charades would involve Kyffin playing Cleopatra, draped in an old lace curtain and with Gwilym acting as Antony. The 'conquest of Everest' was also a theme, and one can well imagine Kyffin and Gwilym's portrayal of Sherpa Tensing and Sir Edmund Hillary at the summit. Claudia felt Kyffin was a remarkable person, commenting that 'He was always the same, warm and welcoming and encouraging us in our work'. Gwilym likewise noted that 'Kyffin was very supportive as an artist friend. The period during the 1950s, when I was teaching in Llangefni, was a tough time, particularly as an artist'. Claudia, praising Kyffin, added 'What a man! We were so fortunate to have him as a friend.'

Llion Williams, John Clifford Jones and Leslie Jones were also good friends and gave Kyffin professional support, advice and friendship over many years. They would often be seen together at exhibitions, where Kyffin would lambast the art world. He relished reading the art magazine *Jackdaw*, with its irreverence for those in the upper echelons of the art world. There was often a mischievous air to his conversation with friends, invariably followed by laughter.

One close friend recalled Kyffin's encounter with a rather loquacious lady at Pwllfanogl. Seated in Kyffin's front room on the old settee and with Kyffin ensconced in his red armchair, the lady started to talk on a 'rather tedious topic' and in a 'very persistent

manner'. She continued talking for a long time until Kyffin, in utter despair, felt he could only escape her verbal onslaught by feigning illness. His thespian efforts proved absolutely worthless, however, as she was so absorbed in her own monologue that she missed the performance.

At his gatherings at the RA he was supported by friends and former Slade-trained artists, Diana Armfield and her husband, Bernard Dunstan. Bernard was instrumental in Kyffin becoming an ARA in 1970, leading to his acceptance as an RA in 1974. He also had a wonderful friendship with Slade artist Margaret Thomas, a lyrical painter, essentially in the English tradition and without pretentiousness, who lived near Kyffin in Highgate. Kyffin would sometimes take his large palette when it became heavily laden with dried oil paint to Margaret, and her father would burn the paint off with a blowlamp. Arriving at her house in Highgate, Kyffin would complain, 'It's breaking my arm!' Margaret also painted a lovely portrait of Kyffin in his famous yellow waistcoat which, with great delight, he had purchased from Brynkir Woollen Mill.

Artists Diana Armfield and Bernard Dunstan

One character Kyffin particularly liked at the RA was Roland Vivian Pitchforth. He served in the Wakefield Battery, Royal Garrison Artillery, in World War One, and was profoundly deaf through repeated exposure to artillery fire. Kyffin was good with Pitchforth, whom he endearingly referred to as 'Old Pitch'. He had a wonderful shock of white hair and Kyffin often sat with him at RA functions, where they would communicate with notes written on a pad. Kyffin, with his sense of humour, would often write a wry comment about one of the guests or a speaker. On one occasion, when Sir Thomas Monnington PRA was making an address, 'Old Pitch' wrote, 'What's he saying Kyffin?' Rather unwisely, Kyffin quickly scribbled, 'Rubbish!' Pitchforth's loud vocal response, at a hushed moment, was 'Bloody fool!' Kyffin cringed with embarrassment as the whole room appeared to glower in their direction. At a later time, Kyffin invited Pitchforth to Anglesey for a holiday with him. Pitchforth also knew Tunnicliffe who was an old friend from his days at the Royal College of Art (RCA). Tunnicliffe and

Pitchforth, along with fellow 'northerners' Henry Moore, Barbara Hepworth, Raymond Coxon and his wife Edna Ginesi, and 'southerners', Edward Bawden, Percy Horton and Edward Burra, exhibited at the Redfern Gallery. Kyffin knew Raymond Coxon and his wife Edna through Tunnicliffe.

Kyffin made arrangements to take Pitchforth to meet Tunnicliffe at his house, Shorelands, Malltraeth. They arrived rather early and were a little taken aback when a straight-talking Tunnicliffe told them to 'Clear off!' Tunnicliffe added, 'Go and take a walk around the Cefni estuary, there are plenty of birds there to see.' On their return to Shorelands, at the appointed time, Tunnicliffe was amiable but remonstrated with them for almost ruining a watercolour wash he had been applying to a painting, adding that 'Being artists you should have known better than arriving too early for an appointment.' Afterwards they all saw the funny side of this and over tea they discussed the early years at the RCA. They spoke of John Piper, Tunnicliffe's friend at the college, who was always avoiding his art classes and eventually dropped out of the RCA altogether. Piper was from a wealthy family but, nevertheless, Tunnicliffe was able to encourage him to enrol in night classes and to achieve some of his ambitions as an artist. Kyffin also discussed Tunnicliffe and Pitchforth's good friend, Eric Ravilious, and his wonderful wood engravings, as well as his premature death as an official war artist in Iceland in 1941. Tunnicliffe explained to Kyffin and Pitchforth that he shared lodgings with Ravilious in Earls Court. One night Tunnicliffe thought there was an intruder in his room. He got up stealthily from his bed with a heavy object in his hand. He then stumbled around in the pitch-dark bedroom only to find a roll of tracing paper on top of the wardrobe flapping in a draft. This discovery was much to Ravilious' relief, as he thought he was going to be the recipient of the heavy object. One can imagine the level of good humour that took place between Kyffin, Tunnicliffe and Pitchforth, three of Britain's outstanding artists.

Another important artist mentioned by Kyffin was Sir William Rothenstein (1872-1945). He was the principal at the Royal College of Art in the early 1920s when Tunnicliffe and Pitchforth were students there. Rothenstein was a prolific painter, influenced by Degas' compositional arrangements and by Whistler's subdued palette and figure style. Tunnicliffe and Pitchforth occasionally attended Sunday evening soirées at Rothenstein's London home in 13, Arlie Gardens, W8. It was here that William Butler Yeats (1865-1939) and many of London's most recognized artists and literati often gathered to discuss the conundrums of the art world. Kyffin recalled that Rothenstein had studied at the Slade under Alphonse Legros and at the Académie Julian in Paris. He was a fine portrait painter who regarded 'pure abstract art' as a 'cardinal heresy'.

Rothenstein was a northerner who, much to Tunnicliffe's delight, pronounced Yorkshire as 'Yarkshire'. Clearly much of the conversation at Shorelands fell in line with Kyffin's own deeply held beliefs about art.

Kyffin relished recounting all this with Tunnicliffe and Pitchforth, and listening to their anecdotes. Kyffin himself was a superb mimic and would imitate Tunnicliffe's Cheshire accent, reciting part of his 1954 inaugural speech as a Royal Academician when he stated, 'I much prefer the birds and flowers of Anglesey to those of Piccadilly.' This drew roars of laughter, not only from the Royal Academicians present at the function, but also from Kyffin himself as he later regaled friends with this anecdote. Kyffin also realised, perceptively, how serious Tunnicliffe was about art and how serious he should be about his own work. Towards the end of his life, and in frustration with the fatiguing and pernicious effects of his cancer, which he referred to as 'Old Bogey', he again mimicked Tunnicliffe, who had died in 1979, with 'I've done me whack'. Indeed, both artists by the end had done more than their whack!

In 1981, three years after Tunnicliffe's death, his superb reference collection of art was put on display at Christie's in London in preparation for their auction on Friday, 15 May. The collection of measured drawings and sketchbooks was estimated at £1.5 million, and a copy of Christie's well-illustrated auction catalogue, which was in great demand, was secured. About this time I often stopped at Athen Studio in Llannerch-y-medd, and discussed the pending auction of Tunnicliffe's work with the owner, artist Keith Andrew and Tony, his brother. Keith also had on display a number of Kyffin's prints, notably a wonderful Welsh Black linocut with a bright green spread of grass highlighting the dense black cattle. Over tea, we expressed our concern for the future of the Tunnicliffe art collection. Keith had great empathy with Tunnicliffe's work as he was himself a successful watercolourist and printmaker. Some of Tunnicliffe's works had remained on Anglesey for over thirty-three years but would now be auctioned at Christie's and possibly dispersed around the world. Keith had discussed the matter several times with Kyffin who occasionally called by and who was equally concerned as to the outcome. After many discussions at Athen Studio, and much support from Keith and Tony, I approached my employer at the time, Shell UK Oil, seeking financial support to make a purchase. Their representatives, Sior Hughes and Blair McDowell, said the company would be interested, and suggested that £75,000 could possibly be made available. Clearly this was not enough by itself as the collection was valued at £1.5 million by Christie's. I also petitioned the island's MP, Keith Best, who raised the by now national topic of Tunnicliffe's collection at Prime Minister Margaret Thatcher's questions in the House of Commons on 9 April

1981. Nicholas Edwards, Secretary of State for Wales, responded on behalf of the Prime Minister:

> I have received a number of representations both from individuals and national bodies expressing deep concern at the prospect that this important collection could be dispersed. I share this concern and hope that discussions currently taking place with the interested bodies will lead to a satisfactory outcome.

Nicholas Edwards, however, could give no assistance or assurances. I continued to muster support from many influential individuals and even contacted Sir David Attenborough at his London home, but he appeared to be in favour of the auction going ahead, as he knew many people who were keen to acquire Tunnicliffe's work including, apparently, royalty. With limited time left I approached local councillor, Elwyn Schofield of Anglesey Borough Council, hoping that there might possibly be an outright purchase of the collection by the authority before the auction took place. Anglesey Borough Council had a fund of several million pounds accrued from revenues paid by Shell UK Oil for its operations on the island. Six councillors, a quorum, were asked to meet Chief Executive, Leon Gibson, to convene an emergency council meeting. The proposal to purchase Tunnicliffe's work was supported by a majority of councillors, particularly: Elwyn Schofield, John Gwynedd Jones, Ronnie Madoc Jones, John Meirion Davies, Keith Evans, John Smith and John Victor Owen. Support also came from Councillor Meurig Hughes, a long-time advocate of the arts in Anglesey. Leon Gibson then approached Christie's with the view to purchasing the collection through the Acceptance in Lieu (AiL) tax scheme, which allows people to offer items of cultural and historical importance to the state in full or part payment of their inheritance tax, capital transfer tax or estate duty.

After intense negotiations, the collection was eventually purchased as a 'private treaty bid' for approximately £400,000. With the special tax adjustments and support from the island's Oil Revenue Fund (Shell) of £183,432, as well as a grant of £100,000 from the National Heritage Memorial Fund, £100,000 from the Victoria and Albert Museum, a members' donation of £16,518 from the Royal Society for the Protection of Birds, and donations from various companies and individuals, the sum was reduced considerably. This purchase was, according to the national press, 'Anglesey's moment of glory'. At all stages, up to the final purchase, Kyffin was involved, sending a barrage of letters to various newspapers, as well as helping to seek legal confirmation of the validity of Tunnicliffe's will. Kyffin and Lady Anglesey, as well as Lord Cledwyn of Penrhos (a Shell UK external

director), were also consulted at several stages of the acquisition, for their expertise and steadfast support of the arts in Wales.

Kyffin was elated with the outcome to save the Tunnicliffe collection, even with all the problems it had unearthed. Lady Anglesey was equally delighted and enthusiastically organised a grand celebration at Leggatt Brothers' gallery in St James's Street, London SW1. The Mayor of the Isle of Anglesey Borough Council, Councillor Keith Evans, and I were invited to attend the gathering held in the upstairs rooms of the gallery. Sir Hugh Leggatt was also deeply involved in the latter stages of the collection's acquisition through his role with the National Heritage Memorial Fund. The Leggatt family at this time had devoted 160 years to the art business in London, as well as many charitable ventures in the UK. In the crowded St James's upstairs gallery, Kyffin stood close to Geraldine Norman, *The Times* saleroom correspondent, who had supported the saving of the collection. Kyffin said he was enjoying the celebrations and found it a great opportunity to catch up with many old friends. One of these, Nicholas Edwards MP, mentioned his efforts in the House of Commons. Also present was Ian Prestt of the RSPB, whose father-in-law, Reg Wagstaffe, was an eminent zoologist and close friend of Tunnicliffe. Kyffin then approached Keith and me to chat about the acquisition. The party went on well into the evening with all the guests thoroughly enjoying themselves. Keith and I thanked our hosts, Sir Hugh Leggatt and Lady Anglesey, and after bidding farewell to Kyffin, we travelled back to our hotel. As we passed through Trafalgar Square Keith commented 'What a proud day for Anglesey'. Later on, in Pwllfanogl, Kyffin presented me with an inscribed thank you copy of his autobiography *Across the Straits*.

The time had now arrived for the Tunnicliffe collection to be cared for in Anglesey. A small part of it was displayed at the Llangefni Library (Oriel Môn) in August and September 1981, while two further exhibitions, selected from Tunnicliffe's measured drawings, took place at the National Museum of Wales, Oriel Eryri, Llanberis, between 14 June and 12 September. In 1982 Anglesey Borough Council employed Denise Black as the Curator of the Tunnicliffe Collection. Denise had previously worked in the museums and arts field at Scunthorpe. During the period from the acquisition in 1981 until Denise Black's appointment, the Tunnicliffe Collection had been cared for by Mary Axon at the National Museum of Wales, Cardiff. Not long after the acquisition, Kyffin became concerned that a new Anglesey gallery to display Tunnicliffe's work, as stipulated in the terms of the V & A and other grants, would not be built. He intimated to Denise Black that he would like to give a number of his paintings to the proposed gallery. When he was eventually satisfied that the gallery would be built he gave, in 1987, some fine examples

of his own work, and *Storm, Trearddur* was purchased. Denise Black now recognised that Anglesey's collection of Tunnicliffe's art would be significantly improved by further additions of work by Kyffin and other Anglesey artists, and set about achieving this.

I was employed, after leaving Shell UK in 1990, by Anglesey Borough Council, and started work with the new Arts Section team, with Denise Black and Dr Kath Davies, based initially in Plas Arthur, Llangefni. We monitored the building of the new gallery, Oriel Ynys Môn, Rhosmeirch, to house Tunnicliffe and Kyffin's art, as well as other Anglesey collections. The project architects were Alex Gordon and Partnership of Cardiff who, by way of recommendation, had completed significant new additions to the National Museum of Wales in Cardiff. As the building of Oriel Ynys Môn neared completion in mid-1991, the process of employing and training staff, and organising an exhibitions programme was well under way. Kyffin was at this time acquainted with the new gallery design and in regular contact with Denise and the team. He continued to make significant donations of drawings and paintings to Anglesey's by now burgeoning collections.

The first exhibition to be held at the completed gallery was of Tunnicliffe's work, and this was on display when Her Majesty the Queen officially opened the gallery on 25 October 1991. Denise escorted the Queen and her entourage around the heritage section, as the guests patiently awaited their arrival in the main art gallery. The guests I particularly remember at the opening were coxswain, Richard 'Dic' Evans, RNLI receiver of the Gold Medal and Bar for bravery, and his mechanic, Evan Owen, receiver of the RNLI Silver Medal for bravery. They were introduced to Her Majesty appropriately standing near the Royal Charter display. The Queen immediately recognised Richard, as they greeted each other with broad smiles. Richard had previously been invited to Buckingham Palace for the award of the Silver Medal for gallantry at sea. He had also appeared on *This is Your Life* and was by now a British household name. Kyffin used to visit Dic at his home in Moelfre, where they talked about the old days when Kyffin's great-grandfather, James Williams, started a lifeboat service in Cemlyn in 1828, which evolved into the RNLI in Anglesey in 1882. The Queen was then escorted by Denise and the Mayor, Councillor Goronwy Parry, through to the main assemblage of over two hundred guests and dignitaries. The Queen was first introduced to Kyffin who, giving a deep bow, was also greeted with an approving smile. They chatted for a while, and when I asked him later what Her Majesty had said, he replied, 'Oh, she just asked how I was, and what a lovely gallery.' After the formal speeches the Queen was introduced to the gallery staff in the reception area. She had officially asked for former Buckingham

Palace housekeeper, Miss Ann Jones, who lived in Maes y Dref, Llangefni, to be at the presentation. The Queen asked Miss Jones how she was keeping and then informed her that 'The Queen Mother is in good health, although a little frail', followed with 'She sends her regards, I'll tell her I've seen you.' With all the official ceremonies completed a great celebration then followed. Kyffin appears to have thoroughly enjoyed the day and was more relaxed and comfortable in the presence of royalty than most of the attendees.

Kyffin continued to keep in touch with the gallery staff and Denise, who later married Meredith Morris. The next exhibition was by the artist Keith Andrew, which ran from the beginning of November to 22 December 1991. This exhibition's private view was a great success, especially with Kyffin and an array of guests and artists attending the new gallery. Kyffin appeared to love these events if he was in good health. At times, however, he had to forego some of his commitments because he felt ill. This was a complex situation which was occasionally misconstrued by some as Kyffin being petulant. This was far from the truth as Kyffin frequently had premonitions of petit mal attacks. He rarely made people aware of this dilemma, however, and often merely said, 'I think I'm coming down with a touch of flu.' On one occasion he attended an exhibition opening at the Oriel Ynys Môn and I noticed he was unwell. As the evening progressed I realised he had disappeared, and went to my office where he had kept his coat. I found a note neatly written on a scrap of paper: 'John, not well, have gone home, will be better in the morning. Kyffin.'

Kyffin tried to explain the problem: 'My premonition [of petit mal] is like an aura that affects me badly.' Denise Morris by this time had gained great respect for Kyffin, but also had great sympathy for him when he had to leave the gallery alone after evening functions, particularly if he appeared unwell. He could often look a sad figure, especially when he had rings under his normally twinkling eyes and his moustache appeared to droop even more than usual. He often developed his moustache to a military standard, then, for some unknown reason, just trimmed it right back. He must have been in fine fettle when he left for Patagonia in 1968 as his moustache was bristling on his passport photograph, where he looked like a gringo bandido. These changes may have been linked with his state of health and how he was feeling emotionally.

His level of confidence appeared to fluctuate as is often indicated in his many self-portraits. In some of these he stands almost iconic and bold, looking directly from the canvas; in others he stands hesitant and almost forlorn. I understood that he had suffered these unpredictable problems for many years, even in London, but that did not make it any easier to accept as he wandered from functions at Oriel Ynys Môn to his lonely Pwllfanogl sanctuary. By now the Oriel's collection of Kyffin's work was steadily increasing and

Denise Morris and the team made plans to have an exhibition of his magnificent portrait paintings in 1993 (as detailed in the next chapter).

In many ways, however, Kyffin's second major retrospective, 'Landscapes', at Oriel Ynys Môn in 1995, involved an even greater input from Denise Morris and her team. It took many months to organise this ground-breaking exhibition, and when the landscape paintings were eventually collected and delivered to the gallery for the 'hang', the range of Kyffin's work was astounding. It had previously been agreed with Kyffin that each work would have plenty of wall space. This would allow the viewer to absorb the paintings better. To comply with this, and give the team a clear insight into the layout of the gallery, I was asked to produce a plan. I opted to make a model of the various proposals and presented this at an exhibition meeting. Kyffin was amused that I had not only made a model of the gallery but also scale watercolour miniatures of each of his landscapes. In jest I offered to sign these for Kyffin, which drew a humorous response. On the day of the exhibition layout, Kyffin arrived early and in a lively mood. His large landscapes were brought in one by one with great reverence by staff and placed in appropriate positions. This was quite a long process and, after a while, as more works entered the space it was realised that the planned hang and spacing was going astray. Kyffin had requested more and more works for the exhibition and he himself appeared to arrive almost daily during the preparations with new examples. There were too many paintings but with careful adjustments most of them were fitted in, much to Kyffin and the public's delight.

The morning after the hang I arrived at the gallery to find Kyffin attending to one of his paintings. He had his red handkerchief in his hand and, with copious amounts of spit, was cleaning a large landscape. I tried to show concern, with obvious reluctance, but with a smile on his face and twinkle in his eye he said, 'I painted it, and can do what I like with it.' Unbeknown to Kyffin and me at the time, this technique, but with a cotton bud rather than a handkerchief, has become a standard practice with museum conservators for removing dirt from oil paintings. On another occasion, when he was checking some of his watercolour drawings, I caught him surreptitiously scratching a tiny amount of paint from the roof line of an old farmhouse. The miniscule alteration added a glint of light to the silhouetted apex of the roof. The effect was incredible, giving the painting a new and improved dimension. This confirmed his exceptionally skilled artistic eye. He often wanted to change paintings, especially his early works, as many artists do. But if they belonged to a gallery or organisation, it became problematic. He would often contact the National Museum of Wales, and ask if he could exchange paintings they owned for his later works. He considered his later work to be of better quality and more representative

of his style. The many tactful replies he received rejecting his proposals puzzled him greatly. He recollected, possibly as a means of justification, that:

> At Shrewsbury School I went in for an art competition and I won the first prize. I thought I was the only boy who went in for the prize, and the prize was awarded by the headmaster's wife, and she was some sort of relation, so I didn't take it all very seriously. But later on I learned that the Keeper of Art in the National Museum of Wales, with whom I didn't really get on, I never knew why…had also gone in for this prize and I had beaten him with my landscape watercolour.

The keeper was Robert 'Rollo' Lonsdale Charles who was born in 1916 and did indeed go to Shrewsbury School, and later to Corpus Christi, Oxford. He died prematurely in 1977 in London at 60 years of age. Clearly, Kyffin appeared unaware of an art gallery's remit to protect collections and preserve the chronology of an artist's output. This was a dilemma for gallery directors who, understandably, with Kyffin's standing in the art world, had to employ considerable diplomacy and tact. The clash with keepers of art was also linked with Kyffin's unrelenting desire to have a special gallery for Welsh art in Cardiff. He claimed he had made a request for a gallery but Rollo Charles, his alleged adversary, was equally unrelenting and replied with 'Never as long as I am Keeper will there ever be a room in the museum for Welsh art.' Kyffin claimed he tried for over thirty years to convince the National Museum of Wales (NMW) of the necessity for a gallery dedicated to Welsh art. He considered his efforts were in vain but conceded that it was possibly due to other influential people in Wales not emphasising the importance of this quest. He also considered that the 'main reason is that the people of Wales are interested in music, they're interested in literature, but they haven't an interest in art. And the only way they could become knowledgeable about Welsh art was if there was a room with all the Welsh artists of the past in it.'

Kyffin's disdain for those individuals who were opposed to a specific gallery for Welsh art also included Dr Peter Cannon-Brookes, and Timothy Stevens, described by Kyffin as 'a very nice man' until it was revealed that he said 'Not over my dead body will there be a room for Welsh art.' Kyffin was also critical of the NMW Arts Committee, even though he was a member himself at one stage. His concern was that until a qualified Welsh keeper of art was in post at the NMW there would be no room dedicated to Welsh art. On one occasion an Art Committee member, the art critic, William Feaver, asked Kyffin, 'Why on earth should there be a gallery for Welsh art?' This encounter made Kyffin angry,

but thinking better of the situation, he commented later, 'I changed the conversation eventually or I would have said something I shouldn't have said.' This was probably a wise decision, as Feaver was an experienced and well-respected art critic for *The Observer* who had been widely published. His catholicity of art interests left his readers knowing exactly where he stood, and he was firmly convinced that 'Art should be about the way we live. It should reflect our lives.' Nevertheless, Kyffin had the last word, albeit in private:

> I was damned livid because he knows nothing about Welsh art, nothing at all, or Wales. I am told that if I wrote a letter to the *Western Mail* the response of pouring vitriol on the museum would be intense, but as the museum has had such a terrible time over the purchase of the Rubens works, and it's got into very bad odour, I wouldn't dream of doing that, because after all it would be worse than having no room for Welsh art.

As can be seen, Kyffin had much on his mind at this time and his criticism of aspects of the art world continued. He would expound on these themes sometimes when visiting Oriel Ynys Môn. He was highly motivated when it came to art but always with Wales in mind. A great deal of what he had to say on first meeting him was critical of the 'art establishment' and its alleged mishandling of art in Wales. After these initial outbursts, he would appear to calm down and talk about everyday affairs. Kyffin was delightful company, especially when he expressed his strong views on art during a meal. If Denise Morris and I sat outside the Oriel for lunch with him in fine weather, he would always fetch his sunglasses from his car. This allowed him to concentrate more, as he was very sensitive to bright sunlight, which he explained was exacerbated in the past by his drug treatment for epilepsy.

On another occasion during his 'Landscapes' exhibition, Kyffin sat at his favourite table in the gallery café. He preferred this corner location as it was a little out of sight of the entrance area and less likely to incur intrusions from his many fans. One day Kyffin and I were about to start our meal when a lady who had purchased a copy of Kyffin's *Portraits* book from the gallery shop approached our table. Kyffin was just savouring a spoonful of soup when suddenly the lady thrust *Portraits* under his nose and asked him to sign it. I felt a little anxious but Kyffin calmly put his spoon down and duly signed and inscribed the book. He was still smiling when I asked him, 'Didn't you find that rude?' 'No, not at all', was his reply. He conceded it was inconvenient at times but he felt indebted to the people who bought his work.

The 1995 'Landscapes' Exhibition drew in many people and was again one of the gallery's most popular exhibitions. Visitors were always keen to see the location a painting depicted, and where to find it. We kept an array of detailed maps at the gallery to assist visitors. There were fifty-nine large paintings in the exhibition which included, from the National Library of Wales, *Snowdon from Ty Obry, Llyn Cau and Farmers, Cloud over Crib Goch* and *Farmers on Glyder Fach*. The National Museum of Wales loaned their superb *Farmers on the Carneddau*. Two government paintings, from the Welsh Office, were also included, *Fachwen, Winter* and *Farm below Crib Goch*. HTV kindly loaned their *Waterfall, Cwm Glas* and University College, Swansea assisted with their *Snow, Penrhyn Du* and *Spring Snow, Cwm Dyli*. Together with many other landscapes and Oriel Ynys Môn's *Storm, Trearddur* and *Snowstorm, Penmon*, there were plenty of places where Kyffin had painted for people to investigate.

Occasionally, I find time to go to these locations myself, sometimes with friends, to see how Kyffin gathered painting information. He explained that, like most artists in their early years, he would undertake quite detailed sketching and painting at a location. However, he not only found this inconvenient in inclement weather, but also that it constrained his ideas back in the studio. His relative impatience to get on with his studio painting was sometimes frustrated by the detail in his sketchbooks. His father, Henry, always accused him of being impatient, asking 'Why do you always go bang at everything?' Kyffin discovered that the spontaneity and beauty of a sketch could be totally ruined in the ambitious attempt at its enlargement in the studio. Gradually, he started to sketch in a quick, simple, and efficient manner in the field, still acquiring enough information to work up a painting in the studio. Watching him sketch a landscape was a delight. He would take up a wide stance for stability, and with his sketch pad resting on his left hand and arm, he would start drawing. He would, sometimes, while standing and leaning against a wall, cross one leg high above his knee, and use this as an improvised easel. Invariably he wore, for protection from the wind and rain, a stout raincoat and a cap which gave him a characteristic look. Once he had started sketching his head remained fixed in the subject's direction, just moving up and down enough to gather the essential features. He made rapid strokes with his 4b or 6b pencils, just enough to delineate the main subject matter, be it mountains, waterfalls or cottages. His line was always true and varied in width to produce a wonderful effect. His pencil infrequently left the paper, so as not to break the eye, mind and hand co-ordination. He spoke of 'interpretation' and 'lost and found' in his drawing. He occasionally gave tips on watercolour and drawing. He explained that to make a man look heavy, one needed to draw a darker line under his

boot. His shading, or hatching, was done very rapidly indeed, but his use of soft pencil was always efficient and effective. He sometimes put in a wash of colour but this was usually done in the studio. His friend Morys Cemlyn-Jones, who went on holiday with Kyffin several times, was always fascinated when Kyffin used his own saliva to dissolve watercolour paints. Kyffin explained that it was convenient as he did not always carry water around. He also claimed that the enzymes in the spit benefitted the paint.

Kyffin attended the September 1999 opening of Swtan, the seventeenth-century cottage which was reconstructed by the National Trust with support from Anglesey County Council, and leased to Cyfeillion Swtan (Friends of Swtan, formed 1998) as a visitor attraction. He had given the project much support and made a speech at the opening ceremony's large gathering. Kyffin had visited the cottage with his father in the 1920s. After the opening ceremony, in bright sunshine, when nearly everyone had left, he looked around to see how much Swtan had changed. Clearly he was reminiscing as he studied the renovated building with its pristine white-limed walls and immaculate thatched roof. On his previous visits he had noted that the straw thatched roof was lined, for additional insulation and protection, with gorse.

As I stood with him he took out his sketch book and instinctively started drawing the thatched building. He worked rapidly and drew the cottage from the seaward side. This view was chosen because the sun would not be directly on his pad. Swtan was in shade from this angle but at least there was no glare to affect his eyes. There was an endearing rhythm to his work that fascinated me. I tried to photograph him but was entranced by his rhythmical movements and total concentration. Within a few minutes he had almost finished his sketch. He broke off from his task to recall an oil painting he had done many years before of Swtan, now in the collection of Oriel Ynys Môn, where he had missed out painting one of the old cottage's chimneys. He used the word 'curious' several times in response to this lapse. I am sure he would have painted the chimney in at Oriel Ynys Môn, given half a chance. As he finished his drawing he was able to talk in a more relaxed manner about his visits to the cottage as a child, and how he had listened to Hugh Jones, Swtan's owner. Kyffin described how 'Old Hugh' would sit by the blazing 'simne fawr' (large open fireplace), stroking his long steel-grey beard, delighting Kyffin with the stories about the Roman General, Gaius Suetonius Paulinus. Hugh claimed the general attacked Anglesey in AD61 from Porth Swtan's beach in a rearguard action.

This attack took place at the same time as Roman troops assailed massed Druid soldiers across the Menai Strait. Some of the stories were told by Hugh with a certain amount of embellishment, to thrill the young Kyffin and his brother Dick as he rowed them offshore

in Porth Swtan. But Kyffin could never figure out why 'Old Hugh' always appeared to be on the side of the Romans rather than the side of his Celtic forbears. I often revisit places where Kyffin had taken me, places he told his wonderful stories about, especially the places he had painted.

On one of these excursions I went with Iwan Dafis, a Kyffin devotee from the National Library of Wales, and Ian Jones, a colleague from Oriel Ynys Môn. We explored around the Llanfair-yng-Nghornwy area, where Kyffin found many subjects of interest to paint. This is the area where Kyffin's father took him as a child, an area that became so nostalgic for him. After making our way around the promontory we came to Rhoscryman Fawr and Rhoscryman Bach where Kyffin had painted several times. Eventually, we found the spot from where he had drawn the farms. This was on the road above Rhoscryman with Mynydd y Garn and its monument standing high behind us to the east. As we looked almost due west, we could see below the shape of Rhoscryman outlined by Porth Dwfr, Holyhead Bay and with a sun-glistening horizon highlighting the scene. We stood comparing the actual scene with a print of the painting we had with us and were intrigued with Kyffin's accuracy. It was not necessarily accuracy of detail, but how he had succeeded, as usual, in capturing the essence of the location. There is nothing particularly special about Rhoscryman, other than its natural beauty, so typical of this coastline. But what is fascinating is the ambience Kyffin managed to convey in a simple sketch. I had always considered that because of the rapidity of his field sketches accuracy did not matter. But even with Kyffin's rapidity on the sketch pad, the finished work was, nevertheless, true to the subject. He also appears to have gathered a great deal of information mentally, to be synergised into creative energy back in his Pwllfanogl studio.

This energy often drew on the stories his father, Henry, had told him about the remote and ancient place of Llanfair-yng-Nghornwy, sometimes referred to as 'yr ardal wyllt' (the wild district). It was here that Kyffin's father told him the legend of Bonnie Prince Charlie's links with the area. Allegedly, Prince Charlie was seeking sanctuary after his defeat at Culloden and landed in a secluded cove at this remote Anglesey location. As Kyffin explained, this story is not as ridiculous as it first appears. This part of Anglesey is on the sea route from Scotland to the Isle of Man and then on to France. The Prince's final destination was the Vatican City, where he died on 31 January 1788. He was eventually buried with his brother, Cardinal Bishop Henry Benedict Stuart, in the crypt of Saint Peter's Basilica in the Vatican. Also, and more importantly, as Kyffin explained, there were many Jacobite sympathisers in Llanfair-yng-Nghornwy. Kyffin claimed there is evidence that Anglesey's dominant landowners in this area, the Bulkeley family, were Jacobite

sympathisers at this time, a suspicion strengthened by the finding of busts of the two Pretenders and of Henry Stuart, Cardinal Bishop of York, in the Baron Hill inventory of 1822. Moreover, a secret docket of letters addressed to the head of the Bulkeley family had been discovered, detailing Jacobite fortunes in 1715. The family were also linked to the location by the marriage, in 1749, of the sixth Viscount Bulkeley to Emma, daughter and heiress of Thomas Rowlands of Caerau. This ancient house was the alleged hideaway of Bonnie Prince Charlie. Kyffin's art was bound up with such historic and romantic factors whenever he painted, for it was more than visual information that he gathered. This particular quality in his art is probably why devotees and collectors are subliminally influenced by his work and style.

Kyffin's connections with Oriel Ynys Môn, together with his painting for the Thackeray Gallery in London, the Albany Gallery in Cardiff, and six works for the annual summer exhibition at the Royal Academy of Art, meant he had a full diary of functions and events to attend. He would often drive himself to local Anglesey functions but in his later years he would ask friends to transport him. He always went to his cousin, Captain John Mills, over the Christmas break for a meal. I collected him on several occasions and, as we travelled from Pwllfanogl to Pentraeth, he invariably regaled me with the story of his family being invited to Rhiwlas, the Mills' old house near Traeth Coch, for Sunday lunch. As the two families sat down for the meal, Kyffin and his cousin John watched as the latter's father, Lieutenant Colonel Frank Mills, with military precision, sharpened the large carving knife and proceeded to assail the joint of beef. On one occasion, Kyffin was momentarily distracted by a large tabby cat he spotted through the dining room window. The superb tabby appeared to be familiar with the Colonel's garden, as he was leisurely scratching holes in the neatly kept flower beds. As any child would do, Kyffin drew everyone's attention to this fact. Within seconds, Colonel Frank Mills' composure changed and he leapt up the stairs with immense vigour. A window slammed open and a deafening shotgun blast echoed around the house. As quickly as Colonel Frank had left the table, he was back again, and continued skilfully carving the joint. With his composure also returned and knife in hand, he asked, 'Anyone for more meat?' There was a long silence. Kyffin laughed about this as he later told the story and wryly felt guilty for the poor tabby's demise.

With government reorganisation in 1996 Anglesey regained its administrative independence and became a county authority. At this juncture Denise Morris applied for the post of director of leisure. The interview appeared to go well for Denise, but the directorship was given to Mrs Elspeth Mitcheson, previously of Gwynedd County

Council. The two got on well initially, as they were both deeply interested in the arts. The halcyon years at Oriel Ynys Môn faltered, however, when Denise Morris and Elspeth Mitcheson developed serious differences. Denise felt there was a particular prejudice against her management methods and, inevitably, with time, felt disenfranchised. A grievance procedure was initiated by her and this culminated, after a protracted and unsettled period, with Denise resigning her post. She then pursued a claim for 'constructive dismissal' against the authority. A tribunal date was set, with the case to be held in Caernarfon. The relatively high-profile case attracted media attention. I was summoned to attend the hearing as a witness.

On the day of the tribunal I reluctantly arrived at Penrallt, part of Gwynedd County Council's offices and the hearing's venue, to be met by a large group of cameramen and journalists. As I entered the tribunal room I noticed Anglesey County Council's legal team seated close to Elspeth Mitcheson. Denise Morris was seated nearby with her legal team. To make the situation a little more unsettling, I noticed Kyffin sitting at the far end of the well-packed room, along with Lady Anglesey and an extensive group of artist friends. Kyffin had raised a considerable sum of money for the services of Denise's legal team, through the sale of a collection of his judicial caricatures.

At this stage Kyffin had cancelled his eightieth birthday celebration exhibition at Oriel Ynys Môn and transferred it to Plas Glyn-y-Weddw. This made life a little difficult for the newly incumbent principal officer, Alun Gruffydd. Alun worked well with the Oriel team and, fortunately, over time, turned the situation around. Nevertheless, Kyffin refused to enter Oriel Ynys Môn until Elspeth Mitcheson had departed.

With these thoughts on my mind, and with a tense atmosphere, I sat in the tribunal and wondered how this situation had developed. Furthermore, the tribunal progressed rather tediously, with all the details of the preceding months being trawled over. Eventually, and much to my relief, I was summoned to a side room to meet with Denise Morris's counsel. I was questioned about the poor relationship between 'Mrs Morris and Mrs Mitcheson'. I had previously spoken about the case with a solicitor friend who proffered the advice 'Ensure you leave the tribunal with your integrity intact by telling the truth.' Denise's barrister accepted my answers to his questions, but when I countered with what I hypothetically thought Mrs Mitcheson's County Council barrister and legal team would ask me, and how I intended answering, I was dismissed. The barrister felt I was a 'hostile witness' and asked me to leave the room, and tribunal if I wished. The tribunal was later brought to a conclusion with the announcement that Denise had failed with her claim for 'wrongful constructive dismissal'. This was based on the technical grounds of her

'not having fully exhausted the Authority's grievance procedure'. Understandably, the decision of the tribunal greatly upset Kyffin and Denise, and was indeed traumatic for all involved.

This was also a very sad period for Oriel Ynys Môn, as some artists had turned against the gallery, with one or two refusing to exhibit their work at planned exhibitions. The situation worsened for a while as some individuals refused to talk to staff. Most of this was illogical but somehow the staff and venue appeared to be tainted by association. Inevitably, the gallery moved on and visitor figures were still buoyant. One member of staff who was not easily perturbed by adversity commented, 'They need us more than we need them!' I maintained contact with Kyffin and went out to lunch with him regularly. He was distraught and would go over Denise's situation many, many times and was greatly concerned about her health. I agreed with him that it was, indeed, a sad loss and that the effect on the gallery was considerable in many ways.

At an earlier time, Gaynor Cemlyn-Jones, who had amassed a fine art collection, including work by Augustus John, made arrangements for part of this collection to be bequeathed to Oriel Ynys Môn. Kyffin had discussed this with her as he felt her collection would have considerable benefits for the gallery and Anglesey. This legal arrangement (a codicil) was changed just prior to the Caernarfon tribunal, allegedly on Kyffin's advice. He had suggested that Gaynor's collection should now be left to the National Library of Wales, one of Kyffin's favourite beneficiaries. Some five years after the alterations to her will, Gaynor Mair Cemlyn-Jones died, on 26 April 2003.

Gaynor had been a generous benefactor to the local community and was greatly respected, and had a special interest in marine conservation at the School of Ocean Sciences. She also promoted, through the Pen-y-Clip Trust, marine archaeology and the first PhD programme on this subject. Unfortunately, Gaynor's will, when read out, detailed that her art collection should go to the National Museum of Wales, and not, as Kyffin specified, the National Library of Wales.

One of the items in the bequest was a beautiful Gwen John oil painting which was shown at the Chenil Gallery, London, 1926. Her brother, Augustus John, arranged the exhibition to assist her financially. The setting for the painting is in the artist's flat at 29, Rue Terre Neuve, Meudon, and shows a room with table and teapot in a soft light. Gaynor Cemlyn-Jones's apparent mistake in the codicil to her will was made, according to her brother, Morys Cemlyn-Jones, 'because she was unwell at the time'. Kyffin was very angry indeed with this situation, as he still appeared to resent the National Museum of Wales, but he could do nothing about the situation. He contacted Morys, who sympathised

with Kyffin over his sister's mistake, but he felt that 'she should never have made the codicil changes to her will, especially in her condition'. Morys avoided any misguided allegiances, as he has great respect for Oriel Ynys Môn and its arts role in Wales. This problematic period for the gallery fortunately turned more favourable as time went on. Kyffin eventually returned to visiting the gallery in Llangefni, and settled back into his routine of having lunch with me in the café, and also at the Penrhos Arms, Llanfairpwll. He later attended a number of exhibitions and was by then building a good rapport with the newly ensconced principal officer, Alun Gruffydd, and the rapidly evolving gallery team.

On 27 February 1998 an exhibition titled 'North Wales at its Best' opened at Oriel Ynys Môn. This was a highly successful touring exhibition that had previously been shown at Bodelwyddan Castle, the Williamson Gallery, Birkenhead, the National Library of Wales, Aberystwyth, and the Grosvenor Museum, Chester. The exhibition was the idea of Lady Anglesey but was carried out in collaboration with Steve Brake, County Arts Officer, Denbighshire County Council and Colin M. Simpson, Curator, Williamson Art Gallery, Birkenhead. Of course, Kyffin was the main advisor and also wrote a stimulating essay as an introduction to the catalogue. I searched the Oriel's collections with Kyffin and Lady Anglesey for suitable exhibits, as did other curators in their galleries. Mike Francis of the National Library of Wales also assisted, and Leslie Jones, Kyffin's friend, spent much time researching biographies and visiting Oriel Ynys Môn. The idea of the exhibition evolved in 1996 and was intended to show both Welsh and English artists as they toured North Wales in the eighteenth, nineteenth and twentieth centuries. The exhibition, as Lady Anglesey envisaged it, would be her personal tour of North Wales depicted through these artists' eyes. The content was diverse and included not only the grand mountainous landscape but also vestiges of the industrial landscapes of the past, as well as Charles Tunnicliffe's portrayals of the areas' birds and animals. The Napoleonic Wars had caused a surge of artists travelling to see the beauties of North Wales. With the Grand Tour of Europe out of the question, as Kyffin indicates in his catalogue essay, 'Wales, Cumbria and Scotland became the source of their dramatic inspiration'. Richard Wilson was one of the first to be inspired, but the majority of the finest paintings were by English artists, such as Paul Sanby, J. M. W. Turner, Thomas Girtin, and watercolourists like Thomas Rowlandson and Anthony Vandyke Copely Fielding.

David Cox's visits to Betws-y-coed came later, and attracted many types of artist to the Conwy and Llugwy valleys. The range of work displayed in the exhibition was impressive, especially the later work by John Piper, Charles Tunnicliffe, Iola Spafford,

David Woodford, Peter Prendergast, Christopher Hall and of course Kyffin himself. The exhibition emphasised North Wales as a very special place of artistic heritage in Britain. At the close of the exhibition, on 5 April 1998, Kyffin commented that he was 'astounded at the amount of good art in collections along the North Wales coast to the Wirral'.

Oriel Ynys Môn continued to evolve, with many successful exhibitions, especially under the leadership of Alun Gruffydd. The team had settled down to the often arduous task of balancing the creation and the setting up of a vast range of exhibitions, together with the running of six heritage venues around the island. Kyffin always praised the staff at the gallery for their teamwork and dedication to the arts on the island. The most significant later development was the building of Oriel Kyffin Williams in 2008. The idea of a gallery dedicated to Kyffin had been around since about 2000. Kyffin himself was eventually convinced by the argument that it would be Anglesey's tribute to him for all his support and generosity over many years.

The innovative idea of raising money for a new Kyffin Williams Gallery by selling prints of the art he had donated started well. A trust slowly evolved, to give financial support and a public face to the scheme. Kyffin was delighted with the formation of the Sir Kyffin Williams Trust. In the chair was Kyffin's friend, Professor Derec Llwyd Morgan, with current members Mary Yapp, Annwen Carey-Evans, Lord Dafydd Wigley, Dr Paul Joyner, David Meredith and Alun Gruffydd, with John Rees Thomas, Pat West and myself acting as the Trust's secretariat. In the early stages of financing the project Kyffin was brought to the gallery to select twelve of his drawings from the gallery's collections for reproduction. This process evolved into two sessions, with Kyffin scrutinising hundreds of his drawings on one day, and making his final selection on another day.

He found the selection process difficult and fatiguing as there were over four hundred wonderful sketches and drawings to go through. As they were brought before him for scrutiny, he was a little reticent, if not shy, about making his final choices. Eventually, however, the twelve works were chosen and Kyffin gave his reasons for their selection. He noted that he sought good composition but was also keen to represent his favourite places on Anglesey. *Llanrhwydrus Church*, near Cemlyn, was linked with his cleric relatives from the nineteenth century. It was also remote, and near the bird reserve at Cemlyn where he loved watching common and arctic terns diving for fish. He rather liked the dark ink wash of *Carmel*, a chapel with a magnificent view to the south, of a resplendent Snowdonia mountain range. He could never resist explaining that the black Indian ink wash he used should always have a blob of brown paint, usually burnt umber, added to reduce opacity. He also chose *Mynydd Bodafon*, described by him as an extinct volcano,

with beautiful cottages in the bowl of the mountain. His view of *Caernarfon* was unusual in style and was taken from Plas-y-borth, Anglesey, looking across the straits with Eryri (Snowdonia) magnificent in the background. His most popular location on Anglesey, where he attended preparatory school, was Trearddur Bay; here he chose two sketches as prints, *Rough Sea at Trearddur* and *Trearddur*. His sombre ink wash depiction of Aberffraw Church, with looming sky, was also selected. As expected, *Pentre Pella* was chosen, as he had a fascination for this secluded Holyhead mountain village, with its narrow streets once paced by endless quarry and farm workers. *Bwthyn* (Cottage) is a lovely drawing with watercolour added, and shows a group of shippons partly hiding a traditional farmhouse. Slightly out of context for this project, Kyffin chose to reproduce *Farmer*, a local shepherd in a typical market day attire and stance, leaning on and supported by a hazel crook.

A favourite print is the view of *Fedw Fawr*, on the eastern seaboard of the island with Ynys Seiriol (Puffin Island) in the middle distance and, further away, on the mainland, the Carneddau range. Kyffin mentioned that Fedw Fawr was once owned by his Williams ancestors who had much earlier given it to the University in Bangor. He loved the geology of this area, explained to him in detail by his friend and well-known geologist, Margaret Wood. He was fascinated with the flora, where orchids abound, and with the sinkholes (dolines) that perforated the plateau, exuding funnelled water from the carboniferous limestone cliff face. He claimed that the sinkholes held many sheep and Welsh mountain pony skeletons. In the summer he watched black guillemots here at their most southerly British nesting place. He would watch the same bird in wintertime at Cemlyn Bay, retreating, half frozen by the biting sleet-laden easterly wind, to Mrs Rowlands' house in Llanfair-yng-Nghornwy, for 'crempog' (pancakes) and a 'panad' (cup of tea). This was not the Mrs Rowlands of 'portrait' fame, but the lady who had cared for him when he was a baby on holiday with his parents near Porth Swtan. Kyffin invited her to his 'Portraits' exhibition in 1993 where he chatted at length about his grandfather and his family.

As can be seen, all these drawings were chosen by Kyffin with great care as he wanted his best work reproduced by Curwen Press. There was, however, a delay with the initial capital required for the printing processes to begin. This would eventually be resolved but for Kyffin time was not on his side. He forecast that he would not see the gallery project come to fruition and, with hindsight, he was right. He pondered a great deal on this and then, one day, while having lunch at the Penrhos Arms, he mentioned he had something for me on our return to Pwllfanogl. We spoke about the project and how, to him, it appeared to lumber on too slowly. As I was leaving Pwllfanogl he gave me a cheque, saying it was a gift to be used for the printing costs with Curwen Press. I looked at the

Kyffin selecting images for prints in the company of John Smith

folded piece of paper and noticed the neatly written sum of £60,000. I was speechless; I understood his dilemma and realised, now, how short time was for him.

Curwen Press is based at Chilford Hall not far from Cambridge and had originally been established by Reverend John Curwen at Plaistow in 1863. Kyffin had a long association with Curwen and was always keen to explain their links with artists like Henry Moore. In the 1920s Oliver Simon, the renowned book designer, joined the press, with his brother Herbert joining as managing director a little later.

Oliver had contact with outstanding artists such as Paul Nash, Edward Bawden and Eric Ravilious at the Royal College of Art. This led to them being commissioned by Oliver for the reproduction of their work. Today Curwen has the enviable presence of Stanley Jones on their team. Stanley, with his vast printing experience, oversees most of the printing operations at Chilford Hall. He has had the good fortune of working with

many of Britain's renowned artists, as well as being an outstanding artist himself. Kyffin had tremendous respect for Stanley and the team at Curwen, and therefore recommended their involvement in the project.

The digitisation of Kyffin's drawings, as well as all the other printing processes, took place at Curwen Press. This necessitated myself and colleague Ian Jones travelling to Chilford Hall with the twelve original drawings. At Chilford we were greeted by manager, Jenny Roland, a key figure at Curwen, who then took us through to the printing room to meet Stanley Jones. We were shown the whole process by Stanley and given an insight into some of Curwen's history. We were intrigued by the incredible atmosphere in the room, with its aromas of inks and solvents pervading the air, and the gentle sound of reciprocating presses. The offset lithography process and the high standards of printing were of great interest to us. Stanley reeled off the names of world-famous artists, Alan Davie, Ceri Richards, John Piper and Henry Moore, with whom he had worked closely. We could only listen enviously to his reminiscences.

Some weeks later we returned to Chilford Hall to collect Kyffin's original drawings. With all the printing done, he began signing the three hundred and fifty edition prints of each drawing, requiring altogether four thousand two hundred signatures. Michael Adams, a director at Curwen Press, would deliver quantities of the prints to Pwllfanogl for Kyffin to sign on a weekly basis. As one can imagine, this was rather an arduous task for Kyffin, especially considering his state of health at the time. With the prints now available to generate a fund, however, and everyone eager to start the project, architects were summoned and designs were gradually resolved. With the gallery architects, Russell Hughes and Partnership, appointed, Kyffin became involved in all the details of the design. The difficulties of blending in the new building and allocating adequate exhibition space, as well as other technical aspects, took considerable time. Kyffin by now appeared unwell but was still fighting his terminal ailment with extraordinary fortitude and grace. I had taken him to hospital for check-ups, and friends, especially Denise Morris and Sally Goddard, continued to care for him. On one excursion with him to Derby to see his friends Gillian and Richard Rowlands and to collect a painting, he became ill and so we had to return to Pwllfanogl. After ensuring he was comfortable and did not need a doctor, I continued on the journey. He never seemed to complain, even with all his discomfort. He could never understand how he contracted lung cancer when he was not a smoker. At times we considered that his years of exposure to artists' oils and solvents may have been a contributory factor.

The process of building the new Kyffin Williams Gallery started in 2007 and was

completed and opened on 18 July 2008. Kyffin's friend, Shirley Paget, Marchioness of Anglesey, was invited to open the new gallery, the £1.5 million cost being made up of contributions by the Welsh Government, Anglesey County Council, Isle of Anglesey Charitable Trust, the Arts Council of Wales, and a remarkable contribution of £200,000 by the Sir Kyffin Williams Trust, made possible by a spirited campaign spearheaded by the trust chairman, Professor Derec Llwyd Morgan. The resulting gallery is a wonderful commemorative centre for Wales's greatest artist, built within close proximity to his Llangefni birthplace. At the opening Lady Anglesey recalled some memories of her friendship with Sir Kyffin, and the wonderful years he spent in Pwllfanogl. He was a regular visitor to Plas Newydd where he would embark on discussions about art, with occasional philosophical digressions by Lord Anglesey, which Kyffin endured well.

The following evening, 19 July 2008, a special event took place to thank friends and supporters of the gallery over the years. The evening culminated with eloquent speeches by Kyffin's long-time friends, Professor Derec Llwyd Morgan and David Meredith. The Oriel Kyffin Williams project was managed by the Oriel team, John Rees Thomas, Pat West and me. The building work was undertaken by R. L. Davies & Son Ltd. The whole project and the ensuing series of exhibitions have been well received. At times one has a sense that Kyffin is still around, especially after the installation of a new exhibition. His exhibitions now attract many thousands of visitors every year, who are keen to gain insight into his prodigious output of art.

The Portrait and Kyffin –
the 1993 Portraits Exhibition

A T THE AGE OF TWENTY-SIX, Kyffin painted several masterly portraits. He had a keen eye since childhood and tremendous powers of observation, but added to this was his remarkable memory. He could remember shapes, colour and expressions.

Some of his first portraits were of his 'Taid', Reverend Owen Lloyd Williams, of his brother Dick and of Gwilym Owen, a native of Llŷn. (Painted entirely with the brush, Gwilym Owen's portrait won a prize for Kyffin at the Slade College of Fine Art at Oxford.) Influenced by his father, Kyffin had always felt at home with people and, according to his own testimony, it was by painting the human face that he had been able to introduce emotion into his painting, which was extremely important to him.

From the 1960s to the 1980s, he was pre-eminent among Welsh portrait painters. People of any official standing in Wales would have their portrait painted by Kyffin Williams in his London studio in the 1950s and 1960s and later at Pwllfanogl, in Anglesey. Drawings could be done elsewhere, as in the case of the literary figure Kate Roberts, but the portraits would be completed in the studio.

A brilliant and prolific portrait painter like Van Gogh, Kyffin, who was born 28 years after the latter's death, had no interest in a psychological study of those who sat for him; he was concerned to secure a likeness. This, of course, is what he was expected to do in his official portrait commissions, but when Kyffin was free to choose those who sat for him, that is paint portraits of interesting people he met in Wales and beyond, then a portrait of an old lady could be a portrayal of great age rather than an exact portrait of an individual. Kyffin was always aware that one stroke of a brush or palette knife could change 'a look of confidence to one of apprehension' or 'a look of tenderness into one of cruelty'. It was the art of the portrait painter to catch the moment; to know when to stop painting, and not be tempted to meddle with the portrait. Kyffin, however, would have no hesitation

Kyffin with his *Chelsea Pensioner* painting

if a portrait 'did not work' to scrap it and use the canvas, if the size was appropriate, to portray a mountain or a stormy sea!

No doubt, portrait painters have always faced the dilemma of having to choose between securing a likeness or of conducting a psychological study of those sitting for them – or indeed seeking to do both at the same time. It is said that David Hockney, in the period 1962 to 1975, found it impossible to paint commissioned portraits since he was devoted to the double truth of likeness and of evoking the character of the sitter.

Van Gogh, greatly admired by Kyffin, wrote to his sister Willemien in 1890 that, 'I would like to do portraits which would look like apparitions to people a century later', which indicates that likeness was important to Van Gogh as it was to Kyffin. Van Gogh also wrote that 'a painted portrait is a thing of feeling made with love.' Kyffin would certainly have concurred with that view. Love of humanity was paramount to him. Kyffin, however, went further than mere admiration of Van Gogh, for he adopted Van Gogh's practice in some of his portraits of clearly defining the face with a black line, and on occasion not only the face but most of the human form as, for example, in the portrait of *Mrs Money* (oil on canvas, 1957), which can be compared with Van Gogh's *Madame Augustine Roulin and Baby Marcelle* (oil on canvas, 1888), or, again, Kyffin's portrait of *Henry Williams Hafotty* (oil on canvas, 1956), and Van Gogh's portrait of *Peasant Girl in Straw Hat* (oil on canvas, 1890).

Julian Bell, writing about the self-portrait (and Kyffin painted many self-portraits), observed that, 'I have a face, but a face is not what I am'. It was all to the good if on occasion what people 'were' became obvious through the paint on the canvas. But as Kyffin said, 'only subconsciously may I at times have revealed some hidden aspect of the character of my sitter'.

Realistic portraiture developed in Flanders and came, according to Kenneth Clark, to immediate perfection in the painting of Jan van Eyck (*c.* 1395-1441). Certainly, Kyffin embraced the art of the portrait, always maintaining that people portrayed in Dutch paintings were people you felt you could approach with ease, whereas people portrayed by Italian painters appeared more formal and difficult to approach. Kenneth Clark felt that no one had looked at the human face with more dispassionate eyes and recorded his finding with more delicate hands than Jan van Eyck. Kyffin had expert knowledge of Dutch and Italian painters; he had experienced at first hand the powerful emotion of the human face as portrayed by them in paintings in galleries across Europe. But long before his visits to the great galleries of Europe, Kyffin had studied the faces of his fellow countrymen and women in Anglesey, Llŷn and Merioneth.

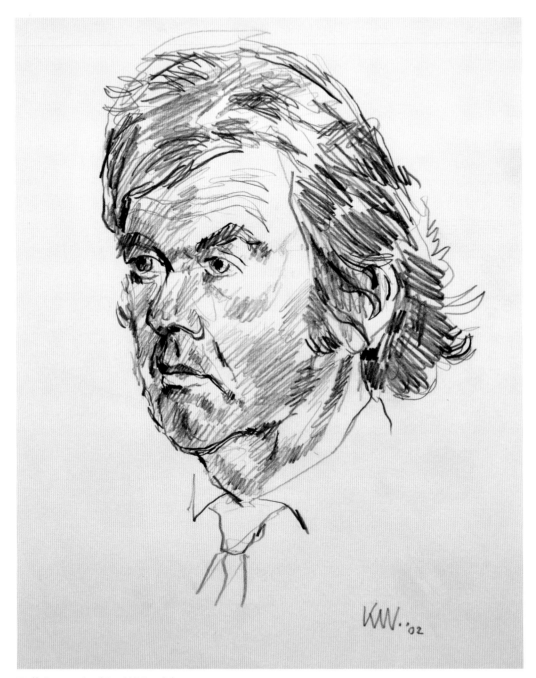

Kyffin's portrait of David Meredith

When David Meredith, in 2002, asked Kyffin to paint his portrait to be published in his autobiography, Kyffin immediately said that he had not painted a commissioned portrait for over fifteen years. In fact, on reaching the age of seventy, he had decided not to accept another portrait commission. On the day of the request, lunch became the priority and the matter was forgotten. Kyffin met many problems during his official portrait years in the 1960s, 1970s and 1980s. Some of his portraits met with the disapproval of wives or committees. Some individuals had specific requests: Dr Huw T. Edwards wanted to be painted with a twinkle in his eye, while Sir Dafydd Hughes Parry wanted to be painted in the full regalia of the University of London, where he was vice chancellor. Some portraits were refused. One was sold for a paltry sum but was subsequently bought back by a member of the family and today has pride and place in the family home.

Kyffin took great delight in relating the cut and thrust of his experiences with his 'commissioned portraits' but there was no doubt that the worry of securing a likeness did take its toll and was, as Kyffin said, 'an unsatisfying exercise'. He also said that every portrait he had painted had been a considerable strain, since nothing came easily to him. On the other hand, he also believed that some of his best paintings were portraits. The majority of these were completed in a day.

Three weeks after telling David Meredith that he no longer accepted portrait commissions, Kyffin suddenly said at Pwllfanogl one afternoon: 'What about this portrait?' He had set the scene in his parlour ready for work. Kyffin sat at his desk with his back to the window and the light. David Meredith was placed to sit opposite him about four feet away in the light. The sitter was instructed to look at Kyffin's grandfather clock in semi-profile.

Before David Meredith took his place in the chair opposite Kyffin, he had gone to look in a mirror on the wall to preen himself and tidy his hair, unaware that Kyffin had come in suddenly behind him. Kyffin immediately said, 'Ruffle it up, your hair's too tidy.' Obeying the maestro, Meredith took his seat near the desk and, with ruffled hair, gazed at the clock with the light streaming in on his face. Midway through the process, Kyffin stopped, uttered a loud 'Ah!' and tore up the 20 inch x 16 inch sheet of paper before him and threw it on the floor. He then said, speaking to himself, 'Start again'. Within twenty minutes, the portrait in pencil was complete. Meredith had been wondering midway through the process what part of his head Kyffin was drawing when he had rubbed his pencil to and fro on the paper with great vigour. On seeing the finished portrait, he could see that it had been his hair that had received the vigorous treatment!

Kyffin asked Meredith if he was happy with the portrait, to be given a very effusive reply. It was interesting that Kyffin's only comment on it was, 'I've made you look serious'. In his introduction to his first book of *Portraits*, Kyffin said, 'The mood of melancholy is more satisfying in a portrait than a smile, for melancholy often denotes a depth of feeling, whereas a smile is a transitory thing that tends to irritate.' Kyffin also once observed, 'I don't paint caricatures – I paint what I see.'

Some of his early portraits were painted with the brush; later in his life he would perfect the use of the palette knife, causing amazement among his fellow artists that he could use the knife to place a colour on the canvas with such exactness as not to disturb other colours, a vital consideration in his portrait painting and a task difficult to achieve. Kyffin recollected: 'In my early years as a painter of portraits, I found it impossible to paint the smooth face of a girl. The reason for this was my use of the palette knife for painting in broad and rough areas of paint; it was difficult to achieve the delicacy necessary…the most important element in a portrait is its mood…and often this is more likely to be that of the artist rather than that of the sitter.' In 1993, a retrospective of Kyffin's portrait paintings was held at Oriel Ynys Môn at Llangefni with Llion Williams, the Director of the North Wales Arts Association, observing in the introduction: 'The portraits of Kyffin Williams are highly charged with passion and tension, but also have great humanity and strength. These same qualities emanate from the character of the artist himself.' This retrospective was the largest exhibition of portraits ever held by Kyffin, a total of 114 paintings in all.

In *Portraits*, published by Gomer Press in 1996, eighty-one portraits are featured, providing a remarkable cross-section of society – farmers, housewives, cleaners, professors, administrators, judges, college principals, soldiers, children, inhabitants of Patagonia, nuns, poets, politicians, and one or two self-portraits – all works of brilliance that set Kyffin apart from ordinary portrait painters, and all portraying people who viewers feel they can relate to and approach. It could be said that even Kyffin's landscapes were portraits, i.e. portraits of the land.

The 'Portraits 1944-1991' exhibition was planned to run from 3 April to 31 May 1993. The planning for this was extensive, with portraits coming from all over Britain. John Smith was fortunate in being asked to drive Kyffin around north Wales to collect a number of important works. With great delight he would collect him from Pwllfanogl, and travel around Gwynedd and the Llŷn Peninsula to gather the portraits. Inevitably, Kyffin would tell fascinating stories about the local landed-gentry and aristocracy. There seemed to be tales for him to tell around every bend on Llŷn. He pointed out *plasau*

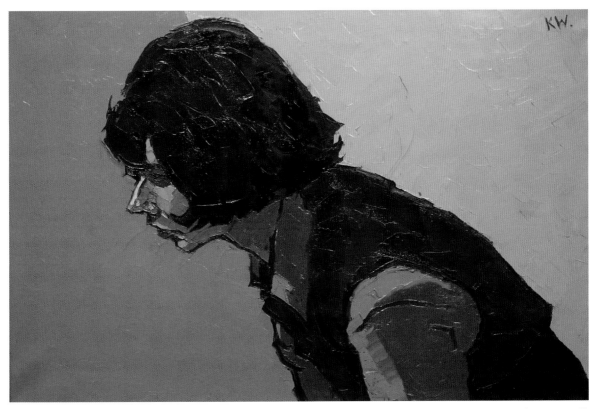

Yolanta in profile

(manor houses) and many estates, and told of all the illicit and extramarital activities that had taken place in such a small patch of Gwynedd. It should have all been recorded for posterity. On one excursion to Llŷn a call was made at Plas Glyn-y-Weddw, where Kyffin had exhibited for some years. He explained how the entrepreneur, Solomon Andrews, had restored the 1856 dower house of Lady Elizabeth Love Jones Parry, Madryn Estate, at the turn of the twentieth century. Kyffin's Cardiff agent, Mary Yapp, who owns the Albany Gallery, is a descendant of Andrews. After the house purchase Andrews turned Plas Glyn-y-Weddw into a place of entertainment with dances and a restaurant, with paintings displayed on the walls. He also started running a horse-drawn tram service along the dunes from Pwllheli. In his autobiography Kyffin comments on the many paintings displayed at Plas Glyn-y-Weddw, noting that, although good, many of them were copies and worth little.

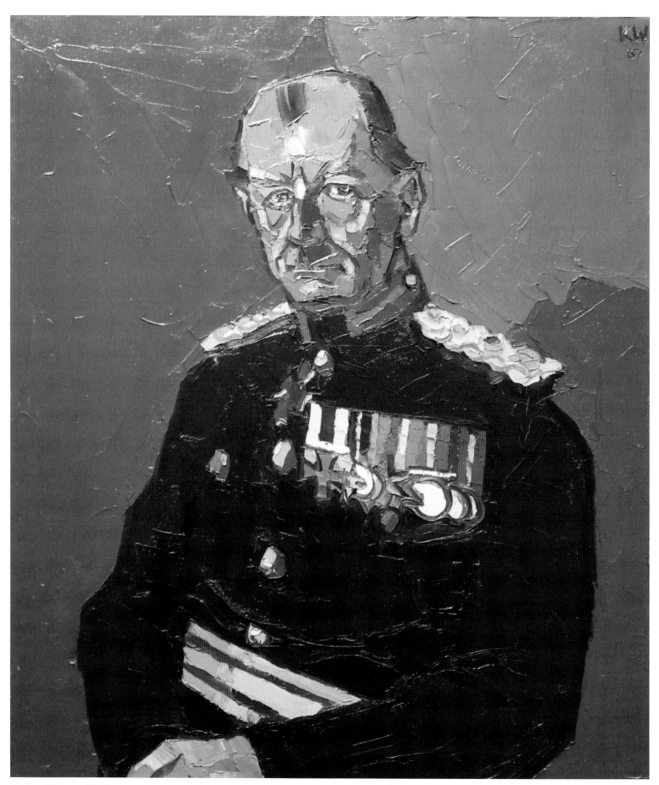

Colonel Wynne-Finch

It was here, many years later, that Kyffin's friend, David Jeffries, would become the successful director. On occasions Kyffin and John would call on David and his partner, Nigel, near Rhydyclafdy, to partake of memorable lunches. Kyffin was fascinated that the location was so frequently prone to lightning strikes, and that David's house had been damaged on one occasion. He considered that it was under David's directorship that Plas Glyn-y-Weddw gained momentum. Kyffin was familiar with the area around Pwllheli from his training as a land agent with Yale and Hardcastle, Pwllheli, from 1936 to 1939. Kyffin explained that George Yale, his principal with the firm, was a canny character who was always able cleverly to avoid expenditures on the tenants' properties – which, invariably, was the original reason for their visits. He felt that Donald Hardcastle, the other partner in the firm, was a more sincere person, as well as being a great batsman with Pwllheli cricket team. After a *panad* at Plas Glyn-y-Weddw, John and Kyffin made their way from Llanbedrog towards Sarn Mellteyrn, and then by a short cut to Cefnamwlch.

There Kyffin had arranged to collect Colonel Wynne-Finch's portrait from his son, Charles Edward Wynne-Finch. Approaching Cefnamwlch Kyffin asked John to slow down near Congl y Cae, with Mynydd Cefnamwlch in view, to tell him about a fox hunt he had once attended there. The hunt, which Kyffin had initially described as they travelled along, had taken a number of turns in Llŷn but was now following the fox up the steep slopes of Mynydd Cefnamwlch. At the top the fox disappeared, possibly into an earth or the woodland of Coed Cefnamwlch, and was eagerly sought by hunters and hounds alike. With much howling and baying in the distance, Kyffin relaxed for a while and took out his sketchbook from his deep poacher's pocket, and started sketching the panorama before him. The view stretched down to Uwch Mynydd, at the tip of Llŷn, and across to Bardsey and the glistening expanse of the Irish Sea. Within minutes, as he was deeply engrossed in his sketching, there was a tremendous yell of 'Look out', when the fox ran full pelt between his legs and scarpered back down the hill. The hunt gave chase as a startled Kyffin tried to compose himself and quickly secure his sketchbook in his pocket. After he finished his story he was still laughing as they drove down the lane to Cefnamwlch to collect the colonel's portrait.

As they approached the enclosure of ancient buildings and walled gardens, they were met by Colonel Wynne-Finch's son. After a brief exchange of greetings Kyffin was handed what the colonel's son cheerfully described as the 'family heirloom'. Driving away Kyffin waved goodbye, but immediately explained that the 'family heirloom' description was not quite true.

The painting had been originally commissioned by the Denbighshire magistrates

where Colonel Wynne-Finch had served for fifty years. Kyffin said that the colonel looked rather formidable on the day of the portrait, especially as he was dressed in his Lord Lieutenant's uniform. He felt the colonel was too serious and had a dominant piercing eye, especially when he commented that Kyffin had painted his medals too large. Kyffin finished the portrait rather quickly, much to the sitter's surprise and apparent disappointment. The colonel thought he would be on holiday in London, travelling to and from Kyffin's studio for a week. A photograph of the painting was forwarded to the Denbighshire magistrates and accepted. It was duly framed, packed and delivered to the magistrates and presented to the colonel and his wife at a special function. The portrait was unveiled after the speeches and, to everyone's surprise, the colonel's wife leapt to her feet, protesting that she would not allow the portrait to enter her house and that she much preferred garden furniture. Kyffin was not present at the function as he was teaching at Highgate School, but was promptly approached by the *Sunday Express* for his comments on the 'dilemma'. The colonel and his wife had already spoken to the press, but Kyffin replied with 'No comment'. As he later explained, 'I had received my fee, and felt the colonel himself was satisfied with the painting at the time, as the magistrates were.' The painting had a happy ending though, as it was bought for £150 by a High Court judge at an exhibition in the Tegfryn Art Gallery, Menai Bridge. The judge, after the colonel and his wife's death, sold it to their son at a much greater price. Kyffin reckoned he only made £75 out of the sale. The painting has been shown at Oriel Ynys Môn at two 'Portraits' exhibitions and is always well received by visitors. Kyffin commented later: 'The colonel was briefly denied access to the company of his forebears at the Wynne-Finch's family home of Voelas.'

After a lunch break at the Nanhoron Arms Hotel in Nefyn, a favourite stop for Kyffin to have soup and apple juice, they continued back to Anglesey discussing the difficulties associated with portrait painting, especially colour and the perennial question of gaining a likeness.

Kyffin claimed females were more difficult to capture in a portrait because of their skin textures and tones. He recalled an encounter with one female sitter:

> I remember painting a portrait of Dame Eileen Younghusband, daughter of the famous Indian explorer Francis Younghusband, she was a very formidable lady and she was President of the National Institute of Social Work Training but she insisted on being painted in a green sleeveless silk garment and she had massive arms. She rather frightened me actually, and anyhow I painted these huge arms. I was very stupid, I was

really after the truth, I always have. It is a great failure to be too honest. Anyhow, the painting was sent to the National Institute of Social Work Training and I went to the unveiling of this portrait. I remember somebody got up to speak and he praised Dame Eileen Younghusband to the stars, and he went on and on, '…and now Dame Eileen, we come to the moment when we present you with your portrait. I hope you like it? I hope people do not say the same thing as Mrs Churchill said when she got Winston Churchill's portrait?' There was a heavy silence and nobody clapped, and I walked out sorely disillusioned. It was a very good portrait but, there we are, sometimes you have to do these things. Many other portraits of mine have been absolute disasters but some have come off, but what I did, I always try to paint a portrait and if I fail, I can always sell it as a picture, do you see?

In total there were 114 portraits to be shown at the exhibition. This included twelve paintings from the National Library of Wales's magnificent collections. The rest were from private and public collections, as well as the Oriel's collection.

With all the portraits delivered safely to Oriel Ynys Môn, the task of hanging the collection was soon under way. Kyffin assisted with the layout, and regaled the Oriel staff with lots of stories about the portraits that were springing up around us. The morning before the private view John Smith entered the gallery early. Switching on the lights, he was suddenly alerted by a hundred or more faces suddenly peering at him. The portraits had a powerful but slightly unnerving effect, though he grew used to this. Some had the uncanny effect of the eyes following you wherever one stood in the room. Staff could be seen wandering around the gallery to see if there was a point where this phenomenon changed. Kyffin explained that this effect occurred because there is no real perspective in a two dimensional painting, therefore the eyes continue to look at you wherever you stand.

The evening of the private view was full of activity with councillors and guests all trying to get a glimpse of the exhibition. Many of Kyffin's old friends arrived at the gallery and, understandably, wanted to chat to him about past times. Roger Williams-Ellis, Sir Jeremy Chance, Morris Cooke, Jim and Nesta Davies, Dennis and Mary Yapp and a plethora of friends eagerly reminisced with Kyffin as he moved agilely around the exhibition space. Kyffin himself looked extremely well and enjoyed every minute of the occasion. Keith Andrew posed in front of Kyffin's portrait of him as journalists made notes and cameras clicked away. A proud Annwen Carey-Evans, Kyffin's close friend, also stood by her portrait for the eager cameramen. As the formal part of the evening began, the authority's chief executive, Leon Gibson, introduced the main guest and speaker, Lord

Cledwyn of Penrhos. Lord Cledwyn, with a hint of humour in his voice, looked around the audience of invited guests and noted the presence of his old friend, Lord Thomas of Gwydir, before beginning his speech with:

> Mr Chairman, My Lord Lieutenant, My Lords, Ladies and Gentlemen, Annwyl Gyfeillion (Dear Friends), I'm sure you will all agree that it is a privilege and a pleasure to be here this evening at this splendid exhibition of portraits by our friend Kyffin Williams. Like most of you I have attended many ceremonies and events in Anglesey, eisteddfodau, endless concerts with great choirs and singers like David Lloyd and Ceinwen Rowlands, I know I'm taking you back a bit. *Nosweithiau llawen* and last but not least, preaching meetings, where great orators from whom Lloyd George and Aneurin Bevan could have taken lessons. But very few exhibitions of paintings, it is an interesting fact. I was somewhat upset; I was very upset a fortnight ago to read a column in the London *Evening Standard* by a writer named A. N. Wilson. He is well known and it was an offensive attack on the Welsh people. I thought for one moment that I might report him to Meibion Glyndŵr, but on reflection I decided that he was not worth shot and shell. But I am going to read some of his words in the *Standard*, which is a paper with a wide circulation, and here it is. 'It is curious,' he said, 'in these over-sensitive times when racially prejudiced expressions are never heard on civilised lips that we still speak so freely about Welshing. Is it a sign that the Welsh are held in such universal derision that nobody minds insulting them. I don't know, but I feel that one reason for it is that the Welsh have never made any significant contribution to any branch of knowledge, cultural or entertainment. Choral singing, usually flat, seems to be their only artistic attainment. They have no architecture, no gastronomic tradition, and since the middle ages no literature worthy of the name. Even their religion Calvinistic Methodism is boring.' – I am bound to say that I object to that last point – but I think we mustn't allow ourselves to be upset by so prejudiced an outburst but it did set me thinking a bit, what qualities or gifts do we have as a people?

Lord Cledwyn, with laughter all around, continued, and expressed his thanks to Kyffin for his role in providing some enlightenment on the relevance of art in Wales. He then quoted Kyffin:

> I don't believe we are congenitally colour blind but sight lazy, and the only time we exercise our appreciation for colour is in the old song 'Oes Gafr Eto' (Is there another goat) – it is quite a short effort! When Hedd Wyn wrote 'Dim ond lleuad porffor ar

fin y mynydd llwm', did he really see a purple moon? I believe it is more likely that he composed this poem as he staggered happily away from a tavern in Trawsfynydd.

Lord Cledwyn, with a mischievous expression, was in full flow, with his captivated audience laughing heartily. Kyffin was also greatly amused with the anecdotes and, as he stood behind Lord Cledwyn, he threw his head back in laughter. Lord Cledwyn rounded his speech off with:

> This year the University of Wales celebrates its centenary; its chief founding father was also an Anglesey man – Hugh Owen – and I am glad to be able to tell you that there are celebrations this year in all parts of Wales, and there is a centenary degree ceremony in Cardiff later on in the year, and in this degree ceremony, to celebrate our centenary, some people of international repute will be honoured. For example the President of the Republic of Ireland, Mrs Robinson, is one, Pavarotti is another, but another, and he is the one that makes me feel best of all, Kyffin Williams will also be honoured. My friends he more than deserves it for all that he has done and for what he is, an Anglesey man at his best, and I have great pleasure in declaring the exhibition open.

The evening was a tremendous success and Kyffin managed to socialise with many of his friends and distinguished guests. He appeared to have an abundance of energy and must have crossed the gallery space dozens of times for photographs, and congratulations from friends, fellow artists and other guests. As the private view drew to a close, and with all the guests departed, staff said their goodbyes to Kyffin in the reception area. By the entrance door he peeked outside to take note of the weather. He then rolled up his jacket collar against the chill of the night air, and after a quick 'Nos da' to Denise Morris and John Smith, he dashed from the gallery to his car in his usual bounding gait. His fitness, even at seventy-five years of age, was impressive.

Over the next few weeks he needed his energies to attend the exhibition, as it proved to be one of the most successful held at Oriel Ynys Môn. His many followers were always delighted to see him at the gallery. This interest in his work also delighted Kyffin, as previously at the age of seventy (in 1988) he had said he would not paint another portrait. Although he always felt that his portraits were amongst his most significant work, as he got older he could not stand the stress of possibly not achieving a likeness. He wanted to be free just to do his art. Clients, understandably, always wanted to see a likeness, but often, as in the case of Colonel Wynne-Finch's wife, this was a matter of personal perception. He claimed he always attempted to 'paint the truth', which was often revealed

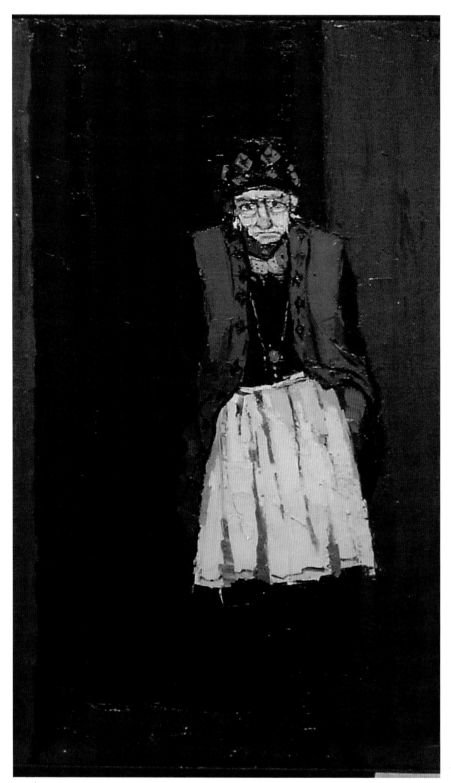

Mrs Rowlands

in his great empathy for his subjects. In fact he was obsessed with truth in his art, although he had the ability, as many great portrait painters do, to devise nuances of imbalance in his portraits that keep viewers guessing. A simple device here is the placing of his subjects low on the canvas, thus indicating a diminutive person or character. His application of impasto paint was never easy, especially in the case of delicate skin in his female portraits. He realised, in moments of palette knife pleasure, that he had walked a very dangerous tightrope between abstraction and realism. At Pwllfanogl he was asked if he had painted a portrait of his friend, Charles Tunnicliffe. He said he had not, and when asked if it would be possible to do so, he rejected the idea, explaining he always preferred to paint truthfully from the living subject.

There were occasions when Kyffin would refer to a photograph to assist with details. Mrs Rowlands, the matriarchal lady from Cefn Du Mawr, near Llanfair-yng-Nghornwy, appeared to intimidate Kyffin to the point that he only asked to photograph her for the portrait he wished to paint. To ask her to pose for several minutes, while he sketched away, would have been out of the question. It was Hugh Jones of Swtan who directed Kyffin to Cefn Du Mawr.

There, Kyffin was greeted by Mrs Rowlands's son, who took him into the farmhouse's old kitchen where his elderly mother was seated between the fireplace and window. Kyffin noted that she was around ninety years of age and wore a lace cap and heavy grey waistcoat, which hung over her pristine, naturally folded white apron. The only embellishment of her traditional, almost Victorian, Welsh attire was a brass necklace. The necklace's appendage was a crucifix that glinted in the sun above her apron. Mrs Rowlands greeted Kyffin in an unexpected way by kissing him with great affection. Her expression of bewilderment led Kyffin to realise that she had clearly mistaken him for his uncle, for whom she had great fondness. Kyffin's quest to find the grave of his Celtic ancestors was frustrated when Mrs Rowlands appeared reluctant to reveal the ancient burial place. She intimated that the former tenant of the nearby smallholding, Rhydybeddau, a Mr Peters, who was always in need of money for drink, had a terrible experience when he searched for the grave. During his digging he had heard the persistent sound of rattling chains, which Kyffin considered 'Was probably due to his advanced condition'. Kyffin persisted in his quest and asked Mrs Rowlands where the bodies were buried, until in a stern but mocking mood she whispered to him in Welsh 'Dan y domen dail' (Under the dung heap). Kyffin must have seized the opportunity, as she stood assertively in the doorway, to absorb her character visually and to take a fleeting photograph as an aide memoir. He later felt that the finished portrait was not like her, but it still gratified him as personifying 'indomitable old age'.

Later, Kyffin mentioned to Denise Morris that Mrs Rowlands's portrait had come up for sale. Denise managed to secure enough funds for the matriarch's purchase. Mrs Rowlands's portrait has graced many exhibitions both at Oriel Ynys Môn and other galleries in Wales. She always commands the attention of visitors who somehow appear to show respect for her age and her direct, formidable look. Her eyes follow one around the gallery with an air of candour and truth, a frequent attribute of Kyffin's portrait work.

His portrait of William Lee probably epitomises this quest for truth. William was a remarkable person who had been very unfortunate in developing epilepsy after a horrific accident as a child. Later, while suffering a grand mal attack, he fell into a fire and lost an eye and badly damaged an arm. Kyffin met William at the Epilepsy Society meetings in Anglesey and, in 1982, asked him if he would like to have his portrait painted. He agreed and Kyffin duly collected him from Bodffordd and took him to his Pwllfanogl studio. After the painting was finished William, much to Kyffin's surprise, walked from the studio without looking at the finished portrait. The painting was a good likeness but Kyffin was not entirely satisfied. The following day he put a larger 36 inches x 36 inches canvas on his easel. He felt he needed to paint even more of William into the portrait, although he acknowledged that the finished work was less of a likeness. This did not disappoint him as he considered he had captured even greater qualities of William in this painting. Kyffin exhibited the work, titled *Larry*, at the RA. William was often in Llangefni, where he would always enquire with great politeness, 'How is Mr Williams keeping?' He knew Kyffin was a regular visitor to Oriel Ynys Môn. He once mentioned he did not mind the name 'Larry', and always praised Kyffin's artistic abilities. William was a kindly man with a broad knowledge and many ideas. His brother John came to the 'Portraits' exhibition that was launched on 5 February 2010, by Rolf Harris. John had his photograph taken alongside his brother William's portrait. He was a little overcome with emotion and conceded that Kyffin's portrait was a good likeness. Some artists, including Kyffin, consider that portrait painters unintentionally or subliminally reveal much of themselves in their work. This is probably why many people empathise so much with Kyffin's portraits.

One day John Smith received a call from Mr David Pugh of Abergele regarding the new edition (2007) of Kyffin's *Portraits*. David had the book brought to his attention because on the cover is a portrait of his grandfather, also David Pugh. As David junior explained, his grandfather was a very tall and proud man. He worked for the railways as a foreman and his son, Dan, had been a lance corporal in Kyffin's platoon in the Royal Welch Fusiliers at Pwllheli. The Pugh family had lived in Pwllheli for some years but

came originally from Porthmadog. David Pugh senior was also a local councillor and the secret of his fresh flower buttonhole, that Kyffin so admired and painted, was a concealed silver sheath filled with water. One day, Kyffin set off from his home, Doltrement, in Aber-erch, to cycle about a mile downhill to Aber-erch Station. The station and line were originally run by the Aberystwyth and Welsh Coast Railway and later by the Cambrian Railway. It transferred to the Great Western Railway and in 1948 to the London Midland Region. Kyffin used to catch the train from the station on a regular basis. It was convenient to travel to Porthmadog and then in the direction of Ynysfor, where he met up with Captain Jack Jones and the Ynysfor Hunt. Aber-erch Halt, as it was often called, had an old wooden waiting room with a felt roof. At an earlier time this tinder-dry hut was set on fire by sparks from a passing steam train and burned to the ground. As Kyffin cycled to the station to catch the train to Porthmadog, he realised it was just leaving the station platform. David Pugh, as foreman on the Cambrian Railway, was travelling on the train. Looking back from the guard's van he spotted Kyffin and alerted the driver, requesting that he reverse the train back into the station. Kyffin cycled along the platform and with David's assistance quickly put his bicycle into the guard's van. David, with a characteristic ruddy complexion, was smiling broadly and commented: 'I wouldn't have done that for anyone else.' Kyffin noted that the railways were happy in those days. David Pugh loved his work on the railways, and was something of a local character, with a slightly bent figure, always smiling and often proudly displaying his buttonhole flower. These features would appeal to Kyffin's sociable nature, particularly as a portrait painter. It is also pleasing that the portrait is still admired today by David Pugh's family.

Kyffin's 1993 'Portraits' exhibition was a significant occasion for the establishment of Oriel Ynys Môn as one of the best art galleries in North Wales, with extensive praise coming from the media, and with its annual visitor figures rising to over 65,000.

Hendre Waelod, Cwm Nantcol

15

Unearthly Chills and Vibes
but Calm at Cwm Nantcol

I N LATER LIFE KYFFIN revisited places that had inspired him with their beauty
and ambience. Often these were recalled from his childhood or youth, places such
as Moel y Gadair, the low hill near his former home of Plas Gwyn, Pentrefelin,
with its panoramic views of Aber Glaslyn, the Moelwyns and Rhinogs, and the long
sweep of Cardigan Bay. Kyffin's interest in the countryside as a boy was encouraged by
his father, Henry, who introduced him to many interesting places and wrapped them in
their histories and legends. Henry, Kyffin, and his brother Dick often travelled in a rickety
pony and trap (frequently held together with string) to the more remote parts of Anglesey.
One such location, when the Williams family were on holiday near Church Bay, was
Llanfair-yng-Nghornwy with its spectacular views of Holyhead Harbour, Ireland and on
a clear day, the Isle of Man and distant Cumbria. These images of Anglesey and Gwynedd
would be indelibly set in the mind of Kyffin and evocatively linked with his eventual
success as one of Britain's most iconic painters.

After leaving Shrewsbury School aged 17, Kyffin was indentured by his father to
Yale and Hardcastle the Pwllheli-based land agents. The company acted on behalf of
many large estates in the Pwllheli, Porthmadog, Llŷn and Anglesey area. Lord Harlech
employed the firm to manage his affairs in the vicinity of Ardudwy. It was here that Kyffin
was introduced to new and spectacular landscapes in remote parts of the Welsh highlands.
One venture, to resolve a minor dispute, took Kyffin and George Yale, his principal in
the firm, into the Cymoedd of Ardudwy, the picturesque valleys near Llanbedr. The
best known of these are Cwm Bychan and Cwm Nantcol. It was to Cwm Nantcol that
Kyffin and George Yale made their way in the late 1930s to visit Hendre Waelod, an
ancient farmhouse that nestles deep in the glacial-carved cwm below Mynydd Moelfre. A
little further on, past the remote farms at the end of the cwm, Rhinog Fawr (720 m) and

Rhinog Fach (712 m) along with Y Llethr (754 m) dominate the skyline. From Hendre's elevated position, and looking to the north-west, one can see distant views of Cardigan Bay and the dragon-spine silhouette of Llŷn.

It was in Cwm Nantcol, as an emerging artist, that Kyffin would be inspired to paint some of Wales's most striking mountain scenery. In this rugged terrain, with its evidence of pre- and medieval history, Kyffin came to experience the meaning of being Welsh. To be immersed in a truly remarkable landscape, with people historically bonded to the land and speaking Cymraeg was clearly an inspiration to the young land agent. Later, when he worked in London and yearned for Wales, it was this aspect of hiraeth (longing), along with human survival, that led him to empathise with the farmers of Cwm Nantcol. Hiraeth would be a recurring theme that strongly influenced his painting after he finished his studies at the Slade in 1944, but more so when he started to teach at Highgate School

The Sweep of Cardigan Bay, near Harlech

in London. He would often refer to the changing seasons in highland Wales, with spring's plethora of flowers and summer's bounty of harvests. He would contrast this with the farmer's endeavour to survive the harsh, unforgiving highland winters. Cwm Nantcol, in comparison with its close neighbour Cwm Bychan, has few trees and can be a bitterly cold place, frequently cut off when northeasterly blizzards sweep through Bwlch Drws Ardudwy and down from the ice-encrusted peaks of Rhinog Fawr, Rhinog Fach and Y Llethr. It was in Cwm Nantcol that Kyffin began to understand these essentially Welsh nuances, particularly the farmer's relentless ancient struggles with nature. This sense of Welshness would later permeate Kyffin spiritually and artistically. He would carry this empathy throughout his life, often reflecting upon it when alone and immersed in his art. The endless striving to encapsulate and distil these feelings through his art was a metaphor for his life. In the early part of his career as an artist, these powerful murmurings were sometimes the precursors of petit mal epileptic attacks, which frequently manifested themselves in the form of an aura. This process could also end in depression. But Kyffin adapted to these setbacks, and learned to employ such powerful emotions by channelling them creatively into many of his best known landscape paintings of Wales.

It was to Cwm Nantcol that Kyffin, Nicholas Sinclair (the artist's godson and a professional photographer) and John Smith travelled in 1995. After Kyffin's successful 1993 'Portraits' exhibition and book launch at Oriel Ynys Môn, it was decided to produce another book to commemorate his equally successful 1995 'Landscapes Exhibition'. Nicholas and John were asked by the Oriel's principal officer, Denise Morris, to take Kyffin to one of his memorable painting locations for a photographic shoot. Nicholas and John had met some years before at Kyffin's 'Portraits' exhibition in Oriel Ynys Môn, and got on well together as they were both interested in photography and art, as well as music.

Cwm Nantcol was chosen with a sense of hiraeth by Kyffin as a starting point for the project. John collected Kyffin and Nicholas from Pwllfanogl early one morning for the drive to the remote valley in Ardudwy. Kyffin was dressed warmly in a Harris Tweed jacket and a sober, well-worn green tie, and greeted John at his sea-sprayed front door with a smile. The photographic equipment was quickly gathered from the house, as Kyffin brushed past the aromatic rosemary and lemon balm herbs standing like sentinels at his gate. He loved herbs and had planted fennel all around his home and studio. In summertime the fennel stood as high as a man and appeared to grow everywhere along his shoreline in the sandy soil and among the beach pebbles. Kyffin claimed Pwllfanogl meant 'Fennel Pool'; John would tease him and say that it referred to the crenellations in the walls on the opposite side of the harbour. Kyffin would often rub his hand through

the towering rosemary bushes as he left the house, and then breathe in the lingering aroma. Entering the now loaded car, he commented on the large number of mallards, mainly drakes, inhabiting Pwllfanogl's wind-sheltered bay. The weather was remarked upon and with a chuckle from Kyffin, and acknowledging smile from Nicholas, they set off for Cwm Nantcol.

After negotiating Pwllfanogl's infamous pot-holed, tree-lined lane, they soon passed over Britannia Bridge and then travelled west to Caernarfon. Several miles further on, a little past Garndolbenmaen, Kyffin indicated where his long-time farmer friend, Ernest Naish, lived in Cwm Pennant. Kyffin often visited this location to sketch and had several other friends living in the valley. One of his favourite locations for sketching was the winding road up to the Old School House in the cwm. Kyffin would often quote the poet Eifion Wyn: 'Pam, Arglwydd, y gwnaethost Gwm Pennant mor dlws, a bywyd hen fugail mor fyr?' (Oh Lord, why did you make Cwm Pennant so beautiful, and the life of an old shepherd so short?) Driving on, in a southerly direction, they soon reached the high ground above Tremadog, where the panoramic view revealed the distant profile of Ardudwy, with Harlech Castle standing out like a sentinel in the morning sunlight. Passing through Tremadog, Kyffin mentioned that Lawrence of Arabia, Thomas Edward Lawrence, was born here in August 1888, the illegitimate son of Sarah and Sir Thomas Chapman. Chapman left his first wife, and his Irish baronetcy, to live with Sarah Lawrence, and also adopted her name. The family fled the village of Tremadog one night under the cover of darkness, pursued by angry shopkeepers who were owed money. Kyffin revealed that they were apprehended near Afon-wen station. As Thomas was born in Wales he was eligible to study at Jesus College, Oxford, where Kyffin's many relatives had also studied.

After negotiating a bustling Porthmadog, the cob embankment was crossed. Here it was noticed that Kyffin, almost with one eye closed, was peeking left at a mixed flock of mute swans and waders that had congregated in the brackish tidal shallows. He informed Nicholas and John that this was once a great tidal estuary called Traeth Mawr, stretching from the sea to the far-off reaches of Aberglaslyn and the ancient island of Ynysfor where his friends, the Jones family, lived. Before Madocks's 1811 embankment construction this was a treacherous place where many souls were lost crossing the wide, quicksand-infested estuary from Llanfrothen to Tremadog.

At the next village, Minffordd, Kyffin indicated, in a low voice, where the London-based artist, Manfred 'Fred' Uhlman, used to stay in a cottage close to Portmeirion. The journey to Ardudwy continued and a little further on Kyffin announced 'Take the short

cut!' John braked and turned sharp right in Penrhyndeudraeth, and slipping quickly past the church, they headed toward Pont Briwet, an old wooden toll bridge. The tollgate keeper eagerly collected the fee and commented on the weather, 'Mae hi'n braf' (It is fine). Kyffin responded with 'Ydy' (It is) and 'Hwyl' (Cheerio). The car rumbled across Afon Dwyryd's estuarine bridge as oystercatchers sheltered in the lee of rushes and mallards preened on the tidal sandbanks. By now, and with the piping of disturbed waders in the air, Kyffin stirred a little more from his morning repose.

On the winding road to Harlech he began regaling Nicholas and John with local Ardudwy stories and legends. His vast knowledge, gentle smile and witty embellishment of these tales revealed his essentially artistic world and wistful outlook. Harlech was, typically, bathed in sunshine and busy with tourists. Further on, Kyffin indicated where to turn left in Llanbedr, near the old Victoria Inn. Very soon, after a few bends in the country lanes, they came to Capel Salem, Cefn Cymerau, nestling in a hillside clearing,

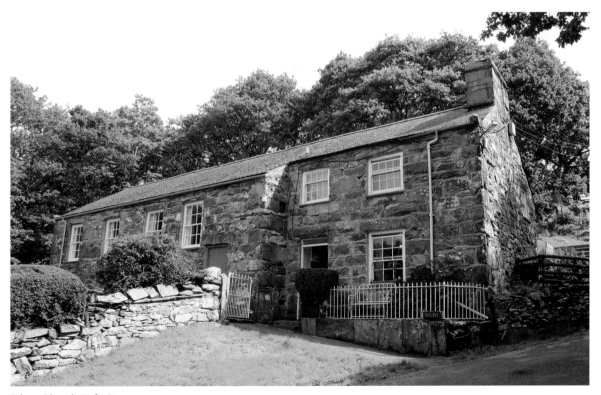

Salem Chapel, Cefn Cymerau

protected by ancient oak woods. Kyffin mentioned *Salem*, Curnow Vosper's famous painting of the 1851-built chapel. Vosper's nostalgic 1908 depiction of local people shows Siân Owen in her ornate borrowed shawl, with other chapel-goers who posed at 6d (2.5p) an hour for the artist. The finished work was exhibited at the Royal Academy of Art, where it was purchased by Lord Leverhulme for £100. Kyffin added that it was a great deal of money at the time, and the painting had since been displayed in the Lady Lever Art Gallery on the Wirral. Following their brief glimpse of the isolated chapel, the three drove onward and upward towards the lower reaches of Cwm Nantcol. Here fast-running streams scythe through ancient peat bogs and tumble down rocky waterfalls on their way to Cardigan Bay. This is a bucolic valley, occasionally frequented by nimble-footed feral goats, where bumblebees and other insects vie for the blossoms of sparse, wind-bent hawthorn bushes.

Here and there in the valley drifts of purple loosestrife and occasionally willowherb brightened the marshy stream margins. The car slowed a little on the narrow, winding lane, as a startled ewe leapt forward attempting to escape an entanglement of brambles. Kyffin was by now fully alert and craned his neck to see what the commotion was, and sighted a group of sturdy, crossbred cattle grazing up to their bellies in the marshy undergrowth. One could sense him composing a painting of this scene, with the Rhinogs in the background wrapped in a blanket of clinging cloud. A little further on a stop was made at the picturesque bridge, Pont Cwmnantcol. Kyffin, while relaxing years later at Pwllfanogl, lucidly described the bridge, waterfall and rapids, which are mantled by an ancient gnarled oak, as if he were conjuring up a painting in his mind. It was at Pont Cwmnantcol that Charles Darwin passed on his 1831 trek surveying North Wales. Darwin recorded the bedded rock at Pont Cwmnantcol and later, in 1880, his survey was compared with a similar survey made at the same spot by Kyffin's great-uncle, the geologist, Andrew Crombie Ramsay. Kyffin's knowledge of the area was remarkable as, with a nod of his head, he indicated, in the shadow of the Rhinogs, the birthplace of John Jones (1597-1660), the regicide, who was present when Harlech Castle fell in March 1647. Jones was born here, in Cwm Nantcol, at Maes y Garnedd. Jones acted as the first of six signatories to the death warrant of King Charles I. In 1656, he married Protector Cromwell's widowed sister, Catherine. Arrested in Dublin in June 1660, he was hanged, drawn and quartered at Charing Cross, London on 17 October as a regicide.

Further along Cwm Nantcol was the distinctive red telephone kiosk aglow in the morning sunshine. With the Rhinogs visible in the distance, Kyffin, Nicholas and John soon arrived at Hendre Waelod. This remote farmstead was owned by Meurig Jones,

Cwm Pennant

who Kyffin knew well from his many painting visits to the area. Kyffin showed Nicholas his favourite spot where he would sketch the farmhouse and adjacent shippons. He indicated that the best views were from below the farmhouse, with the old buildings to each side. His rapidly sketched compositions, he explained, were initially created at this location and finalised as paintings in his studio. His sketches, he claimed, were best done with little detail as this allowed his memory and creative spirit to take control in a more artistic manner when painting in the studio. His completed paintings of this location often excluded most of the surrounding landscape, except part of the mountain, Mynydd Moelfre, behind the farmhouse, concentrating instead on the robust form of the buildings' stones. Meurig Jones explained that it was these massive stones that interested Kyffin most, more so than the magnificent scenery. Kyffin once revealed that he liked the solidity of large building stones. They gave him a sense of strength and security, especially

if the house or cottage was built on high ground. This 'sense of strength', for Kyffin, also applied to similarly built houses in Cwm Pennant and Dyffryn Nantlle. Kyffin claimed, as one of his little 'secrets', that if he painted an old house on a hillside with a winding lane leading to it, he guaranteed it would always sell.

Cwm Nantcol has a rugged beauty which Kyffin was clearly influenced by and to which he responded in his art. Meurig Jones discovered Kyffin was not only attracted to the buildings at Hendre Waelod but also to the history and culture of the area. Meurig showed him an ancient inscription by the bard, Siôn Phylip, on a large slab of local rock, and now used as a gatepost in Hendre's garden. Siôn Phylip (1543-1620), a contemporary of Shakespeare, was born at this location in the sixteenth century. He is recorded as having engaged in satiric bardic flytings with Edmwnd Prys (1544-1623), who was archdeacon of Merioneth in 1576. Edmwnd lived in the next valley, Cwm Bychan, at Gerddi Bluog, where, before World War Two, Kyffin would call with Ynysfor huntsmen for refreshments. Kyffin discovered from Meurig Jones that Siôn Phylip was buried at the eastern end of the dune-enclosed coastal church of Llandanwg.

After unpacking all the photographic equipment close to Hendre Waelod, Nicholas set up his Hasselblad camera, and soon arranged Kyffin to pose with the old farmhouse as a background. The light was not perfect but a number of good images of Kyffin were produced. Kyffin found it difficult not to scan the landscape while the photographing took place. He showed no sign of impatience, but given the opportunity would probably have taken his sketch book out to draw the scene once more.

A recent visit to Hendre Waelod revealed it has undergone some changes. Meurig Jones still lives in the old house but alterations have been made to the ancient buildings and field walls. Meurig, now retired, showed how his daughter and farmer husband have sensitively converted the ancient shippon into a fine family home. There are still hints of its ancient past showing through the modernisation. In particular, medieval inscriptions chiselled into an igneous rock lintel to the rear of the conversion seem to hold ancient mysteries of their own. The driveway to Hendre is now metalled and the old boundary stone walls have been neatly rebuilt. A colourful mix of chickens and a proud cockerel still peck around Meurig's farmhouse door. Looking down from the old farm it was noticed that purple loosestrife still grows along the fringes of Afon Cwmnantcol. On our return to Llanbedr we paused to view the lower reaches of Cwm Nantcol, where cattle were still grazing sunk up to their bellies in the soft black peat, and the plaintive call of a curlew could be heard echoing down the beautiful valley. In truth, and fortunately so, little has changed in this historic place since Kyffin, Nicholas and John were there in 1995 for the

photo shoot. Kyffin was then seventy-seven and still very active physically. He seemed to stride or jog everywhere and did not think of walking. Nicholas and John were always aware of his diabetes and ensured that he had regular rest and meals on these excursions.

Some weeks later, after Kyffin's visit to Cwm Nantcol, and in connection with the 'Landscapes Exhibition' publication, Kyffin, Nicholas and John set off for Ystrad Meurig in Ceredigion. Their journey was relatively uneventful and passed quickly, and Kyffin was in a relaxed mood as he was going to see friends. Passing through Aberystwyth they turned towards Pontrhydfendigaid and after a journey of about ten to fifteen miles they reached the home of Doctors Glyn and Ann Rees, Bron Meurig Hall. Kyffin introduced Nicholas and John as they set up their equipment. Kyffin and Ann stayed in the kitchen catching up on recent activities. In the large sitting room the preparation for photography took a while, so John went for a walk along the hallway towards the kitchen area. As he passed the stairway that leads to the first floor he felt 'a chill and an unusual presence'. It was a bright sunny day outside, although this part of the house had little light. John thought no more of it, but was a little wary when he returned a few minutes later. Uncannily, he experienced the same feeling again as he passed the bottom of the stairs and this time glanced up to the first floor to see if there was anyone there. He saw nothing and carried on to the large room where Nicholas was already photographing. Hesitant at first, John mentioned to Nicholas his strange experience. Nicholas was a little surprised and laughed; then said that he had also experienced a similar feeling in the room at about the same time. They both laughed the 'incident' off and continued with their tasks.

At lunchtime an excellent meal was prepared by Dr Ann, which Kyffin always enjoyed. After packing all the equipment away and saying their goodbyes, they set off for Anglesey. During the journey, Kyffin was told about the incident at Bron Meurig Hall. He appeared quite amused, but it was thought he would be dismissive of any notion of a presence at his friends' home. Instead, he began telling of a similar experience he had had when staying at the house some time before. It was understood that he would not stay in one particular room at the house, and that he had also had a vision of an old lady with white hair near the stairs, who he mistook for Dr Ann. Ann appears to have been well aware of this phenomenon and felt it was all quite natural. On another occasion at Pwllfanogl, Kyffin mentioned this incident again and recalled the area around Ystrad Meurig as having an interesting history and a number of legends.

Kyffin appeared quite unemotional about the potential of the paranormal in *Across the Straits* where he described spending the night at Treffos with his Aunt Sisli. She was quite used to the appearance of an apparition at the old Williams ancestral residence. This

phenomenon invariably occurred at night. On one occasion when Kyffin was with his aunt on New Year's Eve, she woke from slumber at the stroke of midnight to enquire if the ghost had been. Kyffin was surprised and dragged himself from his reading material, endless copies of *Horse and Hound*. He explained to his drowsy aunt that he had sensed absolutely nothing. He was puzzled that his Williams ancestors could be haunting Treffos. On occasions, though, he did sense certain mysterious events, but these may have been linked with premonitions he experienced before a petit mal attack. He had a particularly galling period of these in the late 1940s at Highgate School. At times, items appeared to fly up at him from the pages of newspapers, which frightened him greatly. Occasionally, he asked friends if they could feel a presence at Pwllfanogl. When asked what type of presence, he would explain that the house was once an old inn, the Boat Inn, and perhaps there were still some old sailors' spirits around. Of course, this could also be linked with Kyffin's tendency to tease at times. He was a tremendous leg-puller and many friends fell for his mischievousness. In a similar vein, Kyffin's good friend Nesta Davies recalled a story he told her about an incident at Cefn Gadlys, Llansadwrn. It was at Cefn Gadlys that he somehow acquired the Williams family coat of arms from Treffos, which depicts choughs. This heraldic emblem has been used by his family for centuries. Kyffin, while at the Slade, also used the crest form – a chough holding a fleur-de-lys in a clenched claw – in his 1942 design for his father's gravestone at Aber-erch. Unfortunately, Kyffin, shortly after obtaining the Williams coat of arms from Treffos, started to detect 'unusual vibes'. This situation worsened and after a while disturbed him considerably, so he returned the emblem to Treffos.

The Williams family coat of arms on Kyffin's
father's grave, Aber-erch

Books and Works of Art

K YFFIN WAS AN ATTRACTIVE prose writer as is evident from his highly readable autobiography *Across the Straits*. In an article in *Book News*, the Welsh Books Council publication (Spring, 1992), Kyffin wrote:

> I was lucky to have been born into a family that had enough money to live in a reasonable manner but not enough to indulge in too many luxuries, nevertheless my father was always ready to give me the money to buy a book if he felt I needed it. So at an early age, I got into the habit of buying books and treasuring them, but it was only gradually that I began to realise that they could become works of art.

No doubt the brilliant illustrations of Archibald Thorburn, Charles Tunnicliffe, Cecil Aldin and Lionel Edwards, mentioned by Kyffin in his *Book News* article, influenced him and directed him from youth to the point when, later in life, he was to illustrate many books himself, especially several Gregynog Press publications, such as *Cutting Images* (linocuts) and *Two Old Men*, based on the work of Kate Roberts. Kyffin's linocuts also illustrate the book *Kyffin: a Celebration*, edited by Derec Llwyd Morgan, also published by Gwasg Gregynog.

The infinite variety of his writing always ensures the reader's full attention. He delights in dialogue. He can be serious, but he can be extremely humorous. His two volumes of autobiography, *Across the Straits* (1973) and *A Wider Sky* (1991), reveal him as a master of the genre. As in his paintings, there is light and shade, there is mood, and a pervading sense of the author's honesty.

But Kyffin would also use the written word extensively in his work as an artist. In 1979, he wrote a masterly catalogue essay for the 'Native Land' exhibition at the Mostyn Art Gallery, which was an exhibition of artists' work from 1699-1979 celebrating the landscapes of North Wales:

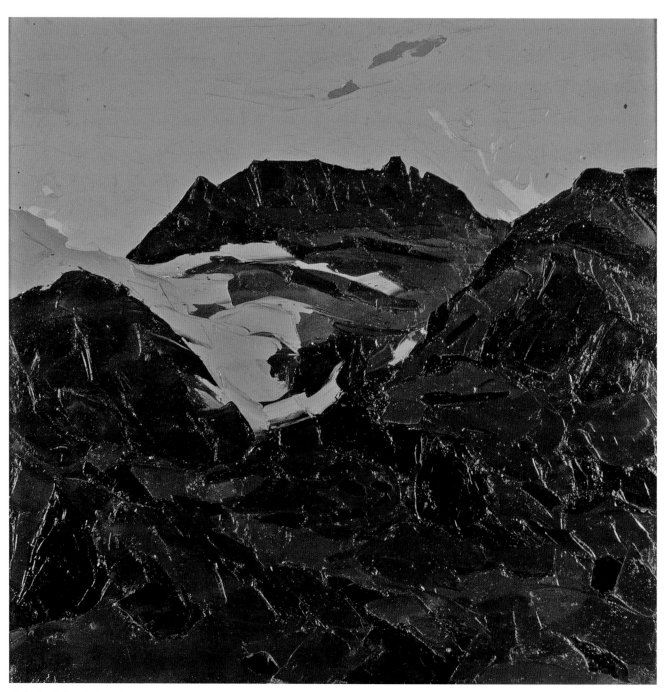

Grib Goch from Nant Peris

It was during the middle years of the nineteenth century that the landscape of North Wales became less remote and consequently less romantic to the enthusiastic English artists. No longer did they have to travel by coach, on horseback and on foot, bearing uncomfortably the paraphernalia of their trade, for the railways were opening up the countryside and access to the mountains of Gwynedd became easier and the expeditions less of an adventure. The Romantic period had ended and a quiet complacency began to permeate the Welsh landscapes of the Victorian painters. The Conwy Valley was the area most favoured by artists in the middle of the century and David Cox and Benjamin Williams Leader did much of their work there. The many painters working in the valley formed the most prestigious group in Wales and from it emerged the Royal Cambrian Academy whose one-time President, Augustus John, made his own contribution when, together with his friends James Dickson Innes and Derwent Lees, he came to the Bala and Ffestiniog areas, at the beginning of our own century.

Innes came from Llanelli and Lees from Australia, but all three were carried away by a romantic artistic fervour that produced some remarkable paintings. The vision was that of Innes, the colourful optimistic vision of a consumptive, but the greatest talent was that of John who unashamedly aped the style of his fellow countryman. To North Wales they brought their girls and posed them on rocks, on slate tips and on the shores of our lakes. The sun always shone, the sky and the lakes were invariably blue and the grass was an emerald green, while in the paintings of Innes the peaks of Arennig took on a roseate hue. The works of Van Gogh and Gauguin had begun to excite young artists in Britain and it is possible that their exuberant colour and their more direct reaction to landscape had influenced, not only the three friends, but Christopher Williams as well.

After World War One more and more artists came to North Wales and made us aware of their own interpretations of our mountains. Stanley Spencer pushed a pram, laden with paints and canvasses, through our countryside and his *Snowdon from Llanfrothen* could only have been created by someone from the Thames Valley, so gentle is the statement and so undramatic the paint. In contrast, John Piper, almost an honorary Welshman, concerned himself with the wildness of our landscape and was always conscious of the geological contortions that lay beneath it. He has returned continually to draw our rocks, our ridges and our screes. John Petts has also been fascinated by the structure of our mountains and has drawn them with remarkable accuracy. These are some of the many Englishmen who have been drawn towards our land, but there are others from further away who have added to the variety of vision that makes the artistic record of our countryside so remarkable. Fred Uhlman has

clothed our land with the mystery of Caspar David Friedrich, while David Bomberg has seen the Carneddau through the eyes of a German expressionist.

All these artists have worked in our countryside because of its beauty and because of the extraordinary variety of its landscape. Anglesey is so unlike the rest of North Wales, for it has been worn down by the passing of time and its rocky outcrops show us continually the complexity of its structure. Across the Menai the old county of Caernarfon is dominated by the presence of Snowdon, for wherever you may be, in Lleyn, in Eifionydd or in Gwyrfai, we relate ourselves to it.

The view of Snowdon from the Traeth at Porthmadog must be one of the grandest in Europe and I do not believe that it has ever been painted satisfactorily. It is a breathtaking panorama. From the Tremadoc rocks to the west our eyes are brought in a sweep eastwards to Moel Ddu, Moel Hebog and down into the wooded gorge of Aberglaslyn. Behind rises Yr Aran and beyond it, and above, the great peak of Yr Wyddfa from which the Bwlch-y-Saethau reaches out towards Lliwedd. Through the gap that is Nantmor, the distant Glyders can be seen before the sinister rocky Arddu, the pointed Cnicht, and the grassy slopes of the Moelwyns complete the semi-circle of mountains. Perhaps it is too grand a view for an artist to contain on a single canvas.

Meirionydd is never dominated by Cadair Idris, and even if it cannot compare in magnificence with Eryri it is nevertheless more remote and broken by many more wooded valleys. The old farmhouses are usually finer and the stone walls bigger and more sinuous as they climb the mountainsides. Further south in Powys the mountains give way to grassy whale-back hills, behind which, undistracted by broken ridges, the sky becomes more important and more obvious.

Artists have passed through the more diffident landscape of Powys and Clwyd in their rush to reach the dramatic landscape of Gwynedd. Richard Wilson painted the Vale of Llangollen, Paul Sandby, the Abbey of Valle Crucis and David Cox created some of his loveliest works on the sands at Rhyl, but for the most part the gentler land of North Wales is still unrecorded and the beautiful landscapes around the valleys of the Clwyd, the Ceiriog and the Tanat are almost unknown to the artist. Moreover most of our artist visitors have come to work during the summer months and have missed the days when our land is at its most paintable. In mid-winter the mountains are at their noblest, in the spring the bright yellow leaves of the trees shine vividly against the cold mountainsides, and in the autumn a magnificent melancholy broods over the land. Always we have our changing weather with us, for the wind and the rain, the snow and the frost, are as important to us as the sun and we can love even the sea mist that creeps in from Ireland bringing mystery to our hills.

Artists who have come to North Wales have been valued guests for they have made us conscious, in many different ways, of the beauty of our land and it is heartening to know that today more artists than at any time previously, whether Welsh or from further afield, are working among us making their own contribution to the praise of our countryside.

Kyffin developed the practice of writing about his paintings for exhibition catalogues (e.g. Albany Gallery exhibition catalogues) with great effect. The following examples, written in his highly individualistic, immediately recognisable handwriting, added greatly to the value and usefulness of the catalogues:

Narcissi
I have always painted flowers although I have seldom exhibited my paintings of them. After the rose I believe that I love the daffodil, the narcissi and the jonquil the best. Maybe the arrival of spring has something to do with it.

Storm Tre-Arddur
As a small boy I spent six years in a preparatory school above the bay, and that is where I absorbed the changes in the sea as it broke on the sandy and rocky shores. I loved the storms when the windows rattled and surf blew wildly across the fields below the house. Ships were washed ashore on the jagged rocks and we rode on shaggy ponies along the cliffs to see them. Yes, it was the storms that meant most to me.

Cloud over Crib Goch
I can watch for hours as the clouds leap and swirl around Crib Goch. I like them when they almost obliterate the mountain, I like them when the sun bursts through them above the ridge, and I like them as, wispy and transparent, they seem to play around its rocky crest.

Tyddyn Gopyn
Tyddyn means a small farm and Copyn is the Welsh for a spider so it exercises the mind somewhat to imagine how it got its name. [In a letter to Kyffin, Dafydd Islwyn was able to throw light on the word 'copyn', explaining that in this instance it 'did not mean spider but came from the word 'cob', as in 'cob malldraeth'.] It is a small stone cottage built on the southern side of Mynydd Llwydiarth with a glorious view

of the whole range of the Caernarfonshire mountains. In the woods behind are foxes, and red squirrels fight a rearguard action against the more aggressive greys.

Penrhyn du

I loved this old farm at Aberffraw with its big chimneys and the wonderful view across to the mountains of Gwynedd, but the landlord has turned three small farms into one large one so that consequently two houses had become redundant and Penrhyn du has been demolished. I painted this picture after the destruction as some sort of memorial to the lovely old farm.

Low Tide, Llanddwyn

The shore at Llanddwyn is immense and stretches for two miles along the north side of Caernarfon Bay. From there we can see the whole of the Coast of Llŷn as it tumbles westward towards Ynys Enlli. I have painted watercolours on this windy shore that have been improved by the wind-blown sand that gave an interesting texture to the work.

We can see from these notes that Kyffin worked hard not only as a professional painter, but as a promoter of his own work. Indeed, he saw it all as one package, completing a painting in time for an exhibition, and in plenty of time for his collection to be framed, which he personally had to pay for. The promotional notes had to be written, and one or more of the paintings had to be made into prints. The proofs of these prints then had to be approved by him and a certain number signed in pencil. It was relentless work which Kyffin carried out with great panache.

In Defence of Art –
The Great Retrospective

At the moment, art is in such a terrible state, it's at some sort of crossroads; there's a conscious attempt by evil-minded people to destroy all tradition in art, because they believe that tradition is holding the future of art back. What these idiots do not understand is that art, or the tradition in art, is the outward expression of humanity and they're trying to kill humanity and there's no humanity in what is considered to be the new art of today now at all!

KYFFIN WROTE THIS IN *Kyffin in Venice* in 2006. He was on a personal mission to defend art. He despaired that huge sums of public money were being wasted on garden sheds and unmade beds, which he compared to throwing money into the Irish Sea from a cliff face at South Stack in Anglesey.

It angered him that so-called art exhibitions were being held at Welsh art galleries, such as the Mostyn Art Gallery in Llandudno; exhibitions which at one time very often comprised two flickering television monitors in large empty rooms showing similar scenes of inane objects performing inane acts empty of meaning. Having done so much to support the arts and crafts activities of the National Eisteddfod, he was increasingly alarmed at the deteriorating standards of the annual Arts and Crafts exhibition. In 2004, one of Kyffin's friends reported to him that during a visit to the eisteddfodic exhibition he had, without thinking, while looking for a pencil or biro to complete a survey form, picked up what he thought was a pencil from a wooden plinth in the exhibition hall. There was a shout of disapproval from one of the officials: 'Don't touch that, you're destroying our exhibition!' The wooden 'pencil' was false, but looked like a Venus HB6! In a letter to his friend, Kyffin gives his humorous response:

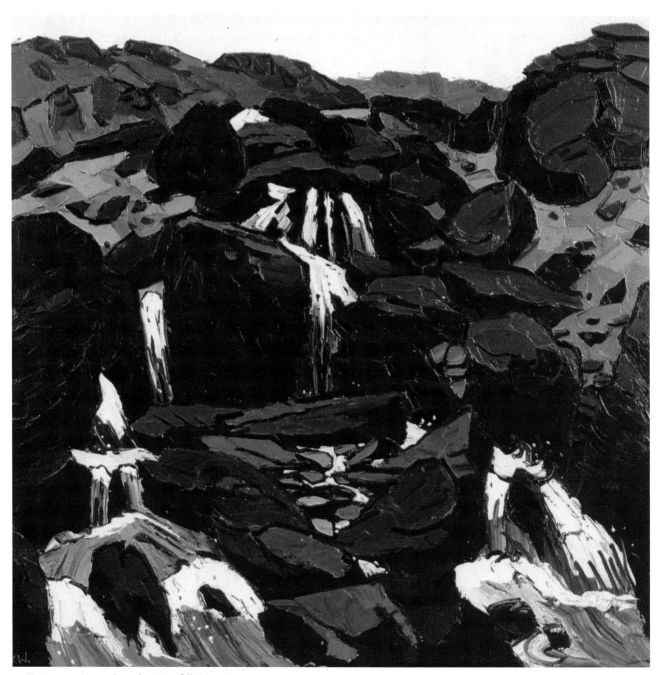

Kyffin's magnificent *Cwmglas Waterfall, Nant Peris*

I am most grateful to you for sending me the information catalogue of the Arts and Crafts at the Eisteddfod, for now I realise the true value of modern art and also realise how wrong I have been in deriding the adventurous artistic geniuses of today. How insensitive of you to mutilate the masterpiece of the pencil!...I feel inclined to increase my criticism of the contemporary art scene rather than diminishing it and let these idiots tear me to pieces in the *Western Mail* and elsewhere.

Cofion Diawledig

Kyffin

Kyffin was never afraid to voice his opinion, and he was never afraid to challenge the authorities, when he thought that the arts were being wronged. His suggestion, while a member of the National Museum of Wales Art Advisory Committee, that they should purchase a painting by Gwen John, was met with the comment that she was of little worth. Kyffin persevered, however, and finally a Gwen John was purchased by the museum. During the 1970s and 1980s, he had several clashes with the Welsh Arts Council (especially with Peter Jones, the council's art director). Struggling artists in dusty garrets were supported financially while successful artists like Kyffin were not. Interlopers, such as many members of the 56 Group of artists, were invited by the Arts Council to represent Wales abroad; Kyffin was not. Arthur Giardelli, chairman of the 56 Group, was venerated by the arts officers of the council, Kyffin was not. They did not seem to realise that the farmhouse on the side of the mountain, much derided by the small city clique at the WAC as a stereotypical Kyffin image, had so much human power to it – or that it meant so much to Kyffin and to those who admired his art, who knew the inhabitants of those farms and cottages and lonely valleys.

It was especially galling for Kyffin to witness such posturing on the part of Peter Jones and his officials at the WAC. After all, Kyffin, who had lived in London for over thirty years, had witnessed numerous artistic trends and fads, in fashion, in painting and design – and he had seen them all come and go like the tide in Trearddur Bay.

Relations between Kyffin and Peter Jones came to a head in 1981 when Kyffin decided that enough was enough, resigning from the board of management of the Mostyn Art Gallery in Llandudno after giving his all to the development of the arts, especially in North Wales.

In a letter to Professor Alun Llywelyn Williams, chairman of the North Wales Association for the Arts at the time, Kyffin writes:

<div align="right">
Pwllfanogl

Llanfairpwllgwyngyll

19.3.81
</div>

Dear Alun,

I feel the time has come for me to resign from the Board of Management of the Mostyn Gallery . . .

I understand from Mr Llion Williams that Mr Peter Jones of the Welsh Arts Council was unhappy that I should be a member.

Consequently as I knew of the persistent prejudice against me it has not been a particularly happy time for me over the last few years.

I decided that if I was to resign it would be at a time of my own choosing. I feel that now is that time and that after 1st April I will no longer be a member of the Board of Management.

<div align="center">
Yours ever

Kyffin
</div>

Kyffin would suffer further insults from the Arts Council. He remembered fellow artist John Elwyn and himself being invited to be the art judges at the National Eisteddfod at Cardigan but that the Arts Council decided that they were only there to judge the children's art, bringing in an artist from abroad to adjudicate the main work.

Dr Meic Stephens would later note in his obituary for Kyffin in *The Independent* that the Welsh Arts Council had 'neglected him for many years'. Meic Stephens also noted that Kyffin in turn was not averse to expressing acerbic views about such bodies as the Welsh Arts Council but 'curiously' Kyffin had 'depended so much on official and corporate patronage'.

In one of his many clashes with authority Kyffin was also appalled that one of the keepers of the National Museum of Wales didn't even look at a magnificent animal sculpture in bronze by Welsh sculptor Ivor Roberts-Jones which Kyffin was proposing to leave to the National Museum in his will. Kyffin regarded Ivor Roberts-Jones's work as 'some of the finest in Europe'. He fought, but without success, to have a major exhibition of his work in Cardiff. Ivor was responsible (after experiencing opposition from Lady Churchill) for the magnificent sculpture in bronze of Winston Churchill in Westminster. On that occasion, it was Kyffin's army greatcoat with Kyffin wearing it, that Ivor used as a model.

Kyffin once said that he got on with the keepers of art at the National Museum even though he disagreed with them very much, but that they were nearly always English and

didn't really understand the needs of the Welsh people. It angered him greatly that figures such as Richard Wilson of Penegoes, Machynlleth, Thomas Jones of Pencerrig, near Llandrindod Wells, and John Gibson, the sculptor from Conwy, who Kyffin believed 'came from an Anglesey family', were not given pride of place as Welsh artists at the National Museum of Wales.

However, the genius of John Kyffin Williams could not be denied. In March 1987, Jeremy Theophilus, director of Oriel Mostyn, and David Dykes, director of the National Museum of Wales, mounted a large retrospective exhibition of Kyffin's work at the National Museum. A total of 131 paintings were displayed. The exhibition was officially opened by the then Secretary of State for Wales, Nicholas Edwards, whose father, Ralph Edwards, had been one of Kyffin's very early supporters. It was a glorious exhibition of art, featuring landscapes, seascapes and portraits; with work in oil, ink wash, watercolour, linocuts, pencil and watercolour, ink and gouache, and pencil; and paintings of Wales, Venice, and Patagonia. The Mostyn and the National Museum had prepared a well-researched brochure with Kyffin's majestic painting of the *Cwmglas Waterfall* in oil on the cover, and a masterly introduction to Kyffin's life and work by his friend, the poet and BBC documentary producer, John

Bust of Kyffin by his friend Ivor Roberts Jones. Oriel Ynys Môn

Ormond. Ormond wrote: 'Kyffin Williams is often concerned with the grandness and wildness of nature, he is temperamentally a kind of belated half-brother to Turner…he is at one with the spirit that runs through the great traditions of Welsh elegiac poetry, of lament and human effervescence and in salute of the courage it takes to endure at all.'

> Felly'r byd hwn, gwn ganwaith,
> Hud a lliw, nid gwiw ein gwaith.
>
> (That's the world, I know it well,
> Magic and colour, our works of no avail.
> > (Siôn Cent, fifteenth century)

This remarkable exhibition was sponsored by HTV Television and Barclays Bank in Wales.

Kyffin at National Museum of Wales Retrospective
Exhibition, 1987

Many distinguished figures in Welsh society attended the opening in Cathays Park, Cardiff. Unknown to the majority of guests, however, there had been serious friction in the build-up to the exhibition. The National Museum had suggested that it should be held at the much smaller and less prestigious venue of Turner House in Penarth, on the outskirts of Cardiff. Had it not been for the determination of Llion Williams, director of the North Wales Association of the Arts, the National Museum would have won the day.

Kyffin had another battle on his hands when he arrived at the museum to find that the exhibition had been hung without consulting him. The result was that the oil paintings were hung in shadow and the watercolours in the light, the exact reverse of what Kyffin would have wished. Why the keeper of art at the time had treated him in such a fashion was beyond Kyffin's understanding, but it was indicative of the National Museum's haughtiness at that time.

Kyffin regarded being made a Royal Academician 'the only thing of any importance really that ever happened to me in my life'. He regarded the Royal Academy as 'terribly important' because people went there and saw and bought his pictures. So he was disappointed that his 1987 retrospective in Wales was not accepted by the Royal Academy, and that they didn't reply to any of his letters for five years. He believed the academy at one time was too keen to exhibit the 'very, very avant-garde'. He believed that if an academy was truly an academy, one of its roles was the preservation of artistic skills, but that the modern work it was then committed to showing was totally unskilled.

Conversations with Kyffin frequently began and ended with an attack on modern art. He believed that 'Modern art is so wrong because it is self-conscious, modern art should be subconscious, it should be in touch with the world around you and come out without thinking, shouldn't be superimposed on something in a self-conscious way – my paintings are subconscious…my mind is like a capacious bucket into which all my experiences have been poured…I have an unusually vivid memory…the colours of Wales are somehow a part of me by now.'

Returning to modern art, Kyffin observed that 'most of modern art is thoroughly bad, you cannot destroy tradition'. He even went further, suggesting that 'there is no such

thing as modern art, from the beginning of time to the end of time there is only good, bad and indifferent art.' In spite of his public attacks on modern art, Kyffin did not want to be regarded 'as an angry old man', yet he felt compelled to make his point, and because of his popularity, ample opportunity arose in the media to make his voice heard. He had not been alone, however, in his criticisms of the Welsh Arts Council. In a debate on the arts in Wales by the Welsh Grand Committee as early as December 1977, Nicholas Edwards, MP for Pembroke, speaking in the Commons said: 'I hold the view that from time to time the Welsh Arts Council has made mistakes, that it has supported pretentious rubbish and encouraged some whose talent will not be acknowledged by later generations.'

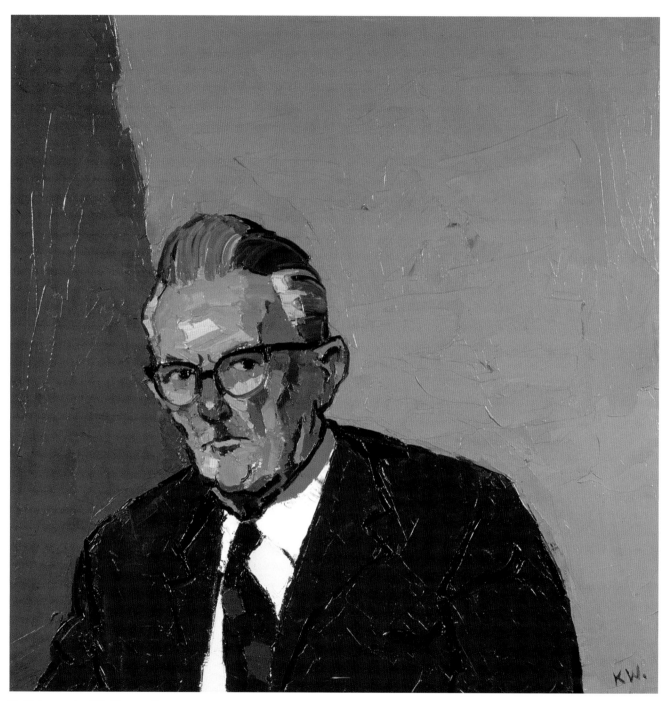

Kyffin's portrait of Sir Thomas Parry

Kyffin and the National Library of Wales

THERE WERE TWO national institutions in Wales that Kyffin felt great affinity with, the National Museum of Wales in Cathays Park, Cardiff, and the National Library of Wales in Aberystwyth, high up on Penglais Hill looking out over the town and Cardigan Bay.

At the National Museum, Kyffin served on the Arts Advisory Committee; he was a member of the Court of Governors at the National Library. Of the two there is no question that Kyffin gained greater professional satisfaction in dealing with the National Library. Being involved in constant verbal clashes at the museum was a great strain. Kyffin should not have had to fight the museum for recognition of the Welshness of some of Wales's greatest painters and sculptors, such as Richard Wilson and John Gibson, and he certainly should not have had to fight to persuade the museum to purchase a painting by an artist whose work could be 'set alongside Chardin and Corot' – a painting, as Kyffin often said, by one of the foremost women artists of the twentieth century, Gwen John. What was the point of a national art collection at the museum if the work of such an artist was not secured for the nation?

By contrast, Kyffin's advice on artistic matters was readily accepted by the National Library authorities, and in turn Kyffin directed a great many national treasures from various quarters there, as well as donating his own gifts to the library's safe keeping. On occasion, much to Kyffin's annoyance, those donating gifts in their will would get confused between the two institutions, with the National Museum benefiting by mistake as a result. On 9 May 1998, when Kyffin was eighty years old, the National Library held a function in his honour, in the form of a retrospective exhibition, 'Sir Kyffin Williams OBE RA – The Artist at 80'. This was the background to words of praise by the president of the National Library, Dr. R. Brinley Jones, together with a special piece of light verse to celebrate his birthday, written and read by Professor Derec Llwyd Morgan, former

principal of University College of Wales, Aberystwyth, and a member of the National Library Council. Professor Llwyd Morgan, later became chairman of the Kyffin Williams Trust, and he and his wife – the author Jane Edwards – were personal friends of Kyffin. It was particularly appropriate that the National Library should honour Wales's greatest artist, for Kyffin had been a friend of the library throughout his long career, and it was to the library that he turned when the National Museum refused his Patagonian collection in the early 1970s. It was also the library that benefited from his substantial and extensive patronage when he donated many hundreds of his works of art as part of his final will in 2006. Simply put, Kyffin felt at home at the National Library, where he was always made welcome and where his opinions were appreciated. He said on many occasions that 'the library has been very good to me'. Successive presidents and national librarians, as well as the staff of the library in various departments, were always helpful and supportive. However, it was typical of Kyffin's generosity that he also donated in his will some of his possessions to the National Museum. He always had to put things right.

National Library of Wales, Aberystwyth

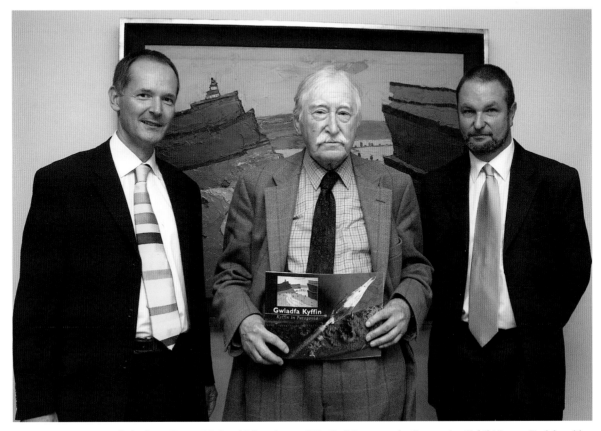

With Andrew Green, National Librarian, and Dr Paul Joyner at the Patagonian Exhibition at Bodelwyddan

In the elegant room at the National Library where the trustees of the library hold their regular meetings, the walls are lined with portraits of the library's presidents since its founding by royal charter on 19 March 1907. Sir John Williams, the first president, whose gift of his vast collection of books was the foundation of the library, was painted by Christopher Williams. The portrait of Sir Herbert Lewis MP, whose 'persistent advocacy' secured public grants for the establishment and maintenance of the library, was painted by M. Forbes, Lord Harlech by Ivor Williams, and Lord Davies of Llandinam by Murray Urquhart, while Dr Elwyn Davies, Professor J. Gwynn Williams and Dr Brinley Jones were all painted by David Griffiths. Griffiths also painted the portrait of Lord Dafydd Wigley of Caernarfon, who retired as president in 2011 and who was succeeded by Sir Deian Hopkin. One portrait stands out amongst all these elegant, impressive portraits,

that of Sir Thomas Parry painted by Kyffin Williams. Llion Williams, former director of the North Wales Arts Association, when he first saw this portrait observed that 'not only was it a likeness, a matter of concern to all portrait painters, but the very character of Sir Thomas seemed to radiate from the canvas, it was indeed a true work of art.' Kyffin's painting stands alone in that it is the only portrait painted by palette knife. It is also the only portrait with part of the background to the head and shoulders painted in bright sky blue. This portrait is the tip of the iceberg, however – a signpost to his many other gems in the National Library.

Because of Kyffin's benevolence, the library possesses 700 colour slides, 250 of his paintings in oil (including his brilliant Patagonian paintings), and 1456 works on paper, that include drawings, watercolours, sketches, and work in gouache and pencil, as well as many hundreds of prints. The remarkable collection also has 36 paintings that Kyffin deliberately destroyed by cutting out a diamond shape from the centre of each one. Unusually, Kyffin kept the cut-out pieces of canvas. Furthermore, there are diaries, journals and letters, as well as Kyffin family albums, notes, and family portraits which stretch back to the eighteenth century. Many of the hundreds of his prints that he donated to the library are for sale to the public. Following Kyffin's death in 2006, Dr Brinley Jones, president of the library, said in a tribute: 'Sir Kyffin was one of the most generous benefactors in the history of the library…the library's collection is the largest collection of his art in the world, this is all very appropriate because he loved the library and supported it in any way he could.'

Kyffin had always visited the National Library, but Michael Francis, formerly of the Department of Pictures and Maps, who had a very close working relationship with him and became a firm friend, bears testimony that Kyffin's visits intensified from the 1970s on. This would tie in with Kyffin's move back to Wales on a permanent basis in 1973. As well as the large exhibitions of Kyffin's work in the library, such as his eightieth birthday retrospective of 1998, and the Patagonian travelling exhibition of 2005, there were many other smaller exhibitions, including drawings from *A Wider Sky* and his illustrations for Alice Thomas Ellis's *Wales, an Anthology* – exhibitions that were also toured by the library to smaller venues in Wales. The library also actively promotes Kyffin's work with greeting cards, featuring many of his paintings. For Kyffin to have the backing and support of such a powerful national institution and its professional staff was a tremendous boost to his morale and his image as an artist. There have been other exhibitions, for example, 'Kyffin a Celebration', an exhibition of fine binding by fellows and licentiates of Designer Bookbinders, with fine examples of the craftsmanship of Julian Thomas, the

A selection of books on Kyffin's life and art

then head of the library's Conservation and Bookbinding unit. Book launches were held in Y Drwm for Nicholas Sinclair's *Kyffin Williams* in 2004, when Kyffin was present, and for David Meredith's *Kyffin Williams, His Life, His Land* in 2008. At this launch, Andrew Green, the National Librarian, said that Kyffin was a beloved man in the eyes of many, not only for his art or his books, but as a person. He also said that Kyffin's book, *Across the Straits,* was one of the best autobiographies ever published by a Welsh person.

The National Library has an ongoing programme of loans and co-operation with Oriel Kyffin Williams at Oriel Ynys Môn. In January 2010 the library exhibited a substantial body of paintings, works on paper, and sketchbooks by Kyffin for the Oriel's 'Portraits' exhibition. Lord Dafydd Wigley of Caernarfon, appointed president of the library in 2007, who also serves on the Sir Kyffin Williams Trust, said of Kyffin:

> I doubt if we will see the likes of Kyffin again. He was as were his paintings full of emotion, mood and love, love of people and the creation. He was this unusual combination as a person so humble and yet as a professional artist bold, sure and assertive. Spending time with Kyffin was an uplifting experience with a whole gamut of feelings coming into play, humour, indignation, wonder and pure passion. I am so very glad that I met him. His bounteous gifts to the library are truly a priceless national treasure.

In the National Library's review for 2010-11, it was noted that the digitisation and cataloguing of the entire Kyffin Williams bequest has now been completed, and in a development that would have given Kyffin great pleasure, the review notes the creation of a special area, 'The Kyffin Williams Store', designed 'to enable the whole Kyffin Williams collection to be kept together – the paintings, the works of art on paper and 3D objects'.

Kyffin and the Animal Kingdom

K YFFIN LOVED ANIMALS and drew and painted them on a regular basis, including cattle in linocut and oil, badgers, goats, guanacos (in Patagonia), foxes, and sheep. But of all the animals, it was the dog and the horse that he favoured most. He had been surrounded by dogs from his youth: there was Bonzo, a hunting terrier of his father's, shared with Kyffin, Wufi, his mother's dog, and Buggerlugs, a friend's dog, not to forget the hunting dogs from the Ynysfor Hunt in Eifionydd and the Eryri Hunt in Nantgwynant. Kyffin painted dogs, hounds and greyhounds with tremendous skill, especially the sheepdog with its hesitant foot, on the verge of speeding forward, yet tied to his master, as Kyffin once said, as if with a piece of elastic. He admitted in one interview that he was especially attracted to the sheepdog because of its wonderfully contrasting black and white coat.

John Hefin, the director of the TV documentary *Reflections in a Gondola*, would often visit Kyffin at Pwllfanogl with his terrier, Sali. After the death of Sali, John reminisced about how welcoming Kyffin had always been to both of them:

> If only I'd asked him to sketch Sali; it would have taken him five minutes, but respect made me backward in coming forward. She was a much-loved three-legged, one-eyed Daeargi Cymreig [Welsh terrier] aged fourteen – or in our terms, 14 x 7 = 98. Kyffin and Sali got on, to put it mildly, and each time we met, his first line was 'How's Sali? Is she with you?'
>
> His relationship with animals was akin to that of the royal family's relationships to corgis. Pets give it to you straight, and their love is unconditional – valuable attributes if your relationship with human kind is somewhat complex.
>
> Both Sali and Kyffin were aristocratic; they had pedigrees. Kyffin's lineage spanned many centuries – Sali's was slightly older, dating back to the Laws of Hywel Dda. Both were, by nature and inclination, terriers. Kyffin's tenacity made him the artist and the

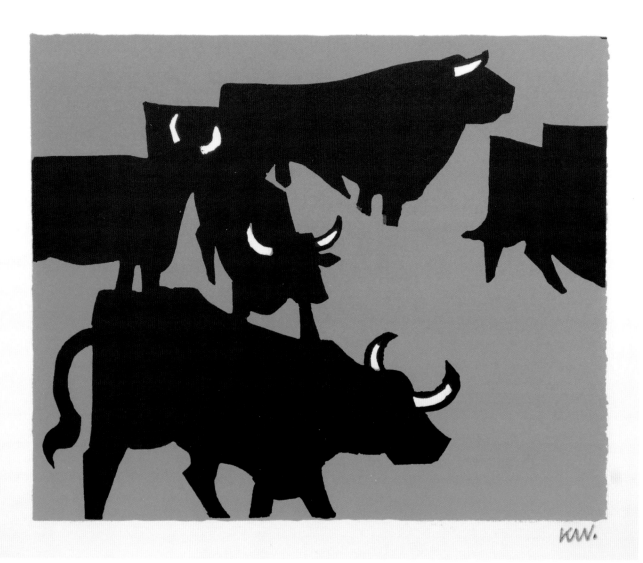

Welsh Black Cattle, linocut

man he was. No labradorial licks from Kyffin when it came to matters such as the National Museum of Wales, cultural tourists and the role of art schools. Sali held the same views regarding postmen and cats.

Both stood out from the crowd, he with that distinctive moustache, green herringbone tweed suit (slightly speckled with oils) and that magnificent bearing. She, that soft, fluffy tripod, whose cruel handicaps were dwarfed by her fighting spirit.

Horses were also important to Kyffin; he was born in the age of the horse and had been surrounded by them since his youth. The Trearddur School crest on his blazer pocket was a pair of charging horses together with the motto 'They can because they think they can'. The young Kyffin rode along the country lanes of Llŷn on horseback. He was aware of the long history of the horse among the Celts, for whom it was at times a deity in itself, as well as being associated with the sun god. The early Welsh tribes worshipped a goddess called Rhiannon, who could appear as a horse and was the mother of Pryderi who became a legendary rider in Welsh folk tale. But when Kyffin accepted an invitation by Cardiganshire Welsh cob breeders, Myfanwy and Ifor Lloyd, to visit the home of the famous Derwen Stud to paint one of their favourite horses, there was no mythology involved, only hard work, sketch after sketch, until perfection was achieved and the magnificent *Welsh Cob* appeared, full of life and vitality on a 20 x 16 inch piece of paper. Today, the drawing takes pride of place at the Derwen Stud HQ. It was, of course, inevitable that Kyffin, as a landscape artist who regularly painted 'en plein air', should see animals around him all the time. He was excited as an artist by the variety of colours they provided to challenge his palette: Welsh Black cattle, for example, against green upland grass, or the pleasing brown, black and grey of Welsh cobs, or the brown-red 'briefly glimpsed' coat of a fox. The movement of paw and hoof provided a further challenge, one that was regularly met by Kyffin.

This challenge of capturing movement in a drawing exercised him right to the end. As he stood to draw and paint in his kitchenette at Pwllfanogl, attempting to portray a black and white sheepdog jumping over a stone wall, he drew version after version until he was satisfied that he had achieved perfection and that 'Mot', 'Fly' or 'Lad' (every Kyffin dog was either 'Mot', 'Fly' or 'Lad') appeared to be moving in midair above the *wal gerrig*, the big-bouldered stone wall. Dogs and horses (as well as goats and badgers) were featured on Kyffin's Christmas cards and his sheepdog posters were much sought after. His expertise also came to the fore in his paintings of birds, from buzzards in Wales to a great variety of birds he saw at close hand in Patagonia.

Kyffin also observed a great variety of birds at Pwllfanogl and regularly discussed their calls, their flight, and plumage with his friends Charles Tunnicliffe ('He paints dead birds', Kyffin would say of him mischievously) and the poet R. S. Thomas, who was an expert bird watcher.

Badgers

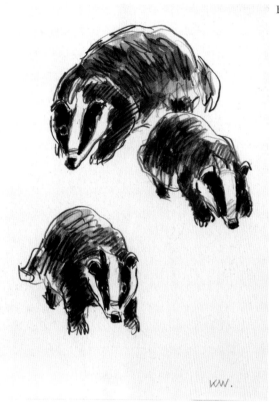

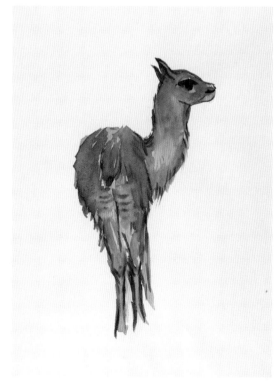

Patagonian Guanaco

Sheepdog and hesitant foot!

Horse at Derwen Stud HQ

A look to the mountains

The Dark Hours

WHEN ASKED ABOUT the place of epilepsy in his life, Kyffin's reply was that it had been a constant presence. Yet he went on to say that he never worried about it, nor had he ever hidden the fact that he was an epileptic, for he was not ashamed of it. He did acknowledge, however, that the illness had inhibited him tremendously. He hadn't been able to do things that others take for granted: he couldn't get excited, for example, or go to dances, but what he did have was his art. Kyffin's actual words were 'the only thing I did have was my art'.

Even without an attack of grand or petit mal, he suffered from epilepsy in other ways – it might be in the form of a sudden attack of terrible apprehension, for example. Such an attack would strike every fortnight or so and the only way to deal with it was 'to ride it'. Epilepsy, he pointed out, was 'all sorts of things' and he realised that he would always remain an 'almost cured epileptic'.

It was a mystery to Kyffin that he could invariably paint better after a mild attack. Not being stimulated to paint when he felt well was a danger to Kyffin, or as he put it, 'It's as if there is no grain of sand in my personal oyster shell.'

Dr Ann Rhys, speaking about Kyffin at the National Library of Wales in 2008, said:

> There were paradoxes [in Kyffin's life], he was vigorous yet capable of long periods of extreme inertia, he was full of fun yet melancholic. He was as quick to praise as he was to condemn. This is what he had to say about the opening of the New Art School at Aberystwyth University: 'The New Art Department will be a great asset to Wales and after a small beginning, great things may bloom; certainly we must thank Kenneth Morgan and Alistair Crawford for their initiative.' But when he condemned, did he condemn. This is in 1996: 'Yes there have been great shenanigans at the Royal Academy but the hordes of Midden have been routed, and we will I hope not be seeing the

gallery filled with heifers, bulldozers, fax machines and embalmed monkeys. Why can't people see that the new art has nothing to do with art, if it is then Botticelli, Piero, Rembrandt and Velasquez were not artists, they were merely copiers – ah well!'

But he worried excessively if he thought he'd upset anyone unwittingly by word or deed and he really did agonise, it was a constructive agony, he always put it right, always.

Another paradox, Kyffin the eternal hypochondriac never once complained when he really became ill with cancer in the last two years of his life. And continually told us he was content, and he was content.

When we suggested moving his bed at the hospice, the St Tysilio Centre, Llantysilio, so that he could see the glorious panorama of the mountains out of the window, he smiled and said 'no need! I see them in here, I am content.'

And we are content that he has left us the legacy of his art but most of all to those of us who knew him well, the legacy of his love – his presence will be stronger than his absence.

The Diaries

As well as recording the time and place of appointments, Kyffin's day-to-day diaries over the years are a fascinating record of his thoughts on a variety of subjects. In addition, there are sketches of mountains, birds and horses drawn in biro and pen. Financial matters are noted in brief – rent, tax and other costs. Paint requirements are recorded, Ivory Black 6 (tubes), Cobalt Green 6 (tubes), Cobalt Blue 3 (tubes), Windsor Yellow 6 (tubes), Burnt Umber 3 (tubes). From 1974 onwards, his paint was normally purchased at Gray Thomas Arts Shop in Caernarfon, but he also purchased paint from Studio C in Bangor. Ed Povey, a fellow artist and a friend, recalled meeting him at Studio C, when Kyffin mentioned he had been suffering with a cold or flu, saying that he had been feverish for weeks. 'Do you know,' he said 'while I had the fevers I could only draw racehorses and greyhounds! What do you make of that?' Ed was speechless, and tried to make a connection to Degas' paintings of horses. Both left baffled and smiling.

It is interesting to note his regular visits to Ynysfor, his haven in Eifionydd from the days of his youth where he spent many happy years hunting with the local farmers. He was still making visits there as late as 2004-05.

Concerning his interview with the Churchill Foundation, Kyffin notes in a 1968 diary entry, 'laugh at yourself'. In 2004 he records 'Biennale, Eisteddfod, Artes Mundi – determined to move away from the public.' Dealing with modern mentality, he notes, 'Technology not humanity'. In 2003 he writes, 'My art helps to focus on contentious socio-political issues, oppression, isolation – the experience of alienation.' In 1967 he comments on Anglesey and his family, 'Despite insular congenital diseases due to inbreeding, the island is healthy, and few members of my family have failed to reach the age 80 in the last 300 years!'

In 2002 he notes in a list: 'will. Honest, distinguished, passionate, paint quality, draughtsman, lover of people and land, cultured, well read, lover of Art, articulate. In a

Self-portrait

world of opportunist Art – will shine like a beacon, took from tradition and added to it.' We will never know if this was a list of comments by others regarding Kyffin or Kyffin musing to himself about himself. In an earlier entry he writes: 'Intuition, imagination, Bravura Exuberance, love of people, no great depth, lack of philosophy.' In 1992 one entry lists, 'Claude, Durer, Van Dyck working from drawings plein air.'

Details of household requirements are listed: tea, sugar, Colgate toothpaste.

In 1985 he muses, 'Knew what to paint', and lists 'Dolgelley (1947) RA, Edward Bawden (Artist) critics, Art Council, continual battle, considered difficult, loner and ever more shall it be so. English and Wales love us or don't, Mrs Yale, Man in Patagonia, most lethal artist in Wales, Caernarfon heat attack Tregaron, Glyn Vivian, Nat Inst, social working, odd beginnings…fostering, battering, C+A meningitis, epilepsy, Disaster in school, common entrance, considered halfwit, McEachran, This officer is immature, Head injuries, Hospital, Slade – incompetence, Highgate School, 200 a year remunary [sic].'

We can recognise in this list many of the high and many of the low points in Kyffin's life. For example, the high point – 'Dolgellau' – when he first painted Cadair Idris in 1947 and realised that perhaps he could be an artist; and a serious low point, epilepsy, an affliction that we know affected Kyffin all his life.

One entry is a complaint, 'No Christian humility, artists (today) more important than subject matter.'

At times, a reader of Kyffin's diaries could be forgiven for thinking they were in fact small collections of limericks – over the years they fill many pages:

> They said that enough was enough,
> The output of work by old Kyff,
> So they finally put strictures
> On his output of pictures,
> So the output of Kyffin was nothing!

> A skinny old fellow called Thomas
> Has sadly departed now from us,
> In his reincarnation
> He attained much inflation
> And is now a large hippopotamus,

> An impulsive old fellow called Jack,
> Went to air his strong views in Iraq,
> He went to complain
> About Saddam Hussein,
> So alas and alack, he never came back.
>
> There was an old man from Sir Fôn,
> Who wished he had never been born,
> On the Island they said
> He was quite off his head,
> That's why he was looking forlorn.

Rugby matches are always noted, especially internationals, such as Wales v. England.

It is not surprising that Kyffin's diary entries in the last year of his life are very sparse. Due to his many afflictions he was finding it difficult to write and was surprised, as he told close friends, that he could still paint (in watercolour).

In 2002, Kyffin noted in his diary that 'due to lack of running water the power of the Island of Anglesey was provided by hundreds of stone-built windmills, today sail-less and impotent, they stand like ancient dumb-bells'.

Although Kyffin claims in the 1985 diary entry that he was a loner, his diaries show that he was constantly in touch with individuals and societies. He was knowledgeable about events in Wales and beyond, and was regularly briefed by friends about the latest artistic developments in Wales.

Omega

TOWARDS THE END of his life Kyffin found it increasingly difficult to negotiate the path and steps that led to his studio to paint. This was mainly due to poor health, but the melancholy that regularly beset him also played a part. In his mind, however, he still wanted to express himself through art.

During his life he had experienced many forms of depression which were clearly exacerbated by frequent grand mal and petit mal attacks, which sometimes occurred as many as nine times a day. According to Kyffin, these attacks may have been at the root of his lifelong depressive nature, though he also blamed childhood meningitis and a traumatic beating inflicted by his nurse. Fortunately, the strong desire to paint overcame this frequent malaise and its associated lethargy. Often, when he was feeling down and friends enquired about his health, he would say, 'Dwi'n llipa' (I'm feeling limp), which was clearly a euphemism for his continually feeling weak and depressed. Occasionally he would use the term 'digalon' (downhearted), though this was more in the context of being upset rather than feeling ill. He would very rarely use the term 'depressed' because of his upbringing and his social and military background. He realised, however, that his 'condition' could be manipulated and turned into a highly effective catalyst in his art. This was not merely a reflection on his own condition; it also involved his understanding of how similar conditions affected other artists, such as David Jones. Although not directly influenced by David Jones's style and technique, he was, nonetheless, inspired by the latter's immense determination to translate his potentially debilitating mental condition into emotive and successful art. From his own cursory military career, Kyffin could empathise with Jones' traumatic World War One battlefield experiences and was familiar with his artistic and literary output, in particular *In Parenthesis*. Kyffin's friendship with Valerie Wynne-Williams (née Price), Michael Wynne-Williams, Greta Berry and Annwen Carey-Evans brought him into close contact with David Jones at

St Mary's Church, Llanfair-yng-Nghornwy

social gatherings in Highgate and Hampstead. These would help sustain him in his own protracted periods of mental adversity. Jeannie Nagy, Sandy Livingstone-Learmonth's daughter, and a close friend of Kyffin, was also sensitive to his complex personality. In her view, Kyffin's dilemmas in life were a manifestation of his whole nature: 'I think his illness gave him a sort of inner loneliness which nothing could ever quite cure and I do believe that his work was what let him express himself most spontaneously and was therefore vital.'

In order to be able to carry on painting, and to assuage his thoughts of illness in his last years at Pwllfanogl, he arranged a sloping drawing board, conveniently placed on top of a chest of drawers in his small, dark kitchen. The top drawer was usually kept open as it brimmed with household bric-a-brac. On top of this drawer rested his sketching and painting paraphernalia: 2b, 4b and 6b pencils, watercolour brushes, sponges, rags and his cherished artist's watercolour pan set. These paint pans always appeared muddy and mixed but, somehow, Kyffin managed to extract the appropriate colour and shade he desired for his sketches and paintings. Above the drawing board he arranged a swan-neck electric light, to illuminate his watercolour pad in the dark confines of the kitchen. He had always preferred to stand when painting but now found he tired quickly. The kitchen area was not like his studio with its glorious untidiness. Even so, and with little regret for the cold, wintertime austerity of his real studio, he still managed to produce a number of successful paintings. Many of these were later sold at Albany Gallery exhibitions in Cardiff.

The process of painting was therapeutic for Kyffin; indeed, it was a distraction from the forebodings of his terminal illness at this time. The paintings were usually from memories of his experiences in the mountains, caricatures of farmers with shotguns and their sheepdogs, hunting foxes. The paintings did not depict formal hunts of the kind Kyffin attended with Captain Jack Jones of Ynysfor, and later with the Eryri Hunt of Hafod y Llan, Nant Gwynant, but revealed farmers seeking revenge on foxes that had decimated their flocks in late winter and spring. The scenes were always near the top of a mountain or rocky outcrop, often with knee-deep snow, typical of the many craggy peaks around Aber Glaslyn, Croesor and Cnicht. Clearly, the artist's early experience of hunting in the mountains was still vivid in his imagination. In his youth he had mixed regularly with shooting and hunting friends, and these traditions became an important part of his life. He had been, as Roger Williams-Ellis recalled, 'a gangly lad but with tremendous stamina and a tenacity for emulating Captain Jack Jones when in pursuit of the fox'. The once gangly lad, proclaimed as Wales's greatest artist, now found his stamina and tenacity had deserted him, as he pursued Captain Jack and the fox for the last time.

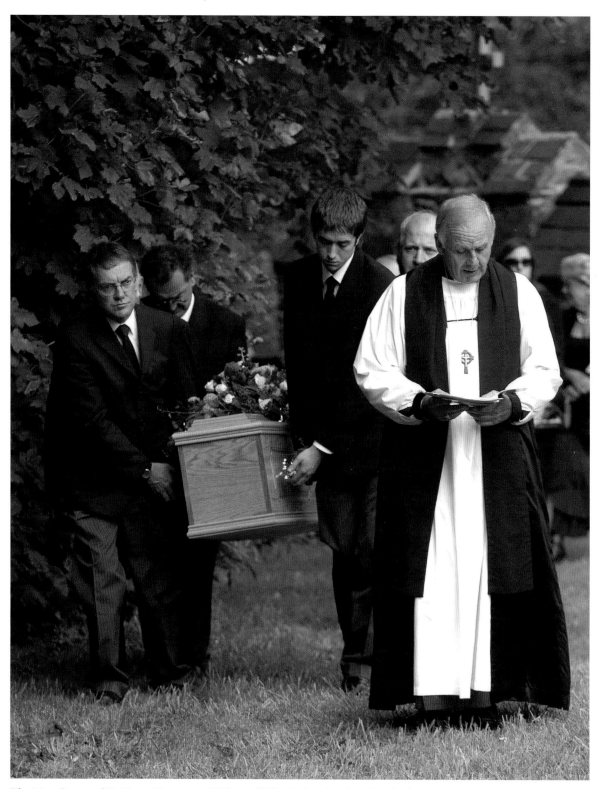

The Most Reverend Dr Barry Morgan, Archbishop of Wales, in the churchyard at Llanfair-yng-Nghornwy

23

At Peace in Llanfair-yng-Nghornwy

KYFFIN DIED SUDDENLY on Friday, 1 September 2006 at 11.30am at the St Tysilio Nursing Home at Llanfairpwllgwyngyll on Anglesey, after spending two weeks as a patient at Ysbyty Gwynedd in Bangor, telling one of his friends on coming out of hospital, 'I picked up some infection or other.'

He had been having treatment for some time for lung and prostate cancer. Visiting him two days before his death, David Meredith had remarked without thinking, on entering his bedroom at the nursing home, 'Ah you can see the mountains.' Kyffin immediately replied, 'No I can't, my bed's in the wrong place.' In reality everybody knew that Kyffin did not need to see the mountains; they were deeply imprinted on the screen of his mind.

David Meredith recalled:

> Kyffin telephoned me earlier in the week to tell me that he was at the St Tysilio Nursing Home, and that he was surrounded by a defensive cage visitor-wise, but that I shouldn't worry, all I had to do was to tell the nursing home authorities that I was there by Royal Command. Kyffin, in his kindness, chose to apologise to me that I was not named in a catalogue that had been published for a Kyffin exhibition. When I said that I would stand on the front porch of my home and shout 'Injustice! Injustice!' at the fields I could, to my delight, hear Kyffin laughing on the phone.
>
> On arriving at the St Tysilio, I found Kyffin in bed; he had said earlier that he was too weak to walk. The conversation jumped from topic to topic. Kyffin was delighted to hear that I had attacked Tracey Emin's modern art in a radio programme and Kyffin reported that he believed he was related to the matron of the home.
>
> In conversation, he remarked that he hoped the prices of his paintings for an exhibition in Cardiff would be kept to a reasonable level. His concern always was that people in Wales would be able to afford his work.

After a brief conversation, with Kyffin obviously tiring, I bade farewell, and placing a hand on Kyffin's hand I promised to return.

As I reached the door, Kyffin's last words spoken in Welsh were, 'Ta-ta rŵan, brysiwch yma eto' (Ta-ta now, hurry back again) – words that no doubt Kyffin would have heard a thousand times in his youth, visiting the farms of Anglesey with his father. Sadly there would be no 'eto'.

Much to his friends' distress, Kyffin had been making arrangements for his death for some time. He would be given comforting replies to his questions, such as, 'Do you think Ieuan Rees [the sculptor] would do my gravestone?' Sometimes, though, these were not questions so much as statements: 'I think this paragraph I wrote as the last words in *Across the Straits* would be suitable to be read at my funeral.' It was a paragraph about a friend's little boy who came to visit him. The boy, walking with Kyffin on the shore at Pwllfanogl, had suddenly asked him, 'What will happen to you here when you die?' The boy had asked the question with a look of concern on his face. As Kyffin said, he knew that he had to reply with a confidence he did not possess. He had replied, 'Oh it will be wonderful, I shall slip away to sea and be swept away by the water and I shall be carried under the bridges and away to Penmon and the open sea.' Kyffin felt the worry seemed to disappear from the little boy's face, who ran off to throw stones into the waters that were destined to carry him away.

Commenting on individuals who had repeatedly promised to publish biographies of him, but never had, Kyffin would say in a jocular way, 'I suppose they're waiting for me to die.'

He would take every opportunity when close friends were at Pwllfanogl to brief them on where this and that of his personal treasures should go, with an implied 'after his death'. The Yehudi Menuhin sculpture by Ivor Roberts-Jones, for example, was to belong to the National Library of Wales, but was to be given on loan to the Tabernacl Gallery in Machynlleth. Friends would also be asked to deliver works of art to various national institutions.

We would learn later that his original will was dated 1999 and that, with meticulous care and several codicils later, he had shared his worldly wealth and all that he owned among family, close friends, and national institutions such as Oriel Ynys Môn, the National Library of Wales, the National Museum of Wales and a variety of charities, several of which he had supported during his lifetime.

Many years previously, a television executive, in his anxiety that Kyffin should take

part in a particular programme, had said, 'We will pay you an excellent fee.' Kyffin's response had been, 'Money means nothing to me.'

When his death came, it was widely reported on radio and television. The BBC repeated the classic TV documentary on Kyffin's visit to Venice in 2004, *Reflections in a Gondola*, and there were tributes on BBC radio as well as on ITV Wales, including *Y Sioe Gelf* – The Arts Show – (Cwmni Da for S4C), where several of Kyffin's friends and fellow artists paid tributes to him.

Artist Rob Piercy observed that Kyffin always stressed the importance of the art of drawing and the art of painting, while the artist and printmaker, and former HMI Arts and Design Wales, Leslie Jones, said that Kyffin painted first for himself, but then for the public, and was always concerned to paint pictures that were understood by the people. He added that Kyffin had maintained that the work of many modern artists was not understood by anyone and that most of it was rubbish. Leslie Jones also noted that painting with a palette knife in the 1940s and 1950s was not popular. As a student he (Jones) had been forbidden to use a palette knife in this way. He believed that Kyffin used the technique as a result of his decision to paint 'plein air', because using a brush took time while with a palette knife he only needed to mix his paint once and then place it immediately on the canvas. In this way, he developed a style like no other. Ann Mathias, a friend of Kyffin whom he had helped to establish an art gallery in Brecon, said that he had been an inspiration to many young artists and that not many people knew that Kyffin had been invited to Highgrove by Prince Charles to advise him on his art. Kyffin had lent Ann his contacts book to help start her gallery.

Artist Catrin Williams revealed that Kyffin had purchased oil paint for Peter Prendergast on one occasion when he had been thinking of abandoning painting. Possibly without this, Prendergast would not have continued to paint and would not have taught Catrin Williams and many others. Catrin also remembered remonstrating with Kyffin over the merits of an eisteddfodic exhibition which Kyffin had criticised. If only he would meet the artist and his discuss his work, she felt, Kyffin would have a better understanding of his artistic process. But Kyffin did not relent in his criticism. Catrin Williams felt that Kyffin was anxious to defend the part of more traditional artists. Alun Gruffydd, who worked with Kyffin while he was at Oriel Ynys Môn, referred to his wonderful gift of over 400 of his paintings to the gallery.

There were references during the programme to the way in which Kyffin's home, Pwllfanogl, became a mecca for school children – large groups of them going back to their schools with piles of prints of Kyffin's drawings. Kyffin was a great believer in the

importance of prints in the promotion of art, which led to his very successful collaboration with the Curwen Press, and to extensive sales of prints in galleries the length and breadth of Wales. Art historian Peter Lord maintained that, career-wise, Kyffin was Wales's most successful artist ever and there was no one else to compare with him. Kyffin had great humour and charisma. Peter Lord also observed that although some claimed there had been no development in Kyffin's work, in fact there had been slow but sure development over a long period of time.

Rob Piercy made the point that Kyffin painted at a time when the Welsh middle class had money to spend on art and that Kyffin's work had been attractive to them in that, although some of it was dark, threatening and dramatic, it was also in a certain way safe. People didn't want work that was too photographic, but neither did they want work that was too modern. Kyffin's paintings fulfilled these requirements.

Rian Evans, a journalist and a personal friend of Kyffin, said that Kyffin's art was more important than anything else, but stressed that Kyffin's work behind the scenes should not be ignored. She felt that his significant contribution to the arts in Wales had been insufficiently acknowledged. His contribution to small art galleries had been particularly

Artist Gareth Parry

important. Peter Lord expressed the view that Kyffin's art went beyond being merely aesthetically fashionable and that he will still be remembered in a hundred years' time.

Gareth Parry, Kyffin's fellow artist and friend, said that Kyffin had told him he had not been happy with any piece of his own work. Gareth found that conversations with him about art came easily. He admired the fact that Kyffin would discuss art without once mentioning his own work. Gareth Parry added that he took great delight in going up close to Kyffin's canvases to look at the paint – it was good enough to eat! He encouraged people to practically put their noses on the canvas and revel in the markings created by the palette knife. In 2011 Eleri Mills, an artist who, like Gareth Parry, was introduced by Kyffin to the Thackeray Gallery in London, paid her own tribute to the 'great old man of Welsh Art':

Kyffin was well into his eighties when we first met at Oriel Plas Glyn-y-Weddw, Llanbedrog. We must have hit it off and kept in touch from then on. There were numerous letters and my visits to Pwllfanogl would involve transporting elaborate home cooking for lunch – I even took the harp along one unforgettable St David's Day – Kyffin wanted to hear the traditional Welsh songs 'Dafydd y Garreg Wen' and 'Ar lan y môr'.

We would usually talk at length about the importance of being able to draw, and the need to always paint with 'love' – he was a deeply emotional man and of course painted from the heart. He often expressed amazement at the huge popularity of his work and the escalating prices for his paintings. He seemed to enjoy his unique position as the great old man of Welsh Art – although sometimes the clamour of collectors made him appear rather isolated and vulnerable. Kyffin was constantly embroiled in debates about contemporary art, art education and the art establishment in Wales, and would tell me about these dramas and warn me against such outrageous art practice with great passion! I found him highly entertaining and relished his company very much.

Kyffin was a very kind and generous supporter of my work. It is due to him that the Thackeray Gallery gave me my first London solo exhibition in 2003, and I shall always be grateful to him for writing the introduction to that exhibition.

The two daily newspapers of Wales, the *Daily Post* and the *Western Mail*, gave prominence to Kyffin's death on their front pages. The *Daily Post* featured a photograph of Kyffin standing at the door of his studio, with the banner headline 'Sir Kyffin, Wales's Finest Artist Dies Aged 88'. The *Western Mail* devoted its front page to a portrait of Kyffin by Cardiff-based painter, David Griffiths, with the banner 'Sir Kyffin Williams 1918–2006'. It too referred to Kyffin as Wales's greatest artist. *Wales on Sunday* published a four-column tribute under the heading 'Wales Was His Canvas', featuring a photo of Kyffin in a gondola from the television programme *Reflections in a Gondola* with the caption, 'When Kyffin Williams died on Friday at the St Tysilio Medical Centre on the Island of Anglesey, his beloved Anglesey, Wales lost a great man, the greatest of Artists.'

The magazine *Cambria*, of which Kyffin had been a patron, featured on its cover a photograph of him by editor Henry Jones-Davies with the simple words 'Kyffin 1918–2006'. *Y Cymro*, the Welsh-language weekly, reported on Kyffin's death under the headlines, 'His Roots in the Very Land of Wales' and 'Loss of an Artistic Giant', while the other Welsh-language weekly, *Golwg*, featured a photograph of Kyffin painting in his studio on the cover, with the caption 'Remembering Kyffin, the artist, the art critic and Welshman'.

Obituaries appeared in *The Times*, *The Telegraph*, *The Independent* and *The Guardian*. *The Independent* obituary, written by Meic Stephens, was headed, 'Kyffin Williams, painter of iconic mountain landscapes of North Wales'. *The Telegraph* featured a photograph of Kyffin by his godson Nicholas Sinclair and the heading 'Artist told he could not draw who went on to celebrate the landscape and people of his native Wales'.

The Guardian obituary was written by Kyffin's friend, Rian Evans, and included a photograph of one of Kyffin's oil paintings. *The Times* featured a photograph of Kyffin in his studio, among his paint tubes and canvases, with the headline, 'Painter who celebrated the landscape and people of his beloved North Wales with passion and humour'.

The Times was Kyffin's paper, which he read as a part of his daily routine. The uncredited obituary was not as detailed or comprehensive as those in *The Independent* and *The Guardian*, but it caught accurately Kyffin's spirit of defiance and independence, pointing out that 'Sir Kyffin Williams was a portraitist, a painter of North Wales landscapes and seascapes and an amused chronicler of his own and other people's foibles.'

Later *The Times* would publish a highly complimentary tribute in their 'Lives Remembered' column by one of Kyffin's former pupils, Roderick Thomson, who recalled that

> On entering the Art School as a pupil at Highgate in 1950 one was enveloped by the culture, enthusiasm and liberty of John Kyffin Williams, a tall, rangy figure dressed in khaki trousers, a coat of Welsh tweed and a Royal Welch Fusiliers tie . . . as we worked he would lope around stirring things up, enthusing, encouraging, helping. By the openness of his approach and his words and actions, he conveyed without didacticism, the absolute necessity of truth, sincerity and integrity, values by which he steered his own life and which permeate his drawings, painting, prints, writings and civic achievements.

Roderick Thomson's perceptive, warm tribute rang true with all those who knew or had worked with Kyffin over the years.

The Welsh dailies also gave extensive coverage to Kyffin as an artist and person on their inside pages, in features by David Greenwood in the *Daily Post* and Tryst Williams in the *Western Mail*.

Both the Thackeray Gallery in Kensington and the Albany Gallery in Cardiff held exhibitions of Kyffin's work in his memory. The Thackeray retrospective was a non-selling exhibition, while arrangements for the Albany Gallery exhibition had been on-going before Kyffin entered the nursing home at Llanfair P.G.

Sarah Macdonald-Brown, director of the Thackeray, wrote:

> This Retrospective Exhibition is in memory of Kyffin Williams. It was a great loss to
> us when Kyffin died last September, as he had such a special place in the gallery's life.
> This exhibition is our way of saying thank you to him, as his time with us in Thackeray
> Street, all thirty-nine years of it, is worth celebrating. It has been quite a journey, going
> through years of records, to discover Kyffin's extraordinary legacy of art.
>
> To represent him, in our way, we have chosen twenty-eight oils, borrowed from
> public and private collections, many of which have never been seen in the gallery
> before. This select group, supported by twelve watercolours and drawings, shows all
> that Kyffin was passionate about, with the earliest work being painted in 1947 and the
> latest in 2004.
>
> In conjunction with this show, we are delighted to have copies, hot off the press, of
> *The Art of Kyffin Williams*, written by Nicholas Sinclair, and published by the Royal
> Academy of Arts. Kyffin was working closely on this book over the last two years with
> Nicholas and it is, in itself, another tribute to him.

Mary Yapp, owner and director of the Albany Gallery in Cardiff, and Kyffin's agent,
recalled:

> The special relationship between the Albany Gallery and Kyffin began over 30 years
> ago when my father Philip Andrews introduced me to a fellow colleague on the Art
> Committee of the National Museum of Wales – an artist called Kyffin Williams.
>
> I could not have foreseen then that our meeting would lead to such a long and
> successful collaboration, or that he would become not only Wales's greatest painter, but
> also a very dear and loyal friend.
>
> Today, the Albany without a Kyffin show seems unthinkable. This retrospective will,
> I hope, both honour his memory and attempt to fill the void which his passing has
> left. I further hope that in the works I have selected, some of which are from private
> collections, his warmth and artistic integrity will be reflected.

Later in the year, Gareth Parry RCA, one of Kyffin's fellow artists and a friend, would
pay him an extended moving tribute:

> Patrick Procktor, a leading British artist (1936-2003) said, despite being brought up
> with a background where nothing indicated that he would ever be a painter, that
> when he went to school in North London, he did have the opportunity to paint

under an art master, Kyffin Williams, who cared. And so gradually his interest in art blossomed.

Kyffin did care. It was obvious to me and anyone else who knew him. He cared about Art, its history and traditions, the old and the new, the future of art and especially the future of 'Welsh Art'. He believed like Van Gogh that painters handed the brush down to each other. He (Kyffin) was influenced by the masters. They inspired him. He talked about them with depth and insight. 'If the fundamentals of drawing, tone, colour and composition were important to them, how could they not be to him, or anyone else?' he asked.

He talked to me over and over about the works of others, but hardly ever mentioned his own. I find this to be one of his many endearing characteristics. Once when I asked him about his own painting, he surprised me by talking about his 'dark periods', when doubts pervaded his world, adding that he had never been, and never would be, satisfied with what he produced. Like all serious painters, he was striving for 'something else'. It comforted me!

I feel that many people have yet to realise how great a painter Kyffin really was. Sometimes he is rather glibly dismissed as being just dark or sombre. On the contrary, I have always thought of him as a great painter of light, the beautiful, subtle umbers and 'greys' emphasizing the light that suffuses his paintings. Like many of those he admired, he conveyed much with deceptively little, worked within nature's bounds but was never her slave.

He 'abstracted' in the true meaning of the word and evolved a highly individualistic way of painting.

Kyffin was a master of composition, a great 'designer' of a picture. Everything placed instinctively to heighten or highlight mass, weight, distance, height and so on. Smaller objects, a fence post, boulder or a splash of light etc, acted as counterpoints.

Those sensitive, telling portraits owed much of their success to this ability to 'design' both in line and colour, complimentary or otherwise. There was often much subtlety in the work and a masterly use of underpainting.

Regrettably, I only met Kyffin towards the end of his life. His work never directly influenced mine; I would have been completely engulfed by it, as his myriad imitators have been! But despite our differing backgrounds, we had much in common. We were both influenced by the same things, 'Cymru' (Wales), the people, the land and that rugged beauty that he almost made his own. Can anyone now think of Crib Goch without visualizing one of 'his' images of it?

A few days after Kyffin's death his friend, John Smith, recalled how very ill Kyffin had really been. In late August 2006 his lung cancer caused a recurrence of major congestion and required urgent treatment. His brother, Dick, had been similarly afflicted with pulmonary problems. Kyffin was taken to Ysbyty Gwynedd but after treatment made a little progress. He was very weak and there was considerable concern as these recurring attacks had taken a serious toll on his ability to recover. John Smith recalled:

I visited him at Ysbyty Gwynedd and briefly spoke to him and left a get well card. He smiled – as usual – and not wishing to fatigue him, I immediately left. The following morning there was a phone call for me. In disbelief I spoke to Kyffin and was astonished to hear him sounding so well. He told me that he had been moved to St Tysilio Nursing Home, in Llanfairpwll. He asked if I would call over to see him as he was interested in an advertisement the Oriel had placed in the Royal Academy of Art's magazine. Later in the day I phoned St Tysilio's reception asking if it would be possible to visit that evening. The nurse in charge mentioned that Kyffin was not well enough for a visit, so I said I would try in a few days. 'No, no,' was the reply. 'Try tomorrow evening, please!'

I made arrangements the following day and arrived at St Tysilio's, situated near the Menai Strait, and not far from Pwllfanogl, around 5.30pm I was escorted along a long corridor to his bedroom overlooking the Britannia Bridge by a beautiful Asian carer. Kyffin was sitting up in bed, but was well supported by pillows and on a tray that spanned the bed was a telephone, newspaper, his dark spectacles and radio. He smiled and asked me to sit close to the bed and read from the RA magazine. I asked him if he was being well cared for and he commented 'Well, with these lovely nurses tending to me, I'm fine'. He joked about being in Heaven.

I read from the RA magazine for a while, pointing out the neat illustrated advertisement for his twelve new prints. There was also a short editorial about the prints and his work, which he liked. He started to tell me about the Australian living next door to Pwllfanogl. I knew that the 'Aus', as Kyffin referred to him, had been cutting bushes and shrubs from around Kyffin's studio from a recent visit I had made – thus totally changing the appearance of the place. Kyffin had dwelt on the subject for several weeks as he valued his own efforts to improve Pwllfanogl over the years. His encounter with his neighbour had preyed on his mind and, unfortunately, sapped energy he did not have. I sat quietly as Kyffin continued talking for a while, occasionally using for emphasis, 'damn' and 'fool', and hinting that his Antipodean neighbour would be receiving a letter of complaint. With his genteel but glorious concern I felt, from

past experience, that he was still strong in spirit. His incredible tenacity appeared to be intact.

Time moved on and so I excused myself, saying I would return soon. After shaking his hand I walked towards the door and pausing, turned to say 'Kyffin, don't worry about the Aus', as I punched my open palm in a gesture of pseudo anger. He peered over his spectacles and then burst out laughing and dropped his magazine on the bed. I left the room, also quite happy, but with a deep sense of concern.

The following morning, September 1st, 2006, I was on annual leave and in Bangor. Alun Gruffydd phoned me to say he had received the news that Kyffin had died that morning. I was stunned, how could someone looking so well the previous night die? As I stood trying to take in the news, I recalled a female artist phoning me some years before saying she had heard Kyffin had died. At the time, I instantly phoned Pwllfanogl, expecting no reply. After a long delay the phone was answered with a resonant 'Hello'. It was Kyffin, so I coyly mentioned the female artist's concern. He wittily replied, 'The rumours of my death have been greatly exaggerated.'

While Mark Twain would have been proud of Kyffin's riposte, the female artist avoided me for several weeks. Kyffin was well able to conceal his feelings, partly because of his upbringing and his military training. He had learned to dissipate his deep inner emotions through his very special art. On the morning of his death he had eaten a good breakfast, which he was always keen to do with his diabetes. His godson, Nicholas Sinclair, and Denise Morris and Sally Goddard were nearby when he died, which must have been a tremendous comfort for him in his last moments.

With the extensive ecclesiastical connections of Kyffin's family, it was fitting that the thanksgiving service for his life and work was held at Bangor Cathedral and that the service was conducted by the Archbishop of Wales, The Right Reverend Dr Barry Morgan. Monday, 11 September 2006 was a memorable day. Many of those attending the service arrived early and could be seen searching for cafés in the centre of Bangor. Television and radio crews, and newspaper reporters, positioned themselves inside and outside the cathedral, approaching well-known individuals to arrange interviews after the service.

By 11.00am when the thanksgiving service began, the cathedral was filled with a vast congregation: family, old friends, new friends, members of parliament, lords lieutenant, neighbours, admirers, fellow artists, sculptors, potters, Royal Academy representatives, art gallery directors and owners, representatives of national institutions, lords, members

Bangor Cathedral

of the National Assembly of Wales, ministers, farmers, charity representatives, and simply people who thought the world of Kyffin. The congregation was in fact so large and so representative of Wales that one could almost imagine Kyffin at his provocative best, asking: 'All these people, coming to thank me?'

Following the first hymn, 'The Day Thou Gavest, Lord, is Ended', the Archbishop of Wales spoke: 'The fact that this cathedral is full of people from all strata of society is testimony to the esteem and affection in which he was held – not just as an artist but as a man – we have come out of respect and to give thanks for him.' Dr Morgan added that Kyffin's preferred option was a quiet burial at Llanfair-yng-Nghornwy: 'A quiet burial because he himself was so self-deprecating about his work.'

The Cathedral choir sang Psalm 121, and Psalm 42 was read by a friend and neighbour of Kyffin, the Roman Catholic priest, Father Brian Jones. Then the choir sang 'Ave Verum Corpus' (music by Mozart), followed by a tribute from Professor Derec Llwyd Morgan, friend and chairman of the Kyffin Williams Trust, who said in his opening remarks: 'Some people have come to this cathedral today because they've lost a dear friend whose companionship was an important part of their delight in life. Others have come because they admire the deceased for his work. All of us have come to bid farewell in public to a painter whose genius – for nearly sixty years – has given us wonderful artistic knowledge of many aspects of our being.' He went on to observe that 'When Kyffin moved to his studio and home at Pwllfanogl at Llanfairpwll, overlooking the Menai Straits, he had his beloved Môn under his feet and his beloved Eryri in his sights…'

The congregation then sang the well-known hymn 'Dros Gymru'n Gwlad, O Dad Dyrchafwn Gri', sung to the tune of 'Finlandia'. This patriotic hymn was written by the well-known Welsh nationalist, the Reverend Lewis Valentine. Following a reading from Corinthians by Kyffin's great friend and landlord, the Marquess of Anglesey, Henry Paget, the haunting song 'My Little Welsh Home' was sung by Bryn Terfel accompanied by international harpist Elinor Bennett:

> I am dreaming of the mountains of my home,
> Of the mountains where in childhood I would roam,
> I have dwelt 'neath southern skies
> Where the summer never dies,
> But my heart is in the mountains of my home.
>
> I can see the little homestead on the hill,
> I can hear the magic music of the rill,
> There is nothing to compare
> With the love that once was there
> In that lonely little homestead on the hill.

The words of the song are believed to have been written by the late Huw T. Edwards, the one time unofficial 'prime minister' of Wales and former chairman of the Wales Tourist Board whose portrait Kyffin had painted in 1967. The music was by W. S. Gwynn Williams, one of the founders of the Llangollen International Musical Eisteddfod, and its musical director for many years.

When Bryn Terfel's voice had stopped reverberating around the cathedral, Nicholas Sinclair, Kyffin's godson, spoke with great feeling about his godfather. Mr Sinclair, whose mother was an art student with Kyffin at the Slade, said as part of his tribute that his godfather's work, like that of Rembrandt and Van Gogh, 'was driven by the heart, which enabled him to touch people in all walks of life – Wales has been left with a legacy of paintings which one generation after another will be enriched by'.

Before the Commendation, the gathering sang the well-known hymn 'Mi Glywaf Dyner Lais, yn Galw Arnaf i' (I Hear a Tender Voice Calling Me) to the tune 'Gwahoddiad' (Invitation).

If Kyffin could have seen the huge gathering spilling out of Bangor Cathedral, he would have been amazed that he, John Kyffin Williams – the six crempog boy who was bullied at school, called 'abnormal' by an army doctor, and scorned by the Welsh Arts Council, was responsible for bringing this remarkable cross-section of society together.

Following a half-hour drive across Ynys Môn, approximately sixty of Kyffin's close friends and family arrived at the church of Llanfair-yng-Nghornwy for the burial service. It was the church where Kyffin's great-grandfather, James Williams, had been rector, and where his great-grandmother, Frances Williams, the artist, had ruled the rectory. The Archbishop of Wales conducted the service in the churchyard. This is where Kyffin had wished to be buried, where his 'Taid', the Reverend Owen Lloyd Williams, is also buried with his parents, Frances and James, within sight of the sea, rather than with one of his parents, Henry Inglis at Aber-erch near Pwllheli, or Essyllt Mary at Llansadwrn Church, near Beaumaris.

Later, the archbishop would write in the Albany Gallery Memorial Exhibition brochure:

> When people think about contemporary Welsh art, their minds turn immediately to Kyffin Williams. His paintings of Welsh cottages, hill farmers, mountains and sea symbolise for many people the land that is Wales. Not only was he a great artist, he was a great raconteur, writer and a good and generous man. He was humbled and even surprised by his success. He told me on more than one occasion, as if he couldn't quite believe it, 'people seem to like my work'. In fact, of course, queues of people wanting to buy his paintings would form at galleries whenever he had an exhibition. Institutions and individuals alike testify to his generosity in giving drawings and paintings to them. He was unfailingly generous to charities such as Shelter Cymru and always contributed an original work to their annual fund-raising event. In spite of his fame, the prices his

paintings fetched in later years, and the honours bestowed on him, he continued to live the same simple life that he had always lived on the banks of the Menai on his beloved Ynys Môn, totally at home and at ease with his fellow villagers at Llanfairpwll. He said that he had 'been lucky to have been born into such a land as this'. Wales was extremely fortunate to call him one of its most distinguished sons, and ambassadors.

In 2011 the Archbishop said of Kyffin that, although he did not make a public show of his beliefs, he did in his subconscious often portray religious themes. Dr Morgan recalled how Kyffin had commissioned Jonah Jones to carve in Welsh words from the scriptures on a slab of slate above his hearth at Pwllfanogl. He had also presented the Archbishop with three religious paintings, two original works by himself and a third based by Kyffin on a painting by the devout Venetian painter, Gentile Bellini.

In 2007, a headstone was placed in the churchyard at Llanfair-yng-Nghornwy, designed by the sculptor Ieuan Rees, with the simple wording, 'Kyffin Williams RA 1918-2006'. The stone is a slab of Welsh slate, from 'the mountains of his home'.

Kyffin had invited Ieuan Rees to become a member of the Royal Cambrian Academy of Art and they had known each other for a long time. Ieuan felt it a great honour to be asked to design Kyffin's headstone and explained his approach in a recent conversation:

> In one respect, I considered Kyffin to be very much a country gentleman; his memorial had to be dignified, respectful, regimental even. In another respect, Kyffin was very much a painter, with his heart in the mountains. To do justice, I had to decide on the one aspect or the other. I came to the conclusion that his true heart was in the mountains, therefore it was only appropriate to use Welsh slate, Welsh slate from Aberllefenni in the old Meirionnydd. I chose a piece of slate with a natural riven surface to reflect both the rough terrain that he loved so much as well as the textural qualities of his paintings. When we came to decide on the wording, it was felt that just his name was sufficient. There was only one Kyffin, there was no need to elaborate.
>
> Rather than use the customary design of a headstone sitting on a plinth, I felt it was only right that Kyffin's headstone should appear as if it came out of the earth. I was very proud to have been invited to do the work.

The headstone stands out amongst the other headstones in the graveyard at Llanfair-yng-Nghornwy, not because of its size or grandeur but because of its transparent honesty. Such was the son of Ynys Môn it commemorates.

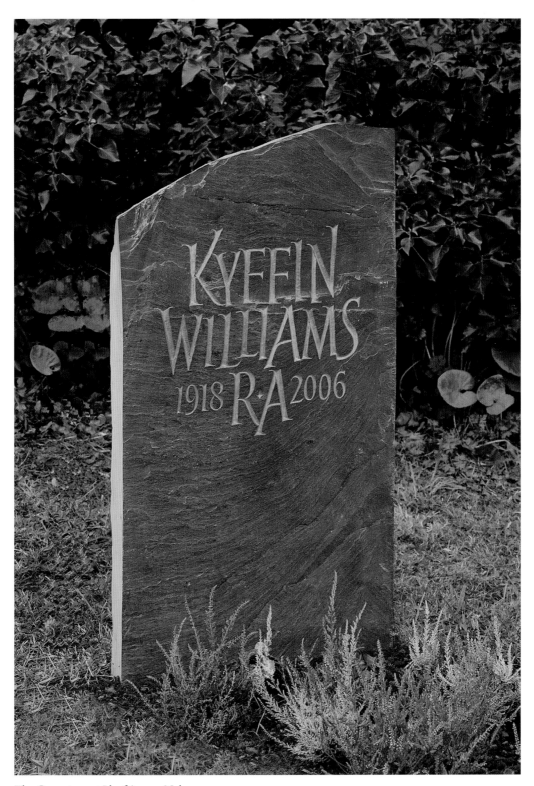

The Gravestone at Llanfair-yng-Nghornwy

Index

Picture and Copyright Acknowledgements

© Estate of Kyffin Williams. All rights reserved, DACS 2012: vi, x, 4 (bottom), 10 (private collection), 26, 52, 62, 70 (private collection), 76, 86, 89, 90 (private collection), 104, 108, 112, 114, 118, 120, 121, 122, 126, 130, 152, 154, 158, 192, 194, 198, 204, 208, 220 (private collection), 226, 232, 241, 242, 243, 248;

ITV Wales: ii, 226, 230;

John Smith: viii, 13, 18, 24, 28, 30 (right), 42, 60, 91, 96, 149, 163, 169, 188, 190, 192, 208, 210, 213, 215, 218, 258, 265;

Fflic Productions: 2, 4 (top);

David Meredith: 3, 7, 106; and for supplying the following images from Kyffin Williams's work: vi, x, 4 (bottom), 194 [photographer: Evan Dobson];

Cyhoeddiadau Barddas: 12 (bottom), 237 [photographer: Evan Dobson];

Oriel Ynys Môn: 12, 33, 56, 64, 66, 73, 125, 144, 148, 160, 197, 204, 229, 244;

National Library of Wales: 30 (left), 234, 235; also for supplying the following images from its collection of Kyffin Williams's work: 90, 108, 112, 114, 118, 120, 121, 122, 126, 130, 152, 192, 208, 232, 242, 243 (top), 248; and for permission to quote from Kyffin Williams's diaries: 247, 249, 250;

Highgate School: 78;

University of Wales Registry: 154;

Elin Wynn Meredith: 252;

Gerallt Ratcliffe/Daily Post: viii, 254;

Ieuan Rees: 269